Final Cut Pro 3 and DVD Studio Pro Handbook

LIMITED WARRANTY AND DISCLAIMER OF LIABILITY

THE DVD-ROM WHICH ACCOMPANIES THE BOOK MAY BE USED ON A SINGLE PC ONLY. THE LICENSE DOES NOT PERMIT THE USE ON A NETWORK (OF ANY KIND). YOU FURTHER AGREE THAT THIS LICENSE GRANTS PERMISSION TO USE THE PRODUCTS CONTAINED HEREIN, BUT DOES NOT GIVE YOU RIGHT OF OWNERSHIP TO ANY OF THE CONTENT OR PRODUCT CONTAINED ON THIS DVD-ROM. USE OF THIRD PARTY SOFTWARE CONTAINED ON THIS DVD-ROM IS LIMITED TO AND SUBJECT TO LICENSING TERMS FOR THE RESPECTIVE PRODUCTS.

CHARLES RIVER MEDIA, INC. ("CRM") AND/OR ANYONE WHO HAS BEEN INVOLVED IN THE WRITING, CREATION, OR PRODUCTION OF THE ACCOMPANYING CODE ("THE SOFTWARE") OR THE THIRD PARTY PRODUCTS CONTAINED ON THE DVD-ROM OR TEXTUAL MATERIAL IN THE BOOK, CANNOT AND DO NOT WARRANT THE PERFORMANCE OR RESULTS THAT MAY BE OBTAINED BY USING THE SOFTWARE OR CONTENTS OF THE BOOK. THE AUTHOR AND PUBLISHER HAVE USED THEIR BEST EFFORTS TO ENSURE THE ACCURACY AND FUNCTIONALITY OF THE TEXTUAL MATERIAL AND PROGRAMS CONTAINED HEREIN. WE HOWEVER, MAKE NO WARRANTY OF ANY KIND, EXPRESS OR IMPLIED, REGARDING THE PERFORMANCE OF THESE PROGRAMS OR CONTENTS. THE SOFTWARE IS SOLD "AS IS " WITHOUT WARRANTY (EXCEPT FOR DEFECTIVE MATERIALS USED IN MANUFACTURING THE DISK OR DUE TO FAULTY WORKMANSHIP).

THE AUTHOR, THE PUBLISHER, DEVELOPERS OF THIRD PARTY SOFTWARE, AND ANYONE INVOLVED IN THE PRODUCTION AND MANUFACTURING OF THIS WORK SHALL NOT BE LIABLE FOR DAMAGES OF ANY KIND ARISING OUT OF THE USE OF (OR THE INABILITY TO USE) THE PROGRAMS, SOURCE CODE, OR TEXTUAL MATERIAL CONTAINED IN THIS PUBLICATION. THIS INCLUDES, BUT IS NOT LIMITED TO, LOSS OF REVENUE OR PROFIT, OR OTHER INCIDENTAL OR CONSEQUENTIAL DAMAGES ARISING OUT OF THE USE OF THE PRODUCT.

THE SOLE REMEDY IN THE EVENT OF A CLAIM OF ANY KIND IS EXPRESSLY LIMITED TO REPLACEMENT OF THE BOOK AND/OR DVD-ROM, AND ONLY AT THE DISCRETION OF CRM.

THE USE OF "IMPLIED WARRANTY" AND CERTAIN "EXCLUSIONS" VARY FROM STATE TO STATE, AND MAY NOT APPLY TO THE PURCHASER OF THIS PRODUCT.

FINAL CUT PRO 3 AND DVD STUDIO PRO HANDBOOK

ADAM WATKINS

CHARLES RIVER MEDIA, INC.
Hingham, Massachusetts

Copyright 2002 by CHARLES RIVER MEDIA, INC.
All rights reserved.

No part of this publication may be reproduced in any way, stored in a retrieval system of any type, or transmitted by any means or media, electronic or mechanical, including, but not limited to, photocopy, recording, or scanning, without *prior permission in writing* from the publisher.

Publisher: Jenifer Niles
Production: Publishers' Design and Production Services, Inc.
Cover Design: The Printed Image
Cover Illustration: Adam Watkins

CHARLES RIVER MEDIA, INC.
20 Downer Avenue, Suite 3
Hingham, Massachusetts 02043
781-740-0400
781-740-8816 (FAX)
info@charlesriver.com
www.charlesriver.com

This book is printed on acid-free paper.

Adam Watkins. *Final Cut Pro 3 and DVD Studio Pro Handbook.*
ISBN: 1-58450-200-2

All brand names and product names mentioned in this book are trademarks or service marks of their respective companies. Any omission or misuse (of any kind) of service marks or trademarks should not be regarded as intent to infringe on the property of others. The publisher recognizes and respects all marks used by companies, manufacturers, and developers as a means to distinguish their products.

Library of Congress Cataloging-in-Publication Data

Watkins, Adam.
 Final Cut Pro 3 and DVD Studio Pro handbook / Adam Watkins.
 p. cm.
 ISBN 1-58450-200-2
 1. Video tapes—Editing—Data processing. 2. Digital video. 3. Final cut pro. I. Title.
 TR899 .W38 2002
 778.59'3'0285—dc21
 2002009292

Printed in the United States of America
02 7 6 5 4 3 2 First Edition

CHARLES RIVER MEDIA titles are available for site license or bulk purchase by institutions, user groups, corporations, etc. For additional information, please contact the Special Sales Department at 781-740-0400.

Requests for replacement of a defective CD-ROM must be accompanied by the original disc, your mailing address, telephone number, date of purchase and purchase price. Please state the nature of the problem, and send the information to CHARLES RIVER MEDIA, INC., 20 Downer Avenue, Suite 3, Hingham, Massachusetts 02043. CRM's sole obligation to the purchaser is to replace the disc, based on defective materials or faulty workmanship, but not on the operation or functionality of the product.

DEDICATION

As always, to my beautiful wife Kirsten. These five years with you have been the best of my life; I'm looking forward to being together for the 75 or so to follow.

CONTENTS

	PREFACE	xiii
	ACKNOWLEDGMENTS	xvii
CHAPTER 1	INTRODUCTION	1
	A Brief History of Editing	2
	Digital Video	3
	Why Final Cut Pro and DVD Studio Pro for DV?	4
	What You Need	6
	Computer CPU	6
	RAM	6
	Storage/Hard Drive	6
	Camera	7
	Optional (but Highly Desired) Equipment	8
	NTSC Monitor	9
	Analog Digitizers	9
	Deck	9
	Conclusion	10
CHAPTER 2	FINAL CUT PRO HARDWARE AND SOFTWARE SETUP	11
	Setting Up External Hardware from Scratch	12
	Preparing Your Computer for Work in FCP	15
	Setting Up Final Cut Pro	18
	Adjusting Preferences	24
	The General Tab	26
	User Mode Tab	29

	Timeline Options Tab	30
	Labels Tab	31
	External Editors Tab	31
	Scratch Disks Tab	31
Getting the Project Established		32
Conclusion		34

CHAPTER 3 LOGGING AND CAPTURE 37

A Definition of Terms	38
Timecode	38
Timecode Break	39
Drop Frame and Non-Drop Frame	39
Logging versus Capturing	40
Logging	41
Capturing	41
Effective Logging and Logging Practices	41
TUTORIAL: Logging the Final Cut Pro Way	42
VTR Controls	44
Marking Ins and Outs	45
Clip Information	45
A Few Added Notes about Logging	51
TUTORIAL: Capturing	52
Conclusion	58

CHAPTER 4 BASIC EDITING 59

Understanding FCP's Structure	60
Projects	60
Sequences	61
Bins	62
Clips	62
Interface Organization	62
TUTORIAL 4.1: Synchronizing China (or SyncChina)	65
Conclusion	89

CHAPTER 5 ADVANCED EDITING 91

Multiple Tracks and Multiple Sequences	92
TUTORIAL 5.1: Organizing Sequences	94
TUTORIAL 5.2: Getting Started with Multiple Tracks	95

Contents | **ix**

	TUTORIAL 5.3: Multitracks and Keyframes7	107
	Conclusion	126
CHAPTER 6	**REALLY ADVANCED EDITING**	**127**
	TUTORIAL 6.1: Placing Sequences within Sequences	128
	TUTORIAL 6.2: Nesting Sequences	133
	Clips and Sequence Effects	143
	TUTORIAL 6.3: Attribute Effects	144
	TUTORIAL 6.4: Cleanup	153
	TUTORIAL 6.5: Exploring Browser Effects	157
	Conclusion	166
CHAPTER 7	**ALPHA CHANNELS**	**167**
	Advanced Timeline Editing	168
	TUTORIAL 7.1: Preparing for Alpha	168
	TUTORIAL 7.2: Ripple and Roll Edits	172
	TUTORIAL 7.3: Slip Items (Slip Edits) and Slide Items (Slide Edits)	181
	TUTORIAL 7.4: Alpha Channels	185
	TUTORIAL 7.5: Goose's Control Center, or Keying	199
	Conclusion	225
CHAPTER 8	**INTERVIEWS AND TRANSITIONS**	**227**
	TUTORIAL 8.1: Interviews, Photo Montages, and Audio Work	228
	Conclusion	258
CHAPTER 9	**OUTPUTTING YOUR PROJECT**	**261**
	Output Method #1: Recording Timeline Playback	262
	Output Method #2: Printing to Video	269
	Leader	269
	Media	272
	Trailer	272
	Duration Calculator	273
	Notes on Print to Video	273
	Method #3: Edit to Tape	273
	Method #4: Exporting EDLs	274
	Notes on Creating EDLs	274
	Method #5: Batch List Exports	276

	Method #6: Exporting as QuickTime Movies, Stills, Audio Files, or Image Sequences	277
	Method #7: Exporting Final Cut Pro Movie…	280
	Conclusion	280

Chapter 10 — Theory of DVD Interface — 283

- Introduction — 284
- A Brief History of the DVD Medium — 284
- DVD Basics: Definitions and the DVD Format — 284
- Anatomy of a DVD Menu — 290
 - Defining Your Style — 291
- Theory of DVD Design — 293
 - Examples of DVD Menu Design — 296
 - Take Time to Look, Listen, and Learn from the Best in the Industry — 300
 - How Much Is Too Much? — 306
- Conclusion — 306

Chapter 11 — Preparing Files for DVD Studio Pro — 307

- DVD Studio Pro Media Formats — 308
 - Preparing Video and Audio — 309
- Tutorial 11.1: Exporting DVDSP-Ready Video Streams from FCP — 310
- Conclusion — 316

Chapter 12 — Introduction to DVD Studio Pro — 319

- Tutorial 12.1: Creating a Still Menu in Photoshop — 321
- Tutorial 12.2: Setting Up a Still Menu — 331
- Conclusion — 344

Chapter 13 — Motion Menus, Subtitles, and Other Advanced Features in DVDSP — 347

- Tutorial 13.1: Creating a Motion Menu — 348
- Tutorial 13.2: Creating a Motion Menu with an Overlay Picture — 352
- Tutorial 13.3: Outputting Your DVD Project — 359
- Conclusion — 362

APPENDIX A	ABOUT THE DVD	365
APPENDIX B	THE MATROX RTMAC	367
APPENDIX C	NOTES ON "RT" (REAL-TIME) EDITING IN FCP AND OFFLINERT	371
APPENDIX D	FINAL CUT PRO AND 3D ANIMATION	373
	INDEX	375

PREFACE

Digital video is putting the power of professional-quality video into the hands of mere mortals. Specifically, technology that used to only be available on editing suites that filled rooms is now available for editors to use on their desktops. Editors can work at home, animators can edit their work in full screen, and aspiring filmmakers can create their masterpieces on machines affordable to most. Harvesting this technology and power is what Apple's Final Cut Pro™ does best; and this book gets inside this harvested power to help the editor, the animator, the filmmaker, and the student master the tool.

DVDs are the fastest growing technology in history. Never before has a medium swept across the globe with such speed. More and more professionals, businesses, and families include a DVD player as part of their electronic repertoire. It wasn't long ago that creating a DVD viewable by the masses was an expensive, high-end project reserved only for the biggest and best film houses. However, as usual, the rapid development of technology has brought this media into the realm of mortal folks with even more mortal budgets.

Through the emergence of Apple's SuperDrive and now other third-party DVD-ROM burners, everyone (with minimal expense) can create and author their own DVDs accessible through most console DVD players.

WHY THIS BOOK?

Apple's Final Cut Pro has quickly emerged as one of the best editing suites on the market. Its economic price and fantastic power have, in a very short time, made a name and place for it in the market. When working with an Apple Macintosh computer, Final Cut Pro is the way to go for video editing.

Apple's DVD Studio Pro™ was introduced as the professional version of its free iDVD software package. Although iDVD has been getting lots of publicity, the true underlying architecture and power of personal computing DVD authoring can only be seen with DVD Studio Pro. Seamlessly integrated with the SuperDrive, DVD Studio Pro is tops.

These two top applications, both optimized for Apple computers, have another added benefit: they are optimized for each other. For this reason, we decided to write one handbook that covers both software packages. Final Cut Pro can't create DVDs, and DVD Studio Pro can't effectively edit videos. However, with these two software packages working together, major studios, independent filmmakers, animators, and freelance videographers can professionally edit videos and professionally author a final DVD output to rival any DVD output.

WHAT THIS BOOK IS

This book is a *tool* book. That is it analyzes how to use the tools of FCP and DVD Studio Pro. We will be looking at how to use FCP to edit smooth, effective pieces of motion picture using DV. Through this process, we will be looking at almost all the tools of FCP *in action*. As part of this, we will discuss the reasons for using certain tools, and what tools to use for certain types of editing effects.

WHAT THIS BOOK ISN'T

This book is *not* a manual; that is, there isn't a tool-by-tool breakdown of each tool. The tools are introduced in the order in which they assist in accomplishing the goals of each tutorial. We won't be grouping tools by their position on the screen or even by their usage.

This book is also not a book on how to edit. Editing is one of the most unsung, but most important parts, of all TV, film, or video. A good editor is a good storyteller—and a good editor understands a great deal behind the theory of storytelling. Although we will be glossing over issue of various editing jargon, this volume simply isn't big enough to cover all the subtle intricacies of good editing. We won't be spending a great deal of time on the theory of editing or continuity. There are, however, plenty of books out there that can help you in your quest to be a better editor-artist. This book is designed to help you become a great Final Cut Pro and DVD Studio Pro technician. We will be covering how to use the tools—the artistry is up to you.

BOOK ORGANIZATION

As you might have guessed by now, the book is split into two main sections—essentially, two books for the price of one. Section One is an in-depth look at Final Cut Pro (FCP) and some basic cinematography and editing concepts. Note, however, that although we cover some basic issues of editing timing and filming technique, this is not an aesthetic guide or technical manual on these editing practices or filming ideals. Our main focus is on the software and how to use it to create the product you envision.

In Section One, we cover how to capture media, manage the media, and edit the media together using the full arsenal of tools available in FCP. For this version of the book, we will be using Final Cut Pro version 3.x. Undoubtedly, there will soon be new versions of this software available; however, we will be covering concepts behind FCP, not just the software. This way, as the software evolves, you won't be left out in the cold.

Section Two is concerned with authoring the DVD using DVD Studio Pro (DVDSP). Specifically, we will be looking at how to integrate FCP projects into DVDSP. We will look at creating DVDs with slide shows, multiple chapters, alternate angles, still menus, motion menus, and other previously ultra-high-end techniques. As a special bonus, Michael Clayton, a colleague of mine at the University of the Incarnate Word, has contributed a special chapter on the aesthetics and theory of interface design. This added chapter will help move your DVDs solidly into the realm of professional design.

With two main arenas explored, feel free to dance back and forth between the sections. If you are already familiar with video editing, you might want to skip to the latter chapters of Section One, or even jump directly to how to output FCP products for use in DVDSP. If you were lured to the realm of video editing by the prospect of creating your own DVDs and have already used DVDSP, skip the last section and enjoy the coverage of DVDSP's sister product FCP. Either way, there's something for everyone here. Enjoy your movie making!

Acknowledgments

Extreme thanks to Jenifer for her patience and understanding during the writing of this book. Truly, you are an extraordinarily compassionate person.

Thanks for Apple computer for creating such great software that empowers me as an editor and animator.

Thanks to Ana Dias at Matrox for the use of the RTMac.

Thanks to my parents for their understanding during the production of this book. I promise, I'll visit more often now.

Lots of love to my best friends, Amber, Seth and little Jodi.

CHAPTER 1

INTRODUCTION

Interestingly enough, this chapter is largely a technical theory chapter. We will discuss what digital video is; a little of the history of video editing; and how non-linear digital video editing emerged, what it is, and its benefits. Additionally, we'll cover DVD technical specifications and take a look at what hardware is needed to use these new developments in digital video. If you are familiar with the technology or simply don't have much of an interest in it (although having a sound understanding is a wise move as it can make you a self-sufficient problem solver if problems arise at you own studio), then skip to Chapter 2, "Final Cut Pro Hardware and Software Setup," and tear into Final Cut Pro. If not, let's get techy.

A Brief History of Editing

In the beginning ... well, maybe not that far back, but a few years ago, editors worked with one of several film or analog video formats. Editing this way was tedious. Dealing with film meant that the editor had to physically cut and splice the film into one continuous project. If you were a video editor, you dealt largely with tape-to-tape setups. First, you laid down the first segment you wanted to tape, then fast forwarded through 50 minutes of video footage to get the second clip to lay down to tape, then rewound 20 minutes for the third clip—and on and on and on. The problem was that all this forwarding and rewinding was very, well, *linear*. To get to any point in the project you had to fast forward or rewind linearly to that point. Unfortunately, this made for very tedious editing processes. Not only did these editors spend a great deal of time waiting for media to fast forward, but if a mistake was made or a change was desired, it was only with great weeping, wailing, and gnashing of teeth (plus an occasional pair of scissors) that a new clip could be inserted, or one clip shortened.

As computers burst onto the scene, products such as Video Toaster™ on the old Commodore Amiga began to be able to help digitize the process. As computers continued to evolve and the speed at which they were able to process information increased, new uses for computers in video became apparent. However, in these early days, the editing was still linearly based. However, when computers began to be able to store large amounts of information on a hard drive and become fast enough to process that data, well, then—the rules really changed.

With these new larger-capacity hard drives and faster processors came the ability to not only use a computer to control analog devices or

lay additional titles or visual touches to a tape, but to actually bring the footage on the tapes into the wholly digital world of the computer. The ability to *digitize* video (the process of transforming the analog information on a camera or videotape deck into digital information directly accessible by the computer) meant that the computer was able to store footage. This computer-stored footage was *non-linear*; that is, you could jump almost instantly from any point of the digitized footage to any other point in the digitized footage. Moreover, digitized footage (which is usually edited in a Timeline (more on this later)) could be moved around in chunks to any place within the video project—similar to copying and pasting elements in a word processing program. Thus, non-linear digital video editing (NLDVE or NLDV) was born.

DIGITAL VIDEO

Digitizing video, the process of converting the analog TV signal or film into a digital one, is quite an amazing achievement of computing technology. Consider this: video runs at about 30 fps, or nearly 30 frames per second. For a computer to digitize one second of video, it must take each frame individually and divide it into horizontal lines that must be converted into the pixels of color information that computers deal with. For NTSC (the standard in the United States and Japan), it divides this into 640 pixels, each with an individual red, green, and blue value. 480 lines later (that's 307,200 pixels), the computer has digitized *one* frame. Therefore, if each pixel uses about 3 bytes of disk space, for a computer to capture one frame it must process and store 921,600 bytes, or .9MB. This would make each second (30 frames) of digitized footage 27.6MB!

As the technology of digitizing evolved, it was discovered that the human eye is more receptive to brightness than to color. Therefore, a new model, YUV (where Y is for intensity and is measured at its full resolution, and U and V are used to distinguish color difference signals and are measured at one-half or one-quarter resolution), was developed. Digitizing a YUV signal only requires 2 bytes to represent true color, so one second takes 18.4MB (640 × 480 × 2)—still, an amazing amount of data to be processed so quickly.

Not long ago, the only way to do this was by adding hardware in the form of video capture cards. Typically, these cards were expensive, required increased overhead in system extensions, and often took a large amount of energy and time to get to function as designed. However, recently, digital video (DV) burst onto the scene. DV and mini-DV cameras

actually do all the digitizing work. Rather than writing to hard drives, these cameras write digital information to a magnetic tape. Therefore, when moving data from a DV tape to the computer, the computer is simply transferring the information rather than spending a huge amount of processor power digitizing any analog signal.

Digital video has other benefits as well. Analog video, with the exception of late-model beta-sp, is certainly not at the top of the quality paradigm. No matter how pristine the digitizing process, if the recorded footage was recorded on VHS or SVHS, the quality is simply not there to digitize in the first place. Even low-end DV cameras typically provide better footage than any VHS or SVHS cameras do, by nature of the media (DV tapes) on which it is captured.

However, the biggest benefit for our purposes here is that the digital camera becomes, in essence, the digitizing video card of your Mac. Some capture cards are still of immense value (e.g., the Matrox RTMac, which we discuss later), as they are often the best way to capture footage that was stored on non-DV media. Not only does it become the way for video to come into your computer, but also the way to output video from your computer to other analog formats. Specifically, it becomes the method of viewing your editing on an NTSC or PAL monitor. More on how to set this up later.

WHY FINAL CUT PRO AND DVD STUDIO PRO FOR DV?

NLDV has been around for a few short years. In those years, several hardware-driven packages have emerged. These systems (Avid, Targa, Media 100) are fantastic professional systems at a fabulously professional price. Fast as they might be, purchasing one station often consumes the entire yearly budget of mid- and low-range editing houses. Software solutions such as Adobe Premiere have also been around for quite a while. Unfortunately, software solutions require so much rendering time that most folks, other than the hobbyist, simply don't have the time to wait around for these software-driven solutions to do their job.

Apple began to turn the tide with the release of its FireWire technology. FireWire (IEEE 1394) is a protocol that allows for a huge transfer of information from device to device. The real power comes from its capability to transfer huge amounts of information from devices such as a DV or mini-DV camera to a PC. When Apple released Final Cut Pro that used their own developed FireWire technology, all of a sudden a software solution that functioned at nearly the power and speed of the $50k

hardware systems emerged. Although still a software-based solution, FCP is able to seamlessly communicate with DV cameras for smooth video input and output. An off-the-shelf system can be used to edit "broadcast quality" TV productions. Indeed, with enough hard drive space, feature films are edited with FCP. The coup has been that FCP is well within the budget of most any editing, multimedia, or video houses, and creates quality on par with packages 10 to 20 times more expensive.

Since FCP works so seamlessly with DV and mini-DV cameras, it eliminates the need for added video-capture/video-output hardware. As more and more companies see the quality and ease of use that FCP provides, more and more are adopting it as their inhouse tool to use.

During recent visits to a variety of multimedia and video production houses here in San Antonio, Texas, more than one were "upgrading" their single $35k hardware-based editing system to three, four, or five FCP systems. FCP can speed your own workflow, lower your costs, increase your quality, and potentially increase your employability.

With the release of its SuperDrive, Apple entered the consumer-level DVD production arena. Although much of the recent marketing has been aimed at the consumer-level production of home DVDs using iDVD, Apple has also produced an incredibly powerful DVD authoring system called DVD Studio PRO (DVDSP). Although still young and with its share of quirks and growing pains, it has put professional-level DVD editing, scripting, and production into the hands of the mere mortal. So much so that video production houses everywhere are offering DVD output for their clients. As DVD is the fastest-growing technology ever, and more and more consumers are demanding DVD quality, not being able to provide DVD to clients is a serious disadvantage indeed.

Therefore, with an Apple Mac, Apple Final Cut Pro, and Apple DVD Studio Pro, you have an editing and output solution all in one company. This lends its own difficulties, but provides an overall seamless workflow. The software becomes increasingly streamlined to match the hardware, and vice versa.

Therefore, this book is written with this overall workflow in mind. We will be covering projects and tutorials that are captured and edited using FCP with an eye to output on DVD. We will take time to talk about other outputs as well, but the focus will be on using FCP and DVDSP to edit and create professional-quality DVDs for use in consumer DVD players.

WHAT YOU NEED

What you *need* and what you *want* are, of course, two different things. To further complicate the issue, there are multiple layers of need depending on your requirements of speed, quality, final output, and cameras. As of Final Cut Pro 3, the level of what is needed begins to become a bit clearer.

Computer CPU

For FCP 3 to work with any type of reliability, you will need to have at least a blue-and-white 350-MHz G3. This machine has some key components that are vital to digital video editing, the most important of which is FireWire. Without FireWire, FCP is just another software package and doesn't really rise to the level of a professional editing package. To use some of the newer capabilities of FCP such as real-time transition previews, you will need to have at least a G4 500-MHz machine. G4 Titanium PowerBooks will work well for a portable solution. One of the most amazing things to emerge is the iMac G4 that makes for fairly powerful little editing stations.

RAM

As usual, the more RAM the better. RAM becomes particularly important if you want to use some of the powerful tools such as RAM previews. Plan on *at least* 512MB of RAM. Although reasonably reliable at 256MB, RAM is cheap, and if you want to do any switching back and forth between FCP and a program such as Photoshop, you will need the RAM.

Storage/Hard Drive

No matter what machine you have, plan on big hard drives—as much as you can afford. We suggest hard *drives* because an optimal setup includes one hard drive for your applications and operating system (OS), and another for your captured media. This isn't absolutely necessary; in fact, if you are using a portable solution such as a TiBook, it isn't even a possibility (unless you go external). We've done many an editing job on a machine using one large drive for both applications and video footage storage. But, again, hard drives are cheap. Even though FCP 3's Media Manage continues to improve, if you are online for a big project, there is nothing more annoying than having to stop to clear space on your hard drive. If you are using a TiBook or an iMac, this means working

with external drives, which are a bit more expensive, but in the long run, worth it.

Many different types of drives are available. Not long ago, RAIDs, SCSI, or Ultra-SCSI were the only hard drives fast enough to handle digital video. With the advent of FireWire and the CODEC (more on this term later) that accompanies it, slower, less expensive drives will suffice. We won't delve too deeply into all the different hard drive options here, but, in general if you are using an internal drive on a G4/G3 tower you can use EIDE, ATA, and UltraATA drives. If you are on an iMac or Ti-Book, your only real option is an external FireWire drive. Some editors claim that 5400-rpm (revolutions per minute) drives will work for IDE or FireWire drives; however, we have found that the most reliable setup is to ensure that your drives are spinning at least 7200 rpm.

FCP suggests that you will need 1GB for every five minutes of video. However, keep in mind that you will tend to shoot and capture footage at a ration of 3:1 to what you will actually use in the final project, so don't figure on having a 10GB drive for a 30-minute project. Plan on capturing up to 90 minutes' worth of footage for the 30-minute production. To compound this number, remember that as you create transitions or other text on screen or special effects, FCP creates new clips that must have a place to live as well. Therefore, plan on having enough space for 5:1, or about five times the space you will need for your final project.

Camera

Strictly speaking, a camera could indeed be an optional piece of equipment. However, you probably already have one that you use extensively or you wouldn't be reading this book. What camera to use or buy, and even what format to tape in, are beyond the scope of this volume. Some low-end formats such as Hi8, Betamax, VHS, SVHS, and 8mm are floating about. However, these formats typically provide substandard quality and should be avoided if possible. For the majority of this book, we will assume you are using a DV or mini-DV camera. However, there are other options that work well, including DVCAM, DVCPro, 3/4″ U-matic, D-9, BetacamSX, D1, D2, D3, D5, D5HD, D9HD, and HDCAM.

Make sure that whatever camera or deck that you use to preview your footage has FireWire (sometimes called iLink or IEEE 1394). Without it, bringing your footage into FCP is a more complicated matter. The following is a list of cameras that are "qualified" to work with FCP. Many of these cameras come with various caveats, so be sure to check out www.apple.com/finalcutpro/qualification.html for the specific issues that surround your particular camera.

Canon Elura	DCR-PC10
Elura 2	DCR-PC100
GL1	DCR-TRV7
Optura	DCR-TRV8
Optura Pi	DCR-TRV10
Ultura	DCR-TRV11
Vistura	DCR-TRV17
XL1	DCR-TRV20
XL1s	DCR-TRV120
ZR	DCR-TRV310
ZR10	DCR-TRV320
ZR20	DCR-TRV510
ZR25	DCR-TRV520
ZR30 MC	DCR-TRV530
JVCDV600UA	DCR-TRV720
GRDVL815U	DCR-TRV730
GRDVM55U	DCR-TRV900
GRDV20000U	DCR-TRV7000
GRDVP3u	DHR-1000v
GY-DV55OU	DCR-VX1000
GY-DV700WU	DCR-VX2000
Panasonic AG-DV2000	DSR-11
AJ-D250	DSR-20
PV-DV100	DSR-30
PV-DV200	DSR-40
PV-DV400	DSR-1500
PV-DV600	DSR-PD100A
PV-DV800	DSR-PD150
Sony DCR-PC1	DSR-1600
DCR-PC5	DSR-1800
DCR-PC10	DSR-2000
DCR-PC100	DVMC-DA2
DCR-TR7	DVMC-MS1
DCR-PC1	GV-D300
DCR-PC5	GV-D900

OPTIONAL (BUT HIGHLY DESIRED) EQUIPMENT

"Highly desired" means that your life will be so much easier if you have this optional equipment. It also means that it is really a *want* and not nec-

essarily a *need*. Do consider carefully all of the equipment discussed in the following sections. If you are into video editing for the long haul, you really will need these important tools.

NTSC Monitor

As you work in FCP, what you see on your computer monitor is a low-resolution version of the data that FCP is actually using. To get a good idea of what is actually happening and to see what type of quality you are really looking at, it's necessary to have some type of NTSC monitor. Many professional NTSC monitors are available in almost any city, but if you are tight on funds, a regular color television with RCA jacks will do in a pinch. This TV or NTSC monitor is the most "highly desired" of the options in this list. It is important that you have an idea of what your colors are doing and how your project looks on a TV. Besides, it is always more fun to get a good idea of the type of quality you are really working with as you edit.

Analog Digitizers

If you are in the situation of having a lot of footage shot with a nondigital interfaced camera, or if you have some stock footage on Beta or VHS, then you will need some way to get this analog information digitized. There are many different digitizing cards on the market. Just a few are listed on Apple's site of "qualified" devices—we've had the best results with the Aurora Igniter and the Matrox RTMac cards. Again, many people never need a digitizing card, but if you have any media that is important to digitize, the investment will very quickly pay off.

Deck

When you are ready to capture footage via a FireWire-capable camera, you will be using VTR controls. VTR stands for *videotape recorder*, and typically refers to high-end equipment. In the capture window when it refers to VTR, it is referring to the fact that it is using your camera as a deck. Decks are usually machines ready for lots of playing, fast forwarding, rewinding, stopping, and overall wear and tear—your camera is usually not designed for this.

For small projects or capturing long footage clips, using your camera as your VTR or deck is not a problem. However, over time, all the stopping and starting can begin to wear down your camera's motor. If you are working in large volumes, a good deck is simply worth the investment. A

deck will last you many camera motors' worth of capturing. This leaves your camera to do its visual job, and the deck to do the hard physical labor.

Conclusion

Okay—enough of hardware talk. Well, actually, there will be much more later, but enough for now. There's a lot of theory that we haven't even touched on in this chapter. We will save the nitty-gritty theory and reasoning to each chapter, but, hopefully, this chapter has given you an overall look at digital video and what you need to work with it. Now on to grabbing the information that will allow us to do what we came here for!

CHAPTER

2

FINAL CUT PRO HARDWARE AND SOFTWARE SETUP

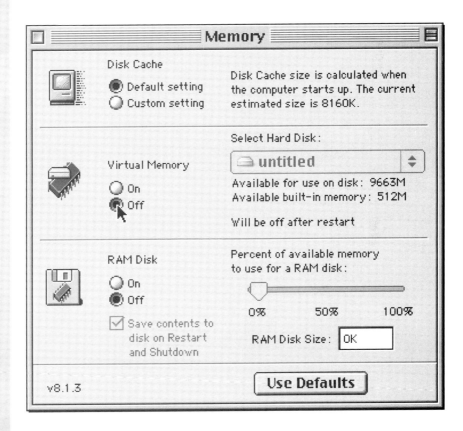

As discussed earlier, one of the most powerful parts of FCP is its integration with Apple's hardware. Although more powerful than Premiere or After Effects alone, without proper utilization of the hardware possibilities you might as well be using Premiere or After Effects. When the hardware is appropriately arranged and configured, FCP and your Mac become a complete synergistic editing studio much more powerful than the simple sum of the parts.

If you have not set up your machine to run FCP, keep on reading; if you are already set up and know that your setup works, just skim through this section. Remember, though, that there are a few issues (especially with speakers) that might not be what you expect, so take a quick look.

SETTING UP EXTERNAL HARDWARE FROM SCRATCH

1. Assuming that you are setting up your FCP studio from scratch, unplug everything (including your speakers) from your Mac except your monitor, keyboard, and mouse.
2. Using your FireWire DV connection cable (Figure 2.1), connect your DV camera or deck to your Mac.

 One of the much-lauded benefits of FireWire is its capability to be hot-swappable. That is, you needn't turn off your machine or camera to plug in the device—so just plug away. Take care with the small end of the cable that goes into your camera, as it is very susceptible to being bent or broken. A bent end means that cable is finished, and FireWire cables aren't cheap.
3. Attach an NTSC monitor or TV to your camera's AV In/Out port.

 When you plug your camera into your CPU via FireWire, what you are actually doing is installing an external digitizer to your Mac. As discussed earlier, your camera is the digitizing device, as it records information digitally to the DV or mini-DV tape. Considering the camera as your digitizing card also means that the camera or deck will act as the output device outputting analog information. Most cameras come with some variation of a 1/8″ AV In/Out plug (Figure 2.2). The one shown in Figure 2.2 is the Canon version. This is the plug that outputs a digital signal ending in RCA plugs. These RCA plugs can be plugged into most devices, including TVs, NTSC monitors, VCRs, and other decks. For a prosumer level setup, plug these RCA jacks into a VCR that is attached to your TV or NTSC monitor. This will allow you to check your composition and colors on the TV,

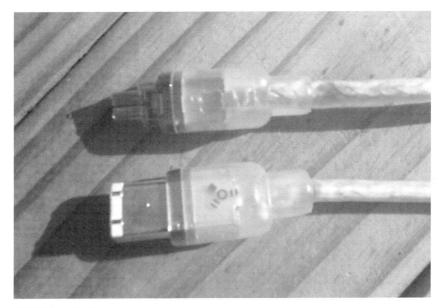

FIGURE 2.1 A FireWire cable. Take care with the small camera end.

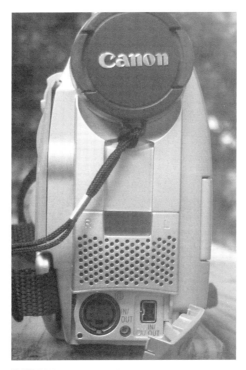

FIGURE 2.2 AV In/Out Plug on a Canon ZR-10.

and very easily record a quick version of your editing composition to tape.

4. Attach your computer speakers to your *camera*.

Another true benefit of the FireWire technology is that it not only transfers video from device to device, but also carries the audio with it. If you have a TV, you can actually use the speakers in the TV as your audio monitor. However, most small TVs have rather poor speakers, and many don't have stereo input or output. To rectify this problem, take your computer speakers and plug them into the camera's headphone jack. Note that you cannot use Apple's Pro Speakers—they are typical proprietary Apple hardware that only plays well with an Apple CPU. Moreover, if you are using the new USB speakers, they will need to remain connected to your Mac. However, most people have a pair of computer speakers laying around that usually have better sound than the TV that you are using to monitor your edits. This takes your speakers out of commission for other applications, but will give you a good, clean, and accurate view of your sound output.

Don't be seduced with the capability to have FCP output audio through the CPU. Although you can get sound to come from your CPU, when you are attached to a FireWire camera or deck, the most accurate sound is that which is traveling on the FireWire along with the video. If you are using your TV to monitor your video, but are using your CPU to drive your sound, you will find that the sync is never quite "on." Therefore, on those projects that deal with very accurate cuts, or cuts to the beat, you really need the speakers connected to the camera.

If we wanted to create a simplified schematic of the hardware setup, it would look something like Figure 2.3. Remember that when setting up your hardware, although your Mac is doing most of the work and is the device you deal with primarily, it is actually the camera/deck that is the center of the digital setup.

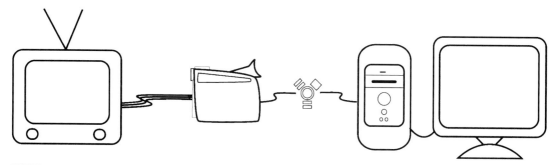

FIGURE 2.3 Schematic drawing of the external hardware setup.

PREPARING YOUR COMPUTER FOR WORK IN FCP

After all your external hardware is set up, there are some things that you will want to do to your Mac to make it more optimized to edit digital video. Some of these steps you will want to do at the beginning of every project, while others need to be done just once when you first set up your system. In either case, make sure that you spend some time optimizing your system to keep your workflow smooth and your output fast.

1. Install that second hard drive.

 You probably already have a second hard drive installed either internally or externally (via FireWire) on your machine; if you don't, do it now. Hard drives are very inexpensive devices and there really is no reason not to dedicate one to media storage. In a pinch, your standard hard drive will do, but if you are serious about editing, be serious about the necessary hardware and drop the extra $100 for an extra hard drive. From here on, we will refer to this second hard drove as the "media" hard drive, as it will store all of the captured and stored media for the editing projects.

2. Optimize your media hard drive.

 Digital video is considered a *lossless* compression—that is, it has no loss of data. When capturing footage from your camera (via FireWire), you are actually transferring data straight from one medium to another. What this means is that you are storing huge amounts of data on your media drive. In order for FCP to run well, it needs to be able to access this data easily and quickly. Making sure that your hard drive is optimized to allow for this will keep you in the groove.

 Many digital video guides suggest segmenting your media drive with the reasoning that it optimizes the space. Personally, we would argue against this. The first problem is that if you need to capture a very large clip, FCP might have to actually split the captured clip between two partitions, thus defeating the purpose of a large drive. Second, it's simply easier to have all your media on one physical and virtual drive—when you need to clean things up, you only need to do so for one drive. In general, not partitioning your drive ends up saving you time in the long run.

 The best way to optimize your drive is to make sure and use something such as Disk Utility to "wipe" your drives clean. Don't just delete all the files on the drive; use the "Erase" function of Disk Utility to truly clean up the drive. This will eliminate any fragmentation that might be lurking in the halls of the drive and give you a tightly knit group of magnetic particles to begin writing to. In general, after each major project, back up your captured media and erase the

media drive. This will optimize your process and keep your hard drive running efficiently, storing and retrieving media quickly and without a hitch.
3. If you are using OS 9.x, adjust the memory allocation.

If you are working in OS 9.x, you will want to adjust the memory allocation for FCP. *Memory allocation* is the amount of memory that Mac OS allows a certain program to use. Standard allocation right after installation is usually fine for small projects, but if you plan to do any serious editing or deal with long clips, you will want to adjust this. To adjust the memory allocation, find your FCP application on your hard drive and single-click it. You can then press -I and change the Show: Setting to Memory. Alternatively, go to File>Get Info>Memory (Figure 2.4) and change the preferred size to at least 256000 K (meaning 256MB). This, of course, is assuming that you have over 256MB of random access memory (RAM) in your ma-

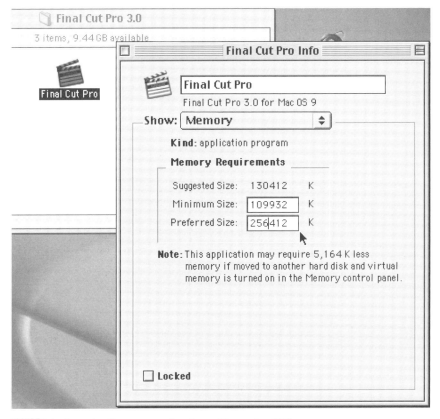

FIGURE 2.4 Accessing the memory allocation settings using OS 9.x.

chine (which is highly recommended). By allowing FCP to have access to more of your RAM, you are empowering FCP to work better for you.

Among the improvements that Mac OSX brought to the table, memory management was one of the most welcome. If you are using FCP with OSX, no need to worry about memory other than realizing that the more memory you have, the smoother FCP runs. Mac OSX will simply give FCP whatever memory it needs when it needs it.

4. If you are using OS 9.x, disable Virtual Memory.

 Go to the Apple pull-down Menu>Control Panels>Memory, and change the Virtual Memory setting to Off. You will need to restart for changes to take effect (Figure 2.5).

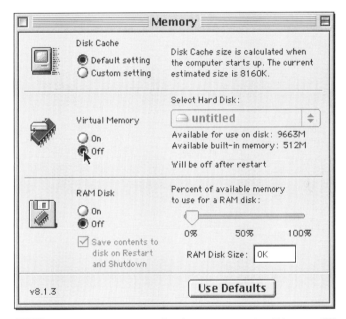

FIGURE 2.5 Memory control panel. Make sure to turn Virtual Memory off if using OS 9.x.

Virtual memory is Apple's way of substituting your hard drive for RAM. Although this seems like an inexpensive way to increase your memory to infinitum, it actually has all types of bad effects for FCP.

The first problem with virtual memory is that it accesses your hard drive. If there is one thing that FCP must be able to do, it is access your hard drives (especially your media drive) completely unimpeded.

If your hard drive keeps getting used for storing little bits of information intended for RAM, FCP will have to wait in line for data. Waiting in line means that FCP cannot get the data it needs when it needs it, which will result in dropped frames and a great deal of frustration. Also problematic to virtual memory issues is the fragmentation that happens to your hard drive. With virtual memory active, little chunks of data keep getting written and erased off your hard drive. All this dumping and emptying begins to leave little holes where data should be. These holes end up making your hard drive run slower because it has to cover more ground to get the important information.

The second big problem with virtual memory is that it's slow—very slow. RAM is fast because the storage medium is static; that is, no movement. When the computer needs to dump information, it puts it in RAM, and when it needs it, it grabs it quickly because the data hasn't moved anywhere. If your hard drive is acting as RAM (as it is when you are using virtual memory), your Mac will drop some data on the hard drive, and then the hard drive will have to spin to access some more data somewhere else. Then, when your Mac needs the data dumped as part of the virtual memory process, it has to spin the drive again to track down where the data is. Since FCP's smooth workflow depends on your computer being able to access data quickly, virtual memory can cause many problems as time goes on.

[Big sigh of relief.] Your hardware is all set up. Note that some of the things listed previously are only needed for OS 9. In addition, note that many of these new settings for memory are easily changed, so it's no problem to switch a setting or two back for other applications when necessary. Just make sure that before you launch FCP again, you switch things back. The preparation discussed previously might seem like a lot to deal with, but when you get in the editing groove, nothing is more frustrating than having to take time out to find out why you are dropping frames or why your sound will not stay in sync. If you can avoid the potential problems with careful setup, your work will go smoother and you will get much more done.

SETTING UP FINAL CUT PRO

Along with the power of FCP comes *a lot* of settings—and we are really talking *a lot*. These setting allow us to alter and change almost everything

about the working process, but they also are the reason for the vast majority of problems in FCP. In class, easily 8 out of 10 problems are related to an errant setting. Therefore, before we get into any of the details of editing, we need to make sure that our tool, FCP, is configured correctly. There are slight differences between OSX and OS9, so take careful note of which is which in the following discussion.

In either OS9 or OSX, Final Cut Pro attempts (as is consistent with Apple's overall GUI theory) to provide the same interface as the one you left. This means that if you change things around in FCP for one project, finish the project, shut FCP down, and come back the next day, upon opening FCP, you will be presented with the same interface and even the same project. This is nice if you want to work on the same project, because you can just pick up where you left off. However, this can be a disaster when starting a new project. Sometimes, as you work on a project you will need to make adjustments to settings or tools; however, you don't want these changes to carry over into every project. Whenever you open FCP with the intention of starting a new project, it's a good habit to select File>Close Project. This will close out most of the windows and leave you with a setup similar to Figure 2.6.

This is a good start to clearing your digital palette, but there are other things to take note of. Often, FCP will keep the settings of the last project floating around in its preferences. Therefore, also get into the habit of checking to see if your Audio/Video settings and your Preferences are appropriately configured.

Let's start by making sure that our Audio/Video settings are set up correctly. The first time you launched FCP, you were presented with the Choose Setup dialog box (Figure 2.7). This dialog box allows you to set your Easy Setup from the beginning; this becomes the default Easy Setup for all future projects. However, as time goes on you might want to change this Easy Setup, which is primarily a way of selecting a group of preferences optimized for how you plan to work.

The simplest way to access the Easy Setup options (and thus your Audio/Video settings) is with Edit>Easy Setup with OS9, and Final Cut Pro>Easy Setup with OSX. The dialog box shown in Figure 2.8 allows you to select one of four or more presets. These presets are settings that include everything vital to your Audio/Video setup, including the size of your video, the frequency of your sound, and how your computer allows you to monitor the video you are capturing and editing. In general, the presets available (DV-NTSC, DV-PAL, OfflineRT-NTSC, and OfflineRT-PAL) are the only presets you will need. Of course, there are exceptions to this (e.g., if you are working with film or plan to be working primarily

FIGURE 2.6 After closing the last project, you will be presented with a workspace similar to this.

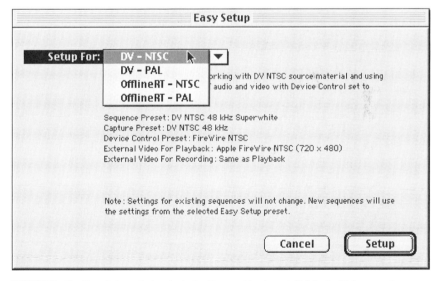

FIGURE 2.7 The Choose Setup window. This only appears the first time you launch FCP.

FIGURE 2.8 The Easy Setup window includes the most basic and vital Audio/Video presets.

with Web-distributed media), but in general, these presets will work well. In fact, for the next couple of tutorials, we will be using the DV-NTSC Easy Setup preset.

On occasion, you might want to change the presets and the Audio/Video settings. Access these with Edit>Audio/Video Settings in OS9, and Final Cut Pro>Audio Video Settings in OSX (Figure 2.9).

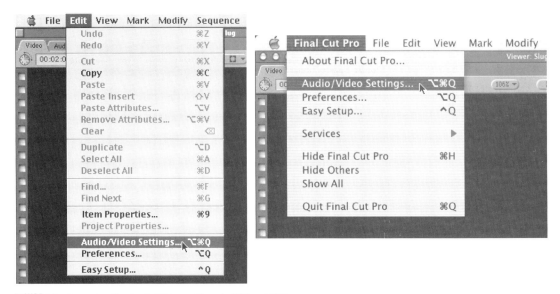

FIGURE 2.9 Accessing the Audio/Video settings in OS9 and OSX.

You will be presented with a dialog box similar to Figure 2.10. Notice that along the top of the window are several tabs that allow you to jump to various parts of the settings. The first tab is the Summary tab. Here you can make general changes to various parts of your Easy Setup using presets that are either included with FCP out of the box, or presets that you created.

By clicking on other tabs, you can create new presets. However, *use caution*—adjusting presets gets you further and further from what FCP is optimized for. Although you have complete control to change almost every attribute of every piece of your media, you might find that some alterations cause FCP's real-time editing capabilities to be thrown out the window. Compounding the danger of new presets is the reality that some presets (e.g., Sequence Presets) have very inflexible characteristics. For a Sequence Preset, once you have attached a preset to a sequence, the timebase (fps) become fixed; you cannot just go in and change the timebase of a preset for sequences already assembled. To shift the timebase in a preset for a sequence, you would have to delete all the media in the sequence and undo any work done previously.

FIGURE 2.10 Audio/Video Settings initial dialog box displaying the Summary tab.

Having stressed that caution, let's look at one more. If you *must* have a setup different from the presets included, don't just edit the presets created; duplicate the preset you want to edit, and edit the duplicate. Once you start changing settings around, it becomes very difficult to remember what you changed the settings from. Just as you would never want to destroy source media, don't destroy your source presets.

Therefore, if you must tweak presets, begin by selecting the preset you want to change, and press the Duplicate button (Figure 2.11). The resultant dialog box will allow you to shift the various settings of the Sequence, Capture, Device Control, or External Video presets.

Since adjusting presets is dangerous and discouraged, we will not delve into many of the particular settings listed here. The only real preset of note that you might want to be familiar with is the Anamorphic 16:9 option. Remember that if you activate this for the duplicate of the Sequence preset, you will also want to do so for the duplicate of the Capture preset in the next tab.

So, if it's best not to fool with presets, why did we even begin looking at them? Well, it's good practice to just take a second at the beginning of your project to make sure that the factory presets are what are selected and active before you begin capturing and editing. Although the chances

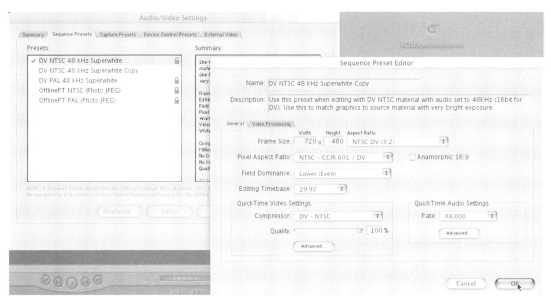

FIGURE 2.11 Adjusting presets by first duplicating the extant preset.

of these being changed are remote (unless there is more than one editor working on your machine), the pain you will endure if they are different is long lasting. It just takes a second to make sure that everything is set as it should be (typically, DV-NTSC Easy Setup), but it can save you hours of recapturing media.

ADJUSTING PREFERENCES

The preferences of FCP are a bit more flexible, but it is equally as important to have them right. Any problems with settings are usually buried in here. To access the preferences, go to Edit>Preferences…(OS9), or Final Cut Pro>Preferences… (OSX). There are a few very fortunate things about the preferences. The first is that the preferences out of the box are pretty darn good—usually, you don't need to change these at all. The second great thing about preferences is that they are incredibly powerful in problem solving and optimizing FCP for your project.

Unfortunately, there are a few unfortunate things about preferences as well. The first is that unwittingly setting a preference wrong can set you back hours as you attempt to track down the problem. The solution to this is, of course, to be *very* careful about changing the default preferences, and make note of what changes you make. Then, if you end up

with some unexpected performance problems you can go back and shift those preferences back.

The second problem is that FCP has such a good memory about preferences that are set. If you change a preference, it stays changed—even after restarting the computer or FCP. If your preferences really get changed around, so much so that you cannot remember how to get them back to what they were, you can change them back by following these steps:

1. Quit Final Cut Pro.
2. Find where FCP saves the preferences in the System Folder/Preferences/Final Cut Pro User Data (OS9), or Users/YourUserName/Library/Preferences/Final Cut Pro User Data (OSX). The file is "Final Cut Pro 3.0 Preferences" (Figure 2.12).

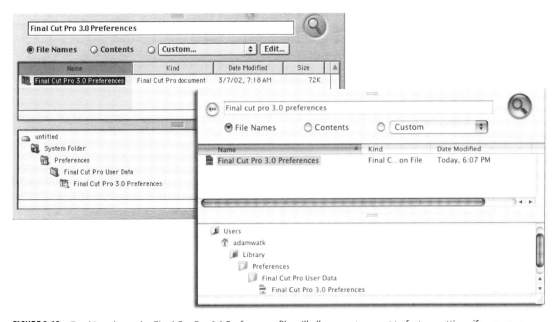

FIGURE 2.12 Tracking down the Final Cut Pro 3.0 Preferences file will allow you to revert to factory settings if necessary.

3. Throw this file away. Upon restart, FCP will create a new Final Cut Pro 3.0 Preferences file with the original "factory installed" settings.

This trick also works well if you find that tabs or windows that you know are usually visible as part of the interface have mysteriously disappeared, and you cannot seem to track them down. Although you can make almost any window or tab visible if it accidentally gets hidden or closed, sometimes it's just easiest to get a new set of preferences.

Therefore, having said that the factory preferences are *usually* great for most projects, let's move on to the preferences in case you need or want to shift the "factory feel" around.

The General Tab

The first tab in Preferences is the *General* tab (Figure 2.13). This tab is primarily concerned with preferences that affect the functionality of FCP in relationship to the user—you. Not all of these preferences are particularly relevant to most users, and some are beyond the scope of this volume. However, let's look at a few important ones.

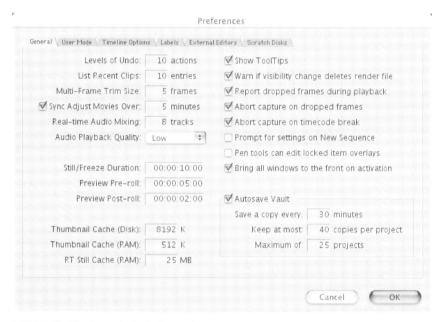

FIGURE 2.13 The General tab of FCP's Preferences.

Levels of Undo

One of the greatest things about FCP is the ability to do multiple Undos. That is, the ability to go back in your workflow several steps. It was not long ago that most applications only allowed for one Undo, so if you did something wrong and then did something else after that, the original sin was stuck. With these multiple Levels of Undo, you can repent several actions back. The default is set to 10, although you can have up to 99 levels

or as little as 1—neither of these is a really good choice. One Level of Undo abandons this important feature entirely, while high settings for Levels of Undo places an unnecessarily high strain on your RAM. Since your RAM is very important to the workflow and your effectiveness, you don't want to have it all tied up remembering what you did 97 steps ago. Set this to your editing style; if you are typically one who needs to jump back a whole bunch of steps because of poor planning or because you like to experiment as you edit, then leave this number higher. Although it would be wiser when experimenting to save sequential copies of your Project file with appropriate names so you can jump back to a version you liked better if your experimenting goes awry.

Sync Adjust Movies Over

This is the front end of a fairly technical issue; more technical than we want to delve too deeply into here. The basis of this setting is to empower FCP to get its fingers into the Audio/Video sync for clips of certain lengths.

Typically, FireWire DV does all the syncing work, but FCP assumes that sound coming in from a deck or camera is exactly 48 or 32 kHz. It makes sure that when the mouth is moving, the sound matches the shapes of the lips. However, sometimes with really long clips this sync can "slip." Sometimes, a camera or deck will actually record audio at a level slightly different from exactly 32 kHz or 48 kHz—this is where the slippage emerges. Regardless of the camera or deck you are using, this slippage can occur with large clips. In general, it is wise to leave Sync Adjust Movies Over activated, and the setting of 5 minutes is a good one.

The only real exception to this is when you are dealing with tapes with *timecode break*. However, as we will discuss later, timecode break is something so sinister that you will want to make sure that when you are capturing, you are not using a tape with timecode break anyway. Since we will be looking at ways to fix timecode break, don't be too concerned about ever turning this setting off.

Real-Time Audio Mixing

Sound was one of the areas in which early versions of FCP was very weak. As FCP has progressed, so has its sound capabilities. For the most part, FCP v.3 handles audio fairly well and allows for seamless and real-time editing of captured sound and imported sound. This setting allows you to tell FCP how many levels of sound it is allowed to attempt to mix in real time (or without rendering). If you have a particularly complex

audio design, you might need to increase this setting. However, if your video is complex and you have lots of clips and many layers, you will not want all of your processor power used for the audio. Lowering this value is sometimes a good way to buy yourself some flexibility in editing speed if you begin to get dropped frames. Audio mixes render quicker than complex video combinations do, and it's easy to tell FCP to render an audio mix.

Audio Playback Quality

When you capture audio/video from your DV device and you are using the standard DV-NTSC Easy Setup, you are capturing your audio at 48 kHz. 48 kHz is a pristine sound, and FCP works with it very well. However, you might be importing music or other foley (sound effects) that for some reason might be saved at a different frequency. In general, you want to try to keep all of your audio files that you will be working with at 48 kHz, but sometimes this cannot be avoided. Audio Playback Quality tells FCP how to deal with these *imported files*. It does not deal with audio imported through FireWire DV.

With lower qualities, your interface will stay snappy. You will be able to change the audio level and apply certain real-time effects to a large collection of sounds. Your layers of sounds accessible in real time are increased with lower-quality levels. As the quality level rises, the playback quality increases as you edit, but you will be forced to render the audio more often, thus slowing your workflow. In general, make sure that your audio is right at 48 kHz or whatever your Easy Setup is set for, and you can avoid having to worry about this at all.

The "Cache" Settings

The three settings at the bottom of the left column—Thumbnail Cache (Disk), Thumbnail Cache (RAM), and RT Still Cache (RAM)—are all ways to adjust the way in which FCP allocates its resources. By shifting these you are telling FCP that it can use more (or less) disk or RAM space for certain caches. Caches are little packets of information that FCP relies on to provide you a snappy interface—getting you the visual information as to what you are doing and where you are as quickly as possible. Remember, however, if you turn these settings way up, you will be able to quickly see thumbnails and RT Stills, but potentially at the risk of dropped frames during playback. In general, the default settings are spot on.

The settings in the right column are generally preferences that deal with how FCP communicates with you, the user. Some of these you

might want to turn off as your proficiency with FCP increases (e.g., ToolTips), while others you will *never* want to turn off, such as *Report dropped frames during playback*, *Abort capture on dropped frames*, and *Abort capture on timecode break*.

Dropped frames are the death of a capture process. Dropped frames during capture means that the computer was too busy, had too much going on, or was not able to write the data it was acquiring fast enough, so it had to "drop" some. Without the solid 30 fps (actually, 29.97—more on this later), your footage stutters, stumbles, and overall becomes useless. It is vitally important to know if there were problems during the capture process. Turning any of those settings off removes the safeguards that make sure your media captures cleanly.

The last two settings of the right column—*Prompt for settings on New Sequences* and *Pen tools can edit locked item overlays*—in general should be left off. If you begin to get several sequences in a project that have different settings, you will be in a constant state of rendering. It's best to pick settings for a project and maintain those throughout the entire project. Locking layers (much more on this later) is a way of safeguarding work that you have done earlier in the editing process. Allowing tools (e.g., the Pen tool) to work on locked layers really defeats the purpose of locked layers—leave this option off.

Autosave Vault

This is a really cool and easy feature to have. It's also a potential lifesaver for the "Save-Impaired." Often, editors get so involved in the editing process or so engrossed in the continuity of the project that they forget to save. Although FCP is an incredibly stable program, there always remains the possibility of it crashing, or you losing power, and so forth. The Autosave function actually saves your project at certain intervals (versions). Make sure you leave the Autosave Vault active. It can save your sanity in the unfortunate instance that you do lose power or crash with unsaved work. The settings in this part of the interface essentially allow you to define how much of your hard drive space is going to be allowed to be taken up with these Autosaved versions of your project. Usually, FCP project files are fairly small, so leaving the values high here is not a problem.

User Mode Tab

Leave this as Standard; changing to Cutting Station simply reduces your tool set.

Timeline Options Tab

Generally, this tab allows you to define what type of face FCP is going to present to you. Remember not to be seduced by some of these settings. For example, it's nice to have a Filmstrip setting for the Thumbnail Display (Figure 2.14), but this slows your movement in FCP tremendously. Likewise, it's great to have Filter and Motion Bars (Figure 2.14) to show you when a clip has a filter on it, and it can be really helpful to see the Audio Waveforms of your audio files (Figure 2.14)—but these all take up a lot of your machine's attention. It's far more feasible to activate Audio Waveforms for the audio tracks you need to see, and leave the rest without. In future tutorials, you will be able to see how slow even the fastest Mac becomes when it needs to present added visual information such as waveforms.

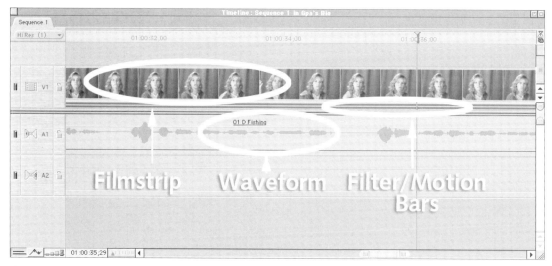

FIGURE 2.14 Thumbnail Display set to Filmstrip, Audio Waveforms, and Filter and Motion Bars. Nice to see, but slow to work with.

Something easy to pass over, but should be mentioned about the options available in this tab, is the Drop Frame option (Figure 2.15). If you are planning to use your project in any type of broadcast capacity, leave it on. We will talk much more in the next chapter about Drop Frame versus Non-Drop Frame, but for now, we'll just say that the default setting of having Drop Frame selected is a good one. Leave Drop Frame on.

FIGURE 2.15 In the Timeline Options, leave Drop Frame on. It will save you much pain and frustration.

Labels Tab

We will discuss later FCP's benefits and shortfalls of labeling clips as you log and capture them. The Labels tab allows you to shift the color choices assigned to these labels, and even change the names of the categories.

External Editors Tab

The ability to have another application process certain media and then bring those processed files back into FCP is really amazing. Unfortunately, it's so advanced that we will not be covering it much in this volume. The Final Cut Pro User's Manual contains some great discussion of the ins and outs of this feature, so, for this book, suffice it to say that you can define what application you want to process what types of files in this tab.

Scratch Disks Tab

Now we are into a *very* important part of FCP's functionality. If you are a Photoshop veteran, you are probably familiar with the concept of a Scratch Disk. As in Photoshop, Scratch Disk is the location that FCP can dump and grab large pieces of information as it works with them. If you have followed the recommendations listed earlier in the book, you have a separate hard drive—a media drive. This media drive is your primary Scratch Disk.

FCP will be dealing in large amounts of media currency. As you capture DV audio/video, you will be dealing with gargantuan files that will be combined and effected into combinations that FCP will need to render

into new, equally large files. Having a location to quickly drop and grab files is vitally important to smooth working in FCP.

On the most basic terms, this Preferences dialog box enables you to choose which drive you want to use as the Scratch Disk. Keep in mind that it's generally best to keep all your audio/video capture and render on the same drive (your media drive). If you are lucky enough to have multiple media drives, you can set your rendered files to be saved on a different drive. However, for most users, placing your audio/video capture and render on the same drive works great.

It's not really enough to simply set your media drive as your Scratch Disk, however. Your media drive is probably very large. When you select that drive as the Scratch Disk, and begin capturing media, FCP will create a folder "Capture" and place the captured media there. If you are the type of editor who deals exclusively with one project until it's completed and then starts the next, this will be fine. However, most of us are working on several projects at a time. Because of this, it's important that you take a minute to organize your Scratch Disk so that you control where things are going for different projects. Note Step 7 in the following tutorial to see how to optimize this preference to your advantage.

GETTING THE PROJECT ESTABLISHED

Okay, we're finally set up and have our preferences more or less established (except for Scratch Disks). *Projects* are the files in which Final Cut Pro stores all of your edits. It's important to note that a FCP Project file does not actually contain any of the media you are editing; rather, it contains links or references to where the various media can be found.

Organizing your media on your various hard drives is half the battle of effective editing, and all the battle when it comes time to back up work, or archive a finished project. Therefore, when you are ready to start a project in FCP, follow these steps:

1. On your Mac, on *any drive other than* your media drive, create a new folder entitled FCP Project Files, or something more to your liking. We will be storing the Project files of our tutorials here. You will want to be able to store your own projects in a similar folder—away from your media files.

2. On your media drive, create a new folder "TheNameOfYourFile_Media." If you are planning to follow the tutorials in subsequent chapters, you can label this "SyncChina_Media." The idea is that we will be using this drive as the Scratch Disk, and this folder will store

all the media of the project. Keeping all of our media together will make housecleaning easier and save tons of time when it comes time to wrap up a project.
3. Inside of this SyncChina_Media folder, create a new folder "SyncChina_CapRen." This folder will include the Capture and Render files for the SyncChina project. Now, as you follow the tutorial, you will not actually be capturing media to this folder, but we will set up the Preferences to render to this folder. For your own projects, as you capture media from your deck or camera, you will capture the files to this folder as well.
4. Back in FCP, make sure that you have no projects already open. If you do, select File>Close Project.
5. Now, create a New Project. You will be given a blank slate, and you should have all of your tools and windows available (Figure 2.16).

FIGURE 2.16 When a new project is created, you should have all of the tools and windows visible. If not, delete the Final Cut Pro 3.0 Preferences as outlined previously.

6. Save the Project (File>Save Project). It sounds weird to be saving things before you have done anything, but this will make sure that our Autosave functions are saving files with good names, thereby making it easier to track things down. Make sure to save this Project file in the folder FCP Project Files that we created in Step 1. If you are planning to follow the tutorials in this book next, then name this file "SyncChinaProject."

7. Open the Preferences (Edit>Preferences…[OS9], or Final Cut Pro>Preferences…[OSX]) and jump to the Scratch Disks tab. Here we want to make sure that FCP knows to store any captured or rendered files to the folder we created in the SyncChina_Media/SyncChina_CapRen folder. Just click the Set button, navigate to the folder SyncChina_CapRen on your media drive, and click Choose. After you have done this, double-check to see if the description to the right of the Set button matches what it should (e.g., Media Drive:SyncChina_Media:SyncChina_CapRen).

Something to note about this step is that it becomes incredibly important that when organizing files like this, you *must* set the Scratch Disks preferences every time to open a different Project file. If you forget, you will end up with footage of your baby mixed in with the footage of Chinese camels. Without remembering to set the Scratch Disks Preferences for every newly opened or re-opened project, you might as well not set up CapRen folders at all.

Now, you are ready to edit.

Conclusion

All of this seems like a lot of work—and it is. Once you set up your hardware, software, and General Preferences to something with which you are comfortable, you will not need to be constantly fooling with all the things we talked about. It will be simplified down into the seven steps listed in the preceding section.

You might think that those steps are labor intensive—they might be, considering that for most applications you simply select File>New and you are ready to go. Remember, however, that you are dealing with larger files and probably more files when editing in FCP than most any other application you can run on your Mac. Extraordinary projects require extraordinary measures. When it comes time to collect your files or put a project to bed, you will be very happy that you took the extra time to organize as discussed previously.

Now that we are all set to work, we can actually get to work. The next chapter covers capturing media, and the chapter after that gets into the nitty-gritty of some basic editing techniques. If you are new to editing in FCP, skip the next chapter and jump directly to Chapter 4, "Basic Editing." There, you will be able to use already captured media and hone your editing skills before tackling your own media. On the other hand, if you have media to use on DV or mini-DV, and you would rather use it as you go through the tutorials, then Chapter 3, "Logging and Capture," is the next chapter for you. Either way, read on—the best and most enjoyable is yet to come.

CHAPTER

3 LOGGING AND CAPTURE

In trying to determine what topics to cover and in what order, choosing where to put *logging* and *capture* is the ultimate chicken-or-the-egg dilemma. On the one hand, when actually working on a project, the first step (after the setup described in Chapter 2, "Final Cut Pro Hardware and Software Setup") is always logging and then capturing your footage. However, when trying to learn FCP, it's usually beneficial to be able to begin editing first so you know what FCP can do, and how to do it.

We have chosen to put logging and capture first. Some people like to jump right in and start doing the tutorials, but not in the traditional way of following the tutorial step by step using the included footage. Moreover, FCP is not for the faint of heart. A person just "fooling around" with digital video would be using free applications such as iMovie. If you have spent the money to purchase FCP, you probably have a clear idea of what you are going to do with it, and this chapter is for you. Capture your own media and use it in place of the sample media included in the following chapters.

For those of you who would rather get your hands dirty with editing, and do not have any specific footage to capture right away, skip to Chapter 4, "Basic Editing."

A Definition of Terms

Before we go too far, let's discuss some important terms that we will be using fairly freely in this and subsequent chapters.

Timecode

One of the benefits of DV is that the camera or deck understands exactly where the playhead is on the tape. Rather than the old method of "about 3 minutes 40 seconds into the tape," DV knows when it's 3 minutes 39 seconds and 14 frames into the tape. Not only does it know this, but will arrive at exactly the same frame every time you tell it to. While traditional analog video had a bad habit of resetting its counter to zero each time you turned the power off or put a new tape in, DV has absolute timecode (except in the case of timecode break; see the next section). This means that if you take a DV tape out, and then later put it back in, the camera or deck knows where on the tape the playhead rests. Therefore, it also knows how to get to any other place on the tape.

Timecode is usually represented in a series of numbers: xx:xx:xx:xx or xx:xx:xx;xx (depending on whether it is drop frame or non-drop frame). Timecode reads largest to smallest from left to right; that is, you

have Hours:Minutes:Seconds:Frames. Therefore, a timecode that reads 01:34:14;12 is 1 hour, 34 minutes, 14 seconds and 12 frames into the clip or tape. FCP has some incredibly quick and easy ways to manipulate timecode using just the keyboard. We will talk much more on this in the next chapter.

Timecode Break

This is bad news. Timecode break is when a tape has been removed and replaced into a camera and then recorded on again, or when a tape has been fast forwarded or rewound and not returned to *exactly* the same position on the tape before recording again commences. What happens in these situations is the camera again records a timecode of 01:00:00;00 at whatever point it begins recording again.

This means that you have two 01:00:00;00s on the same tape. Now, when you tell your camera to go to 01:15:23;26, it will go to whichever one is closest to its current position. Timecode break takes the absolute timecode reference and throws it out the window. In all reality, logging and capturing a tape with timecode break is a lesson in futility. Although it can be done, it is rarely worth the time and effort.

In order to regain your absolute timecode, you will need to transfer your footage off your timecode-broken tape and onto a new DV tape. You can do this by hooking two DV cameras or a camera and a DV deck together via FireWire and recording from one to another. It's important that you do this with FireWire, since that's the only way to ensure that the digital signal stays digital and that you have no image degradation in the transfer. By recording the entire contents of the timecode-broken tape to a clean tape in one continuous dub, your new tape will have clean timecode and be easy to work with.

Drop Frame and Non-Drop Frame

This is truly one of the weirder aspects of video. At the most basic level, *drop frame* (DF) and *non-drop frame* (NDF) are essentially two ways of counting the same media. Do not let the names confuse you; no frames are actually "dropped."

The idea is this: there are 29.97 frames per second of standard NTSC (the video standard used in the United States) actually *counted*, even though there are actually 30 frames there. However, when using NDF, every 30th frame is counted as a new second. The problem with this is that with a frame 0 and 30, you end up with extra frames over larger periods of time. A piece of footage that shows an NDF timecode of two

hours long would actually last two hours, seven seconds, and six frames. Confusing, right?

Now, this is not a big deal for most people. A change of seven seconds over two hours does not seem to be a big issue. However, if you are running a TV station and you are selling time for ads or scheduling the quick-fire change in programming, an extra seven seconds of time unaccounted for here and there makes a big deal. Therefore, DF emerged as a way of getting timecode counts to actually match real-world time.

What drop frame does is simply not count (in the timecode) frames 00 and 01, except every 10th minute. Of course, those frames are still shown, but are not counted. This means that a two-hour timecode of DF really lasts two hours—no extra time, no extra frames; the timecode and actual time match.

So, how does this effect you, the editor? Well, if you left the Drop Frame option checked in the Timeline tab of your Preferences (Figure 3.1) as described in Chapter 2, you are in great shape. Since DF is the standard for NTSC (the standard of video used in the United States), you want to be sure and edit in Drop Frame.

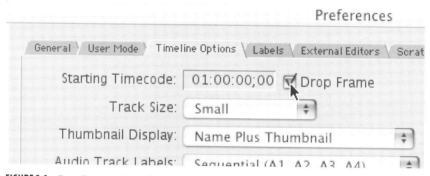

FIGURE 3.1 Drop Frame activated in the Timeline Options Preferences.

LOGGING VERSUS CAPTURING

Before we get too far into *how* to log and capture, we should first understand what these terms mean. Often times, people group these two terms together because they simply think they are doing both at the same time since FCP groups the log and capture functions into the same window. It's easy to think in terms of "I'm logging the clips I want FCP to capture." Unfortunately, although this might be acceptable for small, short projects, it is a very poor train of thought for complex projects that deal with a lot of raw footage.

Logging

Logging is the process of cataloging the footage you have on tape to keep a log, or record, of what footage is on which tape. The old-fashioned way of logging a tape was to simply burn in the timecode and write down in a notebook what was happening *about* when. With DV, you could do this as well if you choose; in fact, FCP has an interesting way of importing Excel spreadsheets that have logs organized appropriately. However, the easiest way to work with the idea of logging is to do so right in FCP.

Often, with small projects, you can afford to go through and just log the best clips with the idea that you will only capture what you log. With this method, you simply do not log any of the media you do not want, as you are not going to capture it.

With larger projects, where footage might be present on a variety of tapes and you might have hours of footage, it will be important to do a cleaner, more extensive form of logging. Basically, with large projects, especially when you might have more than one editor or assistant editor working on the project, log *everything*. This means logging the wasted space on the tape—for example, the times when the camera operator forgot to turn off the camera and recorded 10 minutes of his thigh as he carried the camera to the next position. Log everything.

This, of course, does not mean that all of this is captured. Logging does not actually bring any media into FCP; it simply keeps track of where things are. Logs are stored within the Project file and carry on through the entirety of the project. This is important as sometimes in the editing process, you discover that you need a clip that you did not capture originally. Because you have the log, you can quickly go back and capture the clip you want because FCP knows where on what tape that clip is.

Capturing

Capturing is the process of actually moving the digital information contained on the DV tape to your hard drive. Ideally, what to move from tape to hard drive has all been designated because of careful logging. You need not capture footage that you will not use. Capturing is about bringing online what you are going to use to make your project.

EFFECTIVE LOGGING AND LOGGING PRACTICES

Logging is a pretty easy process, so easy in fact that often people do not use the full power of FCP's logging capabilities. In the next section, we

are going to look at how to do general logs, and how to make use of the tremendous arsenal that FCP allows when logging tapes.

How to cover logging and capturing is a tough issue. Without common media, there really is not a detailed step-by-step process that can be put to paper and followed. What is included here is a general step-by-step guideline of how to make use of effective logging and then capturing.

Logging the Final Cut Pro Way

1. Label your tapes. Even though in the process to follow, FCP will know the timecode, it relies on you to make sure that you have fed it the appropriate tape. A tape without timecode breaks looks just like any other tape to FCP. In fact, if you have not taken the time to label the tapes, those two tapes might look exactly the same to you, too. Especially with large projects that have several tapes' worth of raw footage, it becomes *very* important to make sure you have those tapes labeled not only as part of that project, but so that they are also differentiated between other tapes of the same project.

2. Start Final Cut Pro, making sure that you *do not* get a warning complaining of a missing DV device or missing external video (Figure 3.2). If you do, it means that FCP does not see or does not recognize your DV camera or deck. Be sure to fix this issue and select Check Again before proceeding. Recent versions of FCP are better at recognizing DV FireWire devices jumping in and dropping out once it is all fired up. However, it's always best to start with a clean setup where every piece of equipment is playing well with the other pieces.

 If you get this warning, start out by checking to see that everything is plugged in (both to a power source and to each other) and that the device is powered up. Often, if you are using a camera to do the capture, the camera will go to "sleep" or shut down if it's been idle for too long. Just turn the device off and on again, click Check Again, and all should be alright.

3. Set up your Project file as outlined in the previous chapter. This setup process includes closing old projects, creating the appropriate folders for capturing and rendering, assigning those folders in their appropriate place in the Scratch Disks tab of the Preferences, and creating a new project file (File>New Project).

4. Open the Log and Capture window by going to File>Log and Capture … or by pressing ⌘-8. The Log and Capture window is broken down generally in Figure 3.3.

 It's fairly important to understand what all these tools are, so before we move on to the next step, let's discuss Figure 3.3.

Chapter 3 Logging and Capture | **43**

FIGURE 3.2 If you get this warning, take care of the problem before continuing. Although not fatal if simply editing, it is fatal if you are about to log or capture clips.

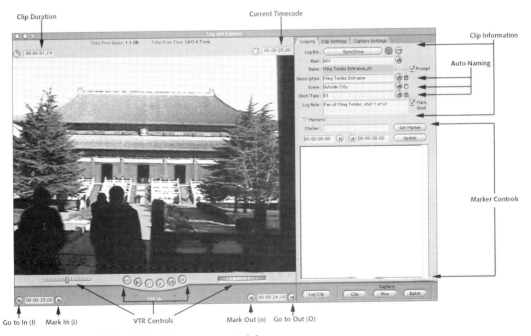

FIGURE 3.3 The Log and Clip window. There are many tools here.

VTR Controls

The Log and Capture window can be broken up into several sections. The first and largest section on the left side allows you to interact with your VTR (videotape recorder). Assuming that you have set up your FireWire camera or deck correctly, you will see "VTR OK" at the bottom center. Immediately above the OK are the controls that allow you to control your camera/deck from within FCP. These VCR-like controls, called the *Transport controls*, allow you to play, stop, rewind, fast forward, and advance and go back one frame at a time (Figure 3.4).

FIGURE 3.4 Transport controls.

To the left of these is the *Shuttle control* (Figure 3.5). This control method is a software attempt at approximating hardware shuttle devices that by grabbing and dragging the handle to the left or right, the camera will play-fast forward or play-rewind. The farther to either side you drag the handle, the faster it will rewind or fast forward.

FIGURE 3.5 Shuttle control.

To the right of the Transport controls are the *Jog controls* (Figure 3.6). Again, this is a software impersonation of a hardware jog device that allows you to fast forward or rewind by rolling the device to the left or right.

These controls are cute, but in reality, they're not of much use for most editors. The best way to deal with navigating through your footage is to use the keyboard shortcuts:

- **Space:** Starts and stops playback.
- **J:** Moves backward. If tape is already playing, pressing "j" will begin to rewind quickly. Each time you press "j," the speed at which the

FIGURE 3.6 Jog controls.

camera/deck is rewinding will increase. The amount of the speed increase depends largely on your deck/camera.
- **K:** Stop or pause.
- **L:** Moves forward. If tape is already playing, pressing "k" will begin to fast forward. Each time you press "k", the speed at which the camera/deck fast forwards increases. The amount of the speed increase depends on your deck/camera.
- → **(Right arrow key)** Moves forward one frame at a time. Shift-→ moves forward one second at a time.
- ← **(Left Arrow key)** Moves backward one frame at a time. Shift-← moves backward one second at a time.

Marking Ins and Outs

As you begin to log your clips, you will want to be able to tell FCP where a particular clip or section begins and ends. At the bottom left and right of the left section are the Mark In and Mark Out buttons.

The keystrokes for Mark In and Mark Out are "i" and "o." What this does is put all of the important keys within easy reach of your right hand. Press Spacebar to start playback, then press "i" to mark where you want the clip to start, and then press "o" when you want it to end. By using, "j," "k," and "l" you can move forward and backward to refine where you want these In and Out marks to be. Note that "I" and "O" (capitals) are the keystrokes to Go to the In and Out. This is a quick way to check if the Ins and Outs are really when you want them to be, and gives you a great point to refine from.

Between the Go to In and the Mark In buttons is the timecode that represents when the In point is set for the current clip; the same on the right side for the Out. Notice that you can actually select these values and manually enter a timecode value.

Clip Information

Along the right side of the Log and Capture window are three tabs. The first, *Logging,* is where you enter all the information about the clip you are currently logging, including the name and any other important

information you might need in the editing process. It's important to manage these input fields well. Although they do not all need to be filled in, the more complete they are, the easier it is to decide which clips should be captured and which should not.

The only input field that must be entered is the Name. All the others might or might not need any attention depending on the nature of your project. Notice that the *Mark Good* checkbox next to Log Note. In general, if you know as you log that a particular clip will definitely be captured, it's helpful to check the Mark Good option as you go.

Notice that almost all the input fields have a button beside them. For Log Bin, notice that you can actually add a new *bin*. A bin is a container for a certain collection of files. Therefore, if you know you are logging a big collection of clips from the Ming tomb, you can log them directly to a "Ming Tomb" folder.

Next to Reel, Description, Scene, and Shot/Take is a little button with a little slate on it (Figure 3.7). This button will incrementally increase the information listed in the adjacent input field. If the listed reel is China01, clicking the button next to the Reel input field will change the value to China02, and so on.

FIGURE 3.7 Slate button.

Next to the Slate button are the Auto-naming controls. Although these are not usually the best tools to use since they surrender control over names to FCP, they can be useful if you have a lot of clips in rapid succession for which you will not be changing the descriptions. FCP takes the information contained in the input fields and integrates them into the Name input field. Generally, leave these off, as you will want to be able to manually enter the relative fields and control the Name input field much more specifically.

Below all the input fields that allow you to name and describe your clip are the Marker controls. Markers are little clues that you can give

yourself or another editor to important parts within a given clip. We will use markers much more extensively in some of the tutorials later to help mark sync, but they can also be used to help break up a long clip into smaller, manageable chunks of information.

Below the Marker Controls is the Log Clip button. When you have marked an In and Out and the appropriate input fields are entered, you can click the Log Clip button to enter the clip's information into the log for your project. The keystroke for this is F2.

A quick note about the other tabs besides Logging. *Clip Settings* and *Capture Settings* (Figures 3.8 and 3.9) allow you to alter the nature of the

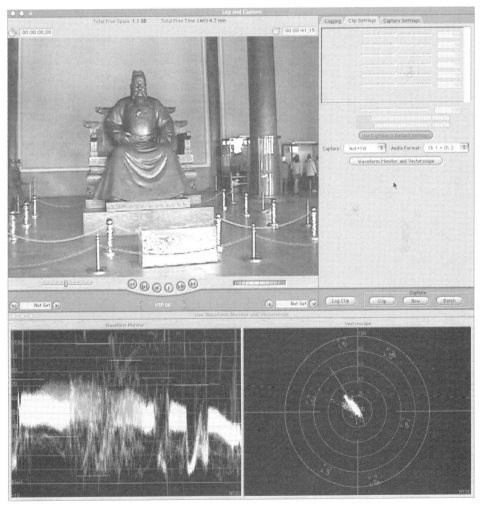

FIGURE 3.8 Clip Settings tab. In general, leave this alone, as all of this can be adjusted once the clip is captured. With FCP's RT capabilities, it's often best to leave this for the editing process.

FIGURE 3.9 Capture Settings tab. Unless you change devices mid-log, this should be left alone.

clip or change how FCP deals with your camera/deck. In general, it is usually easiest to bring in the media in its current state (no need to adjust Clip Settings) and adjust any color or white balance within FCP. It's also usually best to not alter the Capture Settings unless you change devices as you are logging.

Now, back to the tutorial.

5. With a tape in your camera/deck, rewind the tape to the beginning. You can do this manually on the camera/deck or by pressing "J" on your keyboard.
6. Fill in the appropriate information in the Logging tab input fields. None of the information is required, but it can be extremely helpful later. Do not worry about the Name input field if you have "Prompt" checked. FCP will ask you for a name as you go.
7. Press Spacebar on your keyboard to start your camera/deck rolling. Keep in mind that there needs to be a bit of excess footage at the beginning of the tape because FCP needs a bit of preroll before it captures any given clip.
8. Mark an In point. Once you are 15 seconds or so into the reel, you can begin marking Ins and Outs. To mark an In point, press **i** on your keyboard.

9. When the tape has played enough to encompass a given clip, you can do one of two things:

 A) Press "o" on your keyboard to mark the Out point. The Out point is the end of the clip. You can then click the Log Clip button, which will present you with a window (Figure 3.10) prompting you for a Name and Log Note.

FIGURE 3.10 The prompt given after clicking the Log Clip button or pressing F2 on your keyboard.

 B) Simply press F2, the keystroke for Log Clip, and FCP will automatically mark the Out point where the tape is currently on the playhead or at the point currently visible in your Preview window. By pressing F2, you will be presented with the same prompt to enter a Name and Log note.

 Note that if you know that this is a clip you will want to eventually capture, it's a good idea to check the Mark Good option.

10. A couple of important and very nice things happen when FCP is logging using this method. The first is that when using F2 to indicate that you are ready to log a clip, you are not only marking the Out point automatically, but you are also marking the In point of the next clip. This is important if you are assuming that you will log the entire tape and only capture the clips you plan to edit.

 As we discussed earlier, it's smart to log everything. By doing so, you will know what every bit of information on your tape is, including excess footage, footage that's slightly better, good takes, and the takes that are keepers. If you do not log everything, and just log the clips you think you will be capturing, you are limited to those clips you capture. Often, you

might find that the clip you captured just does not work for the purpose you need it to, and that there was another clip that you saw while logging and capturing that did not seem quite as good at the time. However, if you didn't log that other clip, you would have to go and track down that tape and again go through the entire tape looking for that one elusive clip. If you had logged the clip to begin with, even though it had not originally been captured, you could simply select the clip from your log and tell FCP to capture it.

The second important thing that happens is that FCP automatically stops the tape to allow you to name the clip without worrying about important footage passing you by. Since the new In point has been set, you simply need to press F2 the next time you want to mark an Out point and name the new logged clip. In theory, after entering the first In point, you could log the rest of the tape with simply the F2 button! Pretty snazzy, eh?

11. Refine your In and Out points. Although in theory, you can simply press F2 and then enter the names of your clips, it's usually the case that you need to refine where you set those In and Out points. Remember that once you click the Log Clip button (or F2), it is not easy to adjust those points. Therefore, if you are not happy with an In point or have missed where you want to put the Out point, press Spacebar to stop playback rather than logging the clip. You can jog or shuttle back to where you want the In or Out point and again press "i" or "o" to overwrite the extant or In or Out point. Once you are pleased with the In and Out points, press F2 and name the clip.

 Some of the benefits of doing this more labor-intensive but meticulous method is that you can be generous with your Ins and Outs. Because transitions require added footage, it is good to have a bit of footage before the most important part of the clip and a bit after. How much is largely up to you, but in general, you should plan on two to five seconds in either direction. You might know that you will need some more than others, but remember that it's easier to leave captured footage off of an edit than have to go back and re-log and recapture a clip that is not long enough.

 Using this method, you can also log clips that might be overlapping. Especially if you are planning on having montages or a collection of rapid-fire shots, you might want to capture a piece of your footage twice; perhaps once as the end of one clip and once as the beginning of another. With this method, your In point can be before the Out point of the clip before it.

12. Repeat your process of choice for the duration of your tape. When you have logged the entire tape you can choose to either capture the "keeper" clips on that tape or continue logging with the next tape in your project, and then go back and capture everything you need on all of your tapes at once. Typically, it's best to be able to really see all of what you have cap-

tured before making a final decision of what to capture, so it's usually the best choice to log all of your tapes and then capture all of your tapes.

A Few Added Notes about Logging

Logging can seem to take an eternity. Often, this task is best left to assistant editors. However, if you are doing all of the logging yourself, keep in mind that effective editing is effective continuity. Personal workflow becomes very important. If you have to take three hours to track down some phantom section of footage that you know you saw, but did not log its location, your workflow is wrecked.

Here are a few additional tips to keep in mind when editing:

- Be accurate with your media. Label those tapes. Make sure that the label you physically put on the tape is the same label you give the tape in the Reel input field. It does no good to log tapes and then not be able to give FCP the right tape when the time comes to capture.
- Keep clip names short but not cryptic. The number of characters that Macs can deal with in a name is limited, so you can have real problems when clips are longer than 10 minutes. Aim at making sure that the clip names are less than 26 characters. Also keep in mind that a super cryptic name that no one else understands or that you do not understand half an hour after logging the clip doesn't do you much good either.
- Be descriptive with your labels other than the name. When inputting log notes, make sure you have enough information there so you know what the clip is when the time comes to capture. A few extra keystrokes are not going to put you very far behind, but capturing the wrong clip because of not enough information will.
- Log everything. This means even the stuff between keepers. You want to be sure you know what's on every tape—everywhere. When you have logged excess footage, you know it's excess footage by looking at the log and do not have to second-guess that you might have missed some important footage when you see a gap in the log timecode.
- Overestimate your In and Out points. Plenty of elbow room on either side of your clip comes in very handy. Even though the Batch Capture dialog box allows you to add handles, this is a very clumsy way to give yourself extra room. If you keep your Ins and Outs loose, you will know what you are getting and will not have to worry about FCP taking over too much.

CAPTURING

Okay, well actually, we will not capture yet. If you have been religiously logging the entire tape, your Browser will show a whole lot of logged clips. The clips will all have a red line through them indicating that they are not *Online*, meaning that FCP does not have them on disk or linked specifically to that name. However, even though you have the entire tape logged, you will not want all of the clips you have listed here. Therefore, before you capture, you will want to take some time to add information if needed and sort the information you have.

1. If you have not already done so, close the Log and Capture window.
2. In the FCP general standard interface, your Browser window (Figure 3.11) is sitting in the bottom left-hand corner of your screen. You probably have visible four columns: Name, Duration, In, an Out. Much organizing can take place here if need be. In the situation of the clips captured for the SyncChina tutorial, the clips could be easily organized into bins by location. Although the smart editor would create most of these bins in the Log and Capture window and log the clips directly to the intended bins, there might be some additional organization you want to put into place.

 To create new bins select the Browser, then select File>New>Bin, or press ⌘-**B**. A new folder or bin will appear in your Browser that you can rename. To move clips into a bin or from one bin to another, just click and drag. Release the mouse and the bin will be placed in the desired bin.

 Take a minute to select all of the complete trash clips—those clips that are logged just so you know that it's not missing area on the tape, or those shots of when you forgot to turn the camera off—and place them in a new bin called "Junk." You will probably never need to mess with these clips again, but they are still part of the log so you know your media.
3. Qualify the remainder of your clips. FCP has some built-in labels that let you begin to separate your wheat from the chaff. Select any clip, and then hold the Control key down as you click on the name of the clip again; or if you have a two-button mouse, right-click on the name of a clip. You will be presented with a pop-up menu (Figure 3.12) that allows you to do a variety of things with the clip. The one of interest to us here is *Label*. By going to Label, you can choose to qualify the clip by the default labels of Good Take, Best Take, Alternate Shots, Interview, or B-Roll.

 This allows you to begin to group shots into "Must capture," "Should capture, but might not use," and "Do not capture but keep in mind." Remember that you can change the Label names and colors in the *Labels* tab of your Preferences.

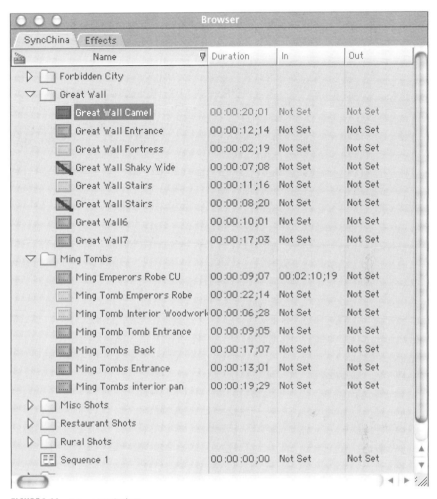

FIGURE 3.11 Browser window.

Make sure to go through all of your non-Junk-bin clips and mark them with a quality label.

4. Expand your Browser. Even though the default setup only shows four columns, the Browser is an amazingly robust tool. Expand the window by click-dragging the bottom right-hand corner of the Browser and you will be presented with a multitude of columns (Figure 3.13). Notice that even when you expand the Browser to fill most screens, there is still a scroll bar along the bottom of the Browser indicating farther columns.

FIGURE 3.12 Qualify your clips using the Label capabilities.

FIGURE 3.13 Expanded Browser.

Since Browser organization is covered so heavily in the manual, and because most people don't need to rework the Browser's organization, we will not cover a lot of that here. However, if you find yourself using certain columns often, know that you can reorganize columns by grabbing the name of the column and dragging it into a new location in the Browser. Also remember that by holding down the Control button and clicking on a column, you can choose to hide it, or make other hidden columns visible (Figure 3.14).

FIGURE 3.14 Some basic Browser organization.

5. Organize your clips by label. By default, your Browser will list clips alphabetically according to the name of the clip. So that we can easily pick the clips to be captured, we want to organize them by the quality label we gave them in the Step 3. Look for the column entitled "Label" and select the bar with the word *Label*. Figure 3.15 shows how the clips are rearranged according to the quality label given them.
6. Select the shots you want to capture. Usually, these are the Best Takes and Good Takes, although you might decide to be a little more detailed and have a lot of Alternate Shots that you would like to have online as you edit.

FIGURE 3.15 Have the Browser organize clips according to the quality labels you gave them earlier.

There are some keystrokes to being able to accurately select multiple clips. By clicking once on a clip, you select it; if you Shift-click another clip further down, FCP selects all the clips between these two clips. By holding the ⌘ key down, you can select multiple clips without selecting clips between the current selected clip and earlier clips. Keep in mind that FCP allows you to marquee (click and drag around) a group of clips; therefore, by holding the ⌘ key down and marqueeing around clips, you can select the clips you want from several bins.

7. Make sure that you have selected all the clips from all the bins that you want to capture. FCP will be smart enough to parse the data and only ask for each tape once, but if you forget to select all the clips you want, you might spend quite a bit of time re-swapping tapes.
8. With all the clips you want captured selected, go to File>Batch Capture, or press Control-C.
9. You will then be presented with the Batch Capture dialog box (Figure 3.16). If you were careful with your In and Out points, you should not have to change anything here. If you were really tight on your In and Out points, you might want to check the Add Handles option and put one or two seconds in there (remember, two seconds in timecode is 02:00). Otherwise, all should be set. Press OK, and watch FCP do its magic.
10. Feed FCP what it wants. FCP will go through and look at the log you have created and ask for a given tape or reel. Once you put the tape in your

FIGURE 3.16 Batch Capture dialog box.

camera/deck, FCP will automatically cue up the exact frame of each In point you have defined and transfer the data to your hard drive until it gets to the Out frame you defined. If you have many clips on a tape designated to be captured, this is a good time to take a break. FCP transfers the date in real time, so if you have 40 minutes of footage to be captured, it's going to take a least 40 minutes plus however long it takes your deck to get from point to point.

When it is done capturing all the clips on one tape, it will ask for the next. Do what it asks, and it will do magic for you.

11. You are done. Get ready to edit!

Conclusion

This method of logging and capturing allows you to move quickly and let FCP do most of the work while you are working at another machine or on another project. By not having to babysit the software as it grabs each frame, you are free to be more productive. The key to quickly selecting the clips you want captured is to carefully log each tape. It's boring, but when you get to walk away secure that FCP is capturing the right clips to your hard drive, it will all be worth it.

Now that we know how to log and capture footage, let's begin looking at how to actually put the footage together into a cohesive project. In the next few chapters, we will look at everything from basic video editing to advanced compositing. However, without effectively mastering the concepts covered in this chapter, there will not be any footage to edit. Therefore, if anything was unclear or if some of your clips did not come in, take the time now to make sure you solve the problems. Then, when you have the clips, enjoy the editing goodness to come.

CHAPTER

4 BASIC EDITING

Yes, this chapter is called "Basic Editing," and yes, the next chapter is "Advanced Editing," but the reality of it is that it's all technically very easy. However, having said that, yes, technically FCP makes the *tools* of editing very easy. No, it doesn't do good editing for you. This is the disclaimer: good editing is a great art. We are covering tools in the next couple of chapters and not much editing theory.

The sophisticated and complex issues surrounding effective editing are extensive and far beyond the scope of this volume. For some great theoretical discussions of editing, see Walter Murch's *In the Blink of an Eye* (Silman-James Press, 2001). You might also want to check out the older, but still relevant, *On Film Editing* by Edward Dmytryk (Focal Press, 1984). However, for a good understanding of the tools to put that theory into practice, read on.

UNDERSTANDING FCP'S STRUCTURE

When people ask what FCP is and why they should use it, the best answer is, "Imagine the best things about Premiere and the best things about After Effects; put them together and you have FCP." Okay, so maybe it is not *that* good, but close to it. The reason that it's the best of Premiere is that it is a solid video editing system. However, it is also much like After Effects in its ability to create multiple layers of compositions, including nested compositions that can be assembled into one large output.

The following is how FCP organizes things.

Projects

FCP saves files called *Projects*. Project files are actually small files that contain a lot of information. The Project file stores where all the footage, stills, and audio clips are on your disk and how you want them all edited together. In addition, the Project file keeps track of any files that are created as a result of renders. The Project file is a valuable file, but remember that it is more of a librarian than a dump truck. It keeps track of where things are; it does not actually contain the files. To have a complete FCP project, you must have the Project file and all of the captures, files, and renders that are used in the project.

For Project files to work best (and for your overall mental health), make sure to set your hard drive up as we did in Chapter 2, "Final Cut Pro Hardware and Software Setup." If your Project file is set up with Preferences that are pointing toward a folder made especially for the active project, you will always know where your files are as you work.

Sequences

When you first start a Project, you will notice that the Browser already has a file in it—a *Sequence*. Sequence 1 is the default file that FCP creates within a Project. Sequences are collections of clips (audio, video, and stills). You edit a Sequence within the *Timeline*. The Timeline is the big long workspace to the right of the Browser (Figure 4.1) Notice in Figure 4.2 that the Sequence you are editing appears at the top of the Timeline.

FIGURE 4.1 Timeline. Timelines are where you begin to construct Sequences.

FIGURE 4.2 Notice that the Timeline has a collection of tabs that indicate what Sequence you are in the process of editing.

Now, a Project can have more than one Sequence. Although, ultimately, Projects are assembled in one master Sequence, you can have multiple Sequences that are placed within the master Sequence. This is called *nesting*.

Nesting is an incredibly powerful method of working and allows for all types of dynamic updates. It also helps keep those long projects in bite-sized pieces. We will be talking a lot about nesting in the next chapter.

Bins

We have already talked a bit about bins. Bins are containers that contain clips that can be used within Sequences. Bins appear as folders within the Browser. You can rename, move, or place bins inside of bins.

Clips

Clips come in a variety of flavors. The most common, of course, is a captured clip. This is usually a file that includes DV-encoded video along with its accompanying audio. However, clips can also be just video, just audio, or stills. Clips are the most basic building blocks of the editing process. Editing in FCP is about organizing clips within Sequences to create a Project.

INTERFACE ORGANIZATION

All of this organization can be seen within the Browser. Figure 4.3 shows a Browser with the name of a Project, several Sequences, bins, and clips. It's important to be able to distinguish FCP's iconography.

Next to the Browser is the Timeline. The Timeline is organized into a default one video track and two audio tracks. Across the top of the Timeline is timecode. A small, upside-down yellow triangle (the *Playback Head*) indicates where or rather when in your project you are. You can manually move this Playback Head around in the project. We will talk more about the various tools in the Timeline later.

Above the Browser and Timeline are two windows that become visible once a Project file is open. These represent an old way of editing that still works into a great digital workflow. The window on the left is called the *Viewer*. In the old days of video editing, you could play the source code and cue up to where you wanted to transfer to the master copy on one deck that contained your source material. Then, on your source deck, when you were where you wanted to be, you could start recording on the master deck and transfer from your source. In this way, your source material remained undamaged. The Viewer represents this source material deck. It also is nondestructive of the clip with which it happens to be working.

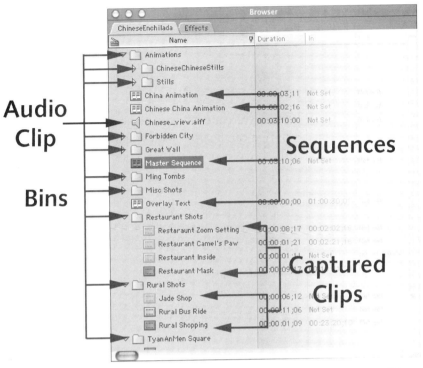

FIGURE 4.3 The Project (ChineseEnchilada) contains three Sequences (Master Sequence, China Spinning Alpha, and Chinese China Alpha), several bins (alsdjfasldjfa), and tons of clips contained within the bins.

The Viewer (Figure 4.4) is actually a complex and robust collection of tools. We will be covering most of the tools contained within it over the course of the book. For now, notice the important regions of the tabs along the top, the clip duration input field on the left, the current timecode input field in the top right, and the playback controls at the bottom. Also note the collection of small buttons on the bottom left (Figure 4.5). Like the playback controls, most of these small buttons are better accessed via keyboard shortcuts.

Next to the Viewer is the *Canvas*. The Canvas actually shows (among other things) the project as you have edited it thus far. When you play your Timeline, the results will appear in the Canvas. Notice that it has its own set of tabs, clip duration, and current timecode input fields. It also has a similar set of tools at the bottom-right corner as shown in Figure 4.5 and its own playback controls. The noticeable difference is the collection of tools at the bottom left of the window (Figure 4.6). This collection of

FIGURE 4.4 The Viewer.

FIGURE 4.5 From left to right, the Match Frame, Mark Clip, Add Keyframe, Add Marker, Mark In, and Mark Out buttons. All of which are so small, keystrokes are the way to use these tools.

FIGURE 4.6 Insert, Overwrite, and Replace tools. Again, just because they are here doesn't mean they are of any great use.

tools allows you to define how clips are added to a Sequence—although there are more eloquent ways to do this, as we will explore later.

Okay. Now that we've talked about how FCP Projects are organized and briefly looked at the interface, let's get to it and do some editing.

TUTORIAL

4.1: SYNCHRONIZING CHINA (OR SYNCCHINA)

1. Make sure your Preferences are set up so that you have your Scratch Disk set with a folder called SyncChina_Media. Make sure this is on your media drive. Create a folder in there called SyncChina_Imported. This is where you will put all the files from the DVD to allow you to follow the tutorial.

 It's worth noting that if you were capturing this data from a DV, the files you captured would be captured to this folder as set in your Preferences.

ON THE DVD

2. On the DVD, find the folder called Tutorials>SyncChina>Imported Media. Take all of the files contained therein and copy them to your hard drive, in your own SyncChina_Imported folder. This will prepare all of the files needed.
3. Close any open Projects.
4. Create a new Project. File>New Project.
5. Save the Project file. Save this file as SyncChina Project. Save it on any drive *except* your media drive.
6. Import the media. Go to File>Import>Folder. This will allow you to import all the files that were transferred from the DVD at the same time. Use this method to import any sound tracks or foley sound effects that you will use in any project. The footage that you are importing for this tutorial was taken with a Canon ZR10 on a recent trip to China—it's essentially vacation video.

 One of the files that this process will import is a sound file called Chinese_View.aiff. *Chinese View* is a great trance track that will provide a great thumping beat on which to build our synced project. *Chinese View* was

composed by Axonic, who generously allowed us to include it on the DVD. More of Axonic's work can be found at *www.mp3.com/axonic*.

Notice that since there were folders within the Imported Media folder, these folders have been imported as sub-bins, or bins inside the main bin of SyncChina_Imported.

Usually, this step would be a combination of importing sound tracks using the File>Import>File and capturing clips you had previously captured. However, since it is not feasible to include a DV or mini-DV tape with this book, pretend that you captured these files.

Your Browser should look something like Figure 4.7.

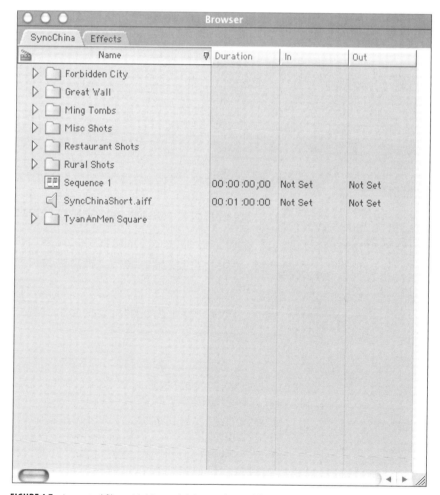

FIGURE 4.7 Imported files with bins, sub-bins, and sound files.

7. Double-click Chinese_ViewShort.aiff in the Browser. This will open this audio clip in your Viewer. As we discussed earlier, the Viewer allows you to view and adjust a particular clip in preparation for placement in the Timeline. In this case, we will be placing markers to help us know where to place video clips.

 Before we place clips, though, let's look at some of the things that appear when a clip is opened in the Viewer. For an audio clip, the most noticeable thing is that you are presented with a waveform of the sound. Waveforms are visual representations of sound. The widest parts are areas of the "most" sound. Often, you can find beats in music simply by looking at the waveform. When a video clip is opened in the Viewer, you see the video, although you can also hear the audio attached to the clip when the clip is played.

 On the bottom of the Viewer are a couple of navigation tools worth noting (Figure 4.8). The first on the left is the *Zoom Control*. This little tool allows you to define how much of the total clip is shown within the Viewer. By clicking and dragging, you will have more of the total audio clip displayed in the window. The second tool is the *Zoom Slider*. This tool allows you to slide through the clip if you click and drag the middle of the bar. By grabbing either of the ends of the Zoom Slider tool, you can also increase or decrease the amount of the clip visible in the Viewer. Give these two tools a try and see how they work. Note that for most clips, these tools do not appear in the Viewer window. However, the Zoom Control and Zoom Slider are very important tools of the Timeline and can be found at the bottom of the Timeline window.

FIGURE 4.8 The Zoom Control and Zoom Slider tools. They appear when "viewing" audio files in the Viewer.

8. Prepare to add sync markers. For now, in your Viewer, click the Play button, or press your Spacebar and listen to what the audio sounds like. Press the Spacebar to stop the playback, and press the Home key to jump back to the beginning. When you have a good feel for what the music does, you can prepare to add markers on the beat.

 We will be placing markers on the beat so that we can accurately make our cuts match the beat of the music. To get the most accurate markers, there are some things you will need to set up. First, make sure that you are playing the audio through your computer speakers. This

seems odd, but there is a slight delay as video/audio travels down FireWire, through the camera, and out to your TV. If you try to place your markers to the beat as you listen to it through your camera speakers or NTSC monitor, you will find that your markers are always just a bit behind. Therefore, to temporarily limit the sound to your computer's speakers, select the View>External Video>Off pull-down menu. Now, when you press Spacebar on your keyboard, you will hear the audio playing via your Mac's internal or attached external speakers.

9. Place markers. *Markers* are tools that allow you to give yourself notes, mark beats, and generally assist you in keeping track of what needs to go where in your project. Markers can be placed in a variety of places, including inside clips and inside a Sequence Timeline. No matter where you are placing the marker, you can do so by selecting the Mark>Makers>Add pull-down menu or by clicking the Add Marker button (Figure 4.9) within the Viewer or Canvas. If you click the Add Marker button in the Viewer, a marker will be added to whatever clip is currently shown in the Viewer. Similarly, if the Add Marker button is added in the Canvas, a marker will be placed wherever the playback head is currently sitting in the Sequence Timeline. Of course, the most efficient method is to use the keystrokes "M" or "`" (the top-left key below the Esc key).

FIGURE 4.9 The Add Marker button. This button exists both in the Viewer and Canvas. Which one you click defines where the marker is placed.

Whether the marker is placed within a particular clip or in the Timeline is actually an important issue. If the Viewer is active and you place a marker using a keystroke or you use the Add Marker button within the Viewer, the marker you place is relative to that clip. Once the clip is placed in the Timeline, no matter how you move that clip around within the Timeline, the markers always stay true in their location *within* the clip. The marker placed 10 seconds into the clip remains 10 seconds into the clip even if you move the clip down 20 seconds in the Timeline.

Conversely, if you place a marker in the Canvas window or in the Timeline, the marker is absolute. That is, no matter how you shift your clips around, the markers in the Timeline stay still. We will talk much more about this later in the tutorials.

For now, assuming that you have listened through the audio file a few times, you are ready to begin placing markers. Press the Spacebar and then press the "M" key at the start of every measure for about the first 28 seconds (00:00:27;27). Imagine each measure as lasting four bass-drum beats. Press "M" at beat number 1.

When the melody line begins at about 00:00:27;27, begin pressing "M" twice a measure or every other bass-drum beat. The idea here is to build tension and excitement by gradually increasing the tempo of the visuals. At about 00:00:41;24, the music will begin sounding four tones followed by a section of percussion. Add a marker at each of these four tones for a total of four sets. On the start of the fifth set of tones, the tones continue past its four-beat. Press "M" to place a marker for each of these tones until the end of the audio file.

It's difficult to describe music in book form; and in reality, it is not too terribly important that your markers match those listed previously. Place your markers where you feel they would work best for the quick-cut editing with which we will be working. If you have followed the model suggested here, your Viewer will look something like Figure 4.10.

Notice that when markers are placed, the markers appear green at the top of the Viewer. At the bottom of the Viewer below the Zoom Control and Zoom Slider is a white bar in which a playback head runs as you play a clip. Markers also appear in this area as pink markers. Using the description provided here, the clumping of the markers would look something like Figure 4.11.

It is not easy to get all the markers exactly as you want them the first time through. You might find that the first couple of times you try placing markers on the beat you end up with a misplaced marker or two, or three, or four, or…

To move to the next marker in a clip or Sequence, press Shift-M. To move backward to the next clip, use Option-M. To delete an active marker (which turns yellow in the Zoom area), select Mark>Markers>Delete, or press ⌘-`. If you need to get rid of all the markers you have placed, select Mark>Markers>Delete All, or press Control-`. Remember that when dealing with markers, like almost everything in FCP, keystrokes are your friend. They will save your poor wrist some wear and tear and increase your speed of working.

Once you have your markers set, move on to the next step. It should be said that markers can be so much more than simple beat markers.

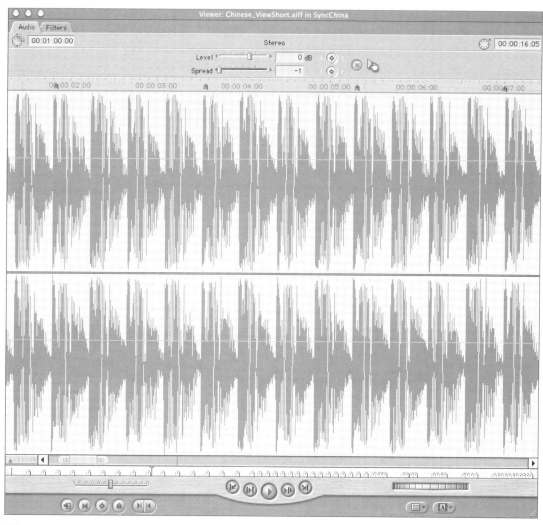

FIGURE 4.10 Markers placed on beats meant to indicate cuts.

FIGURE 4.11 Markers in the Viewer below the Zoom tools show the entire clip's markers.

Later, we will look at how to name markers and use them for all types of other important purposes. However, for now, enjoy the power of using them as a beat marker.

10. Place the audio clip into the Sequence by dropping it into the Timeline. This is one of several ways in which FCP allows you to move clips into a Sequence. Although it has some limitations, it is one of the most direct methods of laying down marked audio clips.

Click and drag Chinese_ViewShort.aiff from your Browser into the Timeline (Figure 4.12). Be careful as you do this, though. Notice that the mouse shifts to several different indicators. In this case, the different clues the mouse gives you are not of tremendous importance. However, it's important to notice that if the mouse is in the top third of the track it changes to a small arrow pointing to the right. This means that it is *inserting* the clip. Inserting means that all the clips after wherever the mouse currently is will be pushed down to make room for the incoming clip.

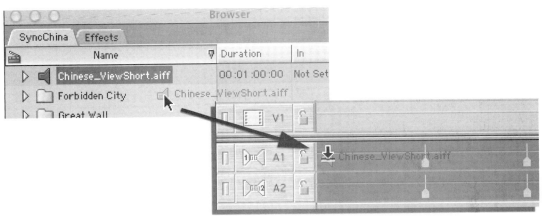

FIGURE 4.12 Placing an audio clip by dragging the clips name from the Browser into the Timeline.

When the mouse moves toward the bottom two-thirds of the track it changes to a Down arrow. This Down arrow indicates that the clip is to *overwrite* any media currently in the track. In this case, there is no media in the audio track, so either will be fine. However, understanding the overwrite versus insert is an important distinction. In the future, you do not want to accidentally overwrite media already carefully placed, and at the same time, you do not want to shift already placed media out of place later in the Timeline.

Several things are important to notice as this happens. The first is that as you look in the Timeline, there are by default two audio tracks indicated by the symbols in Figure 4.13. The yellow highlight indicates that these are target tracks—one for channel 1 (left channel) and one for channel two (right channel). The green box highlighted on the left indicates that the

FIGURE 4.13 The track iconography. Each part has particular communication purpose and functionality. See the color version on the companion DVD.

track is active, and the Unlock icon to the right shows that the track can be edited.

Let's start from the left. The green light indicates that the track is active, and therefore it is played when the Timeline is played. All tracks with the green indicator will be heard in the Timeline. You can turn tracks off by simply clicking this green box. This doesn't delete the track, it simply keeps it from being heard.

The yellow highlight indicates what track the sound should be placed in. As of now, our tutorial file only has two tracks, so this is not a big issue. However, as time goes on, and your number of audio tracks increases, defining what track new audio is placed in becomes important. To designate a track as a target track, simply click on the Left or Right Channel icon.

The Unlock icon allows you to lock down a track. The track will play and be heard, but you can not accidentally change the position or level or anything about it. This is good in a case like ours in which we know that this track will hold true for the entire duration of this project. We don't want to accidentally change something about the track, including inserting or overwriting the audio with audio from one of the DV clips we will be placing in the project.

Now, if you select your Canvas or the Timeline and press Spacebar, the audio will now play as part of the Sequence. Notice that in the Timeline, as you drag the playback head across the clip, it will snap to markers you have placed. You can toggle the Snapping on or off with the button at the top right of the Timeline (Figure 4.14). In general, it's a good idea to leave Snapping on as it allows you to quickly and accurately get to markers and the start and ends of clips.

11. Prepare the first video clip. In the Browser is a bin called "Forbidden City." Inside Forbidden City is a clip called "Chairman Mao." This is one shot taken at the entrance of the Forbidden City in Beijing, China. As discussed earlier, the In and Out of the clip captured from the tape were liberally defined; there is

FIGURE 4.14 Toggling Snapping on and off with the Timeline.

plenty of footage before and after the important part of the clip. This gives us the flexibility to add transitions where appropriate. However, for this tutorial, all of our shifts are going to be quick cuts. Therefore, we will begin by preparing this clip in the Viewer before bringing it into the Sequence.

Double-click the Chairman Mao clip in the Browser. This will open the clip in the Viewer. Press the Spacebar to get an idea of what the clip is about. Notice that at about 00:11:56;11, the camera stops zooming. Remember that in the top right-hand corner of the Viewer, you can see the current timecode of wherever the playhead is within the clip (Figure 4.15).

FIGURE 4.15 Timecode for the clip currently in the Viewer.

By default, when clips are first opened in the Viewer, the In point is defined at the beginning of the clip, and the Out point at the end. In this case, even though we will be further refining the clip in the Timeline, we want to cut out the end couple of seconds of the clip because we know we don't want that section. To cut this out, we will change the Out point.

Remember that at the bottom-left corner of the Viewer is a collection of buttons. The important buttons to us here are the Mark In and Mark Out buttons (Figure 4.16).

FIGURE 4.16 Mark In and Mark Out buttons in the Viewer.

Since we want the beginning of the clip, we don't need to set an In. To mark an Out, you can do one of a few things. Scrub the playhead to the point that you want the Out to be (in this case, 00:11:56;11) and click the Mark Out button. Alternatively, a quicker way to do this would be to simply press "O" on your keyboard.

A quicker way to get to 00:11:56;11 is to simply select the values in the Timecode Input field and type in the value you want. Further, to shorten this process, you can enter the values of 00115611 without any ":" or ";". To further streamline the process, you needn't enter any zeros on the left end of a timecode; you really only need to enter 115611 to get to 00:11:56;11.

Once you have set an Out, the bottom of your Viewer will look similar to Figure 4.17. Notice that in the scrubber bar, a gray bar shows up indicating inactive video; this indicates where the clip is marked Out.

FIGURE 4.17 Scrubber bar with inactive video defined by marking an Out point.

Remember that the Viewer is nondestructive; you are not actually deleting any media from your disk or from the clip. You *are* making parts of the clip so that they will not "transfer" to the master reel, or in our case, the Canvas and Timeline.

12. Prepare the Timeline for the files to come. We know that we will not be changing the audio track China_ViewShort.aiff. Further, most of the audio

in the video tracks is simply ambient noise that we don't want to hear in our project. If we were to now drop the Chairman Mao clip that we prepared in the Viewer into the Timeline or Canvas, we would end up overwriting or shifting chunks of the China_ViewShort.aiff sound down the Timeline. Therefore, to make sure that we don't change the music we have imported and to get rid of the audio of the captured clips, click the locks on both audio tracks (Figure 4.18).

FIGURE 4.18 Locked tracks.

13. Place the prepared Viewer clip into the Timeline. Earlier, we looked at importing media into the Timeline by clicking and dragging it from the Browser to the Timeline. For this step, we will use another method. Since we have the Chairman Mao clip marked with the Out we want, we can simply grab the clip by clicking anywhere in the middle of the Viewer (Figure 4.19) and dragging it to the Timeline (Figure 4.20).

 Notice that the cursor shifts to a couple of different forms as you drag a clip around. We will be talking much more about these variations later. For this step, though, it doesn't matter what the mouse looks like once you have the clip nestled into place on the video track V1. Before you release your mouse, you can see how long the clip will take on your Timeline. When the clip is placed, you can also see how long the clip is in the Timeline.

14. Trim the clip using the Timeline. This clip, even though we trimmed the last few seconds, is much too long for our purposes here. We can see the markers in the audio tracks, and the Chairman Mao clip covers over five markers' worth. If we want to have the cuts on the beats that we established with the markers, we need to shorten the track.

 This can be accomplished in a number of ways. The first way is to edit the clip's duration directly in the Timeline. To do this, make sure that the Selection tool is the active tool you are working with (Figure 4.21).

 The Selection tool actually allows for all types of things. As the name implies, you can simply select a clip, and you can move a selected clip in the Timeline by clicking and dragging it into its new position. It also allows you to make some trims directly in the Timeline.

FIGURE 4.19 Grab a clip in the Viewer by clicking in the middle of the Viewer and dragging it to where you want it.

FIGURE 4.20 Bring the clip into the Timeline, and make sure it is snug up against the beginning of the Sequence.

FIGURE 4.21 The Selection tool allows you to select an individual clip or multiple clips by shift-clicking.

Move your mouse to the end of the Chairman Mao clip in your Timeline. The mouse will turn into a new symbol shown in Figure 4.22. This new trim cursor allows you to drag the end (or the beginning) of a given track to a new place. This trims off the unwanted frames. For now, trim (click and drag) back until you have trimmed to the first marker from the beginning of the Timeline (Figure 4.23).

FIGURE 4.22 When the Selection tool is at the end or beginning of a clip, it becomes a Trim tool that allows you to trim off unneeded frames.

FIGURE 4.23 Trimmed clip to match markers.

Many things happen all at once when you start to trim a clip. The first is that the cursor will "snap" to the end of clips; or in this case, to any markers placed. When you get to the first marker, you know you are on the marker because the cursor has snapped and a line appears vertically through the Timeline indicating visually that you are snapped to a marker. A yellow piece of information will pop up where you first grabbed the clip to indicate the changes you are making in timecode (Figure 4.23). All these things help ensure that the trims you are making are accurate and what you want them to be.

Again, this is a nondestructive method. The original clip sitting in the Browser is unaffected; only the version present in your Timeline shows any results of the action.

This method of getting a clip prepared and fitted to a defined length is the most awkward. For most instances, you will not want to use so many steps. However, it is the "behind the scenes" or what is happening in most basic edits.

15. Perform a 3-point edit. Okay, so before a 3-point edit can be performed, it needs to be understood. The idea is that to every edit there are four points: 1) the source clip's (Viewer) In; 2) the source clip's (Viewer) Out; 3) the point that the clip will begin in the Sequence (Canvas In); and 4) the point that the clips ends in the Sequence (Canvas Out). If you provide three of these four, the computer can figure out the last one. There are several incarnations of this method; let's look at one such realization.

In the Browser, expand the bin Great Wall. Within this bin is a clip called GreatWall6 (not a good name, but we digress). Double-click on the clip and watch it in the Viewer. Between the beginning of the clip and where the Viewer timecode field reads 00:04:56;25 is mostly junk—not what we want. So, scrub the playback head in the scrubber bar to about 00:04:56;25, or enter 45625 in the timecode field and then press "I" on your keyboard to set the In (you could also press the Mark In button, but keystrokes are the way to go). By marking the Viewer In, you have just defined one of the three points needed.

Now, in the Timeline, we will create the other two points. To do this, create an In and Out in the Timeline. Scrub the playback head to the end of the Chairman Mao clip, or press the Up or Down Arrow keys to jump back to the end of the clip or forward to the end of the clip (depending on where your playback head is currently). You will know that you are at the end when the head snaps (Figure 4.24a). Press "I" on your keyboard to mark this point as the In (Figure 4.24b); two points down now.

To create the third point, a little bit of fine-tuning needs to happen. Begin by scrubbing to the next marker. Again, the playback head will snap when near the marker. Now, if you made this point your Out point, FCP ac-

tually makes this frame the last frame that can be filled—which means that the next frame is actually where the cut happens. Unfortunately, this makes the cut too late, as we want the cut to occur on the marker. Therefore, use the Left Arrow key to move one frame back. Now press "O" (Figure 4.24c). You now have three points: the Viewer In point, the Timeline In point, and the Timeline Out point. Notice also that the scrubber bar in the Canvas also shows the In and Out points that you marked in the Timeline.

FIGURE 4.24 a) Snap to the end of the previous clip. b) Create an In point. c) After fine-tuning of the playback head, mark the Out point.

What FCP now understands is, "Alright, when the user chooses to place the clip from the Viewer, she wants me to start the clip in the Viewer at its In point and match that point to the In point in the Timeline/Canvas. Then, I will include as much of the clip as is needed until I see the Out point in the Timeline/Canvas and trim the rest." So, now that FCP understands where and how much of a clip you want to place, drag the clip from the Viewer into the Canvas (Figure 4.25). Don't worry about the Editing Overlay options that appear on the right side of the Canvas when you drag the clip into it. Simply release the mouse with the clip positioned in the middle of the Canvas to accept the default Overwrite overlay option. This is analogous to placing the clip directly in the Timeline as we did earlier and releasing the mouse when you saw the Down arrow indicating an Overwrite placement. Do notice that although we are not using it here, the Insert Overlay edit is present, which is the same as the mouse changing to the arrow pointing to the right when placing a clip directly in the Timeline.

There you have it—a 3-point edit. Remember that you can also do this by marking an Out point in the Viewer as the point that the clip should not pass, and an In and Out in the Timeline, or any combination of any three points in the Viewer and Canvas/Timeline.

16. Continue using 3-point editing to place five more clips: Ming Tombs/Ming Emperor's Robe Cu (Viewer In: 00:02:14;04), Ming Tombs/Ming Tomb Back (Viewer In: 00:02:47;29), Restaurant Shots/Restaurant Camel's Paw (View In: 00:02:17;12); Great Wall/Great Wall Camel (Viewer In: 00:08:51;03); and Ming Tombs/Ming Tombs Entrance (Viewer In: 00:00:15;22). The In

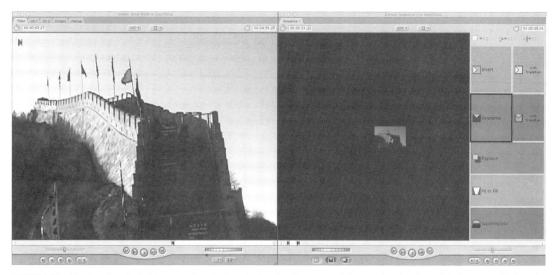

FIGURE 4.25 Moving the clip (with one point, the In point) to the Canvas, and thus to the Timeline with the second (In) and third (Out) points.

and Out points in the Timeline/Canvas will of course be each successive marker. This should put you about 12;07 into the Timeline.

17. Insert Rural Shots/Rural Bus Ride in between the clips Ming Emperors Robe CU and Ming Tombs Back (at about 01:00:05;09). Up to now, when we have been dragging the prepared clip from the Viewer into the Canvas, we have not used any of the Editing Overlay options that appear (Figure 4.26) except for the default Overwrite. These Overlay options allow you to determine how a clip is placed in the Timeline. The default is Overwrite, and up to now, this is not a problem as we were essentially overwriting empty space in the Timeline. However, there are other important Overlay options that can give us tremendous control over our editing process.

This step and the next few tutorial steps will explore how to use these Overlays.

Start by finding the clip Rural Bus Ride in the bin Rural Shots. Double-click it to open it in the Viewer. Since all of this clip is about the same, there is really no need to set any Ins or Outs. FCP assumes that if you have not set an In point, that the start of the clip is the implied In.

To set the other two points needed for the 3-point editing we are working toward, scrub the playback head to the beginning of the clip Ming Tombs Back in the Timeline. Press "I" to set the In here. Now press the Down Arrow key to jump to the end of the clip, and press "O" to set the Out. Essentially, this ensures that the new clip we will be inserting between Ming Tombs Back and the clip before it will take up the same space.

FIGURE 4.26 Editing Overlay options that appear in the Canvas when a clip is dragged into it.

Now that all three points are set, drag the clip Rural Bus Ride from the Viewer to the Canvas. Only this time, instead of releasing the mouse in the middle of the Canvas, drag it to the Insert Overlay (Figure 4.27).

What this will do is push all the extant clips down to make room to place Rural Bus Ride into the space defined by your In and Out points (Figure 4.28).

The only potential pitfall here is that the markers are hand-placed. That is, you placed them by tapping the "M" or "`" key to place the markers. Although they are fairly accurate, humans just aren't that exact. The shifted clips might not match exactly the markers below them that define the beats of the music. You might need to take a moment and trim the previously placed clips to match the markers. Use the method described earlier using the Selection tool turned Trim tool when moved to the edge of a clip.

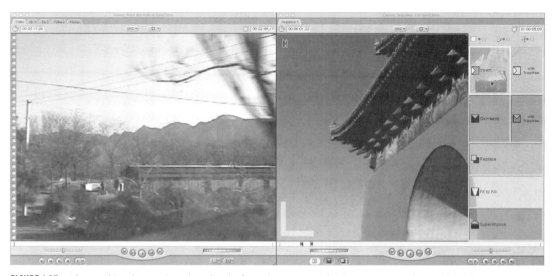

FIGURE 4.27 After marking three points, drag the clip from the Viewer to the Canvas and use the Overlay Edit options to define how the clip is to be inserted into the Timeline.

FIGURE 4.28 New clip inserted into the Timeline without destroying any previous edits.

18. Use the Fit to Fill Overlay Edit option to fill a space within the project. Notice that we are skipping Replace and we won't be talking about Superimpose quite yet. We will talk about both of these later. However, for now, we will look at the interesting and powerful Fit to Fill function.

 Let's create a hole in our Timeline for illustration purposes. With the Selection tool, select Restaurant Camel's Paw and then hold the Shift key down and add Great Wall Camel and Ming Tombs Entrance to the selection by clicking on them. Release the Shift key and drag the group to create a hole similar to Figure 4.29. Remember to grab the group by the Restaurant Camels' Paw clips, and drag until the start of the clip snaps to the next marker.

 The clip we will use to fill this hole is in the Forbidden City bin and is called Forbidden City Spouts; double-click it to bring it into the Viewer.

FIGURE 4.29 Hole created by shifting tracks around.

This shot was taken as the camera was running out of battery juice and the camera operator was trying to get everything he could in before losing power. The problem is that the zoom is too quick, and everything is too shaky for this clip to maintain a long display. To solve this problem, we will edit out all the shaky and hasty zooms. Move the playback head to timecode 00:19:03;27, or enter 190327 into the Timecode Input field. Press **I** to mark it as the In.

The problem now is that the remaining footage is short—very short. In fact, it's too short for the hole that we need to fill. If we were to just set In and Out points on either side of the hole and use the Overwrite default edit, the clip would leave a big hole in the Timeline that would result in a black chunk. This is where Fit to Fill comes in.

There are actually two ways to use Fit to Fill. First, you can mark In and Out points corresponding to the start of the hole and the beginning of the hole. Then, drag the clip from the Viewer to the Canvas and onto the Fit to Fill Overlay option. Alternatively, an easier method is to simply use the Selection tool to select the hole (Figure 4.30). The hole will show up as a dark gray bar. Essentially, this tells FCP, "Hey, this is the hole I want to fill!"

FIGURE 4.30 Select the hole you want to fill with Fit to Fill in the Timeline using the Selection tool.

Now, when the clip is dragged from the Viewer to the Canvas and onto Fit to Fill, FCP will not only put the clip into the hole, but it will speed up, or in this case, slow the clip down so that it fills the hole! Just for fun, if you select the clip and select Modify>Speed, or press ⌘**-J**, you will be presented with a dialog box that allows you to see (or change) the speed at

which the clip is going to be played. In this case your dialog box will show something around 36%.

When this method of editing is used, the Timeline will display a red bar across the top of the new clip (Figure 4.31).

FIGURE 4.31 When Fit to Fill is used, a red bar will appear across the top of the clip to indicate the need to be rendered.

This red bar indicates that this part of the Timeline needs to be rendered. If a clip is ever edited in a way that it changes the basic DV-NTSC or DV-PAL format of 720 x 480 at 29.96 fps, FCP needs to re-render it to make it so. Rendering is a slow process. Often times, with highly sophisticated edits with multiple layers, rendering will take as long as it did to edit the piece.

If you have extra hardware such as the Matrox RTMac, much rendering can be eliminated. Features that really excited folks when FCP v3 came out were those that allowed certain functions to not need rendering as you edited. Of course, these new functions only work on some of the most high-end systems. So, if you are using such a high-end system, and you never get red bars as you edit, you're set. If you have a system that doesn't support all the new doesn't-need-to-be-rendered functions, you will need to do some rendering. If a clip is not rendered, it will play looking like Figure 4.32. However, if you simply scrub the playback head to a point within the unrendered clip and give FCP a minute to think, it will show you that particular frame. Not a big deal here, but very important later when we start working with multiple layers.

To render a specific clip, select it within the Timeline and use Sequence>Render Selection, or press ⌘-**R**. Alternatively, if you are quitting for lunch or for the night, and you have a lot of clips that need to be rendered, select Sequence>Render All, or press Option-R. When to render is largely up to you. Typically, for something like this, there is no need to render as you go. However, there are times when you need to see exactly what the timing looks like, or how layers move together, and taking the

Chapter 4 Basic Editing | **85**

FIGURE 4.32 When a clip needs to be rendered, your Canvas and NTSC monitor will display this message.

time to render is important. For now, go ahead and select the clip Forbidden City Spouts and render it. It should not take too terribly long to render on relatively recent Macs.

An important disclaimer needs to be made here: When a clip is played slower than its source, it is essentially having to take the nearly 30 fps and reduce the number of frames of information it has to work with. If it is slowing to 50 percent of the original speed, it has to drop to 15 fps and play each frame twice. The more you reduce the speed, the poorer the quality will appear, as the clip will tend to play jumpier and jumpier. Use reduced speed clips with caution.

19. Create *subclips*. Subclips are virtual clips that reference a "real" clip already part of your Browser collection. Subclips become particularly useful when you have captured a particularly long clip that needs to be broken down into two clips to be more manageable. Creating subclips is easy, but can

help you organize after you or an assistant were perhaps a little too loose with the Log and Capture process.

To do this part of the tutorial, open Great Wall/Great Wall7 from your Browser. Scrub or play through it in the Viewer to see that this one long zoom could be condensed into two segments: the long shot of the wall, and the closer shot of the wall's stairs.

To create subclips, use the tried-and-true method of marking Ins and Outs. Begin by pressing the Home key to return the playhead to the beginning of the Viewer scrubber bar. Mark the In here ("I" key) and then scrub the playhead to just before the wall on which the camera operator is standing appears. This should be at about 00:05:10;05. Mark an Out here ("O" key).

To create a subclip, use Modify>Make Subclip, or press ⌘-**U** on your keyboard. Take a look at your Browser. A new icon will appear with a default name of Great Wall7 Subclip (Figure 4.33). FCP assumes that the first thing you will want to do with a subclip is name it; and since Great Wall7 is not a particularly good name, take a minute to rename this subclip "Great Wall LS Zoom."

FIGURE 4.33 A new subclip will have a new specific icon and will ask you up front to rename it.

Your playback head is probably still right at 00:05:10;05 in the Viewer. If so, mark a new In ("I") and then press your End key to jump to the end of the clip and mark this as your Out ("O"). Press ⌘-**U** to create another subclip, and rename the new subclip "Great Wall Stair Pan." It's as simple as that.

A few things to notice and remember about subclips: first, they are fast. Second, they are largely independent of the clip from which they came. The clip that subclips come from is called the Master Clip. After you have created subclips, you can even delete the Master Clip from your Browser (select the clip and press Delete) to help keep the number of clips you are dealing with down. Remember, though, that subclips are *virtual* clips; that is, they are just parts of a larger clip. If you remove Great Wall7 from the Browser by pressing Delete, it does not remove the actual media from your hard drive. When you call up a subclip, FCP is still accessing the Master Clip from which it came. Therefore, if you delete the Master Clip from the hard drive, your subclips are worthless.

A really nice thing about this subclip-Master Clip dependency is that you can easily go back to the Master Clip for additional frames. Simply double-click a subclip in the Browser to open it in the Viewer. Then, select Mark>Go to> Master Clip, or press Shift-F on your keyboard. Your subclip in the Viewer will all of a sudden include all the frames originally available in the Master Clip. You can easily mark new Ins and Outs and place into the Timeline or Canvas.

20. Place newly created subclips. Using 3-point editing, trim Great Wall LS Zoom to include only the frames with motion, and place it into the Timeline so that its In is at the end of the Ming Tomb Entrance clip and its Out is the next marker. Place the clip Buddhist Temple in next to keep from having two great wall clips next to each other, and then place Great Wall Stair Pan. Again, make sure to create the Ins and Outs for Great Wall Stair Pan to include the most interesting parts of the clip in the Timeline. At this point, you should have clips cutting to the beat to about 01:00:20;25 in the Canvas (Figure 4.34).

FIGURE 4.34 Your Timeline thus far.

21. Continue with 3-point editing to create cuts to the beat until 01:00:26;03. What clips you use to do this are largely up to you. Stylistically, all of these first collections of clips have camera movement to them. Suggested clips to include are Forbidden City (Viewer In point: 00:21:23;00), Forbidden City Court Pan (Viewer In point: 00:18:25;12), and Rural Shopping (Viewer In point: 00:23:09;28).

22. Use 3-Point editing by marking the Out in the Viewer for Ming Tombs Interior Pan. Open Ming Tombs Interior Pan in the Viewer by double-clicking it in the Browser. Press the Spacebar to take a look at it. There is a great pan that comes to rest on Emperor Ming. The problem is that all of our other clips up to now have been moving clips. In addition, all of our 3-point editing to this point has been done by marking the In point in the Viewer. Unfortunately, there is a lot of scrap footage at the beginning of this video clip if the important part is the statue of the Emperor. We could come and

mark an In to attempt to work out all the scrap stuff at the beginning, but then we would not know if the actual visible clip would have enough of the Emperor. Therefore, for this 3-point edit, mark the Out instead.

Scrub the playback head in the Viewer to the point that the camera pan stops on the Emperor (about 00:00:41;15). Press "O" to mark this as the clip's Out. Now, mark the In and Out in the Timeline; mark the In at the end of the clip Forbidden City Court Pan, and the Out one frame before the next marker. Drag the clip Ming Tomb Interior Pan from the Viewer into the Canvas and release the mouse to accept the default Overwrite Overlay.

What this tells FCP is that you want it to match the Viewer's Out with the Timeline/Canvas' Out. It will work backward from there to define the clip's In. This way, you will ensure that you have the Emperor in the frame as much as possible while still maintaining camera movement.

This should bring you to about 01:00:27;25 in the Canvas' timecode.

23. Skip to 01:00:41;21 in the Canvas Timeline. This is approximately the position of the marker that begins the collection of four tones in the audio track. The space that we left will be filled later.

24. Continue to use 3-point editing to create short snips and cuts to fill the rest of the project. You can fill the rest of these cuts however you like. To see a suggested collection of clips, make sure you check out the SyncChina Project file on the DVD. To fill the rest of the visual track, use all the techniques we have looked at previously. By the end of the audio track, you will be an expert at the process of 3-point editing.

ON THE DVD

25. Take a look at what you have done. Make sure the Canvas or Timeline is the active window by clicking on either. Press the Home button to jump to the beginning, and press the Spacebar. Assuming that you are not playing your edits to the external video, you will get an idea of what you have going on in the Canvas.

To get a more accurate view of your project thus far, select View>External Video>All Frames to see on your external NTSC monitor how everything is editing together and how the sync is working out. Be sure that you are watching the NTSC monitor and that you can't see your computer monitor easily. There will be a little difference in what is playing between the two monitors, and it will drive you nuts if you can easily see both.

You will have a long stretch of black in the project because of the area of the Timeline that we have not worked with yet. Not to fear, though. In the next couple of chapters, we will fill those right up.

26. Take a break—you've done quite a lot.

Conclusion

We covered a lot in this chapter. You learned how to prepare clips in the Viewer, how to import them into the Canvas or the Timeline, and how to use Edit Overlays. You also learned how to create, edit, and delete markers. We will be talking much more about markers and their immense power in later chapters.

Most important, you worked with the incredibly powerful technique of 3-point editing. Effective editors use 3-point editing heavily, and with a firm knowledge of keystroke shortcuts, you can become an editing typist—"typing" out the flow of the project.

Stay tuned, as we have many other powerful editing techniques yet to tackle. In the following chapters, we will look at multitrack editing, transitions, compositing, and filters. However, the building blocks of good editing are contained in this chapter. If certain points are unclear to you, take a second and review them before moving on. Once you are ready, and have rested a spell, move on to the truly fun parts of FCP.

CHAPTER

5 ADVANCED EDITING

So far, we've looked at how to capture footage and import other media. We covered some basic ways to prepare clips and bring them into a Timeline or Canvas. Subclips and markers are within your working repertoire and you are a master at 3-point editing. These are all great features of FCP, but if that was all FCP could do, there would really be no reason to use FCP over any other application.

In this chapter, we will begin looking at ways to use more than the one default track we used in the last chapter. We will look at how to layer video on top of video and use place-setting tools.

MULTIPLE TRACKS AND MULTIPLE SEQUENCES

Up to now, we have been functioning within one video track and two audio tracks. For most editing, this is perfect; the fewer tracks you are working with, the better. However, many beautiful and sophisticated effects can be accomplished by layering one video track on top of another (Figure 5.1). Dynamic movement can be created by animating a particular clip moving across the face of another (Figure 5.2). Multiple tracks are the way to accomplish both of these effects.

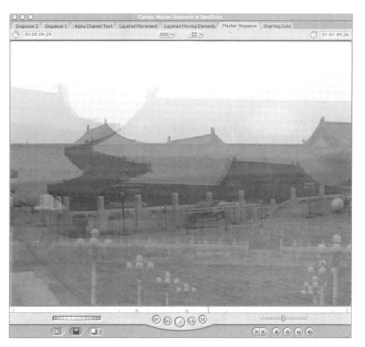

FIGURE 5.1 Visual effect generated using multiple video tracks layered one on top of another.

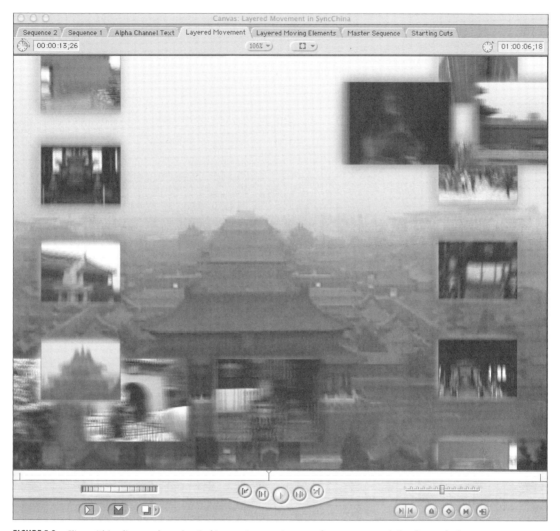

FIGURE 5.2 Clips within clips can be animated to create a great sense of movement and visual complexity.

Before we can get to sophisticated layering, first create a Sequence in which to construct the effect. What we will do here is find the area of our project in which we want to create the effect, and then create a Sequence that will house just this particular effect.

By working in various Sequences, we can take time to carefully construct multiple layers of effects with as many tracks as we need. Then, in one master Sequence in one or two video tracks we can assemble all of our work by bringing in the various Sequences. This is a convenient way to compartmentalize the various parts of the project. Although this is not

necessarily the best method for all projects, it will work great for this project, as it allows us to focus on one segment of our audio track and one video editing technique.

TUTORIAL 5.1: ORGANIZING SEQUENCES

1. Rename Sequence 1. In our previous tutorials, we began building a Sequence that documented a trip to China. In the tutorial in Chapter 4, "Basic Editing," we placed quite a few clips using 3-point editing into a Sequence called Sequence 1. This Sequence will be visible at this point in several places. First, the Timeline will have a tab labeled "Sequence 1" that includes all the work done thus far (Figure 5.3a). The Browser, along with all the clips and bins will have a file called "Sequence 1" (Figure 5.3b). Finally, the Canvas will display along the top that the visible clip comes from Sequence 1 (Figure 5.3c).

FIGURE 5.3 a) Tab in the Timeline; b) Sequence 1 listed in the browser; c) Top of the Canvas.

Click, and then click again this Sequence's name in the Browser and rename it "Starting Cuts." Do not simply double-click, as this will open the Sequence.

2. Create a Master Sequence. We will be assembling all of our effects into one main Sequence. To create this new Sequence, click in the Browser and press ⌘-N, or go to the File>New>Sequence pull-down menu. The newly created Sequence will appear in the Browser and will be ready to be renamed. Call it "Master Sequence." We will be putting much more into this

Sequence later; but for now, double-click Master Sequence in the Browser to open its timeline.

In the Browser is an audio file called "Chinese_View.aiff." This is the full version of Axonic's great tune. Be sure to check out other tunes of his at www.mp3.com/axonic. Double-click this audio file to open it in the Viewer.

The waveform of this track will appear in the Viewer. Press the Spacebar to listen to the entire track once or twice. Using the process of creating markers (tapping "M" or "`"), create markers in the same way we did in the previous tutorials. You can place the marker and decide how to pace things however you would like. The important thing is that we will be creating a montage effect from 00:01:37:09 to 00:02:05:03. If you have been tapping out markers to the beat, you will probably already have one at 00:01:37:09. The key is that you really do not need any markers until 00:02:05:03. The rest of the markers are up to you.

Place this audio file in the Master Sequence's timeline by dragging it from the Browser to the audio tracks.

3. Create a Montage Sequence. The Montage Sequence is the sequence that we will use to create the multilayered effects shown in Figures 5.1 and 5.2. Create a new Sequence and name it "Montage." Double-click it to open it in the Timeline and Canvas.

 Notice that upon opening this new Sequence, your old Sequences—Starting Cuts and Master Sequence—can still be seen as a tab in the Timeline. This allows you to jump back and forth in the Timeline between multiple Sequences' timelines. However, this easy access comes with a price if you are using an older Mac or one without adequate memory. If you begin to experience dropped frames, a good thing to do is to close down Sequences that are not being used.

 To close a Sequence, select its tab in the Timeline and press Control-W, or select File>Close Tab.

TUTORIAL

5.2: GETTING STARTED WITH MULTIPLE TRACKS

1. Open the newly created Sequence Montage by double-clicking it in the Browser. This will open the Montage's timeline and give you a clean slate with which to work.

2. For inspiration, import the section of the audio track we will be editing as well. Because the audio track present in Master Sequence will ultimately be the only audio in the project, we actually do not *need* any audio in this Sequence at all. However, it usually helps establish the timing and mood if

you can readily hear the music that your edits are to accompany. Further, by bringing in the segment of the audio you will be editing, you know how long the entire sequence should be.

Double-click Chinese_View.aif in the Browser to open it in the Viewer. Enter 13709 in the Timecode field to jump to the marker at 00:01:37:09, or scrub the playback head to the marker. You will know you are at the marker, as it will turn yellow in the Scrubber Bar (Figure 5.4).

FIGURE 5.4 When the playback head is on a marker, it will highlight yellow.

Press "I" to mark this as the In. If you have no markers between 00:01:37:09 and 00:02:05:03, you can press Shift-M to jump directly to the next marker at 00:02:05:03. When this marker is highlighted, move back one frame by pressing the Left Arrow key, and then press "O" to mark this point as the Out.

By marking the In and Out, we can use this chunk of the larger audio clips to edit to. Drag the audio clip from the Browser to the Timeline (Figure 5.5). Notice that the "ghosting" will show many of the markers that have been placed outside the Out points. Not to worry, the dark gray bar is the only part of the audio clip that will be imported.

FIGURE 5.5 Import the prepared clip by dragging it from the Browser to the Timeline. Make sure to butt it up against the beginning of the Timeline.

This 27-second clip is what the Montage will be created over. Notice that when you import it, you are only using a small part of the space available in the Timeline. To maximize the workspace, use the Zoom Slider or

Zoom Control to zoom in on the Timeline (Figure 5.6). Zoom in enough so that this 27-second audio clip fills most of the horizontal space.

FIGURE 5.6 Use the Zoom Slider to maximize the space available.

Finally, lock these tracks down or turn off the channels to ensure that the captured clips that will be imported do not overwrite this audio track.

3. Prepare and place Forbidden City/Forbidden City Front Court. Open Forbidden City Front Court in the Viewer by double-clicking it in the Browser. There are a few stray frames at the end of the clip that should be cut out by marking the Out before the camera stops moving. That makes this clip 24 seconds—just a few seconds short of what we need to use it as a base layer of this sequence. To make it stretch to what is needed, use the Fit to Fill function.

In the Timeline, mark an In at the start of the Chinese_View.aiff clip and an Out at the end. Remember that when the Timeline is the active window, the Up and Down arrows jump to the beginning and end of clips currently present.

By marking the In and Out on either side of the audio clip, we are defining the length of time that the Forbidden City Front Court clip will stretch to fill. Now, drag the clip from the Viewer into the Canvas and onto the Fit to Fill Overlay (Figure 5.7).

This will place the clip in the Timeline and slow it down so that it lasts the needed 27;25. Notice in the Timeline (Figure 5.8) that the clip indicates how slow the clip will be played (in this case, 78%). Also notice that since the speed has been changed, there is a red render bar across the entire clip. In most cases, this would be a very expensive choice in terms of time. However, since we will be using multiple layers, rendering will be needed anyway, so slowing this entire clip down is an acceptable sacrifice because it will be absorbed in the overall rendering process. Since the Sequence will need to be rendered as we layer everything on, there is no need to render now.

4. Create a new video track. The default number of video tracks is one. Since the Montage will feature multiple clips atop one another, there will need

FIGURE 5.7 Placing a prepared clip from the Viewer into the Canvas using the Fit to Fill Overlay.

FIGURE 5.8 The imported clip shows how it is slowed and indicates that the entire clip must be rendered.

to be multiple video tracks. To create a new track (audio or video), select Sequence>Insert Tracks. The resulting dialog box (Figure 5.9) will allow you to create as many new audio or video tracks as you need. Further, it allows you to define where the new tracks will be—on top (After Last/Target track) or below (Before Target Track). For now, simply insert one video track. There are much faster ways to insert new tracks, but this step simply illustrates what is happening behind the scenes in later steps.

After clicking OK, the Timeline will now show an additional track entitled "V2." Note, however, that this new track is not the target track. The target track is the track in which new clips will be placed. Since Forbidden City Front Court is already placed, there will be no need to overwrite or insert any clips on that track. In addition, we just created this new track to place clips into, so activate it as the target track by clicking the little Film

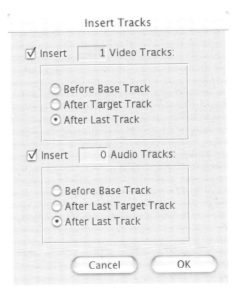

FIGURE 5.9 Inserting a new video track.

icon (Figure 5.10). Now, when new clips are dragged to the Canvas from the Viewer, they will be placed in V2 above the base track V1.

5. Prepare and place Forbidden City Court Pan. This clip is another pan shot of another part of the Forbidden City. There are a few seconds of footage where the camera is not moving, so set an Out to cut out those frames (about 00:18:33;13).

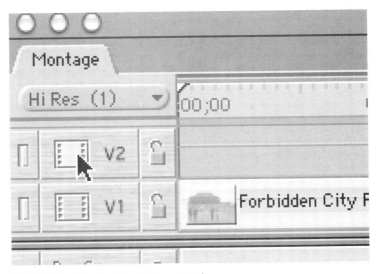

FIGURE 5.10 Activating V2 as the target track.

Move the playback head to the start of the Timeline by pressing Home. Place the prepared clip from the Viewer into the Timeline (and subsequently into the target video track V2) by dragging it to the Canvas. The default Overwrite places the clip in the empty space of V2.

As soon as this new clip is placed in V2, the render bar above that section of the Timeline disappears. This is because the new clip in V2 is completely covering the clip in V1. Since the clip in V2 has not been altered in a way that requires rendering, FCP can ignore the tracks below it. However, this will change in a minute.

6. Activate Clip Overlays in the Timeline. Clip Overlays are additional tools within the Timeline that allow you to define the opacity of a given clip. By default they are turned off to keep the Timeline interface clean. Activate them by clicking the Clip Overlays button at the bottom-left corner of the Timeline (Figure 5.11). The only perceptible change is that all the clips currently imported will have an additional line across them in the Timeline.

FIGURE 5.11 Turning the Clip Overlays on.

7. Use Clip Overlays to reduce the opacity of Forbidden City Court Pan. With the default Selection tool active and Clip Overlays turned on, you can grab the Clip Overlay and adjust the opacity. Figure 5.12 shows how the mouse will change when you are adjusting the opacity of a clip, and a numeric value will be displayed indicating the percentage of opacity of the given clip.

As soon as you begin changing the opacity of a clip that is superimposed on another, the rendering bars will of course again pop up, as FCP will need to render the two clips that are now merged together. Adjust the opacity to what looks good. Notice that the Canvas will show the current frame with the adjustments made in opacity. If you scrub the playback head to a new location, FCP will take a second to think and then display the current frame. Set the opacity of the Clip Overlay to about 60.

FIGURE 5.12 Adjusting the Clip Overlay using the Selection tool.

8. Fade the clip Forbidden City Court Pan in and out using the Clip Overlays. Up to now, the only tool from the Tools box that have been used is the truly multipurpose Selection tool. For this step select a new tool—the Pen tool (Figure 5.13).

FIGURE 5.13 The Pen tool.

Among other things, the Pen tool provides a means to define when and how audio and video clips fade in or out. For example, to fade the clip Forbidden City Court Pan out as it nears the end of the clip, use the Pen tool to create two handles by clicking on the Clip Overlay line (Figure 5.14a). Place one handle where the clip is to start fading and another at the end of the clip. Once both handles are created, use the Pen tool to move the last handle down until the yellow hint box reads 0 (Figure 5.14b). Now, do the same thing at the beginning of the clip so that the clip fades in as well.

FIGURE 5.14 a) Create handles for fades by clicking on the Clip Overlay with the Pen tool. b) Use the handles to fade out the clip.

Click and hold the Pen tool in the Tools Palette. The Pen tool is one of several tools that have multiple tools nested under one button (Figure 5.15). The Pen Delete tool will remove handles created with the Pen tool. The Pen Smooth tool allows for the creation of nonlinear fades. To use it, simply select the tool, and click on any handle. Two Bezier handles will appear (Figure 5.16) that can be grabbed to create gentle slopes in the Overlay Clip's opacity.

9. Add Forbidden City Entrance to the V2 track. Prepare the track in the Viewer by cutting out the frames at the end (set the Out to about 00:20:20;01). In the Timeline, move the playback head to the end of Forbidden City Court Pan by pressing the Down Arrow key. Drag the pre-

FIGURE 5.15 Nested tools beneath the Pen tool.

FIGURE 5.16 The Pen Smooth tool creates Bezier handles for nonlinear fades.

pared Forbidden City Entrance from the Viewer into the Canvas using Overwrite.

10. Use the Selection tool to set the desire opacity *and* do clip fade-ins and fade-outs. Switch back to the Selection tool, grab the Clip Overlay for the newly placed clip, and change the opacity to 60. Option-click on the Clip Overlay line to temporarily switch to the Pen tool to place handles for fading in and out. Adjust the placed handles to facilitate the fades. The clip with all its fades is show in Figure 5.17.

FIGURE 5.17 Clip with Clip Overlay handles created by Option-clicking with the Selection tool.

This ability to use the Pen tool while the Selection tool is active (and vice versa) is a terrific timesaver. Notice that if the Pen tool is activated and the ⌘ key is held down, the tool switches to the incarnation of the Selection tool that allows for the shifting of a clip's opacity. Conversely, when the Selection tool is active, the Pen tool can be evoked by Option-clicking, and the Pen Delete tool is called up when the Option key is pressed and the mouse is over a previously created handle.

11. Add Forbidden City Entrance Pan to the V2 track, and fade it in and out. Open the clip in the Viewer and take time to cut out extraneous frames to make sure the majority of the clip has the actual entrance in view. The Ins and Outs are approximately 00:10:55;12 for the In and 00:10:59;03 for the Out. Make sure to either use 3-point editing to get this clip to fit in the remaining space of V1, or use the Selection tool to trim the clip once it is imported.

12. Use the Superimpose Overlay Edit to place the clip Forbidden City/Forbidden City Pan into a new video track. Open Forbidden City Pan in the Viewer. There will not be any Ins or Out marked in this clip because the entire clip will be used. Move the playback head in the Timeline so that it sits at the handle on Forbidden City Court Pan that ends the fade-in. Mark this as the Timeline's In ("I").

 Grab the clip in the Viewer and drag it to the Canvas and onto the Superimpose Overlay Edit (Figure 5.18).

FIGURE 5.18 Placing a clip into the Canvas using the Superimpose Overlay Edit.

Many great things just happened to the Timeline. First, a new video track (V3) was created. If you cannot see three video tracks, you might need to expand the Timeline and/or pull the separator between the audio and video tracks down slightly.

Second, the Forbidden City Pan clip has been placed on that new track. Use the Selection tool or Pen tool to reduce the opacity of this clip to 30, and set it to fade-in and fade-out. The Timeline should appear somewhat like Figure 5.19.

Another important thing that happens when Superimpose is used is that the new track created is not the new target track. Notice that V2 is still the target track. Activate V3 as the target track for now, as the clips we will be placing for the rest of this tutorial will be in this track.

13. Place Forbidden City/Forbidden City Back PO into V3. Mark the In for this clip in the Viewer at 00:16:35;22, and the Out at 00:16:45;05. Place the clip

FIGURE 5.19 Placed clip using Superimpose. The clip was altered to make it semitransparent.

into the Timeline directly or into the Canvas using the Overwrite Overlay edit. Once it is placed, change the opacity to 30 and fade the clip in and out. Trim the clip in the Timeline if necessary. The result of all the work we have done so far should look something like Figure 5.20.

FIGURE 5.20 Three layers of video tracks.

14. Render. This is one of those times when it's a good idea to take a minute and let your work in this Sequence render out. Even though you know that the timing overall is fairly good since we carefully brought in the music segment that defines our timing, it's a good idea to find out how all your layers work when they are moving. For a collection of clips this size, it should not take long—on the 733-MHz G4 we are using, this Sequence rendered in about three minutes.

To render, press Option-R. This will render all the layers of all the clips of the Sequence. When it is finished rendering, take a second to play the Sequence in the Canvas. If you want to make any changes to the opacity levels, do so now and then re-render.

Tutorial Conclusion

We used a grand total of three video tracks in this tutorial. Technically, many, many more can be used. In fact, in future tutorials we will probably be using more than three. The visual power of this layering of tracks is fairly incredible.

ON THE DVD

Besides the simple layering of tracks, FCP allows for the definition of how those tracks will blend together. By selecting a clip in the Timeline and using the Modify>Composite Mode pull-down menu, you can define whether FCP adds the value of each layered pixel, subtracts, multiplies, or a whole slew of compositing options. Different Composite Modes are appropriate in different cases. Some are difficult to tell a difference in situations like this. For now, see Figure 5.21 for an idea of what the different Composite Modes can do. Remember to look at the color versions of these images on the DVD for the best idea of the subtle differences.

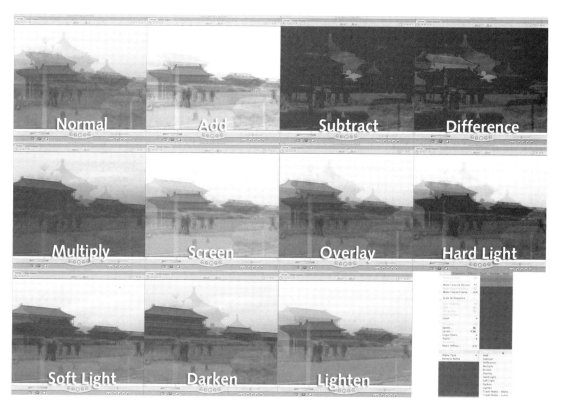

FIGURE 5.21 Various Composite Modes.

TUTORIAL

5.3: MULTITRACKS AND KEYFRAMES7

In Tutorial 5.2, we looked at ways to composite tracks together. In this tutorial, the focus will be on layering tracks—not to gently fade them together, but to create dynamic movement. We will follow the model we used earlier of working with a new Sequence and constructing the effect there.

1. Create a new Sequence (⌘-**N**) and name it Layered Movement. We are going to create a new effect in this tutorial with small versions of clips streaming through the screen. We will actually nest Sequences within this Sequence—but, first things first.
2. Import the sound segment from the audio clip Chinese_ViewShort.aiff. Remember from previous tutorials that a space was left in the Sequence called "Starting Cuts" (Figure 5.22). In this tutorial, we will be filling this space.

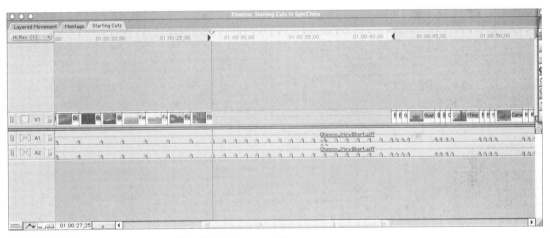

FIGURE 5.22 Starting Cuts hole. This will be filled with a nested Sequence.

First, take a second to remember the area we are going to fill. Double-click the Sequence Starting Cuts in the Browser to open it in your Canvas and Timeline. Move the playback head to the area where the hole is to listen to the audio. The hole matches the area of the music when the high melody begins (at about 01:00:27;25), and goes until the melody ends (at about 01:00:41;21).

To keep the timing on for the new Sequence we are going to construct, we will do the same trick as before and bring the sound clip into the Sequence. Double-click Chinese_ViewShort.aiff in the Browser (make sure to *not* double-click the version placed in the Timeline, as the Ins and Outs that we are going to mark would then affect the Sequence Starting Cuts).

Once the audio clip is open in the Viewer, scrub the playback head to the marker that starts the melody bridge (00:00:27:27), and mark this as the In. Then, play or scrub to the marker at the end of the melody bridge and press the Back Arrow key to move back one frame before pressing "O" to mark this as the Out (00:00:40:26) (Figure 5.23).

FIGURE 5.23 In and Outs marked on the audio Clip Chinese_ViewShort.aif that will be placed into the Sequence Layered Movement.

Now, open the Layered Movement Sequence, by double-clicking it in the Browser, or if it is already open in the Timeline, you can simply click the tab with its name. This new Sequence will open with empty tracks ready for your masterful hand to mold it.

The clip Chinese_ViewShort.aiff should still be the active track in the Viewer. Place this track into the Timeline by selecting the track in the Browser and dragging it to the default target audio tracks A1 and A2. Since the In and Out of the clip were just marked, only the melody bridge will be placed, giving you about 13 seconds' worth of sound.

Before adding additional video tracks (which in this case contain audio), turn off A1 and A2 as target tracks by clicking the small yellow triangles. This will ensure that the video clips' audio won't overwrite our music.

3. Prepare and place the clip Forbidden City/Buddhist temple. In the Timeline, create an In at the start of the Sequence. Now move to the fifth marker of the audio track. To do this quickly, select the audio track and press Shift-M to jump from marker to marker until you reach the marker at about (01:00:04;10). Move back one frame and mark this as the Out.

The beginning of the clip Buddhist Temple is fine, so no need to mark an In there—it is implied if none is indicated. Drag the clip from the Viewer to the Canvas using Overwrite to place the clip.

4. Resize the clip Buddhist Temple. There are a couple of ways to do this. The first graphical way is to visually resize it in the Canvas. To do this, the wireframes must be visible. At the middle-top of the Canvas are two buttons (Figure 5.24). The first button indicates how large the clips will appear within the Canvas. The second allows you to define how the clips are shown. There are several options here, but the only one of concern is the option to show Image+Wireframe.

FIGURE 5.24 Selecting the option to show Image+Wireframe.

Wireframes in FCP are essentially boxes that FCP draws to indicate the size and position of a clip. Scrub the playback head to anywhere that Buddhist Temple is visible in the Timeline, and using the Selection tool, click in the Canvas (Figure 5.25). As Buddhist Temple is the only clip visible at this time, it will be selected with a blue line around it and a white X through it. This blue line and white X are the wireframe.

FIGURE 5.25 Select a clip within the Canvas with the Selection tool to view the clip's wireframe.

Once a clip is selected within the Canvas and the wireframe is visible, all sorts of things are possible. By clicking and dragging the middle of the clip, the position of the clip can be changed. Still with the Selection tool, grab any corner of the clip by clicking and dragging and resize the clip (Figure 5.26).

Notice that by default, FCP maintains the proportions of the clip. This can get confusing when bouncing back and forth between programs such as Photoshop—freely clicking and dragging a selection distorts the pro-

FIGURE 5.26 Resize a clip visually by click-dragging any corner within the Canvas with the Selection tool.

portions. Conversely, holding the Shift key down in FCP allows for the distortion of the clip (Figure 5.27).

After playing with moving and resizing, make sure to undo back to a point where the clip is sitting in the middle of the canvas at full size. Use the Selection tool to resize the clip down to about one-fourth of its original size.

In the Timeline, double-click the Buddhist Temple clip. This will open the placed instance in the Viewer. Remember that this is not the original Buddhist Temple clip, and that clip will remain unaffected by the changes about to be made.

At the top of the Viewer are three tabs when a clip is open: Video, Filters, and Motion. Video is the default and shows you the actual footage of the clip. We will talk more about filters later, but the Filters tab allows you to define parameters of filters that change the visual impact of a video clip. The Motion tab is where our attention lies for this tutorial. Click this tab.

FIGURE 5.27 Shift-click-drag distorts a clip within the Canvas.

The Motion tab presents a variety of things having to do with how the clip is sized, cropped, rotated, and distorted within the Canvas. Also included in the Motion tab are Drop Shadow and Motion Blur. We will look at these in a second.

For now, enter 20 in the Scale input field (Figure 5.28). This will resize the clip Buddhist Temple to 20% of its original size. Usually, it is easiest to use the earlier process of simply grabbing and resizing a clip. However, if the planned effect calls for clips to be, say, exactly two clips across by two clips down, it is much more efficient to simply enter 50 into this value than try and visually scale clips down to exactly one-fourth of the Canvas' space. In this case, we will be moving many clips across the bottom and side, so we will need them to be quite small.

5. Reduce the Image Display Area in the Canvas. The plan for this Sequence is to have clips start off the screen and slide across the screen and off again. The area of the Canvas that actually displays the clips is called the Image

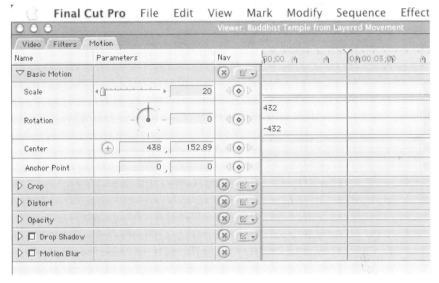

FIGURE 5.28 Resizing a clip using the Motion tab of the Viewer.

Display Area. Therefore, to place the clips off the Image Display Area, we need to make it smaller to give us working room around the edges.

Next to the button that allowed both the image and wireframe to be shown is a button that allows for the various magnification of the Image Display Area of the Canvas. The default setting is Fit to Window. This means that FCP reduces or increases the size of the Image Display Area depending on how large a monitor you have. However, you can choose various magnifications to fit your purpose. On our monitor (running at 1600 x 1200), reducing the magnification to 50% is just right. However, if your monitor is running at 800 x 600, then the entire Canvas only has 400 pixels across at best to place the Canvas, so the visible Canvas is probably already smaller than 50% of its full size. The magnification of the Image Display Area is much different from machine to machine.

Therefore, the best way to work with this button then is to not use it at all. Using the keystrokes ⌘-+ or ⌘— zooms the visible Canvas in or out. Press ⌘— until your Canvas looks something like Figure 5.29.

6. Ensure that Title Safe is active in the Canvas. In Figure 5.29, notice that the Image Display Area has two blue boxes visible. When a television plays a digital clip, it increases the size of the image slightly with the idea that the most important information is in the middle and that the viewer will want to see that information larger. The drawback is that this process cuts off the edges of the image.

FIGURE 5.29 Using ⌘−, the visible Canvas areas can be reduced to allow for maneuvering room.

Using the button described in Step 4, ensure that Title Safe is active. What this will do is make sure that there are two blue boxes visible in the Image Display Area. The larger of the two boxes indicates the area that you can be *reasonably* sure will be visible on a television. The smaller of the two boxes is the area that you can really be sure will be visible. Traditionally, this smaller box is called the Title Safe Zone, meaning that this is the region where you can place titles (text) and know that all the letters will be visible on the viewer's television screen.

7. Move the clip into position in preparation to placing keyframes. As the idea of this sequence is to have collections of clips sliding across the screen, use the Selection tool to grab the clip Buddhist Temple in the Canvas and move it so it is actually off the Image Display Area (Figure 5.30).
8. Place the first keyframe. Keyframes are an integral part of animation. True, this is not animation exactly, but the clips will be animated across the screen, so it's important to understand the concept of keyframes.

FIGURE 5.30 Placement of clip where motion is about to begin.

Assume that an animation studio is animating a sequence in which a character runs up to a log, leaps over it, and runs out of the frame. In many traditional animation studios, the work distribution of experienced animators (master animator) and inexperienced animators is broken down something like this: the master animator comes in and draws a frame where the character enters the screen. She also draws a frame at where the character begins its leap, at the top of its leap, and where it lands. These important defining frames are called "keyframes." The junior animators then come in and do all the work of filling in the frames in between. These junior animators are referred to often as "in-betweeners" and actually draw most of the frames in an animation.

Computer animation, including animating a clip moving across a screen, acts on this same assumption. The master animator (you) indicate important places in the animation, and the junior animator—the in-betweener (the computer)—fills in the rest of the frames.

Therefore, if the planned motion is to have the clip Buddhist Temple move from one side of the screen to the other in the time that the clip plays, a keyframe should be established at the beginning of the clip on one side of the screen, and the second keyframe should be placed at the end of the clip on the other side of the screen. The computer looks at the keyframe and says, "OK, so when this clip starts it's supposed to be on the right side of the screen. When it ends, it should be on the left. So, I will move it between those two points while it plays."

Now that the clip Buddhist Temple is placed on the far right, scrub your playhead to the beginning of the Timeline, or press the Home key. To place a keyframe, press the Add Keyframe button (Figure 5.31) or press Control-K.

FIGURE 5.31 Add Keyframe button at the bottom-right corner of the Canvas.

9. Create movement by moving the clip to automatically record a keyframe. Scrub the playback head to the end of the clip, or press the Down Arrow key to jump to the end of the clip. Notice that when you do this, the wireframe disappears in the Canvas. This is because the end of the clip is actually the first frame of the next clip—in this case, there is none. To make sure that the keyframe we make is set for the clip Buddhist Temple, press the Back Arrow key to move back one frame.

 At this point, the clip's wireframe will be visible in the Canvas. Hold the Shift key down to constrain the movement, and move the clip to the other side of the Image Display Area (Figure 5.32).

 Several important things have just happened. The first is that the second keyframe has been placed automatically. FCP assumes that if one keyframe is placed and the playback head is scrubbed to a new location and the clip is changed, that you planned to have it animated over that period of time.

 The second important thing to notice is the visible clues that FCP provides to indicate the animation just created. The green dots represent the keyframes placed. The purple line with the purple dots represents the path that the clip travels between keyframes and is called a Motion Path.

FIGURE 5.32 Move the clip to the other side of the Image Display Area and record a keyframe.

To further understand this process, scrub the playback head to about halfway through the Buddhist Temple clip and then move the clip in the Canvas to about the middle of the Image Display Area. A new keyframe is placed automatically and the purple line now looks much like a mountain (Figure 5.33a).

To continue with the Motion Path exploration, scrub the playback head a little forward or backward in the Timeline. Right-click on the middle keyframe and select Ease In/Out (Figure 5.33a). All of a sudden, the previously angled Motion Paths become soft, curvilinear, and the keyframe has Bezier curve handles (Figure 5.33b). Use these Bezier curve handles to alter the Motion Path to create much more complex and interesting curves (Figure 5.33c).

Before we move on, notice that in Figure 5.33a that by right-clicking on a keyframe, a Motion Path can be switched back to Linear, or a keyframe can be removed completely. Before moving on, let's look at a bit of what's happening under the hood.

FIGURE 5.33 (a) By creating a new keyframe, the motion path is initially angular until Ease In/Out is selected. (b) This keyframe can be changed to a softer curvilinear point. (c) The Bezier handles can create complex curves for the Motion Path.

Double-click the clip Buddhist Temple in the Timeline. The clip will then appear in the Viewer. Click the Motion tab to get back to where the Scale setting was entered manually. Notice that there are several small diamond shapes in various places. These diamond shapes represent keyframes. Within this window, keyframes can be directly selected, created (Option-click or by clicking the button shown in Figure 5.34), altered, or deleted.

In this case, the only change was the position denoted in the Center track, so it will be the only track with two keyframes. However, notice that animation is not limited to a clip simply changing position. You can change

FIGURE 5.34 Keyframes can be added within the Motion tab of the Viewer by Option-clicking within the desired track or by clicking these buttons. Note that the arrows on either side of the button allow you to jump to the next or previous keyframe.

the size, rotation, how the clip is cropped, and the clip's opacity. Notice that effects like a Drop Shadow or Motion Blur can be changed over time. The concept of animating all these different characteristics is the same as just explored in the clip's movement; so we won't go through how to animate each. However, if the discussion of how to animate one clip makes sense, the rest will fall right into place when your project calls for it.

Now that we have explored how to create and change the path and alter all types of keyframes, use FCP's multiple Undo functions to undo back to the point at which the second keyframe was placed, moving the clip straight across the bottom of the screen.

10. Take a look at the speed in Wireframe mode. By default, FCP is set up to show just the Image in the Canvas. We set the Canvas up to show us Image+Wireframe in an earlier step. However, as soon as we started resizing and animating clips, the dreaded red render bars began to pop up. There are ways to see how the animation looks in real time without having to render things out. Use the right-side button pull-down menu in the top middle of the Canvas and change the setting to Wireframe. There will be no clips available, just the boxes that indicate clips. Press Home on the keyboard to return to the beginning of the Sequence and play it. You will get a real-time view of how quickly or slowly the animation occurs.

 Once you are confident with the pace of the motion, switch back to Image+Wireframe.

11. Place a Slug. Slugs can act as many things. We will be using Slugs as empty placeholders that will allow us to place and animate where we want future clips to go. Later, the Slugs will be replaced with clips, but the clips will fall into the timeframe of the Slugs much easier than if each clip had been 3-point edited into place.

 Slugs can be found in the Browser. The Effects tab of the Browser includes all types of tools that we will discuss in the next chapter. For now, look for the folder called "Video Generators." Expand the folder by clicking the "twiddle" and look for the generator called "Slug." Notice that the Type column lists this as a clip.

 In previous tutorials we created new video tracks using the Sequence>Insert Tracks pull-down menu. In this tutorial, we will use a slightly faster method of the Superimpose Overlay Edit.

 First, create the Ins and Outs on the Timeline that go from the second marker to the sixth (a spread of about five markers). This would put the In at about 01:00:00;26, and the Out at 01:00:05;05.

 Now drag the Clip (actually Video Generator) Slug from the Browser to the Canvas and onto the Superimpose Overlay Edit (Figure 5.35). This will automatically create a new track immediately above the target track—in this case, V1 (Figure 5.36).

FIGURE 5.35 Using Superimpose to place a clip onto a new track.

FIGURE 5.36 The results of a Superimpose edit.

Notice that this default Slug is at the full screen size of 720 x 480. For now, do not worry about shifting the size or position—we'll take care of that in a later step.

12. Duplicate and superimpose a Slug from the Timeline. So far, we have placed clips from the Viewer and from the Browser. However, it is also possible to place clips and copies of clips directly from the Timeline. To illus-

trate this, we will place a copy of the Slug into a new track created through Superimpose.

Begin by making V2 the target track (click the Film Strip icon). Scrub the Timeline playback head to the next marker and mark it as the In. Now, drag the Slug from the Timeline to the Canvas and onto the Superimpose Overlay Edit.

The result (Figure 5.37) is a new track created with a copy of Slug with the same duration. Since all of the clips are going to be visible for the same duration, this saves time by only having to mark one point—the In on the Timeline.

FIGURE 5.37 Clips can be placed on the Timeline *from* the Timeline. This was placed by dragging from the Timeline to the Superimpose Overlay Edit in the Canvas.

13. Place clips using Copy-Paste. Continuing with exercises designed to explore the various tools of FCP, this step will look at copying and pasting tracks. Before we do so, make sure that there is space available in which to place the pasted clips.

 Make sure that V3 is the target video track. Go to Sequence>Insert Tracks and add three tracks after the Last Track (Figure 5.38).

FIGURE 5.38 New tracks created in the Timeline using Sequence>Insert Tracks.

Select either of the placed Slug clips in the Timeline. Select Edit>Copy or press ⌘-C to copy the clip (Slug) into memory. Scrub the Timeline's playback head to the next marker and make V4 the target track. By making V4 the target track, when the clip is placed, FCP knows where to place it.

Now select Edit>Paste or press ⌘-V. The Slug clip will be pasted into the target track V4. Now, move the playback head to the next marker, and make V5 the target track. Press ⌘-V to paste the clip into this track. Repeat in V6. The result of all this copying and pasting should look something like Figure 5.39.

FIGURE 5.39 Clips placed by copying and pasting. Make sure to select the appropriate target track when using this method.

14. Replace the Slugs with actual clips. Now that the slugs are all placed to define where clips will go, let's fill those Slugs with actual clips. One quick way to do this is to use the Replace Overlay Edit.

 First, make V2 the target track. Scrub the playback head to the beginning of the Slug on V2 and mark this as the In. Click on the Slug to indicate that this is the clip you will be replacing.

 Open Forbidden City Back PO from the Browser and edit down any unwanted frames at the beginning of the clip. Once the clip is ready, drag it to the Canvas and select Replace from the Overlay Edit options. In the Timeline, notice that Slug in V2 has been replaced with Forbidden City Back PO. Notice also that it is exactly the same duration.

 Repeat this process for video tracks V3 through V6 using whatever clips you want. Some suggested clips are Forbidden City Costumes, Forbidden City Garden Rock, Forbidden City Garden Statue, and Forbidden City Interior. If you choose to use another clip, remember that the replacing clip must be as long as the Slug. If it is not, you will get a message warning of Insufficient Content for Edit.

Remember, the steps are 1) Activate the target track; 2) Select the clip to replace; 3) Prepare the replacing clip in the Viewer; and 4) Drag the clip to the Canvas using the Replace Overlay Edit.

15. Copy and paste attributes. At this point, the clip Buddhist Temple has been resized and is animated moving across the bottom of the screen. Five other clips are placed and poised ready to be animated. However, going through and animating each clip individually would be a long and laborious process. We just looked at how to copy and paste a clip by referring to its content. However, the copy-paste process in FCP is much more dynamic than that. FCP allows you to not just copy the clip, but to copy all the keyframes of editable characteristics as well. This might not seem like a big deal, except that FCP also allows you to paste certain attributes of a clip and leave others out—including the content.

 Since Buddhist Temple is sized and animated as desired, select it in the Timeline and press ⌘-C to load the clip and all its attributes into memory. Now, select all the clips by marqueeing around them, or Shift-click each until they all appear brown. To paste the attributes, right-click on any of the selected clips and select Paste Attributes (Figure 5.40a). The resulting dialog box allows for the definition of which attributes are to be pasted. In this case, Basic Motion is the only option that needs to be checked (Figure 5.40b). Basic Motion happens to include attributes such as Center, Scale, and Rotation. Click OK.

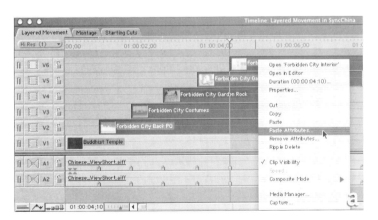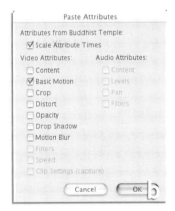

FIGURE 5.40 Pasting attributes with a right-click>Paste Attributes.

To view the results of this action, change to Wireframe mode in the Canvas, press Home to return to the beginning of the sequence, and press the Spacebar. You should see a parade of wireframes one after another parading across the bottom of the screen. This means that each of the

clips received the movement keyframes of the clip Buddhist Temple. Because each clip is offset by one marker, one follows the next.

Switch back to Image+Wireframe to see how the clips look. Although you will not be able to see the clips animated, you can scrub to a position in the Timeline and FCP will render that frame quickly so you can see what's happening.

Although it is not necessary here, go ahead and render the Sequence to see the effect. As this project progresses, there will be several such clips all moving across a background. Because of this, when all of the moving clips are placed on top of the background, they will need to be rendered again. Therefore, there is no need to render now. However, it's fun to see progress, so render and go take a break for a bit before moving on to the next step.

16. Repeat this process for Vertical Movement, but start with Slugs.

- Create a new Sequence and re-title it Vertical Movement.
- Copy the audio from Layered Movement.
- Paste the audio from Layered Movement into Vertical Movement, and then turn these audio tracks "off" so that they are no longer the target tracks.
- In the Timeline, mark an In at the beginning of the Sequence and an Out at the sixth marker (about 01:00:04;10).
- Drag Slug from the Browser under the Effects tab onto the Canvas using Overwrite.
- Copy the clip Slug.
- Use Sequence>Insert Tracks to insert another eight tracks After Last Track.
- Activate the next video track, scrub the playback head to the next marker, and paste. Repeat.
- Replace all the Slugs with clips of your choice. Used in the demo version are Forbidden City Watch Tower, Forbidden City Sundial, Forbidden City Pots, Forbidden City Interior Woodwork, Forbidden City Interior, Forbidden City Gardens, and Forbidden City Exterior Woodwork.
- Double-click the first clip (Forbidden City Watch Tower) in the Timeline and activate the Motion tab in the Viewer. Change the Scale setting to 15.
- Scrub the playback head to the beginning of the clip/Timeline and position the clip so that it is barely off the Image Display Area but will still be visible down the right side of the television screen (Figure 5.41). Record a keyframe.
- Scrub the playback head to the end of the clip Forbidden City Watch Tower, or press the Down Arrow key. Press the Left Arrow key once to

move back one frame. Hold the Shift key down and move the clip to just below the Image Display Area. The keyframe will be automatically placed (Figure 5.41).

FIGURE 5.41 Animated clip Forbidden City Watch Tower moving from off screen top right to off screen bottom right.

- Select the clip Forbidden City Watch Tower and press ⌘-C.
- Select all the other clips in the Sequence and right-click to select Paste Attributes.
- Choose Basic Motion and click OK.
- View the Canvas in Wireframe mode and view the clip's wireframes in motion.
- Render to see how the fun unfolds.
- The Timeline for this Sequence is shown in Figure 5.42.

FIGURE 5.42 Vertical Movement Sequence.

Conclusion

We covered a huge amount in this chapter. We looked at how to place clips in the Canvas and Timeline in a variety of ways. Although this is not comprehensive, it does cover all of the most useful and functional ways of working. We looked at multiple Sequences, altered opacities, and placing keyframes. The beginning of truly dynamic editing has been touched on from all angles.

Right now, you might be a bit confused as to why we have so many Sequences that are similar in theme but are not currently connected. Not to worry. In the next chapter, we will look at nesting Sequences and how to manage large projects by keeping them in just the types of Sequences we have worked with thus far.

If you need to review this chapter, take a second to do so. Get some rest, and read on so we can tear into the parts of FCP that bring it all together.

CHAPTER 6

REALLY ADVANCED EDITING

So far, we have learned quite a bit. However, up to now, most of the concepts covered were aimed at small clips and how to work and assemble individual clips into a Sequence. In this chapter, we get to look at how to put it all together. We will look at how to place Sequences inside of Sequences, how to make a new Sequence out of a collection of clips, and how to use filters and effects.

TUTORIAL

6.1: PLACING SEQUENCES WITHIN SEQUENCES

Keeping organized when doing NLE is very important. Especially with the style of editing today being such a quick-paced collection of hundreds or even thousands of clips, it's incredibly important that all the various parts of a project remain clear and organized in the editor's mind. Creating multiple Sequences is a great step toward this goal.

By creating things in Sequences, most projects are broken down into much more bite-sized pieces. The goal of this short tutorial is to learn how to take all of these bite-sized pieces and begin to assemble them into the 10-course meal.

1. Open Master Sequence. This can be done in a couple of ways. If a Sequence is already open, there will be a tab at the top of the Timeline with "Master Sequence" on it. If there isn't a tab, then locate the clip in the Browser and double-click it. This will open the Sequence in the Timeline.

 Currently, this is a fairly empty Sequence; the only present clip should be the audio clip Chinese_view.aiff. Not to worry, in a minute this clip will have plenty of company (Figure 6.1).

FIGURE 6.1 Master Sequence. Empty except for audio.

2. Locate Starting Cuts in the Browser. Remember that Sequences have a particular piece of iconography that indicates that it is a Sequence rather than simply a clip (Figure 6.2).

FIGURE 6.2 Starting Cuts is located in the Browser. Sequences and mere clips can be differentiated quickly from the iconography in the Browser.

3. Place the Montage Starting Cuts into Master Sequence. Placing a Sequence can be done in a couple of different ways, including 3-point editing. However, since Starting Cuts is, well, the starting cuts, the first frame of the Sequence Starting Cuts should match the first frame of Master Sequence.

 Move the playback head to the beginning of the Master Sequence by pressing the Home key. Now, drag the Starting Cuts from the Browser to the Canvas and accept the default Overwrite Overlay Edit.

 An important thing is happening here behind the scenes. This Master Clip has no target audio tracks; therefore, the audio track in Starting Cuts is not imported—perfect for our purposes here. We will look at this more later, but typically, with active audio target tracks, placed Sequences also place their accompanying audio track.

 The Timeline should look much like Figure 6.3. Go ahead and play the Sequence to see that all the clips inside of the Sequence Starting Cuts are

FIGURE 6.3 Timeline after Starting Cuts is placed into Master Sequence.

now embedded in Master Sequence. Notice that there is still the hole that we left earlier (we will fill this later), and that the sequence really is not long enough to cover all the introductory cuts. This is actually an accident by design, and we will look at how to fix these "designed accidents" later in the book.

4. Place Montage into Master Sequence. Montage is the Sequence in which multiple layers were used to composite various clips together (Figure 6.4).

FIGURE 6.4 The Timeline for Montage Sequence.

Recalling the tutorial in which this Sequence was created, remember that to get the timing just right we brought a chunk of the audio track from Master Sequence and used it as the audio for Montage. There are several benefits to this. The first is that it lets us know in Montage how long to make our edits. The second benefit is that since we used the markers in the Chinese_view.aiff audio clip in Master Sequence, we know that the Sequence Montage will fit exactly into where it needs to be.

Scrub the playback head to the marker at about 01:01:37;11 in the Master Sequence. Make sure that you snap right to the marker. Remember that FCP indicates it is snapped to a marker with the symbol shown in Figure 6.5

FIGURE 6.5 Snapped playback head.

Now for the sake of illustration, we will place this Sequence twice. With the playback head snapped to the correct marker, drag Montage from the Browser into the Canvas. As FCP did in the step before, the Sequence will be placed in the target video track (V1) and Montage's audio track will be dropped because there is no target audio track.

Now Undo what you just did (⌘-Z). For this step, instead use the method of dragging the Sequence Montage from the Browser directly to the Timeline. Take careful notes of all the visual clues that FCP provides (Figure 6.6).

FIGURE 6.6 Placing the Sequence Montage into Master Sequence.

There are many ways that FCP allows for clips or Sequences to be placed directly in the Timeline. Figures 6.7a and 6.7b show a couple of different versions of what the mouse toggles to when dragging a Sequence

or clip into the Timeline. The arrow pointing to the right indicates that the clip/Sequence is going to be placed using Insert. Insert means that all the clips behind the current mouse placement will be moved forward in time to allow for the placed clip. Remember that earlier we also looked at how to do Inserts using Overlay Edits. Figure 6.7b shows the possibility of doing a Superimpose Edit (also covered earlier in the Overlay Edits).

FIGURE 6.7 (a) Placing a clip using Insert in the Timeline. (b) Superimpose a clip.

In most projects, the fewer video tracks, the better. Therefore, the Overwrite Edit (arrow pointing down) is the way to go. The important thing to be careful about is that FCP will indicate when the front or end of the clip or Sequence that you are placing is on a marker or snug up against another clip. Be sure to snap the Sequence to the marker that indicates the front of the space, not the end.

We do this because to make the cuts on the beat, we moved one frame back from the marker when creating the Sequence. This allows the first frame of the next clip to be on the marker. In situations like this, always snap to the marker at the front.

Thus far, two Sequences have been placed within one large Master Sequence. Starting Cuts now has some problems. First, it is too short for the area that it needs to fill. Second, there is a big hole in it. One of the most powerful aspects of nesting Sequences as we just did is that if we later edit Starting Cuts (which we will) in its own Timeline, it will automatically be updated. We will talk much more about this later.

TUTORIAL

6.2: NESTING SEQUENCES

We just looked at placing Sequences that have been created earlier into another Sequence. This process is loosely referred to as *nesting*. However, there are still other ways to place clips or collections of clips into a Sequence. In this tutorial, we will use the Layered and Vertical Movement Sequences created in the last chapter to create new nested Sequences quickly and directly from clips already placed in that Sequence.

1. Open Vertical Movement by selecting the tab in the Timeline if the Sequence is already open, or double-click it in the Browser. This will open the Sequence in the Timeline, which should be similar to where it was left in the last chapter (Figure 6.8).

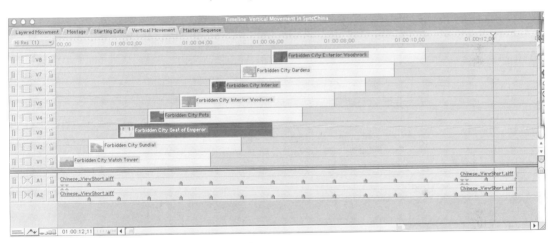

FIGURE 6.8 Vertical Movement as it was left in the last chapter.

2. Select all the video clips in all the tracks (Figure 6.9). The idea here is to make all of the clips placed thus far one new Sequence residing within the original Sequence. Don't worry, this will make more sense in a minute. Select all the clips by marqueeing around them, or Shift-select with the Selection tool.

3. Nest these clips with Sequence>Nest Item(s); the keyboard shortcut for this is Option-C. Immediately, a dialog box will pop up asking what the new Sequence should be named and how big it should be (Figure 6.10). The only thing to change is the name. Call the new Sequence "Vertical Movement Subset."

After clicking OK, the clips that were selected will collapse in the Timeline to a placed Sequence (Figure 6.11). Notice that there is also a new Sequence (Vertical Movement Subset) in the Browser. What happened here

FIGURE 6.9 Select all the clips in Vertical Movement.

FIGURE 6.10 The Nest Item(s) dialog box.

is that in one stroke, a new Sequence was created, named, and placed into the Sequence Vertical Movement.

4. Place the new Vertical Movement Subset Sequence and move it in time and space. "Big deal," you might be saying, "we cleaned up the Timeline. So what?" Well, if all the Nest Items function did was clean things up, that would in itself help with house cleaning. However, the real power of this is the ability to turn around and immediately use the new Sequence created.

The goal of these movement Sequences we have been creating is to save work by not needing to place a whole bunch of clips. We will instead

FIGURE 6.11 New Sequence created as a result of nesting items.

simply place and move the moving clips now contained in the Sequence Vertical Movement Subset.

Drag Vertical Movement Subset from the Browser into the Timeline (Vertical Movement), and place it in the V2 video track so that the end of the Sequence corresponds to the end of the audio track (Figure 6.12).

FIGURE 6.12 Placing Vertical Movement Subset in the Sequence Vertical Movement's Timeline.

5. Move the newly placed Sequence so that it runs down the left side of the screen. In the previous step, we placed the newly created Sequence again into Vertical Movement's Timeline. What this means is that if the Sequence were played, there would not appear to be much difference since the

same clips would be playing in the same space, just two markers later. No problem, though. It turns out that Sequences can be moved and repositioned in the same way that clips were shifted in position in the last chapter.

Make sure that the Canvas is displaying Image+Wireframe. Then, select the Vertical Movement Subset that was just placed in V2 (Figure 6.13). Move the playback head to a location in the Timeline where both Sequences are visible so that you know where to move the V2 Sequence to.

FIGURE 6.13 Select the Sequence you want to move in the Timeline. Make sure that the playback head is in a position to allow you to see the Sequence's placement in the Canvas.

Now, in the Canvas, the Vertical Movement Subset contained in V2 (that you just selected) is shown along with the blue box and white X indicating the Sequence's wireframe. Still using the Selection tool, click the Sequence and drag to the left.

Press the Shift key as you drag to make sure that the clip slides directly to the left and does not move up or down. Because the clips were carefully placed just off the top of the screen and moved to just beyond the bottom of the screen, it's important that their placement isn't disturbed in the vertical direction. Slide the Sequence over so that the edge of the moving clips aligns to the edge of the Viewable area (Figure 6.14).

6. Render. Unfortunately, one of the drawbacks of using nested Sequences in this situation is that the wireframes that we see are the wireframes of Sequences, not clips. Therefore, even if we shifted to Wireframe mode in the Canvas, we would not be able to see how all the nested clips move. However, after rendering, you can get a look at your work thus far.

7. Repeat the process for Layered Movement. Layered Movement was the Sequence created for an earlier tutorial that has clips moving across the bottom of the screen (Figure 6.15).

Open the Sequence, select all the clips therein, and press Option-C. Name the new Sequence "Horizontal Movement Subset." Place another copy of the Sequence from the Browser into the Timeline for Layered Movement in V2 so that it ends when the audio ends. Finally, select the Se-

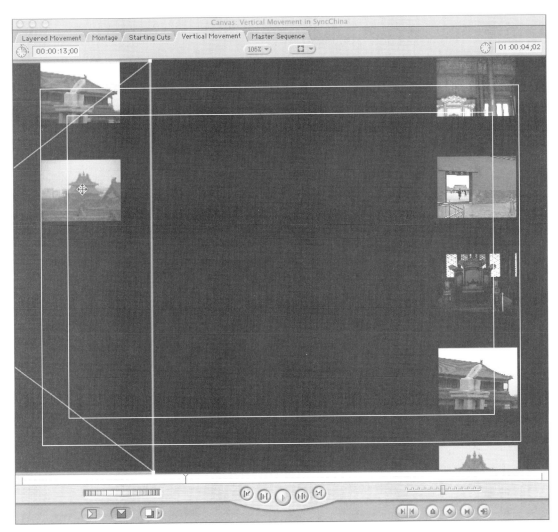

FIGURE 6.14 Moved Sequence.

quence in the Timeline, and in the Canvas (which should be showing Image+Wireframe), move the Sequence up so that the clips run along the top of the screen.

Your workspace should now look something like Figure 6.16.

8. Place V2's content in V3 to make room for the Sequence Vertical Movement. To do this, use the Selection tool to grab the Sequence Horizontal Movement Subset currently residing in V2 and move it up to the vacant V3. Make sure that when you do so, there is no movement along the Timeline. If you get a little yellow box with 00:00:00;00 in it, you know that you

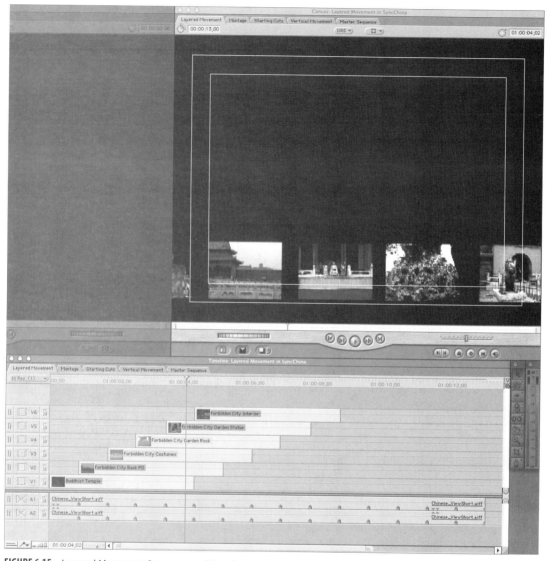

FIGURE 6.15 Layered Movement Sequence and Timeline.

are not changing the timing of the Sequence, just the track on which it sits (Figure 6.17).

So, why do this? The eventual effect will be that the clips moving vertically will flow under the top flowing clips and over those flowing across the bottom of the screen. To get this effect, the Sequence Vertical Movement needs to be between the two Sequences of horizontally moving elements.

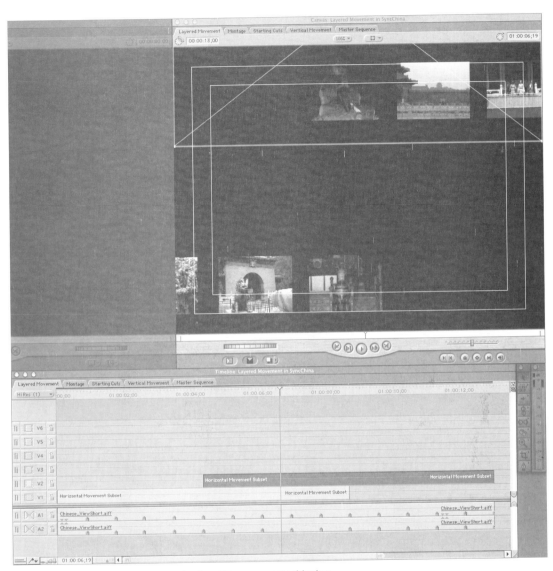

FIGURE 6.16 Results of Nest Items, newly placed Sequence, repositioning.

9. Place Vertical Movement in V2 of Layered Movement. At this point, V2 should be an empty track. Drag Vertical Movement from the Browser into V2. It should fill the entire track and be the same length as the audio track.
10. Nest the nested Sequences. At this point, all of the moving elements are nested into Sequences and placed in the Sequence Layered Movement. However, all the moving elements are presently positioned on the black background. This black background is actually indicating that there is no

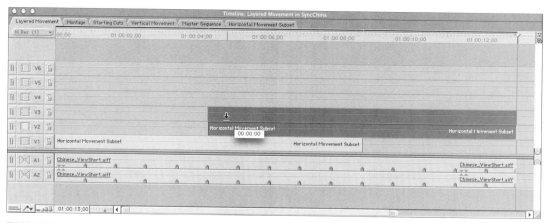

FIGURE 6.17 Repositioning Horizontal Movement Subset.

media below the moving elements. The eventual look for this Sequence will be the moving elements laid over the top of a clip of the Forbidden City.

To prepare for placing the Forbidden City clip *below* all the other moving clips, nest the Sequences. Do this by selecting both Horizontal Movement Subsets and the Vertical Movement Sequence and pressing Option-C. Name this new Sequence "Layered Moving Elements." This will put all the moving elements into one Sequence.

11. Move this new Layered Moving Elements from V1 to V2. As the moving clips are to reside and move above a background clip, we need to make room on V1 for the clip.

12. Place Forbidden City Back Underlay in video track V1. The problem is that Forbidden City Back Underlay is not long enough. Not to worry. Simply set an In at the start of the Timeline, and set an Out at the end of the audio track. Drag the clip Forbidden City Back Underlay from the Browser to the Canvas, and select the Fit to Fill Overlay Edit. Usually, this would be undesirable because Fit to Fill is a render-intensive edit. However, since this segment must be rendered anyway because of the multiple layers and keyframes, it's an acceptable choice. The Timeline should look like Figure 6.18.

13. Clean up a bit. In the process of placing multiple clips on multiple layers, quite a few video tracks have been built up. For your own sanity and to keep the amount of information that FCP needs to keep track of to a minimum, delete tracks that are not in use. Spare tracks in large projects can hide unwanted clips that are not easily seen.

To get rid of tracks, go to Sequence>Delete Tracks. At the resulting dialog box (Figure 6.19), delete the empty video tracks. The result, shown in Figure 6.20, is a Timeline with tracks only where there is media.

FIGURE 6.18 Placed clip under the nested Sequences.

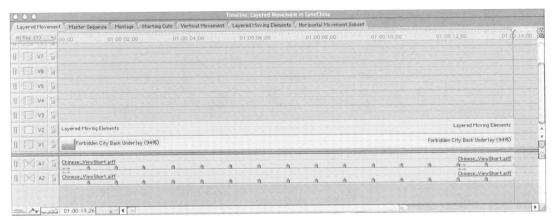

FIGURE 6.19 Delete Tracks dialog box.

14. Render. Take a break and have FCP render these many nested Sequences. In your own workflow, there probably is no reason to render at this point, and in fact, there are some reasons to *not* render at this point. However, during the learning process, it's fun to see how things are coming together, so take a render (Option-R).

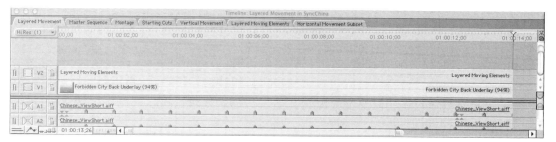

FIGURE 6.20 Timeline for Layered Movement with cleaned-up tracks.

15. Bring Starting Cuts to the foreground of the Timeline. Do this by selecting its tab at the top of the Timeline. Remember that pesky hole that was left from the earliest tutorials? We're about to fill it.

16. Locate the hole in V1 (Figure 6.21). Scrub the playback head to the end clip right before the hole. To do this quickly, use the Up Arrow key. Press "I" to mark this as the In point. Since the Sequence Layered Movement was carefully constructed to match the markers exactly, there is no need to mark an Out because the Sequence will end right when the first clip after the hole begins. Drag Layered Movement from the Browser into the Canvas, and accept the default Overwrite Overlay Edit. The Sequence will drop right into the hole (Figure 6.22).

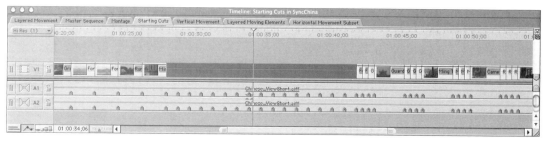

FIGURE 6.21 The hole left in earlier tutorials in Starting Cuts.

17. Now look at the Master Sequence. Click on the Master Sequence tab to bring it to the foreground of the Timeline. Play or scrub through the first part of the Timeline where the Sequence Starting Cuts is placed. Notice that the changes we made in Starting Cuts, in the Starting Cuts Timeline, are automatically updated and carried on into the Master Sequence! The ability to create multiple Sequences and edit them independently while FCP automatically updates other locations where the Sequence is placed is incredibly powerful.

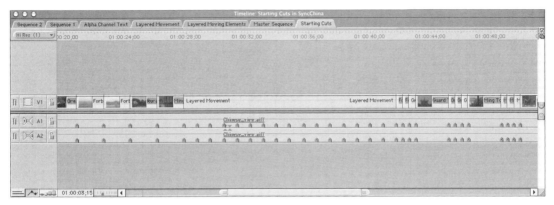

FIGURE 6.22 After dropping Layered Movement into the Canvas, everything is ready to go.

In the Timeline, double-click any placed Sequence, and that Sequence's Timeline will automatically be opened for you to edit. In this way, Sequences can have incredibly large numbers of layers and effects, but the big picture is organized in a much more refined and controlled environment.

Nesting layers also allow for collections of clips to be repositioned, and can even be animated. Sequences can be scaled and rotated. Sequences that are nested can be layered on top of one another. All in all, nested Sequences help keep things organized and clean while still providing the tools for tremendous flexibility in clips and collections of clips.

CLIPS AND SEQUENCE EFFECTS

We've looked at how to import clips, how to place clips, how to edit clips, how to nest clips, and how to nest nested clips. FCP does all of this very well. FCP also provides ways to change the very appearance of these clips that although typically render intensive, provide tremendous power in mixing things up.

There are a couple of different ways to change the nature of a clip or a Sequence's appearance. Almost all of the ways are managed in the Viewer, but some are even enabled there. In the following tutorial, we will explore this method.

TUTORIAL **6.3: ATTRIBUTE EFFECTS**

1. Get to the right clip. If you have been following the tutorials to this point, Master Sequence is the Sequence in the foreground of the Timeline. Double-click the Sequence Starting Cuts in the Timeline. When Starting Cuts is in the foreground, double-click Layered Movement. Then, double-click Layered Moving Elements and finally one of the Horizontal Movement Subset Sequences (the one on V3 for now). This should get you to a place similar to Figure 6.23.

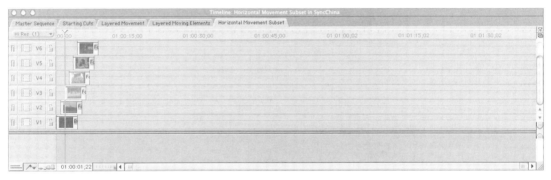

FIGURE 6.23 Accessing clips by double-clicking on nested Sequences.

Take a minute to zoom in on the Timeline so that it is easier to see the names of the clips (Figure 6.24).

FIGURE 6.24 Zoom in on the Timeline using the Timeline Zoom tools at the bottom of the Timeline.

2. Double-click the clip on V1 (Buddhist Temple). This will open the clip in the Viewer.
3. Add a glow. When you double-click the Buddhist Temple clip, the Viewer will open showing the clip at its location and size depending on where

your playback head is at. If you cannot see the clip Buddhist Temple in the Viewer and the Canvas, scrub the playback head so you can.

In the Viewer are three tabs along the top. We already discussed briefly some of the features enabled in the Motion tab; namely, we looked at how keyframes were placed and could be edited here. Remember that if the timing of a movement, scale, or crop needs to be changed, the keyframes can be directly selected here and altered.

However, this is not all that the Motion tab will do. Click on the Motion tab to bring it to the foreground and notice that there are two options—Drop Shadow and Motion Blur—toward the bottom of the window. To add a glow, we will use the Drop Shadow function.

Activate the Drop Shadow and click the "twiddle" to expand the selection (Figure 6.25).

FIGURE 6.25 The Drop Shadow options.

We are adding a glow to help the dark clips stand out a bit from the dark clips behind them. The glow will need to emanate equally in all directions, so set the Offset (how far the drop shadow is *offset* from the source) to −1. Remember to do this by simply typing "−1" in the input field. If you use the slider, you will notice that the Offset can be in positive and negative directions. This will bring the glow just slightly out from behind the clip.

For our purposes, the Angle is irrelevant. However, if we were using the Drop Shadow as, well, a drop shadow, then we could use this function to determine if the shadow fell to the right and down of the clip, indicating

that the "light" was to the top left. By changing this angle, we could make the light source look like it was coming from any direction. Remember that this is animatable (indicated by the Add Keyframe button (Figure 6.26) located next to this setting), so that a virtual light could be made to appear to move.

FIGURE 6.26 Add Keyframe button.

The Color setting does become important to us. In most cases, the shadow color of course is black, but here, the glow color will be white. There are several ways to select a color, including "lifting" a color from somewhere using the small Eyedropper button. Although we will use a different method for this tutorial, to use the Eyedropper, simply select it and click on your screen to indicate what color you want. For our purposes now, click on the black square (color swatch).

This will bring up the Apple Color Picker. There are many different ways to pick colors here, but for now, simply take the slider along the bottom of the black circle and slide it to the right so that you have a value of 100% (Figure 6.27). Notice that as the value increases, the black circle turns into a color wheel from which you can pick any color.

Next down the line is the Softness setting. In real life, multiple light sources usually create softer shadows. Singular light sources (one light bulb, or the sun) create hard shadows. In this case, we want our "white shadow" to be very soft to simulate a glow. Therefore, change the value to 100.

FIGURE 6.27 Adjusting the color of the shadow using the default Apple Color Picker.

The *opacity* indicates how "see through" the shadow is. In our case, the glow needs to be as strong as possible, so set this value to 100 as well.

The Settings and resulting effect on the Buddhist Temple clip are shown in Figure 6.28.

4. Make sure that Buddhist Temple is selected in the Timeline, and press ⌘-C to copy the clip and its attributes into memory. Because setting up the glow involved shifting so many options, it would be truly a pain to do this

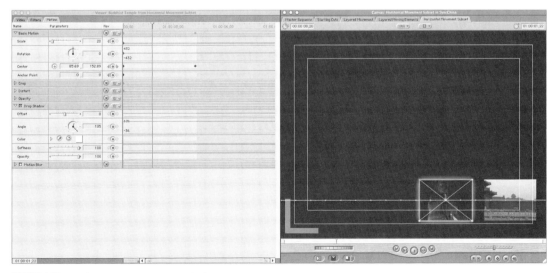

FIGURE 6.28 Adding a glow using Drop Shadows.

with every clip. So instead, we will just copy the Drop Shadow attribute to the other clips in the scene.
5. Select the other clips in the Sequence, right-click on any of them, and select Paste Attributes (Figure 6.29).

FIGURE 6.29 Shift-click to select all the other clips, and select Paste Attributes.

In the resultant dialog box, the only attribute we really want to paste is the Drop Shadow. Therefore, select just the Drop Shadow option and click OK. Now all the clips in this Sequence have the same glow. Scrub through the Sequence to see the effect (Figure 6.30).

6. Click the Layered Moving Elements tab in the Timeline. This brings that Sequence back to the foreground.
7. Paste the Drop Shadow attribute to the *Sequence* Vertical Movement. Do this by selecting the Sequence Vertical Movement in the Timeline (on track V2) and then right-click it and select Paste Attributes. Then, as before, select Drop Shadow and click OK.

This assigns the Drop Shadow to the entire Sequence, which means that every vertically moving clip now has its own glow (Drop Shadow). Scrub the playback head in the Layered Moving Elements Timeline and it should look something like Figure 6.31.

8. Add Motion Blur to the Sequence Vertical Movement. We just looked at how to create an effect (or in this case an Attribute) on a clip and copy it to a Sequence. However, it's also easy to create a new Attribute Effect to an entire Sequence directly.

The trick here is getting a nested Sequence into the Viewer. For clips, double-clicking opened the clip in the Viewer. With a Sequence, however, double-clicking in the Timeline, simply opens the Sequence's Timeline. Well, it turns out that double-clicking an element in the Timeline is not the only way to bring it to the Viewer.

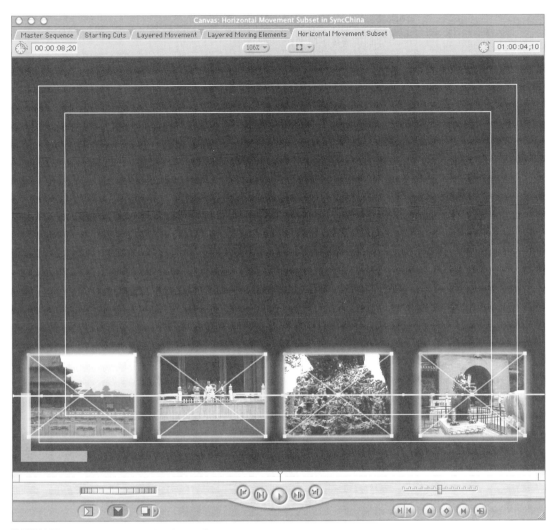

FIGURE 6.30 Glows added to all the clips in the Sequence.

For the Sequences in Layered Moving Elements (or any Sequence or clip), simply select the Sequence in the Timeline and press Return on your keyboard, or drag it into the Viewer. In this case, select Vertical Movement and press Return.

The Viewer's Video tab should look something like Figure 6.32a. More importantly, the Motion tab will allow us to change attributes directly. Notice that since we pasted the Drop Shadow Attributes, the Drop Shadow of this Sequence is already activated and configured. Now we can adjust the Motion Blur Attributes. Expand the Motion Blur Attribute (Figure 6.32b).

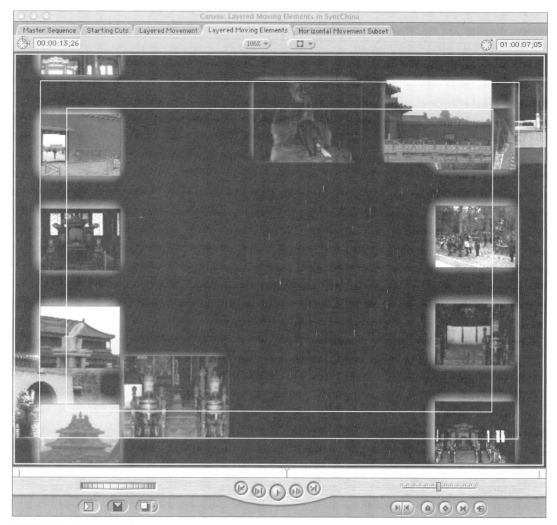

FIGURE 6.31 The Drop Shadow copied an entire Sequence.

Motion Blur is a simulation of what happens when a camera (video or film) is attempting to capture movement. Film at 24 fps, and video at 29.97 fps, is actually capturing large amounts of still images that are played back in rapid succession to give the illusion of movement. In most cases, a single frame shows all the action frozen in time. However, sometimes this movement is so fast that as the camera's shutter opens and closes for each frame, the movement ends up streaked across an individual frame. The Motion Blur Attribute is an attempt to simulate this streaking.

FIGURE 6.32 (a) Video tab of the Viewer when a Sequence is opened. (b) The Motion tab with expanding Motion Blur Attribute.

Since the movement of the clips is computer generated, it can seem much too clean. However, remember that too much Motion Blur can blur the images beyond all recognition. Motion Blur is very time intensive when it comes time to render, and so should be used sparingly. However, in an effort of FCP exploration, we will use it here.

Under the Motion Blur Attribute are two characteristics. The first, % Blur indicates how blurred an object is to be. Since the movement of our clips is none too fast, reduce this to 200%.

The second area, Samples, is a bit more complex. The way that FCP simulates blur is to make several copies of the clip or Sequence and composite them together to give the blur. The more Samples, the smoother the blur with look. However, more samples mean much more rendering time. Typically, lower % Blur values mean you can get away with lower Samples. Conversely, higher % Blur usually needs higher samples so that it doesn't look like simply trailing copies of the clip. For this tutorial, set the Samples value to 4.

The Canvas will take a second to process this information. The mouse will shift from white to black as the computer processes all the information. When FCP finally figures out the one frame that the playback head is on, it will display it in the Canvas (Figure 6.33).

9. Copy the Motion Blur Attribute to the two Horizontal Movement Subset Sequences. Do this by selecting Vertical Movement in the Timeline, and

FIGURE 6.33 Motion Blur for the Sequence Vertical Movement.

pressing ⌘-C to load the Sequence and its attributes into memory. Select both Horizontal Movement Subset Sequences in the Timeline by clicking one and then holding the ⌘ button down as you click the other. This allows you to select multiple clips or Sequences that are not on top of one another or adjacent. Right-click on one and select Paste Attributes. The result should look something like Figure 6.34.

FIGURE 6.34 Pasted Motion Blur into Horizontal Movement Subset Sequences.

TUTORIAL **6.4: CLEANUP**

Before we can really get into the tutorial and explore all the potential effects, we need to take a minute and prepare a Sequence. In past tutorials, there have been some holes left in some of the projects. Since much of this SyncChina project is simply quick cuts, it did not make sense to spend too much time

repeating "prepare this clip, 3-point edit it into place, repeat… ." However, in the process of not filling out Sequences, we have ended up with some holes that need to be filled before we can move on.

In filling these holes, you will be able to see a few things. First, this tutorial will illustrate how updated Sequences are automatically updated in Sequences that they are nested within. It will also show the problems that occur when adding new information to a nested Sequence.

1. Select the Starting Cuts Sequence by selecting its tab in the Timeline.
2. Delete Chinese_ViewShort.aiff from A1 and A2. Do this because the short clip is not long enough for the short cuts; we need more of the overall audio clip.
3. Open Master Sequence and copy the audio in A1 and A2.
4. Back to Starting Cuts, make A1 and A2 the target audio tracks, move the playback head to 00:00:00;00, and paste the audio into place.
5. Trim the audio back to the last marker of the quick cuts (about 01:01:09;16). Remember, this can be done in the Timeline by clicking and dragging the end of the audio clip back to the correct position. Alternatively, double-click the audio track and in the Viewer, scrub the playback head to the desired marker and mark it as an Out. No matter how you do it, your Timeline for Starting Cuts should now appear much like Figure 6.35.

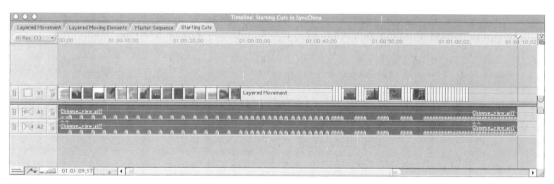

FIGURE 6.35 Starting Cuts with added audio.

6. To save time, copy and paste the clips previously placed in the fast-paced section. First, marquee around the short clips at the end of V1 (Figure 6.36). Select ⌘-C to copy them, and then scrub the playback head to the end of the last visible video clip and press ⌘-V to paste these clips (Figure 6.37). Finally, select the excess video clips (Figure 6.38a) and delete them (Figure 6.38b).

FIGURE 6.36 Marquee already placed clips to select them. Copy them into memory.

FIGURE 6.37 Scrub the playback head to the end of the visible clips and paste the clips in memory in.

This creates a short section where the same clips are repeated over and over. Usually, this would be a bad move because the audience would be bored, but we are going to mix things up by applying Effects to change the nature of the clips.

However, before we move on to exploring Effects, take a minute to see what the preceding steps have done to the Master Sequence.

FIGURE 6.38 (a) Select the excess clips and (b) delete them.

7. Click the tab for Master Sequence bringing it to the front (Figure 6.39). Notice that Starting Cuts now extends to where the super-fast-paced cut ends and a new section of the song begins (01:01:09;17). However, notice that Montage no longer matches the space designed for it!

 By adding to a nested Sequence, the Sequences or clips further down the Timeline are moved down to accommodate the new addition. This is done to make sure that you do not accidentally overwrite edits or clips you need. The problem is that if you are not very careful, all of your edits can end up shifting all over the place.

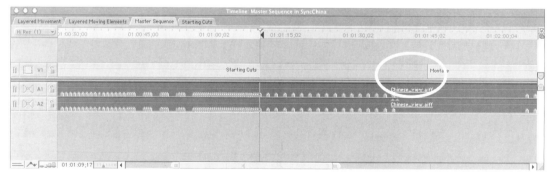

FIGURE 6.39 Starting Cuts automatically is lengthened when the new audio and video is added. However, Montage no longer matches the space for which it was edited.

8. Complete the cleanup by moving Montage back into place in the Master Sequence Timeline (Figure 6.40).

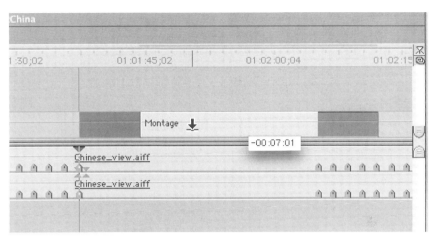

FIGURE 6.40 Final step of cleaning up is moving Montage back into place.

Be sure to remember this in your own editing. As illustrated in this tutorial, this can be a great drawback in nesting Sequences if you begin changing the lengths of Sequences. Take care.

TUTORIAL

6.5: Exploring Browser Effects

Continuing with exploration of changing the look of clips, we will look now at the tremendously robust and tremendously tempting collection of filters housed under the Effects tab of the Browser. These effects can be very seductive. They can create new looks individually or in collections of effects layered on top of each other. You can even get different looks using the same effects but placing them on the clip in a different order. But beware! Seductive as they might be, they are render hogs. Effects essentially cause FCP to change about every pixel of a clip. When dealing with images that are 720 x 480, FCP is pushing, shifting, and altering 345,600 pixels *per frame*. That means that by the time you have a three-second clip at 30 fps, FCP needs to change 31,104,000 pixels. Your Mac might be fast, but we are talking huge amounts of data here. Therefore, use the filters in Effects sparingly; use them only when they push the film's concept forward, not just because they are there.

1. Go back to Starting Cuts by selecting its tab at the top of the Timeline.
2. Zoom in on the last collection of clips and select the last video clip in V1. Double-click this clip to open it in the Viewer. This will probably be Beijing Window.

3. Click the Effects tab in the Browser. This will show a collection of folders starting with Favorites and ending with Audio Filters. Although this is called "Effects," there is more than simple stylization of clips contained here. Each of the folders unfolds to reveal more folders. The sheer amount of tools contained therein could take up an entire book in itself. Unfortunately, we do not have the space or time to cover all of the tools in the Effects tab in this book. However, we will be looking at every area of effects. The exploration of all of the tools is left up to you.

The *Favorites* folder right now will be empty. This is essentially an empty bin in which particular Effects can be placed. This allows for collection of Effects used for one project that can be accessed easily without digging through multiple layers of folders. To place a particular effect in the Favorites folder, simply drag it from wherever it is in the Effects tab onto the Favorites folder. A copy of the effect will be placed in the Favorites folder.

The *Video Transitions* folder contains many tools that we will be using later, so we will refrain from going into too much detail here. In a nutshell, these transitions allow for a large variety of moving from clip to clip. The most common of these, of course, is the Cross Dissolve—but more on this later.

The bin below this is *Video Filters*, which we will be exploring in just a second.

The *Video Generators* bin contains a variety of Effects that allow for the creation of small clips. In earlier tutorials, we used this to create a Slug, or a blank placeholder. If you expand the bin, you will see that there is a variety of tools, including Bars and Tones, Mattes, and Text tools. To use one of these effects, drag the effect into the Timeline or the Canvas. This will create a clip within the Timeline that can be selected and double-clicked to allow you to change the parameters in the Viewer. We will briefly cover some of the text tools later.

The *Audio Transitions* are a couple of great little tools that work similar to Video Transitions that allow for the graceful change from one sound clip to another.

Audio Filters are a collection of powerful tools that can help in fixing defective sound. Have too much white noise in a sound, lots of popping in your interview clip, or are you simply a sound aficionado and are dissatisfied with the background music and want to tweak the bass? These problems can all be solved here. One of the early criticisms of FCP was that it lacked good sound tools. Versions 1.5 and later have taken great strides in this direction. There are many more sound tools besides those contained here, which we will look at later.

4. Add the Effect Stylize/Solarize to the last clip Beijing Window. Expand the bin Video Filters. Find the bin Stylize and expand it. Drag Solarize from the Browser onto the clip Beijing Window.
5. Open the "effected" clip Beijing Window in the Viewer by selecting it in the Timeline and pressing Return, or double-click it. Along the top of the Viewer are the two tabs we already explored: Video and Motion. Click the Video tab to see what the clip looks like with the Solarize Effect applied. Alternatively, scrub the playback head in the Timeline so that it rests within the "effected" clip to see in the Canvas what the clip looks like.

 The third, the tab in the middle, Filters, is the tab of the moment. Click it to open a list of settings that allow for the modification and animation of Filters applied to a given clip or Sequence (Figure 6.41).

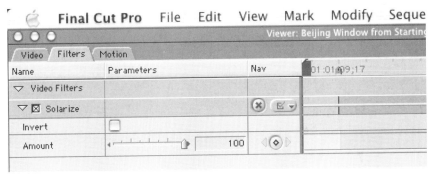

FIGURE 6.41 The Filters tab of the Viewer.

Here, each of the Effect Video Filters that are attached to a particular clip can be turned off or altered. The Solarize filter has a limited selection of changes that can be made, just Invert and Amount. However, others have much more robust collections of parameters that can be altered.

6. Add the Video Filter QuickTime/Color Tint to the same Beijing Window clip. Part of what makes these effects limitless in possibilities is the ability to layer textures on top of one another. Open the bin QuickTime in the Effects tab of the Browser and drag the filter Color Tint to the last clip Beijing Window.

 The Filters tab of the Viewer should still be open. Within it, notice that there are now two filters listed. Notice also that there are more options to this Color Tint filter. For now, simply change the Tint Type to Sepia (Figure 6.42).

 The result of these two filters layering over one another is a unique image—but we're just getting started.

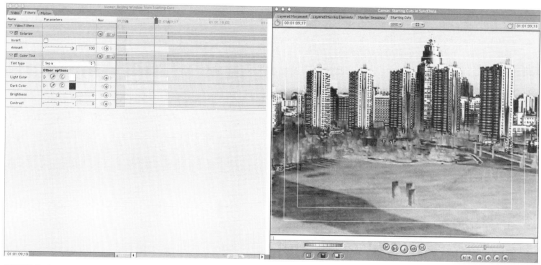

FIGURE 6.42 Layered Filters settings and the result.

7. Reorganize the rendering pipeline of the filters. When FCP takes into account the filters applied to a clip, it starts from the top, applies the filter, and then takes the result and applies the next filter down. The order in which these filters occur in the Filters tab also changes the final result.

To reorganize filters, click and drag a filter into its new position. In this case, drag Color Tint up over the top of Solarize (Figure 6.43). Now FCP is first applying the Color Tint filter to the clip and then Solarizing that result (Figure 6.44). Be sure to check out Figures 6.43 and 6.44 in color on the

FIGURE 6.43 Rearranging filters is easy—just drag and drop.

Chapter 6 Really Advanced Editing | **161**

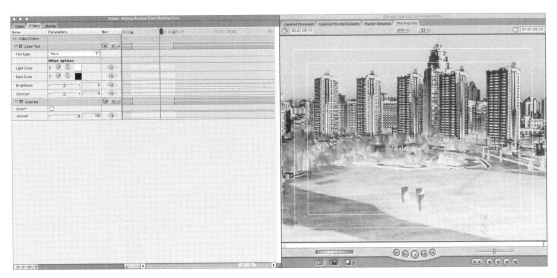

FIGURE 6.44 Result of rearranged filters.

companion DVD if you are not following this tutorial. The differences between Figures 6.44 and 6.42 are quite interesting. The results continue to multiply as increased amounts of filters are piled atop a clip and rearranged. The possibilities are endless.

8. Turn off the filters. After all that, we are going to turn these filters off as we will be animating filters for a collection of clips in future steps. To turn filters off, simply click the small "x" shown in Figure 6.45.

FIGURE 6.45 Filters can be turned off by unchecking these boxes.

To keep things really clean, select a filter in the Filters tab and press Delete to remove it completely. Select more than one filter at a time for movement or deletion by Shift-clicking each.

9. Nest the clips from 01:01:02;06 to the end of the Sequence. Scrub the playback head to 01:01:02;06 and then select all of the clips from there to the end. Do this by marqueeing around them, selecting the first, holding the Shift key down and selecting the last; or use the Select Track Forward tool (Figure 6.46). The Select Track Forward tool selects all the clips on the chosen track that are further down the Timeline from where the track is clicked.

FIGURE 6.46 Select Track Forward tool.

Once all of the clips are selected (Figure 6.47), press Option-C to nest the selection into a new Sequence named "Filtered Starting Cuts" (Figure 6.48).

10. Open the Sequence in the Viewer. Select Filtered Starting Cuts in the Timeline and press Return.
11. Add Stylize/Find Edges to the Sequence in the Timeline—just drag the filter from the Browser to the Timeline.
12. Select the Filters tab, and scrub the playback head in the Viewer to the beginning of the Sequence. This will show the settings available for the Find Edges Filter.
13. Set the Find Edges Amount to 0. This seems odd, since the Canvas will show that there appears to be no filter at all. This is because we will be making the filter change intensity over time, thus building anticipation.

Chapter 6 Really Advanced Editing | **163**

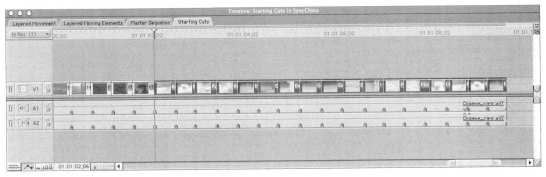

FIGURE 6.47 Select all the clips that have been placed since we started placing repeating clips.

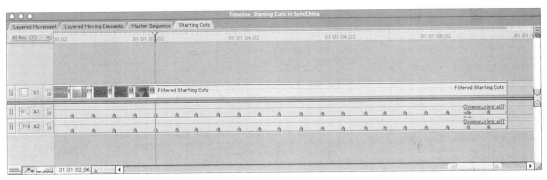

FIGURE 6.48 Group them into a new Sequence called "Filtered Starting Cuts."

14. Click the Insert Keyframe next to the Amount parameter. This indicates to FCP that we are going to be animating this parameter and that 0 is the start.
15. Press the Down Arrow key to jump to the end of the Sequence, and enter 100 in the Amount input field (Figure 6.49). This will automatically create a second keyframe, and the graph next to the Amount parameter will show the rise in strength.
16. Add the filter Blur>Zoom Blur to Filtered Starting Cuts. Again, just drag the filter to the Sequence in the Timeline. This will add Zoom Blur to the list of Filters in the Filters tab of the Viewer.
17. Add a keyframe at the beginning of the Sequence with an Amount value of 0 for the Zoom Blur filter. Do this by pressing the Up Arrow key to jump to the beginning of the Sequence in the Viewer. Enter 0 in the Amount input field, and click the Insert Keyframe button.
18. Scrub the Viewer playback head to five markers before the end of the Sequence. Change the Amount Value to 20; a new keyframe will be automatically placed (Figure 6.50).

FIGURE 6.49 Animated filter.

FIGURE 6.50 New keyframe placed at marker 13.

19. Place the last keyframe at the end of the Sequence with a value of 100 for the Amount. Press the Down Arrow key to jump to the end of the Sequence, and change the Amount setting to 100. Another keyframe will be placed automatically (Figure 6.51).

 What this does is create a slight zoom for the first section of the Sequence, and then the zoom speeds up for the last few clips.
20. Change the Steps value to 10. This increases the render time fairly dramatically, but gives a great effect.

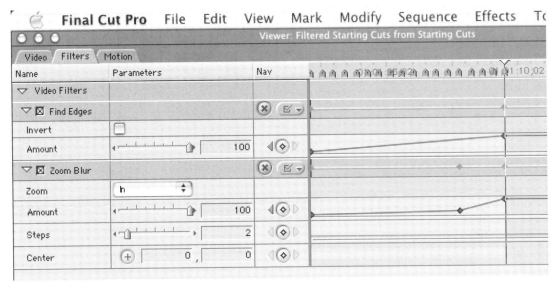

FIGURE 6.51 Keyframe automatically placed as Amount is changed to 100 for the Zoom Blur.

21. Take a truly long break and render. As this change of filters happens over quite a long time in the editing piece and since the filters are quite intensive, this will be a long render indeed. However, if everything is done right, you will end up with a very fun effect (Figure 6.52).

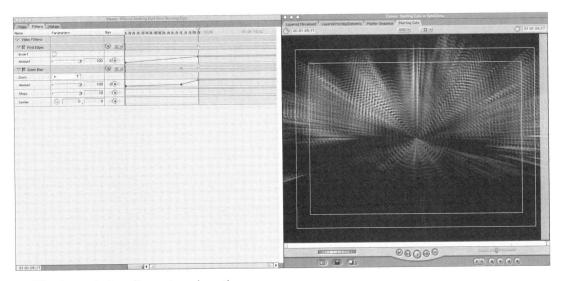

FIGURE 6.52 Result of two filters animated over time.

Conclusion

This was another information packed chapter. We learned how to animate clips, nest Sequences, edit those Sequences, animate a Sequence, apply filters and other effects to clips and Sequences, and how to animate those effects. It is even more amazing that this barely scratches the surface of what can be done.

Much of the latter part of this chapter discusses tools that you might never use. They are powerful and lots of fun, but most movies, TV shows, and even commercials simply do not have a need for Zoom Blurs and freaky filters. However, for that occasional music video or promotional video, these tools are great to have around.

The early part of the chapter about dealing with animating clips, nesting clips, and nesting Sequences is *very* important. Learn how to manipulate Sequences. These nifty virtual containers create organization and effects possibilities many layers deep.

After the last tutorial renders (which will take a while), read on. The next chapter covers some specific case studies. Namely, we will look at how to use Alpha Channels, do some special effects compositing, and work with interviews, narrative, and photo montages.

CHAPTER

7 ALPHA CHANNELS

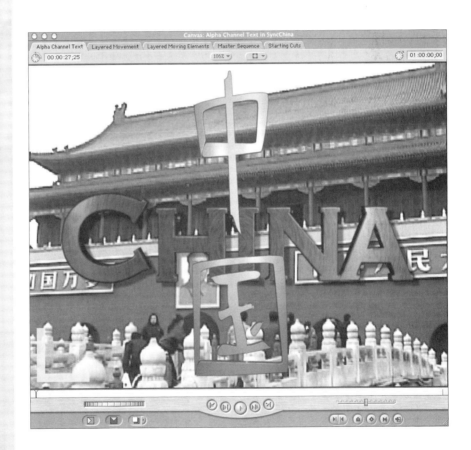

We are soon to leave our Chinese project behind. We will not be completely filling all of the video track through these tutorials, but take a few minutes afterward to flesh out the rest of the project and explore all the tools covered in the first six chapters of the book and in this one.

In this chapter, we will be filling in a couple of holes in the Sync-China project with the use of some computer-animated 3D elements with embedded Alpha channels. We will explore many of the additional tools in the tool palette that we have not had the opportunity to discuss yet.

After we look at some of these tools, we will move on to a couple of other projects. As part of our continued look at alpha channels, we will do a little compositing. *Compositing*, in this sense, is the placement of various video elements together and on top of one another to create one larger image. This usually involves placing 3D elements into footage of the real world, or placing real footage into computer-generated environments.

ADVANCED TIMELINE EDITING

This is where much of the fun actually begins. Using these techniques, you can make FCP do all kinds of high-end things. Take careful note of these methods, as they will help speed along your work in basic editing and can help in many cases where basic editing techniques are causing trouble.

TUTORIAL 7.1: PREPARING FOR ALPHA

This is another tutorial designed to prepare clips for tutorials to come. We will be simply copying and pasting a chunk of clips from another place in our project to fill a hole, and we will then use a series of Ripple Edits, Roll Edits, Slip Edits, and Slide Edits to change around enough to make them appear as different clips.

1. Open the Sequence Master Sequence. This is probably done the fastest by clicking the Master Sequence tab at the top of the Timeline. Notice the hole sitting between the Sequences Starting Cuts and Montage (Figure 7.1).

2. Copy the first 01:00:27;25 from the Sequence Starting Cuts. Click on the Starting Cuts tab in the Timeline and select the first collection of clips be-

FIGURE 7.1 The hole to be filled in Master Sequence.

fore the Sequence Layered Movement begins. Press ⌘-C to copy the clips into memory (Figure 7.2).

FIGURE 7.2 The first 01:00:27;25 of clips from Starting Cuts. These clips will be placed into the hole in Figure 7.1.

Now, jump back to Master Sequence by clicking its tab in the Timeline and move the playback head so that it is at the end of the Sequence Starting Cuts. Press the Up or Down Arrow keys to make sure that you are really snapped to the edge of the Sequence. Press ⌘-V to paste the clips into place (Figure 7.3).

This is a fairly reckless method of bringing clips into a Sequence, and usually would not be the method of choice. However, it will suffice here since the clips match the empty space exactly.

3. Create new markers in the Timeline to keep things straight as we refine. Previously, we looked at placing markers within clips to move with the clips. In this step we will create markers in the Timeline that do not shift. They are absolute markers that will help us keep things clear as we begin the shifting around that we are about to do.

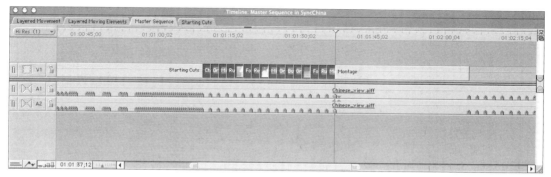

FIGURE 7.3 Pasted clips.

Before we really get going, take a moment to zoom in on the Timeline so that you can see the clips a little more clearly (Figure 7.4).

FIGURE 7.4 Zoom in on the newly pasted clips.

Now scrub the playback head so that it rests on the edit between the Sequence Starting Cuts and the clip Chairman Mao (about 01:01:09;17). Remember to let the Timeline show you when its there by the snapping and triangular hints. Press "M" on the keyboard to place a marker (Figure 7.5).

Notice that with the playback head already resting on the marker, the green marker also has a little red line across the right side of it. This indicates that FCP knows that you have the marker selected. If you press "M" again on your keyboard, a dialog box similar to Figure 7.6 will pop up. This dialog box allows for the naming of the marker. We will visit this dialog box again as we prepare for work in DVD Studio Pro, but for now, simply label it "Alpha Lettering."

FIGURE 7.5 Placed marker in the Timeline.

FIGURE 7.6 Renaming markers consists of selecting the marker, and then pressing "M" on the keyboard.

Notice that now in the Canvas near the bottom center is a semi-opaque box with "Alpha Lettering" shown. Markers in the Timeline will show up within the Canvas as the playback head is scrubbed or stopped in the Timeline.

Place a second marker where the last clip of the pasted clips ends and Montage begins (about 01:01:37;12). Again, do so by pressing "M" and then pressing "M" again to name the marker "Montage."

TUTORIAL **7.2: RIPPLE AND ROLL EDITS**

1. Use the Ripple Delete to delete a clip. In order to provide a little variation in these clips from those contained in the beginning of Starting Cuts, we will change the timing a bit. We will use half the clips and make them twice as long.

 Scrub the playback head back to the start of these clips (around 01:01:09;17). Select GreatWall6, and either right-click or Control-click the clip and select Ripple Delete (Figure 7.7).

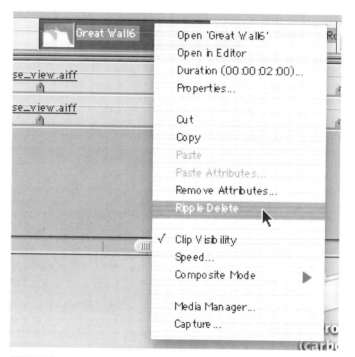

FIGURE 7.7 Ripple Deleting a clip.

Ripple Delete means that the clip is deleted and all the clips after that are slid down (or "ripple down") to snap into the hole it leaves. What will happen in this case is that the next clip (Ming Emperors Robe CU) will slide back to the Out point of the clip Chairman Mao.

This keeps some things very clean but causes other problems, one of which is that when clips begin to be deleted, small gaps are often created. Although these gaps can be easily closed, it's always best to avoid them to begin with. By using Ripple Delete, you ensure that there are no gaps left.

The drawback to this is that the rippling of all the clips after the deleted clips moves the clips off of where they were. Therefore, if you scroll down the Timeline to where the Sequence Montage begins, you can see that it no longer lines up with the Montage marker (Figure 7.8).

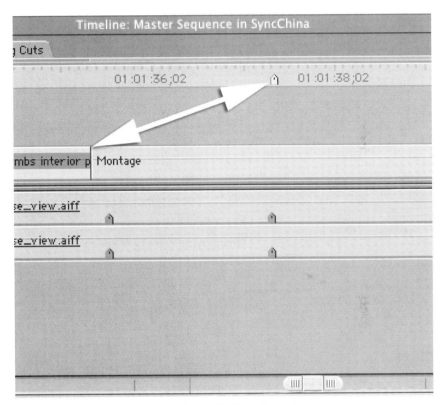

FIGURE 7.8 Ripple Deletes can move objects off of intended markers.

Don't worry about this for now; we will come back to fix it momentarily.
2. Use the Ripple Edit tool to lengthen the clip Chairman Mao. Now that we have gotten rid of a clip, we need to increase the length of another to make up for the lost space. The Ripple Edit tool (Figure 7.9) allows you to change a clip's In or Out point and shifts (or "ripples") all the clips before or after the edit point to accommodate the clip's new length. The keyboard shortcut for this tool is "RR."

This tool requires some special attention when used within the Timeline. Notice that with the Ripple Edit tool selected, as you get near an edit, it will actually swap directions (Figure 7.10). Just remember that the icon is referencing a tape roll. The round part is the roll and the little finger

FIGURE 7.9 The Ripple Edit tool located in the Tool Palette.

indicates where the "film" is coming from or going to. In Figure 7.10a, you are about to Ripple Edit the clip to the left (Chairman Mao), while Figure 7.10b is about to edit the clip to the right (Ming Emperors Robe CU).

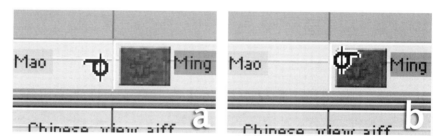

FIGURE 7.10 (a) Left Edit symbol of the Ripple Edit tool; (b) Right Edit symbol for the Ripple Edit tool.

In this case, the clip Chairman Mao will be lengthened, so make sure that the "finger" of the mouse is pointing back toward the clip Chairman Mao.

To use the Ripple Edit tool, click and drag the clip to the new desired length (Figure 7.11).

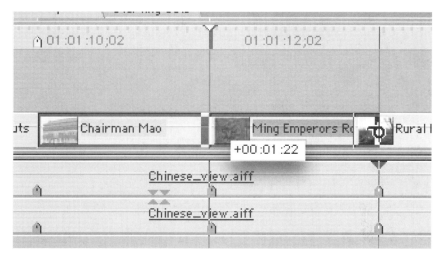

FIGURE 7.11 The Ripple Edit tool in action. In this case, a new Out point for Chairman Mao is being defined.

Notice that while you are dragging with the Ripple Edit tool, all types of clues are being provided by FCP. The darkened outline of the clip indicates the new length of the clip (or where the new Out is to be positioned). The small yellow box indicates the change in the Out point. Finally, FCP will snap to the nearest edit or the next marker. In this case, make sure that you drag out Chairman Mao's Out to the next marker. The results are shown in Figure 7.12.

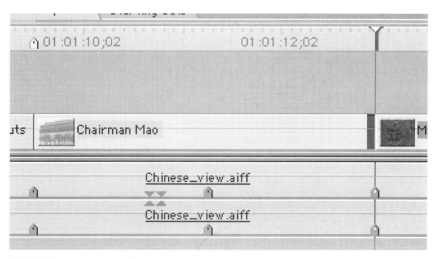

FIGURE 7.12 Results of the Ripple Edit.

Take a moment and scrub back to where the Sequence Montage begins and notice that although it is closer to where it should be, it's not there yet. Still, not to worry, we will get to that in a bit.

3. Repeat the process by deleting Ming Emperor's Robe CU, and using the Ripple Edit tool to expand Rural Bus Ride. The Timeline should look something like Figure 7.13.

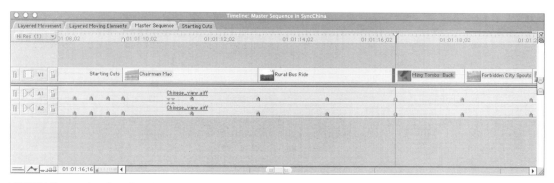

FIGURE 7.13 Results of Ripple Deleting Ming Emperor's Robe CU and using Ripple Edit to expand Rural Bus Ride.

4. Following the same type of style, delete Forbidden City Spouts (Ripple Delete) and then use a right edit (Ripple Edit) to expand Ming Tombs Back.
5. Ripple Delete Great Wall Camel and expand Restaurant Camel's Paw with the Ripple Edit tool.
6. Ripple Delete Ming Tombs Entrance and Ripple Edit to expand Great Wall LS Zoom.
7. Ripple Delete Buddhist Temple and expand Great Wall Stair Pan with the Ripple Edit tool.
8. Ripple Delete Forbidden City and expand Forbidden City Court with the Ripple Edit tool.
9. Ripple Delete Ming Tombs Interior Pan and Ripple Edit Rural Shopping to fill the gap. Take care on this Ripple Edit as it allows the luxury of making sure that the edit (Rural Shopping's Out and Montage's In) occurs right on the Montage marker.

The results of all these Ripple Deletes and Ripple Edits is shown in Figure 7.14.

10. Open Starting Cuts to explore the Roll Edit tool (Figure 7.15).

The *Roll Edit* tool allows for changing the position of an edit by altering one clip's In and the next clip's Out, but not affecting any other clips in the process. The Roll Edit tool does this by affecting only the In or only the Out of each clip. If it shifts a clip's In, the Out is left alone, and vice versa.

Chapter 7 Alpha Channels | **177**

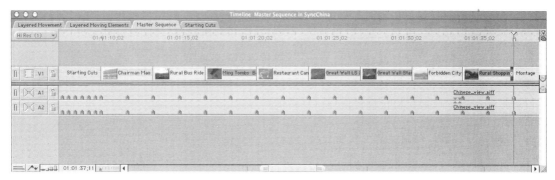

FIGURE 7.14 Lots of deleted clips are replaced by Ripple Edits that bring the Out points of clips outward to fill the gaps.

FIGURE 7.15 The Roll Edit tool shares space with the Ripple Edit tool in the Tool Palette. You might need to click and hold within the Tool Palette to access the Roll Edit tool.

The Roll Edit tool is great for fine-tuning. It is typically used quite late in the editing process. Usually, if you have been very careful with your 3-point edits, there is rarely a need to use it. However, timing always changes through the course of a project, so mastering the Roll Edit tool is important.

To play with this tool, click on the Starting Cuts tab in the Timeline. Although much fine-tuning is probably not needed here, we will play around within this Sequence to get an idea of the usefulness of this tool.

To use this tool, look closely at your Timeline (you will probably need to zoom in on the Timeline), and look for spots where the edit does not quite match up to the intended marker. Figure 7.16 shows an edit where the edit (Figure 7.16a), is just a couple frames off of the marker (Figure 7.16b). This can be seen because the playback head snaps to two different locations.

FIGURE 7.16 This edit and the intended marker are slightly off. This is a perfect situation for using the Roll Edit tool.

To use the Roll Edit tool, select it from the Tool Palette. Then, click and drag on an edit (where two clips meet). Like the Ripple Edit tool, FCP will provide all kinds of clues in the Timeline to indicate the new position of the edit, how many frames the edit is being moved, and when you have snapped to an edit or marker (Figure 7.17).

Perhaps the most interesting thing that FCP provides when using the Roll Edit tool is the change in the Canvas (Figure 7.18). The Canvas will change into a split screen showing both of the clips involved in the edit. The image on the left shows the outgoing clip's Out point, and the one on the right shows the incoming clip's In point. As the Roll Edit tool is dragged along the edit, these images will update to let you know visually where the new edit is.

Another interesting way to use the Roll Edit tool is to open a Trim Edit window. To do this, double-click on an edit (Figure 7.19). This will open a

FIGURE 7.17 Using the Roll Edit. All kinds of clues are provided by FCP.

FIGURE 7.18 The Canvas turns into an editing window that provides information about a clip's In and Out points and how the Roll Edit is effecting them.

FIGURE 7.19 To open a Trim Edit window, double-click the place where two clips meet in the Timeline (the edit).

new window on top of the Canvas and Viewer. This is a special window for making very exact changes to edits (Figure 7.20).

FIGURE 7.20 The Trim Edit window.

On the left side of the Trim Edit window is the outgoing clip, which provides an editable Out point in the scrub bar and with the small buttons reading –5 and –1 on the bottom. If you drag the Out point shown in the scrub bar to a new location, a Roll Edit occurs and the In point of the clip on the right will shift to accommodate. Similarly, if the In point of the clip on the right is dragged to a new location, the Out point of the clip on the left will shift to a new location.

The small –5 and –1 buttons allow for the shifting of In or Out points by five or one frames, respectively. If you are working on an edit where each frame becomes very important, it is probably worth your while to open a Trim Edit window. However, when using the Roll Edit tool directly in the Timeline, the split screen of the Canvas is a kind of mini-Trim Edit window and will provide enough information for most Roll Edits.

To close the Trim Edit window, click on the Close Window button as though you were closing any window in the Finder.

11. Use the Roll Edit tool to adjust any other such mis-synced clips in Starting Cuts.

TUTORIAL 7.3: SLIP ITEMS (SLIP EDITS) AND SLIDE ITEMS (SLIDE EDITS)

To understand what a Slip Edit is, imagine that the clip you see in the Timeline is actually a window. Through this window, we are able to see a part of the overall clip. The left side of the window (our In) prohibits our view of frames that happen to the left or before the clip's In. Similarly, the right side of the window is the clip's Out and so prohibits our viewing of frames after the Out. This is important and is the reason why we set Ins and Outs in the first place. A Slip Edit allows us to grab the clip and slide it left or right to show a different collection of frames through the window in the Timeline. In a Slip Edit, the window stays still, and the frames move beneath it. In this way, none of the surrounding clips (or their "windows") is disturbed.

A Slide Edit is just the opposite. In a Slide Edit, the frames stay still but the window through which we see the frames is moved. This too provides us a different view through the window, but it disturbs the clips before and after. The Out point of the clip before and the In point of the clip after are both overridden and redefined.

1. Open Master Sequence in the Timeline.
2. Scrub to the newly pasted and Roll Edited clips; this is anywhere between the markers Alpha Lettering and Montage. What we are going to do here

is take some of the clips and change their In and Out points within the Timeline. To do this, we will use the Slip Item tool (Figure 7.21).

FIGURE 7.21 The Slip Item tool enables Slip Edits.

3. Turn off Timeline Snapping. With the Slip Edits we are about to perform, we will not want the Timeline continually snapping to the next edit or marker. To turn off the snapping, click the Snapping Toggle at the top right-hand corner of the Timeline (Figure 7.22).
4. Use Slip Edit to shift the Ming Tombs Back clip. Since the first two clips, Chairman Mao and Rural Bus Ride, don't have much to change, the first clip that we will do is the clip Ming Tombs Back. Double-click the clip to get a look at it in the Viewer. Notice that the last part of the clip has a still camera, and the first part of the clip is a pan of the Ming Tombs. We will "slip" the clip so that we are not stuck looking at a still image, but instead have a lot of good motion.

With the Slip Item tool selected, click and drag the middle of the Ming Tombs Back in the Timeline. Again, FCP provides all types of data to assist in this edit.

First, in the Timeline where you have dragged, you will see a dark box that actually indicates how long the unedited clip is. This way, you know how many frames you have below the window to work with. The usual yellow box appears within the Timeline to let you know what the change is in

Chapter 7 Alpha Channels | **183**

FIGURE 7.22 Turning the Timeline Snapping off.

timecode. The Canvas turns into a new split screen with the left image indicating the clip's In point and the right showing the Out. Using these two images, continue to use the Slip Item tool to slip the clip along until the building shown in Figure 7.23 is at the center of the right side's image's

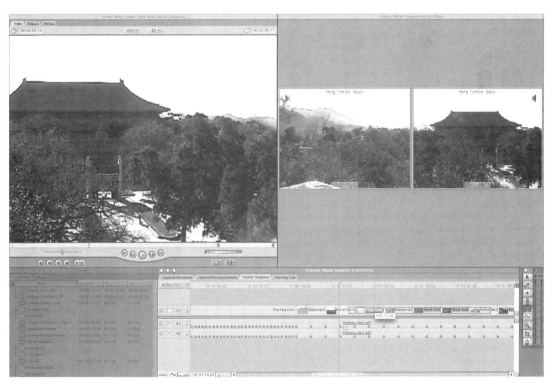

FIGURE 7.23 Using the Slip Item tool to slip frames of a clip along the "window" in the Timeline to achieve a new collection of visible frames.

frame. Using this method, we are ensuring that there is movement throughout the shot. This also takes the original shot that showed the pink building and turns it into an entirely different-looking clip.

5. Using the same technique, Slip Edit Restaurant Camel's Paw so that the first frame available is the first frame shown in the Canvas (Figure 7.24). Simply use the Slip Item tool and click-drag the clip all the way to the right. This makes the In point the first frame available from our captured media and makes the Out focus on the shot of the lamb's intestine in the boiling cauldron.

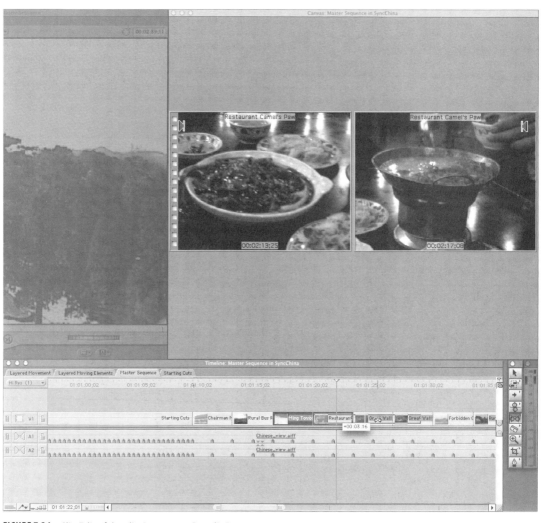

FIGURE 7.24 Slip Edit of the clip Restaurant Camel's Paw.

6. Make any other changes at will to the remaining clips. Shift all the clips a little to make sure that they are different from how they appear earlier in the Sequence Starting Cuts, but how you Slip Edit them is up to you.

TUTORIAL 7.4: ALPHA CHANNELS

Okay, so we didn't get to all of the tools contained in the Tool Palette. Not to worry, we will get to all of them eventually. For now, though, it's time to start looking at some of the more specialized (and fun) functions of FCP.

The first that we will look at is working with Alpha Channels. Images (RGB ones anyway) usually have three channels of information, Red, Green, and Blue. Video is much the same. Each of these channels contains the information as to which pixels are red, green, and blue. When channels are mixed, we get a wide variety of new colors.

An Alpha Channel is a fourth channel that contains not color information, but information on what pixels should be considered transparent and which should be considered see-through. For an example, see Figure 7.25. This shows a still image in Photoshop with the Red, Green, and Blue channels all activated. Figure 7.26 shows just the Alpha Channel activated with all of the rest turned off. To help in visualizing an Alpha Channel, most applications indicate Alpha

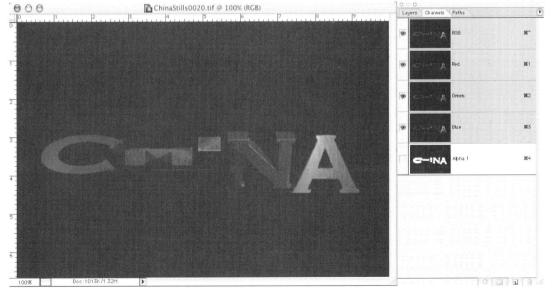

FIGURE 7.25 RGB Channels activated.

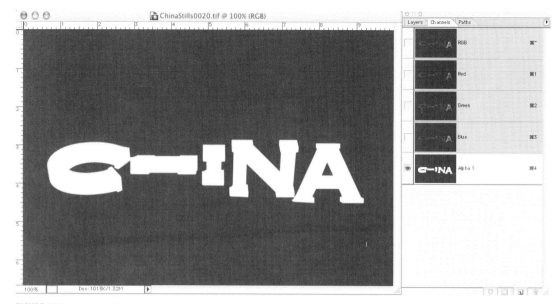

FIGURE 7.26 Image with only the Alpha Channel activated.

Channels with blacks and whites (and semitransparent pixels as various shades of gray). In this case, the black indicates transparent pixels and the white shows opaque ones.

What this indicates is that if this still were imported to FCP (which it will), the white areas of the Alpha Channel will display all of the RGB channel information (color), and the black areas will reveal any clips that lie beneath the image.

Stills can have Alpha Channels and so can animations or movies. A little later we will be working with animations that have Alpha Channels built in. For this tutorial, we will be using a sequence of numbered stills. Each still has been rendered in a 3D application called Cinema 4D to include an Alpha Channel with each still. Most mid- to high-end 3D applications allow for rendering with Alpha Channels.

In this tutorial, we will look at bringing sequences of stills into FCP, using Alpha Channels, and practice on animating Sequences.

1. Confirm appropriate preferences.

 Before we get started on the tutorial, we need to ensure that a few preferences are set up. We will be importing hundreds of stills that are set up as one still for one frame. FCP's Preferences by default are set up so that imported stills take up 10 seconds. Of course, when we import sequential stills, this will not do.

To set things up for this tutorial, go to Final Cut Pro>Preferences (OSX) and Edit>Preferences (OS9), and change the Still/Freeze Duration to 00:00:00;01 (Figure 7.27).

FIGURE 7.27 Preferences in FCP to make sure that imported sequential stills will only fill one frame.

This means that each imported still, when placed into the Timeline, will only occupy one frame's worth of time.

2. To keep things tidy, create a new nested Sequence from the clips in the last tutorial. Select all of the clips in the last tutorial. This includes all the clips between the marker Alpha Lettering (about 01:01:09;17) and the marker Montage (about 01:01:37;12). After these clips are selected, press Option-C and name the new Sequence "Alpha Channel Text" (Figure 7.28).
3. Double-click the Sequence Alpha Channel Text in the Timeline. This will open in the Timeline the clips just nested, but without the other sound tracks or the Sequences before or after.

ON THE DVD

4. Copy the folder ChineseTextStills from the DVD to the folder SyncChina_Media on your hard drive if it is not already there.

FIGURE 7.28 Creating a new nested Sequence containing all the clips that were edited in the last couple of tutorials.

5. Import the folder ChineseTextStills by dragging from your hard drive to the Browser, or by selecting the pull-down menu File>Import>Folder and select it in the resulting dialog boxes. Either way, a new bin called ChineseTextStills with two sub-bins ChinaStills and JungGwoStills will appear in the Browser. Inside each of these sub-bins are collections of numbered tiffs generated by Cinema 4D XL.

6. Place the entire bin ChineseStills into the Timeline as a Superimpose edit. Just grab the entire folder (which FCP interprets as all the contents of the bin) and drag it to the top of V1, so that it matches Figure 7.29. This is the same as if the folder were being dragged to the Canvas and the Superimpose Overlay Edit were selected.

The results of this Superimpose Edit are immediately seen and are shown in Figure 7.30. Notice that the word *China* is placed above the clips below. Because all of the stills had an Alpha Channel, only the text shows up.

FIGURE 7.29 Superimposing a folder of sequential stills.

Chapter 7 Alpha Channels | **189**

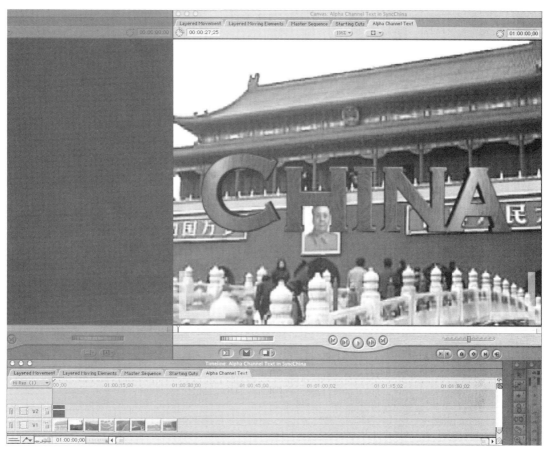

FIGURE 7.30 Results of Superimpose Edit using stills with nested Alpha Channels.

7. Create a new nested Sequence of the newly imported tiffs. Select all the newly placed tiffs by marqueeing around them in the Timeline, press Option-C to create a new Sequence, and name the Sequence "China Alpha Text."

This might seem like a lot of nested Sequences, but there is method to the madness. Before collecting these stills into a new Sequence, all of these stills were actually functioning as many, many individual clips. Figure 7.31 shows the Timeline (pre-nested Sequence) zoomed in very close. You can see in that image that all the stills take up one frame.

If this were the only place that these stills are to placed, this would not be a problem. However, the plan is to use this collection of frames several times. It is much easier to copy an animated Sequence than to do so with hundreds of stills.

FIGURE 7.31 Before completing Step 7, this screenshot was taken to show how each of the sequential stills imported takes up one frame.

Now that you have created a nested Sequence, you can move all the stills easily by moving the Sequence. Additionally, the newly created Sequence is listed in the Browser and so is easy to place in other locations.

8. Repeat Steps 6 and 7 with the folder JungGwoStills. Remember to place all the stills as a Superimpose Edit so that the clips that are already placed in this Sequence are not disturbed. The result of the Superimpose Edit will place the clips on V3. Once the stills are imported, nest the Sequence and name it "JungGwo Alpha Text."

9. Place a Drop Shadow on the newly created China Alpha Text. Select China Alpha Text in the Timeline, and press Return, or drag the Sequence into the Viewer. Within the Viewer, select the Motion tab, and activate the Drop Shadow.

 This will create a drop shadow for the text "China," but the drop shadow will be too far away. Expand the Drop Shadow in the Motion tab and change the Offset setting to around 5. Feel free to change any of the other settings within Drop Shadow to your taste.

 The result of activating and changing the drop shadow should look something like Figure 7.32.

 Notice that FCP recognizes each shape within the Sequence. The Alpha Channel of each still ensures that the shape of the letters are well defined, allowing for true drop shadows.

10. Repeat the process of adding a drop shadow to Junggwo Alpha Text. Select the Sequence in the Timeline, open it in the Viewer, activate Drop Shadow, and shift the Offset to 5. The result should look something like Figure 7.33.

 Now that we have established the look of the Alpha-Channeled text, we need to fill the 28 seconds of the Sequence Alpha Channel Text with variations.

11. Animate the Sequence China Alpha Text moving across the screen. This is a review of earlier exercises. Reduce the viewing area of the Canvas to around 50% or so (depending on your monitor), and make sure that the Canvas is displaying Image+Wireframe.

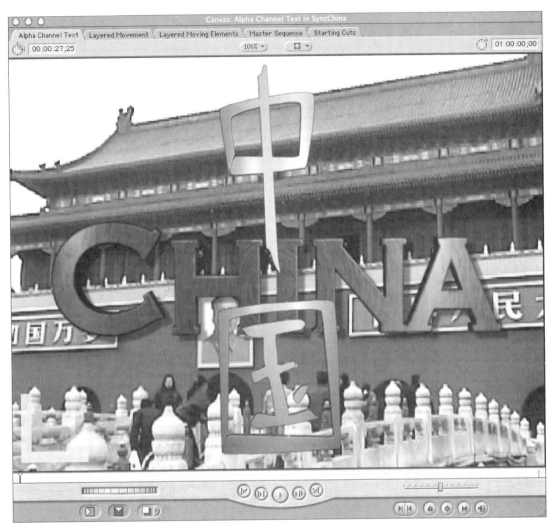

FIGURE 7.32 Drop Shadow placed on the text "China" of the China Alpha Text Sequence.

Scrub the playback head to the beginning of Sequence and select China Alpha Text. Drag the wireframe of the Sequence off to the right of the visible image in the Canvas (Figure 7.34a) and click the Add Keyframe button in the bottom-right corner of the Canvas or press Control-K.

Scrub to the end of China Alpha Text and move the Sequence in the Canvas so that it is off the viewable area. This will automatically create a second keyframe (Figure 7.34b).

12. Animate the Sequence JungGwo Alpha Text moving from the bottom of the visible area to the top as China Alpha Text is leaving. Scrub the

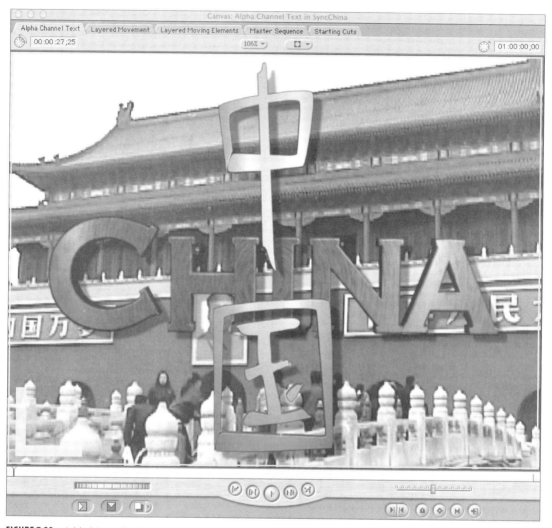

FIGURE 7.33 Added Drop Shadow for the Sequence JungGwo Alpha Text.

playback head in the Timeline to about 01:00:01;26. Drag the Sequence JungGwo Alpha Text from its location so a new location where it snaps to the current position of the playback head (you might need to reactivate snapping in the top-right corner of the Timeline).

Move the Sequence to the bottom of the Canvas and insert a keyframe. Scrub the playback head to the last frame of the Sequence JungGwo Alpha Text, and while holding the Shift key down to ensure that it travels in a straight line, move the Sequence to the top of the Canvas area (Figure 7.35).

Chapter 7 Alpha Channels | **193**

FIGURE 7.34 Animate the Sequence Chinese Alpha Text moving from right to left.

FIGURE 7.35 Animating the Sequence JungGwo Alpha from the bottom to the top of the viewable area of the Canvas.

ON THE DVD

13. Place additional copies of China Alpha Text and JungGwo Alpha Text and animate them. Add as many as you like. Resize them to different sizes before animating their position. Animate the size of some. Rotate some of the Sequences. Use your imagination. Take a look at the tutorial files on the DVD to see what we did.

 Notice that there are all types of fun tricks that can be done with motion paths (Figure 7.36). Also notice that several clips fade in and out by using the Pen tool to have clips fade up and down (Figure 7.37). The point of this step is to play and play some more. Remember that there is a big hit on rendering with this type of thing, but the effect can be lots of fun.

FIGURE 7.36 Shifting keyframes from linear interpolation to curvilinear by making the keyframe Ease In/Out. Do this by right-clicking or clicking the keyframe itself.

14. Copy and paste the Drop Shadow characteristic to all the "Alphaed" Sequences. To do this quickly, we will explore a few selection tools that we have not yet played with.

FIGURE 7.37 Using the Pen tool, clips can be easily made to fade in and out.

Within the Tools Palette exists a collection of tools that allow for diverse forms of selecting collections of clips. Figure 7.38 shows the Select Track Forward, Select Track Backward, Select Track, All Tracks Forward, All Tracks Backward.

FIGURE 7.38 The nested selection tools Select Track Forward, Select Track Backward, Select Track, All Tracks Forward, All Tracks Backward, allowing you to select collections of clips within various tracks.

These are fairly intuitive tools. At its essence, each of these arrows selects all the clips on a particular track or all the clips on all the tracks before or after where the Timeline is clicked. One thing to be conscious of is that these only select Unlocked, Active Tracks. For example, Figure 7.39a shows the Timeline for Alpha Channel Text. After locking video track V1 by clicking the Lock on the track (Figure 7.39b), all the clips after the initial China Alpha Text Sequence are selected using the All Tracks Forward tool (7.39c).

196 | Final Cut Pro 3 and DVD Studio Pro Handbook

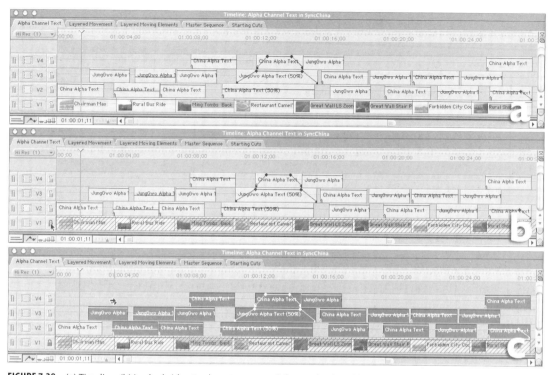

FIGURE 7.39 (a) Timeline. (b) Locked video track protects a track from selection. (c) Using the All Tracks Forward tool.

All the other tools in this set function in much the same way. A notable functionality is that the Select Track Forward tool (single-right-pointing arrow) turns into the All Tracks Forward as soon as the Shift key is held down.

Now, with the first China Alpha Text Sequence having a beautiful drop shadow, we will lift the drop shadow from it and paste it to the rest.

Select the first China Alpha Text and press ⌘-**C** to copy the Sequence and its attributes into memory. Make sure that V1 is locked, and use the Select Track Forward or All Tracks Forward tool to select all the clips *after* the first China Alpha Text. Do this by making sure to click on the Timeline to the right of the end of the Sequence China Alpha Text.

Once all the clips are selected, -Click or right-click on any of the tracks and select Paste Attributes. In the dialog box that follows (Figure 7.40), simply choose Drop Shadow and violà!, all the clips have a matching drop shadow.

15. Render (finally!). The temptation is strong to render early in this process. You want to know how the stills look when played as an animation. It eats you up not knowing exactly how the Sequences look floating in and out of

Chapter 7 Alpha Channels | **197**

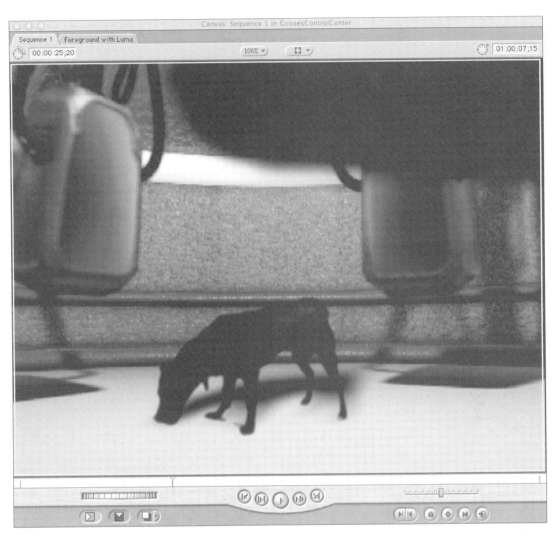

FIGURE 7.40 Paste Attributes dialog box allowing you to paste the settings for the Drop Shadow to all the clips selected in all the tracks.

the frame. It is maddening not knowing how that timing goes on the fade-in and fade-out. Hopefully, you resisted the temptation to render. But why?

With the notable exceptions of certain real-time effects available in the new FCP on some of the fastest G4s and the use of some powerful RT cards such as the RT-Matox; each time a new clip is placed on top of another, or a clip is animated, before FCP can output the final product it must take each frame and figure out what it looks like and write the collection of new frames to a new QuickTime movie. These new movies, although invisible to you in the interface, are called *Render Files*.

These Render Files are quasi-temporary files that are quickly written and are accessed when the playback head reaches a rendered part of the Timeline. The benefit of these Render Files is that they are seamlessly accessed by FCP, so you never realize that the viewer is watching a clip never actually imported manually into FCP by you, the editor. The problem with these Render Files is that they are big, and just too slow to create through rendering—no matter how powerful a machine you might have. Therefore, the ideal is to render only when needed to make sure that unnecessary Render Files are not created on your hard drive, and to ensure that you don't have to take any more coffee-render breaks than necessary.

Therefore, in the process we just undertook, if we had rendered the Sequence China Alpha Text, a new QuickTime Render File (Render File #1) would have been created on the hard drive. However, as soon as it was placed in track V2 and on top of the clips already present in V1, FCP would have had to render the same collection of frames again as it figured out how they looked composited on the tracks below.

Say you rendered again to see how the Alpha Channels looked (Render File #2). Well, as soon as the Sequence was animated in its position, FCP would pop up the red render bar on the Timeline, as the rendered composite of the earlier render was no longer valid. Therefore, rendering would be needed again.

Again, if this were to have been rendered for a great look at how the Sequence animated across the face of the clip below it (Render #3), this render would also be of naught as soon as a Drop Shadow were applied to it. For FCP to show how the Drop Shadow plays out, it would have to render again.

Continuing on with this exercise in futility, let's say we rendered again (Render #4). Surely this will do, right? Wrong. As soon as a new Sequence (in this case, JungGwo Alpha Text) was placed on V3 to overlap China Alpha Text in the Timeline, the area where the Sequences overlapped would have to be rendered again (Render #5)!

You can see how very quickly a huge amount of unnecessary rendering can take place, gobbling up huge amounts of your time, hogging large amounts of your hard drive, and simply wasting your energy.

Think ahead. If you know that a clip is to be further altered down the row in the form of animation, added filters, overlapping tracks, resizing, rotating, or change of opacity, refrain from rendering. If you must know how something looks animated, take a quick look with the Canvas simply showing wireframes. In addition, if you have a Sequence with complex overlappings and motion as just shown here, avoid rendering until you

have everything in place. This creates fewer rendering files and less chance of creating a fragmented hard drive.

And with that. We will leave China for now. We will revisit it when we begin working on DVD Studio Pro, but for now, we have twisted it, manipulated it, and played with it enough.

TUTORIAL

7.5: GOOSE'S CONTROL CENTER, OR KEYING

Goose is my dog. He's a good puppy and makes the house happy. He's also a great actor when he's given a toy coated with peanut butter. What we are going to do in this tutorial is take some footage of Goose shot in front of a sheet in my garage and place this dog in a different location. Sure, this is a rather amateur setup, but the concept is all professional. Keying in front of a blue or green screen is a common tool for film, television, and special effects. We will talk more on the specifics a little later in the tutorial.

We will be layering multiple layers of video atop one another and creating false shadows among other things. In this tutorial, we will not be using sequential stills, but rather some animations that are created as movies. The new and exciting thing that we will do here is use a Luma Matte to define what parts of the animation should let us see through the media to layers below.

ON THE DVD These files are all located on the DVD that accompanied this book. In order to work with them in real time, they need to be transferred to your hard drive. On the DVD, look for the folder called Goose_Media. Within this folder should be four movies and some folders. The movies are Foreground.mov, ForegroundLuma.mov, Goose, and GooseBackGround.mov.

1. Copy the entire folder Goose_Media from the DVD to your hard drive (preferably your media drive if you have one). This is a short project, so these tutorial files should not take too much time to copy or much of your hard drive space.
2. Open Final Cut Pro and close any project that might still be open by selecting File>Close Project. Remember that it is possible to have more than one project open in FCP at a time. Therefore, even after you close whatever project is open (possibly Sync_China from earlier chapters), make sure that there are no other projects open. If the Browser changes so that only the Effects tab is visible, this is a good sign that there are no other projects open.
3. Create a new project in FCP with File>New Project. This will make available a new tab in the Browser.

4. Save the project as GooseControl Center. Use File>Save Project and save this file to your hard drive. If you have a media drive, make sure and save this file to a drive other than where your media is stored.
5. Set up the Preferences in FCP so that all your render files are written to the Goose_Media folder. In OSX, use Final Cut Pro>Preferences, and in OS9 use Edit>Preferences to access them. Select the Scratch Disks tab and click the Set button. Find the Goose_Media folder on your hard drive and click the Choose button (Figure 7.41).

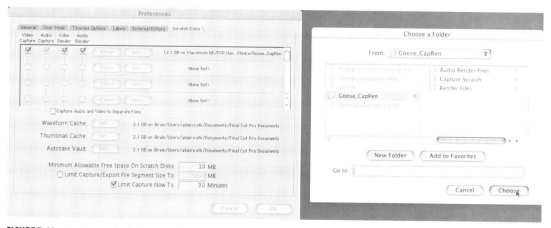

FIGURE 7.41 Setting up the Preferences for the Goose project.

It is important to change this because if you do not, all of the render files that are created as we build this project will be saved into the Sync_China trip—bad news when the time comes to gather everything together for output at a service bureau.

6. Import the folder Goose_Media into your project. This can be done in several ways. The first option is to select File>Import>Folder, then find Goose_Media on your hard drive, and click Import.

 The second method is to use the Finder and go to wherever Goose_Media is stored. In the Finder, grab the folder Goose_Media and drag it into the Browser. This will import the folder and all of its contents.

 After all the files are imported, save one more time and we are ready for action!

7. Take a quick look at all the movies in the Viewer. Notice that GooseBackground is, well, the background. Goose is actual footage of Goose tearing into his favorite toy. Foreground and ForegroundLuma are actually the same clip. We will talk much more about this later, but the black-and-white version is actually the track that will determine which parts of Foreground will be seen.

8. Place Goosebackground into the Timeline (using any of the many ways we have discussed). Just make sure that the clip starts at the start of the Timeline (Figure 7.42). Zoom in on the Timeline so that GooseBackground takes up most of your Timeline space.

FIGURE 7.42 Placed GooseBackground.mov.

9. We are about to place the clip Goose. However, Goose is a captured clip that has its audio intact. Since the sound of the captured clip Goose is unimportant, either turn off the audio clips A1 and A2, or simply make sure that they are not the target audio tracks (Figure 7.43).

FIGURE 7.43 To make sure that the sound in Goose is not brought into the project, turn off A1 and A2 as target tracks.

10. Make sure that the playback head is scrubbed to the beginning of the Timeline (press the Home key to jump back to 00:00:00;00). Place the clip Goose in the Timeline using a Superimpose Overlay Edit (Figure 7.44).

FIGURE 7.44 Results of a Superimpose Edit. This can be done using an Overlay Edit method, or by dragging into the Timeline and allowing the new track to be created.

If you use an Overlay Edit to Superimpose the clip Goose, a new video track (V2) will automatically be created. Notice that when this is done, Goose completely covers up all of the clip GooseBackground that lies beneath it in V1.

11. Place a Color Key filter on the clip Goose in the Timeline. To do this, click on the Effects tab of the Browser. Expand the Video Filters folder, and then expand the Key folder. Drag the filter Color Key onto the Goose clip in the Timeline (Figure 7.45).

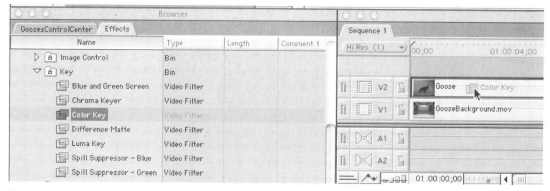

FIGURE 7.45 Applying the Color Key filter to the clip Goose.

In this case, "Key" refers to the process of knocking out certain colors of a clip. Notice that there are several ways to drop out information, including via chroma, blue screen, and green screen. You have probably seen in various "making-ofs" the idea of filming actors in front of a chroma-key green or a chroma-key blue. Then, in post-production, the blue or green is replaced by some other footage or by computer-generated sets.

These filters are built to do just that. The reason why blue and green are used is that they are the tones most unlikely to be found in human skin

tones. The computer can only recognize if a pixel is a certain color or not; FCP doesn't realize, "oh this pixel is the green, but it's in the middle of the character's forehead, so I won't drop it out." It is just not quite that smart yet. Setting up a good filming setup for this type of compositing is well beyond the scope of this volume, so we will not go into it much further.

The pink background used in this footage would be absolutely wrong for filming any type of human. However, since Goose is a black dog, it will work fine. The problem for us, though, is that the pink is neither chroma-blue or green. Therefore, we need to use a special filter—Color Key.

The idea behind the Color Key filter is that you can define what color to actually knock out of the clip. In this case, we are going to want to knock out the pink background, leaving us with Goose sitting in the middle.

12. Adjust the Goose clip's Color Key filter to drop the pink out. To do this, double-click the clip Goose in the Timeline (which will open it in the Viewer), and then click the Filter tab in the Viewer (Figure 7.46). This will give you the opportunity to define how the filter will deal with the clip Goose.

FIGURE 7.46 The Filter tab of the Viewer allows for the definition of how a filter works with a particular clip.

The first thing to change is the Color setting. This color is the color that will become transparent. Notice that there are several ways to pick a color, including expanding the Color option and assigning HSB values. However, for situations such as this, the first button with the Eyedropper symbol on it is our tool of choice. This tool allows us to "lift" a color directly off the clip.

To use it, click the tool in the Viewer, and then in the Canvas click on the color you want dropped out. In general, click on an area of the image that is relatively close to the area that you want to *keep* (Figure 7.47).

FIGURE 7.47 Using the Eyedropper tool of the Color Key filter is done by selecting the tool within the Filter tab of the Viewer and then clicking the Canvas to select the color to be dropped out.

The reason for this is that the most difficult part of the image to drop out and manage is the halo of color right around the characters. If the computer can get a good grasp of how to handle those pixels right around the character, then it does all the hard work for you.

True, in this case there are areas of the clip that are a much darker pink than the light pink right next to Goose, but these are typically on the outskirts of the image and can easily be cropped out. We will look at how to do this a little later.

Now, click a little above Goose's neck in the Canvas. The results of this move will seem a little less than spectacular. In the Viewer, the little color swatch that was blue will shift to a dusty rose color. The Canvas will have kind of a hazy spot around where you just clicked. For some reason, the default settings of the Color Key filter are all but useless. However, they are fairly easy to shift, so hang tight, it will get better (Figure 7.48).

Chapter 7 Alpha Channels | **205**

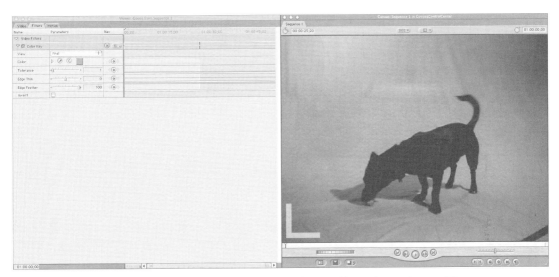

FIGURE 7.48 Initial results of selecting a color for the Color Key to drop out. Not too impressive yet, eh?

The next three settings—Tolerance, Edge Thin, and Edge Feather—are all tools to refine what pixels are actually dropped out. Working with these tools is an art form in itself, and the rules for which to use where will vary widely from project to project. However, we will look at some general rules here.

First, take the last option, Edge Feather, and turn it down to 0. This option is built to soften the edge where the visible pixels meet those dropped out. Sometimes it can help allow keyed objects to "settle in" to a background, but while trying to refine the settings, it's mostly just a mess. Setting it to 0 allows you to have a clear look at what pixels are actually going away and which are sticking around (Figure 7.49).

At this point, things are looking a bit blotchy. FCP is picking a very narrow range of colors, actually only the pixels that match exactly the one that we picked with the Eyedropper tool. In theory, this would be great if the background was perfectly lit and the color was nice and even. Unfortunately, even the best setups usually have some variation in the key color.

So, to fix this, we will allow FCP to select a little wider variation of the keyed color. To do this, turn up the Tolerance setting. Notice that as the Tolerance setting is increased, the Canvas will show more and more of the image disappearing. Selecting how much of the image to actually drop out is usually a process of refining this Tolerance setting and then thickening or thinning the selection with the Edge Thin setting (which we will talk about in a minute). In general, a blue, green, or in our case, pink glow

FIGURE 7.49 Canvas when the Edge Feather setting is set to 0.

around characters is detrimentally distracting, so it's usually best to make the Tolerance setting a little higher than you would initially think. Actually, make sure that the pink around Goose disappears entirely. This should happen at a setting of around 62 (Figure 7.50). Later, we will thicken the "edge" a bit, which will flush Goose out a bit.

We will need to affect the Edge Thin setting to refine what we have set up. However, to get a good idea of what the Edge Thin setting does, there really needs to be some Edge Feather selected. For now, set the Edge Feather to a value of 7 (Figure 7.51).

FIGURE 7.50 Results of a Tolerance setting of 62.

As soon as this setting is added, the harsh, pixelly edge created by increasing the Tolerance is gone; however, a new pink halo has emerged. What we will do is change the "edge" where the invisible meets the visible pixels.

The Edge Thin setting is the ability to take the "edge" of where the invisible meets the pixels and expand or contract it. The default setting of 0 is actually in the middle of the available paradigm; positive and negative values can be selected depending on if you want to expand the edge or restrict it.

FIGURE 7.51 Edge Feather turned up to 7. Notice the pink halo we now have surrounding Goose.

Slide the Edge Thin slider back and forth in negative and positive ranges to get an idea of what it does. Notice that when the values are positive, the invisible pixel's area increases, helping the pink pixels vanish. Negative values make the feathered edge more crisp, but leave the halo more and more defined.

Slide the value around to find the best setting that maximizes the visible Goose, so that there are no parts of Goose's body disappearing, but also making sure that there is no pink halo surrounding the little puppy. This should be somewhere around 33 (Figure 7.52).

FIGURE 7.52 Edge Thin setting at 33. This is in conjunction with a Tolerance setting of 62 and an Edge Feather setting of 7.

Some tips to keep in mind when dealing with these settings: first, make sure to scrub your playback head to various places throughout the Timeline. It turns out that sometimes a setting works great at the beginning of a clip, but horribly halfway through a clip, and then great again at the end. Notice that all the settings in the Color Key Filter are animatable with the Insert Keyframe buttons (Figure 7.53).

However, animating the settings is a slippery slope. It is tough when you start working that microscopically, and it is easy to find yourself fooling around on a frame-by-frame basis. This usually just is not workable in most situations.

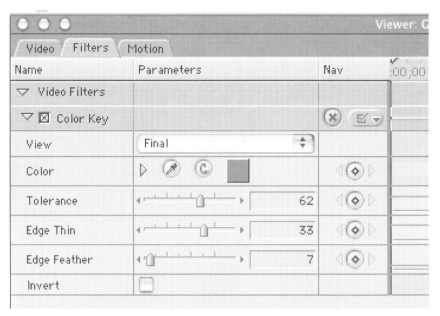

FIGURE 7.53 Insert Keyframe buttons allow for the settings of the Color Key filter to be changed over time.

The solution typically is finding a setting that is a good compromise throughout the course of a clip. Remember that each frame only lasts one-thirtieth of a second, so do not get too caught up in any one frame.

Fixing the key color exactly can be a fairly frustrating process. Make sure that as you get close to the right combination that you begin using the keyboard to change the values numerically up and down one or two values. The sliders simply become too clumsy for fine-tuning.

In addition, make sure to spend your time working with the areas right around the visible characters. Fringe problems around the edge of the frame or far away from the visible character can be easily taken care of with mattes or cropping. However, the pixels right around the character are best handled with the Color Key filter.

13. Make the Canvas display Image+Wireframe, rescale the clip Goose so that he looks correctly proportioned in the room, and slide him into position (Figure 7.54).

 Remember that the easiest way to rescale things is by simply using the Selection tool and grabbing a wireframe in the Canvas. By default, rescaling is set to maintain proportions, so *do not* hold the Shift key down as you rescale, or you will end up with a messed-up image.

14. Crop the clip to eliminate the cord in the bottom-right corner of the clip. In the footage that was taken of Goose, a power cable was draped across the

Chapter 7 Alpha Channels | **211**

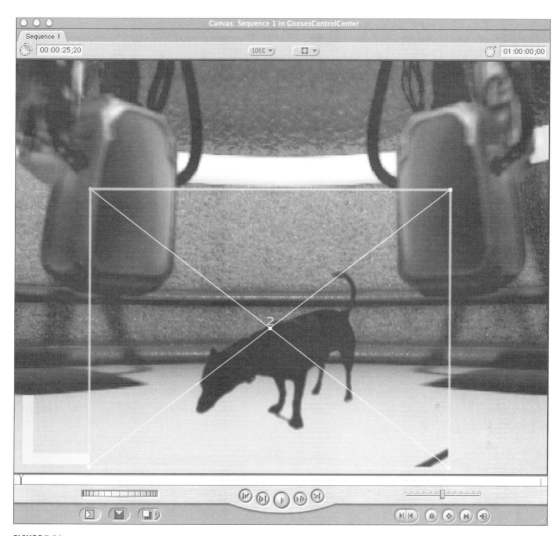

FIGURE 7.54 Goose correctly proportioned in the room.

bottom-right corner of the frame. With the clip rescaled, the cord is easily seen (Figure 7.55).

We cannot easily key this cable out because it's black—the same color as Goose. However, since it is set out at the edge of the frame, it can most easily be gotten rid of with a simple crop.

To do this, since the clip Goose is still the active clip in the Viewer, simply click the Motion tab. This will open the options of Scale, Rotation, and so forth that we previously explored. Expand the Crop settings to reveal the five options of each of the sides and the Edge Feather.

FIGURE 7.55 Offending cable.

To quickly crop out the cable, just grab the Right slider and slide it over visually until the cable is gone in the Canvas. The setting will be about 14 (Figure 7.56).

FIGURE 7.56 Cropping out the cable across the bottom right of the frame.

This is a fairly simply crop, so there is no need to worry about other details here. However, it is worth noting that the crop, especially with the Edge Feather option, can make for nice floating clips with soft edges in a project. Further, notice that the crop settings can all be animated.

15. Create a cast shadow for Goose. We currently have Goose standing in the room. The pink background has been fairly successfully dropped out of the scene. However, in the process, Goose's shadow has been keyed out as well. Since a shadow helps "ground" an object, to make this scene look correct we need to place a cast shadow in it.

The method described here is quick and crude, but it works. Creating a good drop shadow is easy if the intended effect is a shadow of the char-

acter up against a wall. However, having the cast shadow on the ground is a bit different. To do this, we will use a few tools we have yet to play with, and some clever use of filters.

First, start by creating a new layer with a copy of the clip Goose in it. The quickest way to do this is to drag Goose from the Timeline to the Canvas and select a Superimpose Overlay Edit (Figure 7.57). This will overlay the clip Goose on top of the target track (V1 probably), thus putting a copy of Goose in a new track.

FIGURE 7.57 Overlay Edit created from bringing the Goose clip from the Timeline to the Canvas into a Superimpose Overlay Edit.

The reason why it is important to take the clip from the Timeline and not just from the Browser is that we have already defined the Color Key for the clip in the Timeline. Thus, there is no need to redefine any of the filters.

The cast-shadowed version of Goose will be the clip lying in track V2—under the Goose in V3. Before we can start distorting the clip into the flat laying shadow, we need to make the clip look more like a shadow.

16. Deactivate V3 by clicking the green "light" at the far left of the track. This will only be temporary, but is necessary to see what we are doing to the Shadow Goose layer (V2) (Figure 7.58).

FIGURE 7.58 V3 deactivated to allow us to see the results of our manipulations.

17. Apply the filter QuickTime/Brightness and Contrast and the filter Gaussian Blur to the V2 track Goose. Do this by dragging the filters one at a time from the Browser onto the clip in the Timeline.

 Click the Filter tab in the Viewer (if V2's Goose is still the active clip in the Viewer still; if not, open it in the Viewer). Change the Brightness and Contrast settings to Brightness = –100 and Contrast = 100. This makes sure that we are dealing with all black pixels (Figure 7.59).

 Turn the Gaussian Blur Radius setting up to 35 to soften the shadow so that it matches the shadows cast by the rotating televisions of the background more appropriately (Figure 7.60).

FIGURE 7.59 Results of tweaking the Brightness and Contrast settings to make sure we have a pure black version of Goose.

FIGURE 7.60 Gaussian Blur setting of 35.

Now that the shadow is black and has been softened, all that is left to do is get the shadow to "lay down."

18. Activate V3 again by clicking the green light button on the far left. We are going to need to see how the shadow relates to the clean copy of Goose, so make sure that you can see the video on V3.
19. Use the Distort tool to lay the shadow down. Beneath the Crop tool in the Tool Palette is one of the tools we have yet to explore—the Distort tool (Figure 7.61). As the name indicates, the Distort tool allows for the manipulation of each of the corners of a clip, allowing for complete shifting of shapes.

FIGURE 7.61 The Distort tool.

To use the Distort tool, select a clip (usually best selected in the Timeline)—in this case, the Goose that sits in V2 (our shadow)—and then move the tool over each corner of the clip's wireframe in the Canvas (Figure 7.62).

FIGURE 7.62 Distort tool when placed over a corner of a clip.

When the mouse changes to that shown in Figure 7.62, you can click and drag that corner into a new location. It only affects that corner and the other corners stay still; thus, the distortion. Click and drag the corners until the shadow layer appears to be laying down. If you click and drag in the

middle of the clip, you can move the clip. Usually, an effective cast shadow is made with the combination of distorting and moving a clip. The results should look something like Figure 7.63.

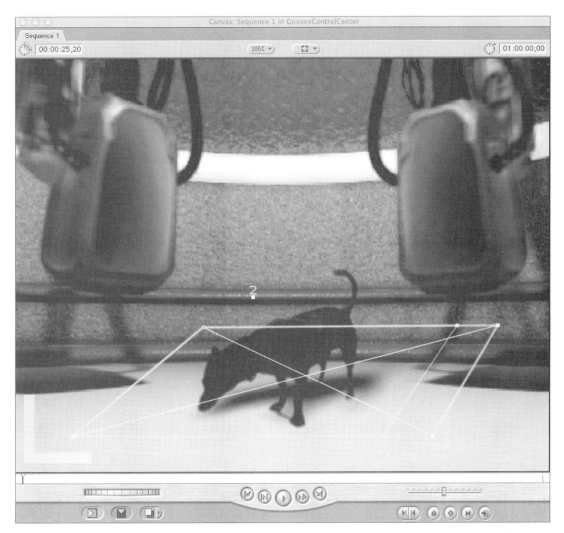

FIGURE 7.63 Results of the Distort tool and moving the clip into position to act as a cast shadow across the ground.

For fun, make sure that the cast shadow version of Goose (V2) is the active clip in the Viewer and click on the Motion tab. Just as we used the sliders within the Motion tab to crop the clip earlier (even though there is a Crop tool in the Tool Palette), notice that by using the Distort tool, the Distort setting (when expanded) in the Motion tab is full of new

Distort		
Upper Left	−99.76	51.94
Upper Right	492.21	49.47
Lower Right	360	240
Lower Left	−360	240
Aspect Ratio		0

FIGURE 7.64 Even though we used the Distort tool from the Tool Palette, a distortion can also be created within the Motion tab.

settings (Figure 7.64). The point is that the Distort tool can also be invoked in the Motion tab.

The exact settings and changes made using this Distortion tool are up to you. Distort and move until it looks right. Don't worry if the feet of the shadow don't line up perfectly with Goose's feet—if need be, turn up the Gaussian Blur filter in the Viewer to blur the area a bit more.

Scrub the playback head to different points to make sure that the placement and distortion created work well to convey a cast shadow.

20. Keeping in line with earlier tutorials, select the two Gooses (V1 and V2) and nest them into a new Sequence entitled "Goose & Shadow." Remember that the keystroke for nesting a new Sequence is Option-C. This, of course, also frees up video track V3.
21. Place Foreground.mov into V3 and trim to fit. Use your favorite method to place the dark clip Foreground.mov into the Timeline. The clip is a little too long for the other two tracks, so trim the clip within the Timeline so that it matches the end of the Sequence Goose & Shadow and the clip GooseBackground.mov (Figure 7.65).

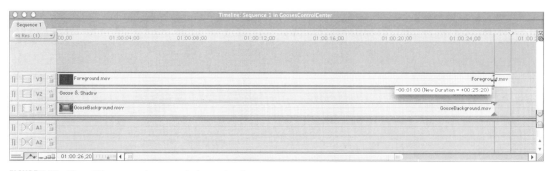

FIGURE 7.65 Placed Foreground.mov and trimmed to fit.

The result of doing this in the Canvas is less than impressive—it should look mostly black. This is because the clip that will eventually be the backside of the spinning televisions has the dark televisions against a black background. We will fix this in the next step.

22. Create a Travel Matte. Mattes are clips or stills that "matte" out certain parts of another clip or still. Mattes allow certain sections of clips to be transparent. A Travel Matte is a special type of matte that allows one video clip to play "through" another. In this case, we will create a Travel Matte using the clip ForegroundLuma.mov. Take a look at that clip in the Viewer and notice that it is just black and white. This will define the parts of the clip Foreground.mov that will be seen.

 To make a Travel Matte, we need to create a "matte sandwich." The order of the sandwich from top to bottom is 1) Foreground.mov; 2) ForegroundLuma.mov; 3) Goose & Shadow Sequence. In general terms, this is 1) Clip to be seen through the matte; 2) Matte; 3) Clip to be seen in transparent areas of matte.

 To do this, we need to create another video track between Foreground.mov (currently V3) and Goose & Shadow (currently V2). Do the following: a) Make V2 the target track by clicking the small piece of film, turning it yellow; b) Select Sequence>Insert Tracks; c) Change the settings to match Figure 7.66. Namely, change the Video Track setting to 1, and activate After Target Track. What this does is place a new track above (after) the target track (in this case, V2). (Figure 7.67).

FIGURE 7.66 Settings for the Insert Track dialog box.

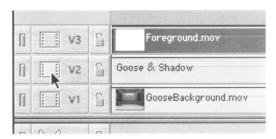

FIGURE 7.67 Making V2 the target track.

The results are shown in Figure 7.68. A new track for the matte (the middle of the matte sandwich) is now available in the new V3. Foreground, the top of the matte sandwich, is placed on the newly created V4.

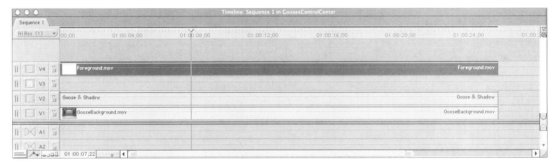

FIGURE 7.68 Result of creating a new track for the matte.

23. Place the clip ForegroundLuma.mov into V3 and trim to match the rest of the clips in the Sequence. Place the clip by either making V3 the target track and placing it into the Canvas (Overwrite Edit, of course), or by dragging the clip directly into the Timeline and into V3. The results after trimming should look something like Figure 7.69.
24. Nest Foreground.mov and ForegroundLuma.mov into a new Sequence called "Foreground with Luma." This keeps our project streamlined and will speed up the preview process.
25. Double-click Foreground with Luma in the Timeline to open the Sequence's own Timeline (Figure 7.70). Zoom in so that the clips fill the space available in the Timeline.
 Still, the image just looks black with an occasional flash of blue.
26. Create the Travel Matte by selecting Foreground.mov in the Timeline and then changing the Modify>Composite Mode to Modify>Composite Mode>Travel Matte Luma (Figure 7.71). The luma, of course, is in reference

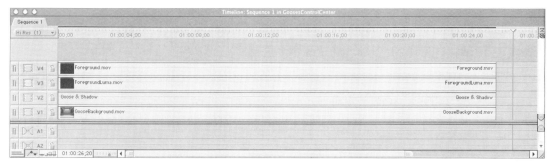

FIGURE 7.69 The Matte Sandwich is complete with the matte layer placed between the clip to show through and the clip to show underneath.

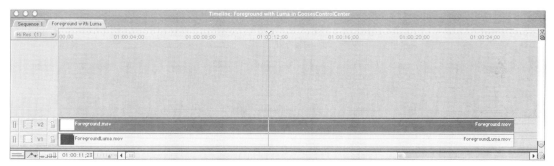

FIGURE 7.70 To work more easily with the Travel Matte, the clip showing through and the matte defining what is to be seen is made into a new Sequence and opened in the Timeline.

FIGURE 7.71 Defining that a clip is to use a Travel Matte that lies in the track below it.

to light. This takes the layer below the selected track, analyzes it, and only shows the parts of the Luma Track Matte that are white.

If you scrub your playback through the Timeline, the televisions moving across the top of the frame should become obvious. Even better is the fact that the checkerboard patter indicates that besides the television, the image is transparent (Figure 7.72).

FIGURE 7.72 Results of creating the Travel Matte—Luma.

27. Click the Sequence 1 tab in the Timeline to bring the main Sequence to the front. Since we edited Foreground with Luma in its own Sequence, the effects are automatically indicated here. Figures 7.73a, 7.73b, and 7.73c show various points in the Timeline.

FIGURE 7.73 Results of the Travel Matte with the nested Sequence atop the background images.

28. Add a Gaussian Blur to the Sequence Foreground with Luma. Although there is already Motion Blur on the moving foreground televisions, we can simulate the effect of a camera depth of field by blurring the Foreground with Luma Sequence further. Simply drag the filter Video Filters/Blur/Gaussian Blur from the Browser to the Sequence in the Timeline.

 Select the Foreground with Luma Sequence in the Timeline and press Return to open the Sequence within the Viewer. Select the Filters tab and change the Radius setting for the Gaussian Blur filter to 25. The result shown in Figure 7.74 is a much softer foreground, giving the effect of a depth of field for the "camera" through which we are viewing the scene.

29. Render and take a break. Now that everything is nested, clips have been given keys to define parts that should be transparent, and other clips have been given Travel Mattes to also define parts of clips that should be seen and parts that should be hidden, let FCP work with all the information and render.

 This will probably be a fairly slow render because so much has been done. However, the results are a great exercise in compositing and a variety of mattes.

FIGURE 7.74 Depth of field effect created by softening the foreground with a Gaussian Blur filter applied to the Sequence Foreground with Luma.

And with that we will leave mattes, Alpha Channels, and special effects behind. They are fun and fairly easy to do in FCP. Compositing and special effects are art forms that can take up multiple volumes in defining, refining, and analyzing models of workflow, theories of construction, and steps of technique. Remember that we have barely scratched the surface of the multitude of things that can be done with mattes,

garbage mattes, and compositing. Hopefully, this chapter has given you a feel for the tools that will allow you to create the types of things in your imagination.

Conclusion

In the next chapter, we will also look at how to create and edit interview segments. This uses a large variety of important ideas, including multi-track editing, still montage creating, effective sound mixing, and sound recording.

But wait! There's more. This just gets us to the point that we know how to edit video. Stay tuned to look at ways to output the video directly to tape using FCP, how to create EDLs for use at a service bureau, and other forms of output. The last part of the book is dedicated to the latest and more powerful craze of output: DVD.

Now, after returning to the Sequence Master Sequence, take a moment to render anything that needs to be rendered, take a break, and then come back for more fun and excitement.

CHAPTER

8 INTERVIEWS AND TRANSITIONS

We have already covered a lot of ground, and there are very few tools that we haven't discussed. Most dark corners of FCP have been illuminated. Unfortunately, without thousands of pages, it is impossible to explore each and every capability and functionality of FCP. Indeed, it is probably impossible for any one person to know all such aspects of such a robust program. Creative folk will continue to use innovative tools in new ways that even the creators had not considered.

In this chapter, we will look at a couple of other functionalities and important corners. We will explore FCP's transition functions and how to edit together complex sound/video combinations in the form of interviews and sound montages.

TUTORIAL

8.1: INTERVIEWS, PHOTO MONTAGES, AND AUDIO WORK

In this tutorial, we get to explore the creation of an interview. This will be done in an *A&E*'s *Biography* style, mixing interviews with music with sound effects with narration. Through the project, we will learn some of the valuable things that FCP can do that we have not yet covered.

Namely, we will work with the idea of a photomontage. Although in previous chapters, we looked at examples of how to animate clips, we will now look at methods of subtle animation to bring life and movement to stills. We will look at how big those stills should be and how to best place and deal with still images.

We will look at some more of the effects contained in the Effects tab of the Browser; namely, *transitions*. Transitions are often covered first in editing books, but in reality, most TV and movies do not actually make heavy use of transitions. With the notable exception of the typical Lucas-Wipe and an occasional Cross-Dissolve, transitions are hardly used at all. However, they do have a time and a place, and so for the last part of this chapter, we will be editing together some footage for an interview project. We will be doing Ken Burns-y' photo pans and scans, and editing split video tracks to one audio.

We have not covered much in the form of sound in this book either. Sound is an incredibly complex aspect of any video production. Since it is so complex, and several volumes can and have been written about it, we will just touch on it here. We will look at layering sounds, controlling volume, and making sure to work with the right sound formats. Finally, we will look at one of the most interesting new functions of FCP: the voice over.

The man being interviewed is my Grandfather. These clips are part of a larger project that I am in the middle of to help document for our family the life of someone who saw the first cars, saw electricity and plumbing come to his

home, and witnessed a host of other changes in society and technology. Grandpa is a retired farmer and equipment dealer from Idaho and Wyoming with many important stories for our family to understand as part of its heritage.

These clips were shot at the end of a rather long day of interviewing (he had been at it for about four hours), so much of the footage lacks energy. Part of the editing challenge in this tutorial will be to take the somewhat tired footage and bring it back to life through interesting sound and additional footage.

By the way, this footage was shot on a budget (none, really). The camera used was a small Canon ZR-10. The studio is my Grandfather's basement with a blanket for the backdrop, a couple of construction lights bounced off of white poster board for lighting, and a couple of flood lights for backlight (thus the glare on the top of his head). Even the sound is low budget; it's actually a $20 mic from the local RadioShack. So, with these very coarse starting blocks, we will look at ways to smooth it all out through interesting editing.

1. Copy the folder Interview_Media from the DVD to your media hard drive. This will simulate the process of creating a new folder on your hard drive that you would create at the beginning of a new project.

ON THE DVD

2. Download and convert a couple extra pieces of media. On the Web site www.bupers.navy.mil/navymusic/ exist some recordings of the Navy Band. Because of distribution rights, we did not include these on the DVD. However, for the tutorial pieces, go to the site and click on the link Audio Clips. There, download *The New Colonial March* from the Marches/Patriotic section. Also download *Drum Cadence 6/8 Time* from the Parade the Colors/National Anthem section.

FCP does import mp3s. However, they hardly ever work well in their default format. Besides having to render, there is often popping and all types of noise problems that accompany mp3 files. But, luckily, you also have QuickTime Pro (it comes standard with FCP).

Open QuickTime Pro, and use it to open each of the downloaded mp3s. Do this by selecting File>Open Movie in New Player. This will open the mp3 into QuickTime Pro, where you can easily save it out to a more appropriate format.

In QuickTime Pro, select File>Export. This will open a dialog box asking how it is to be exported and to where (Figure 8.1). Make sure to define the Where—to save into your Interviews_Media. Change the Export setting to Sound to AIFF, and click the Options… button.

In the Sound Settings, set the Compressor to None and the rate to 48.00 kHz. DV works at the sound frequency of 48 kHz, so by ensuring that the sound is optimized, you reduce the potential for problems within FCP. Change the other options to match Figure 8.2.

FIGURE 8.1 Exporting mp3 files from QuickTime Pro. Exporting to AIFF eliminates much of the audio rendering needs and keeps the sound clean.

FIGURE 8.2 Sound Settings for exporting an mp3 in QuickTime Pro.

Without proper permission, these files of course would be illegal to place in a distributed edited piece. However, it is an appropriate project to use them here, as you are learning a piece of software with a project that will never leave your hard drive.

3. In FCP, create a new Project (File>New Project).
4. In FCP, set up the Preferences for the project. The first part of this step is to set up the Scratch Disks. Remember to do this, open the Preferences with Final Cut Pro>Preferences (OSX) or Edit>Preferences (OS9). Then, click the Scratch Disks tab and set the right location (Figure 8.3).

FIGURE 8.3 Scratch Disks set up for this project. This is a good step to do at the beginning of every project.

The second Preferences adjustment to be wary of is setting the duration of stills. In some of the earlier tutorials, we brought in projects that were sequential stills. However, in this project, there will be no sequential stills; in fact, there will be lots of stills that need to have a fairly good duration within the Timeline. Click on the General tab (still within the Preferences dialog box) and change the Still/Freeze Duration to 00:00:10;00. Remember that you can do this quickly by selecting the input field and entering 1000 (FCP will interpret it at 00:00:10;00) (Figure 8.4).

FIGURE 8.4 Adjusting the Still/Freeze Duration preference to allow for easier use of stills in the photomontage sections.

5. Save the project as "Interview."
6. Import the media assets. There are two quick ways to do this: you can use the File>Import>Folder drop-down menu and find the Interview_Media folder on your hard drive, or you can drag the folder from your hard drive to the Browser.

 This should present in the Browser a couple of sub-bins, including one called "Photos" (and if you saved the converted audio files in the Audio Folder; that sub-bin will appear as well). The remainder of the project will be editing the media contained here.

7. Prepare the clip 02 Navy/Join. These clips were shot at the end of a long day of interviews. When logging and capturing the clips, we kept the Ins and Outs very loose, so occasionally, there is noise from those of us doing the interviewing. Therefore, before we start with the more interesting editing, we need to prepare this clip by creating appropriate Ins and Outs.

 Set the In right before he begins the sentence, "Well, we had to report to Pocatello." You will want to make sure and edit out the "uhh" at the beginning of his sentence. The In should be somewhere around 00:01:43;23. Remember, pressing "I" on your keyboard sets an In point.

 Play through the clip and set an Out right after he says, "…the Navy'd be most advantageous for that." He goes on to talk about not liking the Army, and that really is not important for the point of the clip. The Out point should be somewhere around 00:02:05;15. Remember that pressing "O" sets the Outpoint.

8. Place the clip from the Viewer into the Canvas and accept the default Overwrite Overlay Edit to place the clip.

9. Prepare the clip 03 Navy Training. This clip is later in the interviewing process, but is goes well right after the section we just placed. However, just like the last clip, we need to edit out some of the extraneous noises and stutters. Open the clip 03 Navy Training in the Viewer by double-clicking it in the Browser. Set the In after the noises and his initial stutter when he says, "They sent me to radio school…." This should be at about 00:02:19;25.

 Then, play through the clip, and when he is finished talking about marching "…march to school every morning and every night," mark the Out point. This should be at about 00:02:52;00.

10. Place this clip in the Canvas again using the default Overwrite Overlay Edit, and the new clip will be snug up against the previously placed 02 Navy/Join clip.

 Now we have two interview clips back to back similar in tone and subject, but rather boring visually to watch all at once. To help break up the visual monotony and to help hide the cut where 02 Navy /Join cuts to 03 Navy Training, we will put in some images.

11. Find the place in the Timeline to bring in the image WideGrandpaSailor.psd (which is inside the Photos sub-bin). You can choose where you think it would go best, but a good suggestion is at about 01:00:10;03, right after he says "…which branch of the service." Set an In point in the Timeline here.

 Set an Out point just past the edit after he says, "They send me to radio school." This will be at about 01:00:23;15.
12. With the In and Out points defined, drag the WideGrandpaSailor.psd photo directly from the Browser onto the Canvas and select the Superimpose Overlay Edit. The result will look fairly odd in the Canvas (Figure 8.5), but not to fear. Notice that in the Timeline, a new track has been created with the WideGrandpaSailor.psd image in it. The still image will have been stretched so that it fits the In and Out points (Figure 8.6). Notice that, of course, this will require rendering, but do not render yet; we will get to that in a minute.

FIGURE 8.5 Result of Superimposing a still over the moving footage.

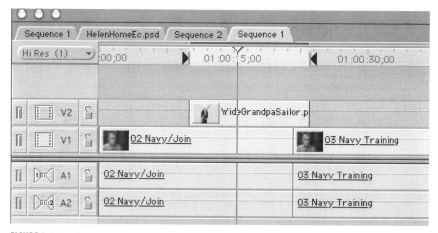

FIGURE 8.6 With 3-point editing, the still image fits right into place to conceal the edit.

13. Animate the still WideGrandpaSailor.psd for a slow zoom out. We already looked at how to animate a video clip over time, and animating a still is much the same. Start by making sure that the Canvas is displaying Image+Wireframe. For now, leave the scale as Fit to Window.

 Scrub the playback head to the beginning of the image, WideGrandpaSailor.psd which is now a clip in the Timeline. We want to have this clip zooming slowly from the moment it appears until the moment it ends.

 Select WideGrandpaSailor.psd in the Timeline and press Return. This will open the still in the Viewer. Click on the Motion tab to allow for numeric alteration of the clip's position and scale.

 Increase the Scale setting to 300. This will zoom in an incredible amount, showing you just the knuckles of the shot (Figure 8.7).

 Although the photo is not of very high quality, the only reason why this hand actually looks like a hand is through planning. The image is actually 2400 x 1302 pixels in size. For an image to look crisp, it needs to be at the standard DV proportions of 720 x 480. Since the plan was to always have this picture with a fair amount of zoom, it was scanned large and kept large so that even at 300%, the pixels did not fall apart.

 In general, planning ahead on your stills is important. If your images are too large, you are using unnecessary space on your hard drive that would be better used for video footage to store the images; if they are too small, then the quality is poor.

 Once the Zoom at 300 is established, move the clips down so that the eyes are at the center of the screen (Figure 8.8). Because WideGrandpaSailor.psd is already selected in the Timeline, and it is all that is visible in the Canvas, just click and drag anywhere in the Canvas to move it.

FIGURE 8.8 Move WideGrandpaSailor.psd clip so that the clip is ready to be animated.

Finally, after all this has been set up, click the Insert Keyframe button *on the Canvas*. This will set keyframes for both the Scale and Center parameter at the same time.

14. Scrub the playback head to the end of the clip WideGrandpaSailor.psd. You can do this easily by pressing the Down Arrow key twice (once to jump to the next edit between 02 Navy/Join and 03 Navy Training and again, to the end of the clip). Remember to press the Back Arrow once to move back one frame so that you are at the end of the WideGrandpaSailor.psd clip.

15. Scale and move the clip WideGrandpaSailor.psd so that it fills the frame. Interestingly enough, you will want to do this very carefully using the following steps:

 First, manually enter the values 0, 0 in the Center input fields in the Motion tab of the Viewer. The reason for this is that since the clip had to be moved down so much to get the eyes centered, once the scale was decreased, the clip (with its lowered center) would not be visible in the Canvas.

 Second, reduce the Scale to get in more of the image. Our setting is at about 45.

 Third, grab the clip in the Canvas and position it as you please (Figure 8.9).

FIGURE 8.9 Results of rescaling and repositioning the clip.

Note that since a keyframe was inserted at the beginning of the clip, these new changes have created new keyframes in the Motion tab and within the Canvas.

16. Find the section where Grandpa begins talking about "They sent me to Alabama…." Set the In point here (about 01:00:28;15). Play on a little more until he says, "…Alabama Polytechnic Institute" and place the Out point on the Timeline there (01:00:34;23). Make sure to place this Out point tight toward the end of the word *Institute*. We will be placing two still clips here as the dialog becomes a little dry and needs to be spiced up visually to keep the audience's attention. However, since we want to keep the audience's attention, the stills shouldn't last very long. Therefore, to get two stills into the time allotted, neither should be very long.

 In the Photos sub-bin is a still called MarchinginLineSmall.psd. Make V2 the target track to make sure that we get all the superimposed images on the same track, and drag the MarchinginLineSmall.psd from the Browser into the Canvas and select Overwrite. This will put the still within the just marked In and Out (Figure 8.10).

FIGURE 8.10 Placing a still using In and Out markers within the Timeline.

17. Animate MarchinginLineSmall.psd with a slight zoom. Rather than simply showing the still, we will give it a slight zoom in the traditional Ken Burns style. We will do a very slow, very slight zoom out.

 To do this, first scrub the playback head to the beginning of the newly placed MarchinginLineSmall.psd clip. Make sure the Canvas is showing Image+Wireframe. Double-click MarchinginLineSmall.psd to open it in the Viewer. For this step, we will enter the Zoom values numerically.

Click the Motion tab within the Viewer and notice that the Scale setting is 81.45. This is because the image is larger than the 720.480 of DV. When FCP places a still image, it resizes it so that will fit within the frame. For now, change the Scale value to 100 and click Insert Keyframe for the Scale parameter (Figure 8.11).

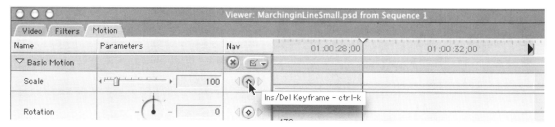

FIGURE 8.11 Animate just the scale by setting a value and then inserting a keyframe for just that parameter.

Now, to actually animate the clip, we need two keyframes. Scrub the playback head to the end of the clip MarchinginLineSmall.psd and change the Scale value to 82; 82 is the magic number, as we know that 81.45 fills the screen, and ensures that the frame is filled with the still with a little bit to spare.

As soon as you change the Scale value, a new keyframe will automatically be created (Figure 8.12).

FIGURE 8.12 Once the first keyframe is inserted, any subsequent changes in the Scale parameter will result in a new keyframe automatically being placed.

18. Immediately mark a new In point in the Timeline. When placing clips into the Project via the Canvas, the playback head automatically moves to the end of the clip just placed. Thus, since we are cutting directly to another still, the position of the playback head (01:00:34;23) is right at the In point for the next clip.

Play a bit and find where he says, "…a college down there." There is a little lull in his monologue there, so we want to make sure that the still

image we are about to place covers this hole. Place the Out at about 01:00:39;03.

Drag the still AlabamaInstitute.psd from the Browser onto the Canvas again using the default Overwrite Overlay Edit. The Timeline should look something like Figure 8.13.

FIGURE 8.13 Two stills placed next to each other to keep the visual interest high when the audio interest lulls.

Before moving onto the next step, scrub the playback head back to the beginning of the newly placed AlabamaInstitute.psd clip (remember, this can be quickly done by pressing the Up Arrow key).

19. Resize the clip AlabamaInstitute.psd so that it fills the frame. Although this can be done numerically, it is most easily done visually. However, since the image will have to be bigger than the frame, we will need to have more space in the Canvas.

 Zoom out of the canvas so that it looks like Figure 8.14. On our monitor running at 1600 x 1200, the setting is 50%.

 Select the still in either the Timeline or the Canvas and then drag the corner of the wireframe out so that it matches the size of the frame (Figure 8.15).

20. Animate a slow pan. Since we numerically numbered things on the last bout, we will use the old visual method this time. Make sure the playback head is still at the beginning of the clip AlabamaInstitute.psd and that it is still selected in the Canvas. Slide the clip in the Canvas a little to the left (Figure 8.16). We want to make sure that the majority of the time, the center building is centered, so we start with it slightly off-center. Click the Insert Keyframe button within the Canvas.

 Press the Down Arrow key once (jump to the next edit) and the Left Arrow key (move back one frame) to get to the last frame of the clip AlabamaInstitute.psd. Now, hold the Shift key down and drag the clip a little to the right (Figure 8.17).

FIGURE 8.14 Zoom out of the Canvas to allow room to scale the clip larger.

FIGURE 8.15 Resized clip. The Selection tool was used. Make sure to *not* hold down the Shift key when resizing the clip in FCP.

FIGURE 8.16 Starting position for a slow pan.

FIGURE 8.17 New position of AlabamaInstitute.psd at the end of the clip. Notice that the new keyframe has been placed automatically.

21. Mark a new In when Grandpa starts talking about marching to class every day (01:00:46;04). For the last part of the Sequence we will take some stills of sailors marching to class, animate them, and use a transition. With this In point marked, drag the still MarchingTall.psd from the Photos sub-bin onto the Canvas (Figure 8.18). This will be entirely too long, but we will trim this up in a second.

FIGURE 8.18 Placing MarchingTall.psd into the Timeline and its result in the Canvas.

For now, resize the newly placed clip in the Canvas so that it fills the frame (Figure 8.19). Remember to do this by selecting it in the Canvas or Timeline and then dragging a corner out to fit. Finally, move the clip so that the soldiers actually fill the frame.

22. Trim the clip MarchingTall.psd in the Timeline to match Figure 8.20. The idea is to make sure that there will actually be a little of the next clip extending past the underlying 03 Navy Training clip, but we want this MarchingTall.psd clip and the next one to be about the same length.
23. Animate a slow pan. Scrub the playback head to the start of MarchingTall.psd and click the Insert Keyframe button on the Canvas. Scrub to the end of the clip MarchingTall.psd and slide the clip in the Canvas down a bit

FIGURE 8.19 Resized and repositioned MarchingTall.psd.

FIGURE 8.20 Trimming MarchingTall.psd in the Timeline.

so that the sailors end up about half out the bottom of the frame (Figure 8.21).

24. Press the Down Arrow key to jump to the next edit (which in this case is the end of the just-animated clip MarchingTall.psd). Drag the still MarchingtoClass.psd from the Browser onto the Canvas and select Overwrite. Trim the clip in the Timeline so that it matches Figure 8.22.

FIGURE 8.21 Animated clip panning upward.

FIGURE 8.22 Placed and trimmed clip MarchingtoClass.psd.

25. Animate the newly placed MarchingtoClass.psd clip so that it pans from left to right. Scrub to the beginning of the clip, select it, and resize it so that it is slightly larger than the frame (Figure 8.23). If the clip is not resized, the edges of the clip would move through the frame revealing the media below. Slide the clip over so that the left edge of the clip is at the left edge of the frame. Click the Insert Keyframe button on the Canvas to define this as the starting point of a moving animation.

FIGURE 8.23 Resized MarchingtoClass.psd clip.

Scrub to the end of the clip (Down Arrow [twice] and then Left Arrow), and move the clip in the Canvas so that the right edge of the clip lines up with the right side of the frame (Figure 8.24).

26. Add transition between the two marching clips. There are several ways to add transitions (which we will look at a little later), but for now, we will use the method of pulling one from the Effects tab.

 Click the Effects tab in the Browser. Besides Effects, this area also houses the often overused but still very useful Video Transitions folder. Expand this folder and view the extensive selection of Transitions available. For this project, we will use the standard Cross Dissolve, which is housed in the Dissolve folder.

 To use it, drag it from the Browser to the Timeline and drop it on the edit, or the space between our two marching clips (Figure 8.25).

 There are a couple of other ways to place transitions, so there's no need to follow these images in your own project—they are just FYI. You can choose to use whichever works best in your workflow.

 Besides dragging a transition onto an edit, you can select an edit by clicking it within the Timeline (Figure 8.26a), and then right-click (or Control-click) the edit (Figure 8.26b) and select Add Transition "Cross

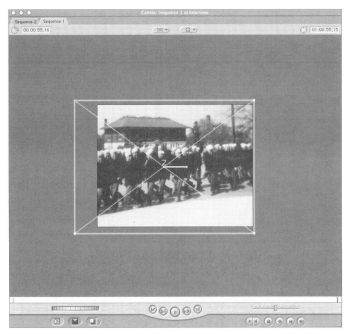

FIGURE 8.24 The second half of the slow pan animation.

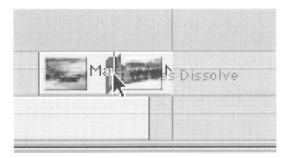

FIGURE 8.25 Placing a transition by dragging it from the Browser.

Dissolve." In this case, Cross Dissolve is the default transition. We will look at changing the default transition in a minute.

Transitions can also be added on-the-fly as you edit into the Canvas. When any clip is dragged to the Canvas, the Overlay Edit options appear. Notice that among the Overlay edits are Insert with Transition, and Overwrite with Transition (Figure 8.27). This functions just like the Insert and Overwrite Overlay Edits, except it places a transition (the default transi-

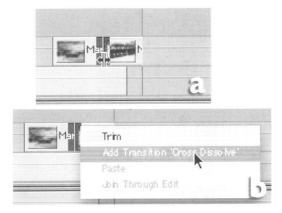

FIGURE 8.26 Adding a transition can also take the form of right-clicking (or Control-clicking) an edit.

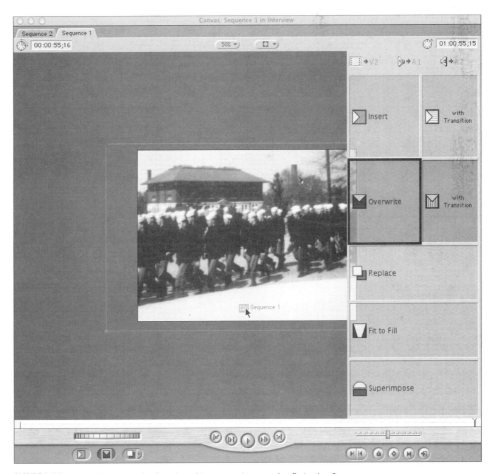

FIGURE 8.27 Transitions can also be placed into a project on-the-fly in the Canvas.

tion) between the clip that is being placed and the clip immediately before it.

Some things to be aware of when working with transitions:

First, in order for transitions to work, there must be sufficient media in both the clip being transitioned from and the clip being transitioned to. In other words, when viewing a clip in the Viewer, the first clip's scrub bar looks like Figure 8.28a, and the clip you want to transition to looks like Figure 8.28b—a transition will not work. In fact, FDC will not even let you place a transition into the edit.

FIGURE 8.28 Two scrub bars showing media without sufficient media to place a transition.

Among students, this is a major cause of problems. Because they failed to capture enough media for good handles, they placed clips into the Timeline without any media. Then, when they try and create a transition, or place a clip with transitions, they become incredibly frustrated when it does not take. If you cannot place a transition, check that media's In and Out. Without sufficient media, FCP simply does not have the frames to make the transition work.

Second, remember that FCP treats transitions in many ways as a clip. Double-click the transition in the Timeline and you can change it in the Viewer (Figure 8.29).

Within the Viewer, assuming that you have sufficient media, you can make all types of subtle or dramatic changes to a transition. These changes include Roll Edits of the transition position, Trimming the transition, which essentially changes the duration of the transition, and Slip Edits of either of the clips involved in the transition (Figure 8.30).

Each transition has its own collection of things possible to adjust within the Viewer. Since each is slightly different and there are many transitions, we will not get too involved with the options here. However, if you happen to have a project that makes heavy use of transitions, remember the power of manipulation possible in the Viewer.

FIGURE 8.29 Adjusting transitions in the Viewer after double-clicking one in the Timeline.

The third thing to note is that the default transition is Cross Dissolve. However, if you are working with a quirky project that calls for another transition to be used and you are using a lot of transitions for some reason, it might be worth your time to change the default. To change the default transition, right-click or Control-click the transition you want within the Effects tab and select Set Default Transition (Figure 8.31). The new default transition will appear in the Effects pull-down menu and will appear underlined in the Effects tab of the Browser.

FIGURE 8.30 Some of the possibilities available in the Viewer when working with transitions.

FIGURE 8.31 Changing the default transition.

27. Use the Cross Dissolve transition to fade a clip out. Transitions can be used for more than just transitioning between clips. In this case, we will use the Cross Dissolve to transition from the clip MarchingtoClass.psd to black—the effect being a fade to black.

 To do this, drag the transition Cross Dissolve from the Effects tab in the Browser onto the clip MarchingtoClass.psd (Figure 8.32). Where the transition is actually placed on the clip is important. Zoom in on the Timeline to get a better view of what the transition is doing. Figure 8.32a shows the incorrect location to place the transition for a fade-to-black effect. In this case, it would be looking for another clip after MarchingtoClass.psd, giving bad results. Figure 8.32b shows the transition placed entirely within the clip, which is correct for this type of fade-to-black effect.

FIGURE 8.32 a) Incorrect placement of transition for fade to black effect. b) Correct placement.

28. *Do not* render. That's right, do not render yet. This setup thus far is just a rough cut. You can still preview the project to get an idea of timing, but right now, FCP looks at all of our stills as Superimposed clips.

 "But they are," you might say. The reality of these stills that have been placed and animated in the Timeline is that they could just as well be quick cuts from the footage of Grandpa talking. This distinction is important because of rendering issues.

 If you were to render the Sequence right now, FCP would treat the layered video as one layered clip to be remembered as two clips atop one another. Even though we cannot see the clip in V1 when we have the images at full opacity in V2, FCP still thinks of it as being composited together. The big deal is that if you choose to move the stills a little later or earlier, but do not move the footage in V1, FCP decides it has to render all over again. However, if the clips were set up as in Figure 8.33, then FCP renders the

stills as their own clips without any reliance on tracks below. Then, the rendered stills can be moved to other locations with no new rendering needed.

FIGURE 8.33 More appropriate-looking Timeline for fully opaque superimposed clips.

How to create such a Timeline is the next step.

29. Independently trim the video of the clip 02 Navy/Join. By default, when a trim is performed in the Timeline, FCP trims both the video and the accompanying audio of the track. This is important, as it is vital, especially with interviews, that the audio and video stay in sync. However, in this case, we want to have the video stop while the audio continues as we view the still above (GrandpaSailor.psd).

To independently trim or edit either audio or video of a clip, simply move the mouse to the end or beginning of a clip as though you were trimming, and hold down the Option key. Then, when the clip is trimmed, only the selected track changes (Figure 8.34).

30. Use the All Tracks Forward tool to give a little more breathing room. In this Sequence, 02 Navy/Join and 03 Navy Training are two clips that came many minutes apart in the actual interview. Since they work together, they have been edited together here. However, the timing between the two clips is a bit too short, and Grandpa's voice comes across a little unnaturally. To help this, place a little space between 02 Navy/Join and the clips that come after.

Easy to say, but it's a bit more complex than simply grabbing the clip 03 Navy Training and moving it. We have placed carefully timed stills in previous steps, and we would not want to have to reposition all of them. Therefore, use the All Tracks Forward tool from the Tool Palette and click

FIGURE 8.34 a) Trimming just the video of a clip by using the Option-drag method. b) The results of the Option-Trim.

on 03 Navy Training as shown in Figure 8.35a. This will select 03 Navy Training and all the stills placed earlier.

When these clips are all selected, simply slide them in the Timeline so that 03 Navy Training starts and snaps where GrandpaSailor.psd ends (Figure 8.35b).

31. Use the Razor Blade tool to free MarchinginLine.psd and AlabamaInstitute.psd from superimposing rendering prison. In an earlier step, we used a simple trim to move the video out from under a still image. However, for the clips that sit above 03 Navy Training, this is a bit more complex. After we see the stills MarchinginLine.psd and AlabamaInstitute.psd, we need to see the video of 03 Navy Training again.

To accomplish this, we will use the Razor Blade tool to cut the clip 03 Navy Training into two sections. The Razor Blade will create two clips from one. The default use of the Razor Blade tool is to cut not only the video, but the audio as well (Figure 8.36a). In our case, we want to keep the audio intact, so hold the Option key down to simply "slice" the video track (Figure 8.36b).

FIGURE 8.35 Use the All Tracks Forward tool to select and move clips to not disturb the placement of layered effects.

FIGURE 8.36 a) The default Razor tool cuts through both audio and video b) Option-Razor tool will allow the cutting of just one part of a clip.

FIGURE 8.37 Trimmed clip after using the Razor tool.

Finally, after slicing a cut in the video track of 03 Navy Training, trim the clip so that there is no video media below the still clips MarchinginLine.psd and AlabamaInstitute.psd (Figure 8.37).
32. Option-Trim 03 Navy Training to remove the video from under the final two "marching" still clips (Figure 8.38).

FIGURE 8.38 Trimmed clip using Option-Trim.

33. Render (Option-R). After all the clips are independent, take a brief break and render. Rendering this many stills into movies will take a little while, but since they are not superimposed, you will not need to render them again if you need to move them to a new location.
34. Place the sound clip The New Colonial March into the Timeline. Scrub the playback head to the beginning of the Sequence (or press the Home key) and mark it as the In. Then, scrub to the end of the Sequence (or press the End key) and mark that as the Out.

Drag the audio clip The New Colonial March.aiff from the Browser to the Canvas and select the Superimpose Overlay Edit. This makes sure that the extant audio clips are not disturbed, as FCP creates another couple of audio tracks to place this new sound. The audio clip will be automatically trimmed to match the Sequence (Figure 8.39).

256 | Final Cut Pro 3 and DVD Studio Pro Handbook

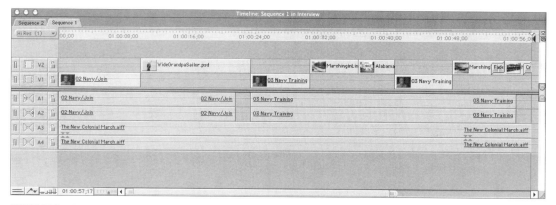

FIGURE 8.39 Placed and trimmed audio track.

Take a listen by playing the Timeline. Notice that the audio is too loud for the Sequence and overwhelms the really important narration by Grandpa.

35. Edit the newly imported clip's audio level. The most intuitive way to do this is to make sure that the Clip Overlays are active (Figure 8.40). These can be turned on with the button in the bottom-left corner of the Timeline.

FIGURE 8.40 Activating the Clip Overlays.

This will make dark pink lines visible on all audio tracks. To reduce the audio level of the entire music track, with the regular Selection tool, just grab the line and drag it down. With only two audio tracks, most Macs can handle mixing the sound in real time, so make an adjustment, listen to the levels, and readjust (Figure 8.41).

36. Fade the audio out at the end of the Sequence. In earlier chapters, we looked at using the Clip Overlays to change the opacity of clips. Using the Clip Overlays, we could make clips fade up and fade down. This same technique can be used with sound. Use the Selection tool and Option-click

FIGURE 8.41 Adjusting the audio level of an entire track.

twice toward the end of The New Colonial March.aiff audio clip. Take the second newly created handle and move it to the bottom of the green bar. This will fade the music out (Figure 8.42).

FIGURE 8.42 Fading music out at the end of the clip.

Notice that the Pen tool is the most effective method of creating and editing these handles. However, Option-clicking with the Selection tool can still save you a bit of time when working with fairly simple changes.

37. Within the Timeline, set an In point at the beginning of the last "marching" clips (01:00:47;29) and an Out at the end of the Sequence. Drag the clip Cadence.aiff from the Browser to the Canvas, and again select the Superimpose Overlay Edit to make sure that FCP creates new tracks for this new sound.

Adjust the volume of the Cadence.aiff clip so that it does not overwhelm the narration. This time, we will fade out using the same transition trick as we did for the last video clip. Click the Effects tab in the Browser and find the folder called "Audio Transitions." Contained are transitions

FIGURE 8.43 Creating an audio fade using an Audio Transition.

specifically aimed at audio clips. Drag the Cross Fade (0 dB) from the Browser onto the end of the Cadence.aiff clips. This produces a quick-and-easy sound fade (Figure 8.43).

CONCLUSION

Interviews are a deceptively complex media to edit. FCP's extensive tools allowing for multitrack editing, and easy-to-use transitions help to ensure that the process goes smoothly. Remember that the techniques described in this chapter can actually be used in a wide variety of projects. Simple photomontages can be created with animated series of stills to create gentle rolling and zooms.

The transitions we looked at are just the beginning. There are many, many transitions nested within the Effects tab. Too many of them are gimmicky to spend much time on, but realize that almost any transition you see on TV or in movies is contained in the Transitions folder. Also remember that besides the transitions, there are many effects that we have yet to explore. Since this is not a manual, we will not look at each, but when you have a moment, it might be worth your time to explore the multitude of tools in that one little window.

The multitrack techniques described here move well beyond just the realm of interviews. This type of editing the video of one clip while leaving its audio unaffected has all kinds of applications, including hiding problems between shots. This allows you to use the video of one character listening to another, while using the superior vocal performance of another clip. Mastering the ability to edit one track of a multitrack clip can help to hide all types of filming problems and make you an editor worth your weight in gold.

All in all, this is most of what we will cover in Final Cut Pro. The next short chapter is dedicated to finding the best ways to export your editing manifesto. We will look at exporting the file directly to tape, to DV, to service bureaus, and even to Edit Decision Lists. Finally, after looking at all of these methods, we will actually export all of our tutorials created thus far to mpg2 streams that are usable in DVD Studio Pro. Immediately afterward, we will look at some of the aesthetics of DVD design and menus and then dive into the tools contained in Apple's other powerful video production tool, DVD Studio Pro.

CHAPTER

9　OUTPUTTING YOUR PROJECT

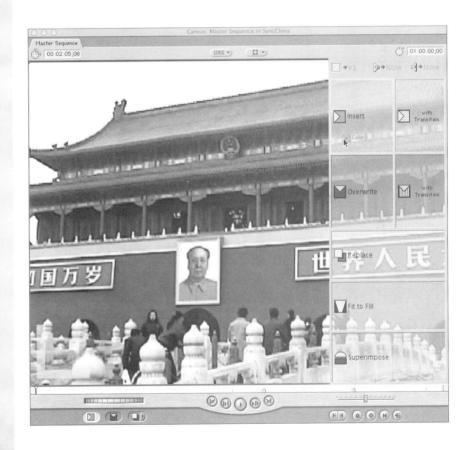

The project is edited. You have carefully captured all the necessary media, brilliantly conceived an editing strategy, and masterfully manipulated the tools to create an amazing piece of editorial excellence. However, all this work is for naught if only those sitting in front of your computer can see the piece.

That is where this chapter comes in. Although it is short, this chapter is concerned with providing the information that allows your masterpieces to be enjoyed by the masses. We will look at quite a few different methods of outputting your project. First, we will look at the simplest form of outputting to videotape. Then, we will look at more "packaged" ways of outputting to tape. We will cover how to prepare files for output at a service bureau where the project can be output to anything from film to other DV to beta. We will cover preparing files for Web distribution and CD distribution. Finally, we will look at getting files ready for output to DVD.

This last part will be the final bridge from the land of Final Cut Pro to the realm of DVD Studio Pro. There are issues with which to contend that are special to outputting to DVD. Luckily, we will look at many of them here. So, if you are following the tutorials faithfully, you may want to just skip to Chapter 11 and read up on how to export files for DVD. However, keep this chapter in mind, as most editing projects end up being output in a variety of ways, and being fluent in various output methods is an important language to speak.

OUTPUT METHOD #1: RECORDING TIMELINE PLAYBACK

Recording Timeline Playback is the process of simply pressing the Spacebar to play your project, and pressing the Record button of a VCR connected to your camera. In the early chapters, we discussed various hardware setups. Figure 9.1 shows a hardware setup that makes for the quickest and dirtiest output. If you have your system set up without the VCR, just add the VCR between the camera and the television. Make sure that the VCR's output goes directly to the TV and that your workflow is uninterrupted within FCP. However, since the signal is going from your Mac, to your camera, through the VCR, and out to your television, all you need to do is press the Record button on the VCR while you are playing a Sequence in FCP.

There are some caveats to this. First, as you know, VHS quality is horrible. Outputting to VHS is okay for quick proofs, but never for broadcast. You have probably seen those public access channels and notice that besides content issues, the quality is so bad that you immediately know

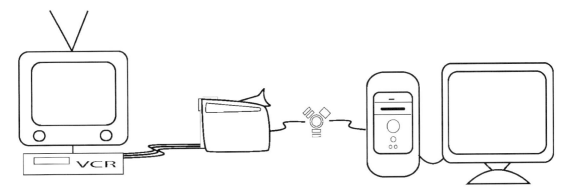

FIGURE 9.1 A slightly alternate hardware setup that allows for quick output to tape.

that that you are watching an amateur-produced program. If you plan to output the project for broadcast use, for heaven's sake, output to Beta or DV—but more on this later.

Second recording off the Timeline is truly WYSIWYG. If the playback head is at 00:00:00;00 and you see in the Canvas the first frame of the Sequence, as soon as you press the Record button on the VCR, that is what will be recorded to tape. Likewise, when the playback head reaches the end of the Sequence and rests on the last frame, you might end up with a still of the last frame that is also recorded to tape.

This is not a deal-breaker, though. To fix this problem, simply add a bit of black to the front and end of the Sequence. For example, Figure 9.2 shows the Timeline for the Master Sequence from the project SyncChina that we did at the beginning of the book.

FIGURE 9.2 Timeline for Master Sequence for SyncChina.

Although you might have added some extra clips to the end of the Sequence to fill up the rest of the audio, for this demonstration, the audio is trimmed back to match the footage available (Figure 9.3).

FIGURE 9.3 Trimmed audio to match video.

Adding a bit of black before and after the Sequence will allow for your project to be displayed only after the tape has played past the leader, and allows the end of the project to end on a black screen. This is easy to do, but makes the packaging of the project a little nicer.

There are several ways to add black leaders and trailers. We will look at two. The first method is to add a few seconds of Black Matte. Move the playback head to the beginning of the Sequence (press the Home key). Click the Effects tab of the Browser and find the folder Video Generators. Within this folder is an icon called "Color." Drag this icon to the Canvas and select the Insert Overlay Edit (Figure 9.4).

This will take all the media of the Sequence and shift it down to make room for the Color Matte you are importing. Double-click the newly imported Matte in the Timeline to open it in the Viewer. Select the Controls tab, and change the little gray swatch to black (double-click the swatch and change to black in resultant window). The results in your Timeline should look something like Figure 9.5.

Note that the length of the matte is dependent on the currently set preferences. For example, in the shots shown in Figures 9.1 through 9.5, the Still/Freeze Duration setting is set to 00:00:10;00 (access this preference with Final Cut Pro>Preferences [General tab] for OSX, or Edit>Preferences [General tab] in OS9). For a leader, 10 seconds is pretty good. This will allow the empty tape at the beginning of the videotape play through before beginning to play the project. Further, if you get good tape before the important part of your Sequence begins to play, all that is recorded is black.

This method makes for an immediate jump start of your project. If this is too harsh, remember that you can stick a transition in between the black matte and the first clip of your Sequence.

For the trailer, we will use the old Transition as a Fade trick. Just grab the Cross Dissolve from the Video Transitions/Dissolve folder of the Effects

Chapter 9 Outputting Your Project | **265**

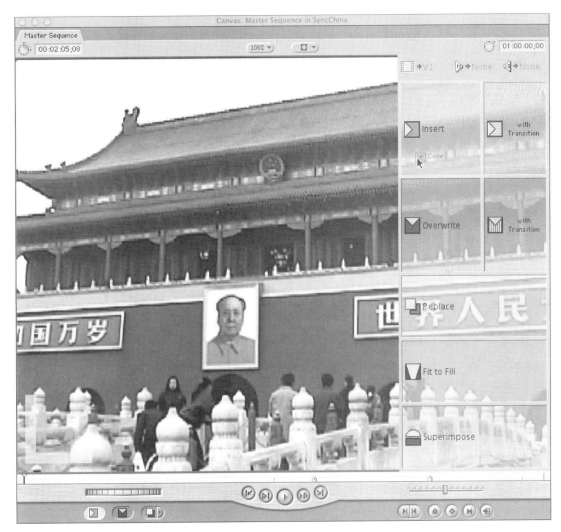

FIGURE 9.4 Adding black leader to the beginning of a sequence with the Matte/Color Video Generator.

FIGURE 9.5 Placed black matte with changed color.

tab in the Browser and drag it to the end of the last clip of the Sequence (Figure 9.6).

FIGURE 9.6 Adding a black trailer by creating a Cross Dissolve transition at the end of the last clip.

What is happening here is that FCP will be Cross Dissolving the last clip to the next nonexistent clip and thus fading to black. To tidy things up further, grab the Audio Transitions/Cross Fade (0dB) from the Browser and place it at the end of the last audio clip. This will fade the audio down as well.

The third caveat to using Recording Timeline Playback is that if you have played with the Render Quality of your Sequence, the quality might be further compromised. We have not talked about changing the Render Quality Settings, but you might have noticed in the top-left corner of the Timeline the button that allows you to toggle between various qualities (Figure 9.7).

FIGURE 9.7 Button allowing for toggling Render Qualities.

The reason we have not covered this much is that most projects are simple enough and most Macs are fast enough these days that it really makes no sense to decrease the quality—it's best to just have FCP render things at top quality. If you have not changed this, then you are fine and ready to output. However, if Render Quality is something besides "Hi Res," you will need to re-render before Recording Timeline Playback.

Although technically, FCP will still play the Timeline and the VCR will still record even if the Render Quality is lower than Hi Res, when outputting to VHS, you want to make sure to take advantage of every quality-raising step you can. Outputting junk quality to a junk medium makes the junk look, well, junkier. If you are outputting to something besides VHS, then you still want to make sure to have Hi Res selected, as the better media will make poor quality renders easier to see.

Before you actually record your output, take some time to do the following:

1. Make sure that FCP is indeed talking to the VCR/TV. If all is working as it should, when you play the Timeline in the Canvas, the TV should show your project.
2. Make sure that FCP is reporting "Dropped Frames During Playback." This can be accessed in the General tab of the Preferences dialog box. Dropped frames occur when your Mac or FCP become overloaded and is unable to play every frame of the project. Dropped frames are bad news and make for stutters in your project. It is important, even for simply VHS proofs, that you know if FCP is dropping frames.
3. Try playing the entire Timeline before recording to make sure that things are going well and that the visual output on your TV is good.
4. If you are getting dropped frames, access the Audio/Video Settings (Final Cut Pro>Audio/Video Settings in OSX, and Edit>Audio/Video Settings in OS9). Select the External Video tab and turn off "Mirror on desktop during Playback." This might make you feel a little out of touch, as you will not be able to see the video playing on your computer. However, the video will be appearing on the TV, and all of your Mac's processing power will be going toward this end (Figure 9.8).
5. If you continue to get dropped frames, close tabs within your Timeline. Remember that it is possible to have multiple Sequences open at once within the Timeline. However, when FCP has to spend energy keeping track of all of these, sometimes performance suffers. By allowing FCP to forget these Sequences, it can spend more energy making sure to play things smoothly.
6. Test your project and setup by recording potential problem sections to tape. Especially if you have used any of the Text Video Generators,

FIGURE 9.8 Turning off playback mirroring. This allows most of the processing power to go to playing the media cleanly and smoothly to external devices such as a camera.

take a minute to record these sections to tape. Take the tape away from the VCR you are using to record, and view the tape on another machine with another TV. Check to see that your colors are good and that things such as titles still show up as you want them to. Make sure that the audio is synced correctly. If everything in this little test output is good, then you are ready to output the entire project.

Once everything is set and your tests look good, actually outputting using the Recording Timeline Playback, is simple. Move the playback head to the beginning of the Sequence, click the Play button in the Canvas, or press the Spacebar on you keyboard and press Record on the VCR. With the proper leader, the project will begin playing when the tape's leader is past. Do not do anything with or to your computer as it plays the media, or you will get dropped frames. When the project has played through, it will fade to black (thanks to the transition placed at the end of the last clip). Let the tape run a couple more seconds before pressing Stop on the VCR.

A couple of other notes to cover before moving on. Remember that besides the black matte that we added to the example, other Video Generators can be found within the Browser. Generators include Bars and

Tone and Slate. Also remember that if you do not want to output an entire Sequence, you can simply mark Ins and Outs in the Timeline or the Canvas. Then, after pressing Record on your VCR, select the Mark>Play>In to Out pull-down menu to just play that specific section. Of course, playing In to Out does not have black leaders or trailers, but works great when you want to take a small section of an edit to a director, producer, or someone else involved with a project.

OUTPUT METHOD #2: PRINTING TO VIDEO

This method is very similar to Recording Timeline Playback in that it is essentially the process of recording in real time directly from FCP to tape. Hopefully, you are printing to Beta or DV, but this will also work when printing to VHS.

The difference between this and the last method is that Print to Video allows for a more packaged output. Print to Video can do things like automatically add pre-program elements such as countdowns and color bars. Print to Video will automatically record multiple passes of your project to tape. Perhaps best of all is the ability to allow FCP to control your VTR (if you have a controllable deck or camera) so that it automatically controls all aspects of output, including when to start the tape rolling.

To use Final Cut Pro's Print to Video functions, go to File>Print to Video, or press Control-M. The resulting dialog box (Figure 9.9) allows you to select what type of packaging you want to use before outputting your project.

The dialog box is split into four main sections: Leader, Media, Trailer, and Duration Calculator. Leader, Media, and Trailer are chronologically organized. Not only are these three sections organized chronologically, the settings within each section are also laid out in the order in which they would appear. Each element is displayed before the Second input field that allows you to define how long each element is to be displayed. Note that all of these Leader and Trailer elements must be rendered before they can actually be printed to video.

Leader

The Leader elements are pre-program elements. Usually, their function is to provide information to help the person viewing the video to adjust the viewing monitor, or provide information about what the person is about to see. Not all of these are necessary, of course, and you only need active the ones (if any) that are relevant to your project.

FIGURE 9.9 Print to Video dialog box.

Therefore, if all the Elements in Leader were checked, when you clicked OK (and after rendering), the tape would have printed Color Bars first with a Tone to assist in setting audio levels (Figure 9.10).

This would be followed by a Black screen and then a Slate, which is essentially a screen of information about the media to follow (Figure 9.11). The slate can include simply the name of the Clip or Sequence being printed to tape, or notes you enter yourself (Figure 9.11). By changing the pop-down menu to File, you can even have FCP present a still image.

This would have another black screen appear followed by a Countdown (Figure 9.12). The Countdown can be FCP's built-in version, or if you have created one yourself, by changing the pop-down menu to File, you can have FCP play your specialized version of a Countdown.

Chapter 9 Outputting Your Project | **271**

FIGURE 9.10 Color bars.

FIGURE 9.11 Display of the computer monitor during a Slate. The slate can include any information, including pictures.

FIGURE 9.12 FCP's built-in Countdown.

Media

If the Print to Video were a sandwich, with the leader and trailer acting as the two pieces of bread, the media is, of course, the meat. The options are simple: play the media from the marked In and Out, or print all of the media. There are options to have the media loop (you define how many), and whether or not to place a black screen between loops (you define how long). For short commercials, PSA, or even music videos, looping the file can give the viewer a second chance to examine the project without having to rewind the tape, sit through the leaders again, or try and find the beginning of the project.

Trailer

Simply enough, the trailer allows you to place just a black screen at the end of the project. This allows for time for you to walk from the back of the room and press Stop on the VCR before the screen goes to snow. The setting is simply a duration allowing you to define how long you want this black frame to be.

Duration Calculator

Notice that you cannot change the values in the Duration Calculator area—this is just an FYI area. The Media value tells you how long the media is (including loops) and how long the Total output is. This will allow you to check to see if your target tape has sufficient length to output the project. Hopefully, this allows you to only need to print the thing once, as you know that everything is ready and it all fits on the tape.

Notes on Print to Video

- If you are using a controllable device for final output, once you click OK in the Print to Video dialog box, FCP will take over. However, if you are using the ol' output-to-VHS VCR method, FCP will prompt you to "Start video recorder now and click OK to begin playback." Just like the instructions say, press Record and click OK, and your VCR will record FCP's output.
- FCP does not let you know that it is finished printing to video—it just stops. Therefore, make sure you keep a close eye on things so that you can press Stop on your VCR at the appropriate time.
- You might want to do a dry run where you click OK when prompted to press Record, but you actually leave the VCR alone. This will play through your Timeline and report if there are any problems such as dropped frames. If all runs well the first time, it should run smoothly the second time through, during which you actually record to tape.
- If you end up with dropped frames, make sure to turn off desktop mirroring in the Video/Audio Settings.

METHOD #3: EDIT TO TAPE

We will not be discussing this in any great length. Editing to Tape is a method of writing media to tape during the editing process. The process is actually frame accurate if you have the correct equipment. The problem with this method is that it is a destructive editing method. It can end up writing over media on a tape, and simply does not provide the flexibility that editing with the Timeline and outputting to tape later does.

Editing to tape is a reasonably well-defined set of tools within FCP, but loses many of the benefits that NLDVEs offer. Therefore, we will leave the discussion at that. Remember, though, that if you have reason to edit in this way, the manual includes fairly detailed instructions on how to Edit to Tape.

Method #4: Exporting EDLs

EDL stands for *edit decision list*. These decisions lists are valuable because they allow your project to be used beyond the realm of Final Cut Pro. With an EDL, many linear and nonlinear editing systems can recreate your editing project. EDLs are created fairly easily within Final Cut Pro. To do so, FCP creates the EDL for individual Sequences. Standard quick-cuts work best for EDL destined projects, although most of the oft-used Dissolve transitions are acceptable methods of editing.

EDLs are indeed lists of edits; in fact, they are nothing but text files. They include timing, clips, and edits in a sequential format. Many service bureaus use online editing systems that are linear in nature before final output. With an accurate EDL, they can still output your project without access to FCP.

In theory, these EDLs would work seamlessly with any editing system you could find. Unfortunately, as with most anything in computer-land, different applications use different formats and protocols. So, plan ahead. If you know that your project is destined for a post-production house, find out ahead of time what the facilities' requirements are for the format of the EDL. Find out other details, including what type of media the EDL can be delivered on.

To export a Sequence as an EDL, open it by double-clicking it in the Browser. This will open the Sequence in the Timeline. Select the File>Export>EDL… pull-down menu. You will be shown a dialog box similar to Figure 9.13.

The options available here are varied and deep. The benefit to this is that you can optimize your EDL for whatever production house you want to take your project to. The drawback to this is that there are more options here than can be covered within the scope of this volume. Chances are that your post-production facility will be familiar with exactly what options should be configured here. Make sure to speak with them in detail about it before starting to configure and output your EDL.

Once the options have been organized to match the specs given to you by your service bureau, click OK. Next, select a location to save the EDL and give it a name. If the number of edits exceeds the number of allowable edits, you will be presented with a second Save dialog box to allow you to save the continuation EDL.

Notes on Creating EDLs

- Create a taped output of your project using Print to Video that you can take with you to the service bureau. This provides a clear picture

FIGURE 9.13 EDL export options.

of what your vision is for the people who might be trying to recreate your editing masterpiece.
- If your project is destined for output at a service bureau, remember to keep things simple. Do not use transitions on any video track but V1 (EDLs do not "see" transitions on other tracks). Stay clear of nested sequences, layered effects, and changes in a clip's speed.
- Before you even start the project, make sure that your FCP system and your deck or camera are communicating well. With bad timecode, things get messy, as EDLs export lists of timecode information.
- If you have tapes that have timecode breaks, make sure to give each broken section its own reel name.

Method #5: Batch List Exports

Batch Lists are similar to EDLs in that they are simply text files. The big difference is that a Batch List can only export the contents of the Browser. It does not actually contain information about editing or transitions. However, if you log clips in Final Cut Pro and then someone else is going to be editing a project, or if you need to edit the project on a different editing system (e.g., an Avid system), then this can be a great choice.

To export a Batch List, make sure that the Browser is displaying clips as a list (View as List). If you want to only include certain clips in the Batch List, make a new bin and drag the desired clips to this bin. Remember that all the columns you can see in the Browser will be exported in the Batch List. Therefore, if you want to show additional columns (Control-click a column header (Figure 9.14)) or hide a column (also Control-click), make sure you do that before exporting.

FIGURE 9.14 Hiding or showing columns in the Browser is accomplished with a Control-click. Make sure to hide or show the exact columns you want included before exporting to a Batch List.

When you have just the information you want to export visible in the Browser, select File>Export Batch List. This will be followed up with a dialog box asking where to save the text file. Choose your location and click Save.

METHOD #6: EXPORTING AS QUICKTIME MOVIES, STILLS, AUDIO FILES, OR IMAGE SEQUENCES

That seems like a long title for this section. And indeed, this little bit will include quite a bit. To use this method, select a Sequence or Clip in the Browser. In the File>Export>QuickTime pull-down menu is nested a huge collection of tools allowing you to take your edited FCP Project (which is essentially a collection of links to files that exist on your hard drive) and export it to one file (Figure 9.15).

FIGURE 9.15 Exporting QuickTime.

Notice that when selecting the Format pop-down menu, you can select a multitude of formats to actually export the Sequence or Clip to. We won't go through all of these different formats and the various options they entail, but we will look briefly at the functionality of exporting to a QuickTime.

Beneath the Format pop-down menu is the Use pop-down menu. Contained here are some helpful presets to assist you in optimizing the output for various media (Figure 9.16). These are similar to the Compressions Wizard inside Terran Interactive's Cleaner (formerly Media Cleaner). These presets can help making your project Web-ready fairly quickly.

FIGURE 9.16 The Use pop-down menu with a collection of presets for various output media.

If you are confident with optimizing your own file with a particular set of compression settings, click the Options...button to open the standard QuickTime Pro dialog box. Here you can change everything from how the audio is compressed to the video CODEC (*CODEC* is a short-hand term for *Co*mpressions/*Dec*ompression) (Figure 9.17).

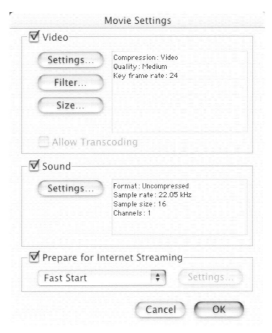

FIGURE 9.17 After clicking the Options button, you can optimize and adjust the QuickTime CODECs to match your desired output.

Delving very deeply into what CODECs to use and when is really beyond the scope of this volume, but remember that Sorenson and Cinepak are good choices for CD-ROM distribution (Sorenson is better), while QuickTime Fast Start and QuickTime Streaming are good choices for Web distribution. Other CODECs (Animation, M-JPEG, DV-NTSC/PAL, and MPEG-2 [which we will talk about in a bit] have very specific uses usually associated with very definite pieces of software. The only ones of real use to us here are the DV-NTSC/PAL setting, which allows you to export a clip for import back into FCP (with no need to re-render), and the MPEG-2, which is the video stream needed for DVD Studio Pro.

Notice that besides QuickTime movies, you can also export series of stills and just the audio track of Sequences or clips.

We will come back to this section a bit later in the chapter, as this is the primary interface for creating DVDSP-ready files.

METHOD #7: EXPORTING FINAL CUT PRO MOVIE...

This is actually close to simply Exporting a QuickTime movie discussed previously. To use it, select a Sequence of clip that you want to export and select File>Export>Final Cut Pro Movie... . The difference between this and exporting to QuickTime is that this method limits the number of options available to change. This method is usually used as a quick way to export your media for use in another program. The file that this exports is a QuickTime movie.

However, there is another really great part of Exporting Final Cut Pro Movie: the creation of References Movies. These are a really clever tool available in FCP. Although QuickTime can do some optimizing fairly well in preparation of publishing a movie for the Web or other multimedia formats, there are some applications that handle this a little bit better. Cleaner (Terran Interactive) and the ever-evolving CODECs of Divx and 3ivx are some optional choices when it comes to crunching your project down.

A Final Cut Pro Movie Reference Movie is a movie that references clips rather than collecting them all into one area. To make a Reference Movie, turn off the Make Move Self-Contained option in the Save dialog box (Figure 9.18).

This leaves all the media independent of the exported QuickTime movie itself, thus speeding the exporting process tremendously. Then, other compression utilities (Cleaner/Divx, etc.) can access the Reference Movie, which *refers* them to the correct movies for final compression. Not only does this save tremendous time exporting large projects, it also keeps the media clean without putting unnecessary compressions on a clip, and saves large amounts of hard drive space.

CONCLUSION

There are layers and layers of information that we have just glossed over in our discussion of exporting files. Part of why FCP is so powerful is that it can be used when editing for everything from broadcast to film to home videos to multimedia presentations to Web animations. Apple's Final Cut Pro Manual has entire chapters dedicated to CODECs and what to use for exporting where. Even these huge chapters are simplistic ways of looking at compressions and media preparation.

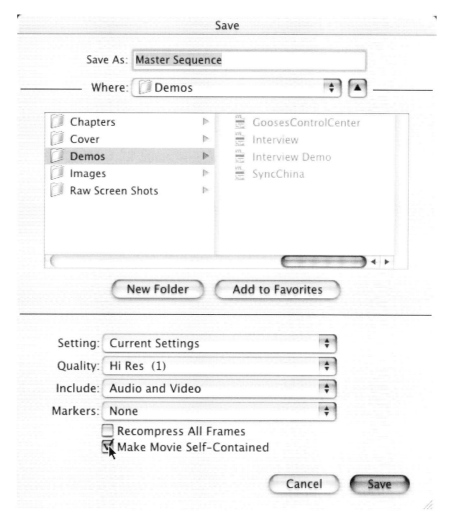

FIGURE 9.18 The Save dialog box for Exporting a Final Cut Pro Movie. Turning off the Make Movie Self-Contained option creates a small file suitable for compression elsewhere.

Do remember to experiment. Export some short clips and see what the quality looks like, how it plays on its destined media, and how it sounds. Compression is an art, and the settings that work great for a music video destined for the Web might not be appropriate for an interview destined for the Web.

Do remember that you can Batch Export (File>Batch Export). When you have a setting you like for interviews and you want to prepare a whole slew of interview clips, use the Export Queue windows to set your preferences, destinations, and settings. Let FCP do the work for you while

you are at lunch. We are not going to be extensively exploring Batch Exports, because this book is written with the assumption that you are using FCP to export an entire finished project, to export at a service bureau, or to prepare files for a DVD that you will author in DVD Studio Pro. However, should you have the need, take a look in Apple's manual for the method of exporting large numbers of clips.

CHAPTER
10 THEORY OF DVD INTERFACE

By Michael Clayton, M.F.A. Computer Graphic Arts University of the Incarnate Word

Introduction

Do you remember the first video cassette recorder, the beloved VCR? It loaded the bulky cassettes from the top, and had a wired remote with a pause button. Owning one meant no more stuffy theaters with 25-cent candy and noisy children.

It seemed that nothing could ever be better than a VCR. Even laserdisc players (with those giant case loaded disks that you had to flip over halfway through) couldn't compare to just letting the tape run. Some people even had those BETA players, but it was hard to find anything to watch. We all thought that nothing could top our VCRs.

We were wrong.

A Brief History of the DVD Medium

In May of 1994, members of the electronics industry announced a cooperative effort to develop a new medium for the delivery of audio and video on a disc-based media called a *Digital Video Disc*, or DVD (it has also been referred to as a *Digital Versatile Disc* by some in the industry, since its large capacity can do more than house audio and video information). Using MPEG-2 compression (the *Motion Picture Experts Group* set the standard for this) they found that they could deliver a brilliant picture and rich sound on these little CD-like discs (which range from roughly 4.7 to 18 gigabytes of information).

The first commercial DVD players hit the market in March of 1997, and were too expensive for the average consumer. Since VHS dominated the market of home video, and laserdisc was deemed as something for the elite, no one thought the technology of DVD would take off.

DVD Basics: Definitions and the DVD Format

The DVD media itself is the same size as a standard CD (120mm), but it is the amount of storage space that is the most noticeable difference. A compact disc can hold between 650–700MB, while a DVD can house 4.7GB. Without sounding too technical, the difference in capacity lies in

the size of the track pitch, minimum pit length, and the laser's wavelength. Basically, the tracks that the information is stored in are smaller and more precise, so more can be included. At a capacity of 4.7GB, a DVD can hold around two hours of video.

But a copy of Stephen King's *The Stand* is six hours long and it's on one DVD. How does that work?

If you recall, when a three-plus hour theatrical film was released on VHS, the movie was available as a two-tape set. One tape was not enough to hold the entire film, so they spread it across two tapes (e.g., *Lawrence of Arabia*, *Titanic*, *Schindler's List*, etc.). DVDs are much the same way. 4.7 GB is the capacity for a single-side single-layer DVD. More specifically, this size DVD is referred to as a DVD-5 (the capacity is rounded up to get the DVD number). Rather than distribute two-DVD sets for movies, manufacturers have created discs with multiple layers. After the first layer of information is used up, the laser in the DVD player skips up to the next layer and plays from there. This slight pause in the playback is called a *layer change*, and is stated on most packaging that it "may cause a slight pause on some players." More layers means more stored footage.

The most popular capacity of DVD that studios distribute is DVD-9 discs, single-side dual-layer discs that can hold about four hours of video. Although this is an incredible amount of space for a huge amount of footage, alas, for some movies, this capacity is still not enough.

Not only can a DVD have two layers, it can also be double sided. The first DVDs that needed more than two hours of space were called "flippers" or double-side single-layer discs. Storage capacity of these discs was 9.4GB, and they were called "DVD-10s." Like the old laserdiscs, you had to "flip" the platter over halfway through the film.

So, for extra long projects like the release of Stephen King's *The Stand* a DVD-18 or a double-side dual-layer disc with a capacity of over 17GB with room for over eight hours was used.

Currently, that's the limit right now. Unfortunately, it is a little difficult to manufacture these DVDs, so studios have started to shy away from DVD-18 and just release multiple disc sets of DVD-5 and DVD-9 class discs (Figure 10.1).

With that much space at their disposal, studios realized they could include a lot more than just video. With the introduction of additional "features" on top of the film itself, it became apparent that some sort of selection screen needed to be inserted so that people could choose from these options. These features included selecting video options, audio options, and special features.

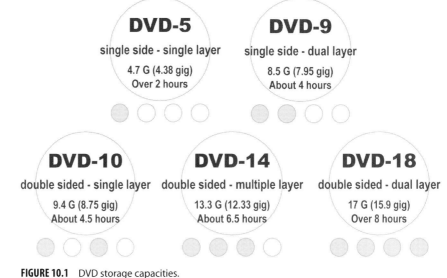

FIGURE 10.1 DVD storage capacities.

Select Video Options

With a VHS tape, all you had to do was put it in the player. The tape had no options for picture and no options for sound—it just played. The DVD format takes this much farther by introducing new options you might or might not be aware of. It is a good idea to learn DVD terminology, anatomy, and concepts.

There are several video options that menus can be created for: the video's format, version, and chapter screens.

One of the revolutionary ideas of DVDs was to introduce the viewer to the film's original aspect ratio (OAR). OAR is the original size of the films theatrical presentation. When we go to the theaters to watch a film, it is very different than watching the same film on your video player at home. Most televisions that consumers have in their homes have a 4:3 ratio. The screen is four units wide and three units high. A large majority of the programs broadcasted on television are shown in this ratio, which is called a *standard* format.

Theatrical releases of the film are often shown in a 2.35:1 or 1.85:1 ratio, which is obviously wider than the ratio of a television set. This is what is commonly referred to as a *widescreen* format (Figure 10.2).

In the past, when a film was released on VHS or broadcast on television, the picture was cropped. This is commonly introduced at the beginning of the movie with the message: *This movie has been formatted to fit the screen*. If you do the math, when a film with an OAR of 2.35:1 is format-

FIGURE 10.2 The relationship in size between the aspect ratios of 2.35:1, 1.85:1, and 4:3.

ted down to an OAR of 4:3, 58% of the image is lost. On a conversion from an OAR of 1.85:1, 46% of the image is cropped out.

There are several methods studios use to reformat a film to the 4:3 ratio. Sometimes they matte out the sides of the image, simply framing the center of the image and then re-running the print to get the proper size, a process referred to as *standard* [reformatting] (Figure 10.3).

FIGURE 10.3 Widescreen images are cropped to fit television screens.

Another method is called *pan & scan*. This process takes it one step further; by *panning* (sliding) the frame across the image and *scanning* (centering the image accordingly) the action as it happens, the viewer is able to see much more of the vital action occurring in each frame. You may notice when watching a movie that has been reformatted using the

pan & scan process, the camera will look like it slides to follow the action. For example, a shot that directors like to use during scenes of confrontation is showing the profiles of two characters on opposite sides of the screen. If they simply crop the shot, all we would see are the characters' noses. By starting the frame on the person talking first and then sliding the camera over to see the reaction of the other person, the audience actually gets to see both characters (Figure 10.4).

FIGURE 10.4 The technique of pan and scan is used to follow the action when cropping a frame. As shown here, the frame slides to show one persona and then the other.

Either way, widescreen enthusiasts argue that cropping the film takes away from the director's original vision and cheapens the experience. However, many viewers complain and are confused by the black bars at the top and bottom of their television screen when viewing a movie presented in widescreen format.

A popular trend with studios today is to release two separate versions of the film and let the audience decide for themselves (e.g., *The Mummy*

Returns, *Cats & Dogs*, and *A.I. Artificial Intelligence*). DVDs have so much storage space that the discs can house both the *widescreen* and *standard* (*full frame*) versions, and a menu can be created to give the viewer a choice (e.g., *8 Seconds* and *Rugrats: The Movie*).

Not only can a DVD house both aspect ratios of a film, it can also allow for different cuts of the film to be on the same disc. *Director's Cuts* are a growing trend in studio releases of DVDs, allowing original footage to be reintroduced to the film.

Unlike the VHS format, there is no need to linearly fast forward to a certain part of the film. DVD is the nonlinear-digital-video viewing experience. You can simply "jump" to a part of the movie via chapter stops. Chapter stops are predefined points in a film's time code that allow you go directly to that part of the film. These menu screens often list the title of the chapter stop or show a screenshot of that particular spot. You can have as many chapter stops as necessary, spaced intermittently or by scene change. You merely select the part of the movie you want to go to and you're there!

Select Audio Options

Audio options on a DVD can include multiple tracks of surround-sound features, languages, and subtitles, as well as commentaries.

The format of DVD allows for home theater enthusiasts to relish in the deep rich sound of the theater experience by including hi-tech audio formats such *Dolby Digital Surround* or *DTS* audio tracks. The audio can be configured according the viewer's home theater system, no matter how trumped up it might be.

In acknowledgment of the diversity of the DVD viewing population in a given region, studios and educators can include *multiple language tracks* and *subtitles* into their discs. *Crouching Tiger, Hidden Dragon*, which won the Oscar for Best Foreign Film in 2001, was a phenomenal success in North America. However, a complaint of many film-goers was that they had to watch the film in Chinese and also read the English subtitles. When the DVD was released in America, the studio included the original Chinese language track and also included an English (and French) language track.

On the same DVD, there are also English and French *subtitles*. Subtitles are the words that appear along the bottom of the screen as the film is playing. They can be turned on or off, and also can change from Spanish to French to English or whatever language that is available.

The feature of *commentary tracks* (where filmmakers, actors, and technical people talk over their films giving insights and special information

of the film making process) were introduced on laserdiscs and carried over to DVD. Since a DVD can hold several audio tracks, more than one commentary can be included on the disc.

ANATOMY OF A DVD MENU

In order to build a DVD, parts of a menu system need to be identified. The components of a DVD menu system are introductions, static menu, menu loops, transitions, and rollovers.

An *introduction* is the part of the menu system that will set the tone of the rest of your menus. Anything goes when it comes to introductions. A montage of photographs, text, and/or video footage panning across the screen is the most popular, such as in releases like *Gladiator* and *Prince of Egypt*. Characters can be introduced, locations set, and certain moods introduced. They can be 3D environments that are slowly panned through, as is the case in *The Abyss: 5-Star Edition*, and *Big Trouble in Little China*.

Introductions can be used to bring the viewer into the interface of the *main menu*. In the main menu lies the access of all other screens. A *static menu* is just a still image with the options designed into it. Taking the movie's poster and adding buttons to it is the simplest way to create a static menu. Basic catalog titles like *The Power of One, Hudsucker Proxy, Ready To Rumble*, and *The Father of the Bride* are examples of poster inspired static menus.

A *menu loop* is an animated menu. The movement can be as subtle as a flickering candle or pulsating light bulb as in *The Sixth Sense* menu, or as chaotic as the fast cars and flashing lights like the menus in *Gone in 60 Seconds*. Remember, the movement is secondary to the options. Do not cloud the menu so much that the users cannot tell what they need to do to get where they want to go.

Transitions occur between menus. This happens regardless of whether the menu is static or looping. Like introductions, transitions are not necessary, but they add to the experience and flair of the design. In *Frank Herbert's Dune* (2000), there is a simple ripple effect that takes the viewer from one menu to another. Transitions like this can easily be done in Final Cut Pro or any NLDVE system. So can others like those in *The Fast and the Furious* and *Cast Away*. Other transitions, like the sandstorm transition in *Prince of Egypt*, are a little trickier and need to be generated with 3D software.

When you use your DVD's remote to make a selection, the effect that highlights the option is called a *rollover*. There are many types of rollovers

you can have. Color and shape highlights are (semi)transparent objects that highlight a selection. Little rocket ships and other space objects highlight selections in *Muppet From Space*, while little umbrellas point to selections made in *Mary Poppins*. DVD Studio Pro has the power to use rollover images on the menu, to physically change the image, not just the highlight. Studios typically do not use this option when creating their menus (at least we've never seen it).

Understanding these concepts helps us to be able to easily call out what we need for the DVD style categories we will be discussing later in the chapter.

Defining Your Style

Luc Besson's *The Fifth Element* was released on DVD in 1997. The menu design was simple. They took the image straight off the movie poster, cropped it to fit the screen, and set the type over it for the selections. The accompanying menus were simply press photos placed in the frame again with text and a simple square highlight to select the features.

One of the newest releases is Steven Spielberg's *A.I. Artificial Intelligence*. The menus were as clean as the promos for the movie. The ambiance and feeling that were set in the film were carried over to the menus. The style was elegant and futuristic, and the options were many. Much more time went into this release than most DVD releases.

Studios do a lot to promote their film and make it catch the audience's eye and increase ticket sales. They create all sorts of promotional materials, posters, press kits, commercials, trailers, and other collateral to sell the film. The same happens when a film is released to DVD.

When a VHS tape hits the market for the first time, its only selling point is the film itself. That's not the same with DVD. In the growing market of new releases and the increasing number of catalog titles being released to DVD, something extra is needed to draw attention to a new DVD.

Obviously, products benefit from the use of good design. DVDs are no different. However, it's easy to see that the motivation behind this new media of DVD being so flashy was to catch the eye of consumers, sell more copies, and thus make more money. That meant that some things needed to be trimmed from the production.

The first DVDs to have an introductory menu contained one screen with the options for aspect ratio, audio options, and perhaps a few other features. Eventually, the menu systems of DVDs became more complicated, branching out to other screens with more options for the viewer to choose from.

As DVDs grew in popularity, studios then wanted to wow enthusiasts with better menus and began to introduce such frills to the menus as film loops, sound effects, music, and animated introductions.

The studios that design and create the menus for DVDs break the films into categories to decide how they will be treated in their release. They are referred to as *A Titles*, *B Titles*, and *C Titles*.

C Titles

This is the most basic of treatment for films that are being released on DVD. All the menus are static (no animation). These are usually older catalog titles (films that were released before the DVD format and are previously not available on DVD) or films that did not do very well theatrically. These are commonly called *bare-bones releases* and contain no special features other than video options, audio options, chapter stops, and maybe one featurette or trailer.

It is done this way at the studio's discretion. Mainly, the DVD menu production is trimmed down so that the production cost is lower and they have a better chance of making money on the DVD distribution and sales. MGM is infamous for releasing C Titles, since it has one of the largest collections of catalog titles.

B Titles

The next step up in production is the B Title. These titles tend to be popular titles that deserve a little better treatment than just a bare-bones release. For this classification of title, the film is either given 1) an introduction, main menu loop, and no transitions, or 2) an introduction into a static menu with transitions, or 3) no introduction, a main menu loop, and other menu loops. Once again, it is up to the studio to decide what level of treatment a film gets, and sometimes studios go out on a limb and throw in other things just because they love the film.

Sometimes a studio will release a film as a B Title only to re-release as an A Title in the future, based on the sales of the B Title.

A Titles

This is usually a large release title, reserved for box office blockbusters or films that the studios believe DVD enthusiasts will pay to have as an A Title. These films get the works—introductions, main menu loops, and transitions. Designers can go to the extreme with these titles and have a lot of fun creating these.

A+ and A++ Titles

These two are every designer's dream. They can pull out all the stops for these films. A+ and A++ Titles are reserved for box office mammoths, studio favorites, and boxed sets.

These titles contain fully animated introductions and menus (sometimes 3D), looping menus, subsequent core pages (special features, audio/video options, chapter scenes, and others), and full transitions to all core pages (and back again). Recent titles to be given the A+ and A++ treatment have been *Snow White*, *Toy Story*, *Toy Story 2*, *T2: Judgment Day*, *ID4* (5-Star Edition), *The Abyss* (5-Star Edition), and *Star Wars Episode One: The Phantom Menace*. MGM has done wonders with all of the titles in its *James Bond* franchise. All 19 films have been given a stellar A+ treatment, especially *The World Is Not Enough*.

Criterion is a company that purchases the rights to film they think deserve a grand treatment. Old and new films alike. *Armageddon*, *The Rock*, *Charade*, and *The Seven Samurai* are a few of their best titles in their expansive library.

Deciding which treatment to give your project is not that hard; making it live up to what you choose is. For example, let's break down the steps of designing a B Title.

THEORY OF DVD DESIGN

When looking at a DVD collect, one might wonder, "what does it take for a good DVD menu?" Take that one step further and ask "what makes anything in design good?"

A Good Metaphor

A metaphor is a symbol that is used to represent something. In this case, the menu of a DVD needs to reflect the film itself to be considered successful. By finding a successful link in the design of the film to the DVD, you can make the transition easier for the viewer.

For theoretical discussion, imagine the gig was doing a menu design for a documentary on the world of professional marble players called *Marbles: Life in the Circle*, and that you knew nothing else about the film itself. This is still probably enough to go on. Naturally, a marble theme would be a great metaphor.

You could use the marble as a button or highlight. Take a photograph of a bucket of marbles and use it as a background, setting the options as

text on top of it. Maybe an extreme close-up of one particularly interesting marble would make for a good textured background.

If that wasn't working, take some photographs of children playing marbles, or get some footage from the documentary team to incorporate into the design of the menu. Grab some chalk and draw a ring on the sidewalk. Take a stick and draw in the dirt. Buy a bag of marbles and spill them on your scanner. Film animations of the marbles in motion could be used as transitions from one screen to the next (albeit you'd have to have a pretty cool setup to get good footage of those shots).

In my experience, it is easier to draw from the resources you have on hand than anything else. It is incredibly time consuming and might not return assets worthy of the time investment to try and get extraneous, out of the way elements. Be creative, explore all of your options, use all of your skills, and come up with something new and exciting.

Thinking Practically about Design

Let's pretend that you and your family go to the beach for a vacation, and you take along your miniDV camera and a digital camera. You shoot a little footage of everyone playing in the surf, building sandcastles, and other candid shots. You want to build this little DVD for your friends and family, but you want it to be something worthwhile, not just thrown together (since a DVD will last through more viewing than a VHS tape will).

For this particular DVD, we need to give it an introduction, a static menu, and transitions to supporting core menus and back to the main menu.

Since the subject is mainly a beach-inspired theme, the obvious metaphor is the beach. In your brainstorming process, you come up with the sketch shown in Figure 10.5.

Using the sand as a background, we want to use found objects from the beach as accents and use the images from the digital camera inside the letters. The transitions are going to occur by panning left and right on the beach. We're going to have three menus: a main menu, chapter selections, and special features. By creating the menu in Photoshop and using Final Cut Pro, we can create our menus, both animated and still.

Creating a great layout is the tricky part. Do we align our options in a horizontal line at the bottom of the page? Stack them vertically in the center of the page? Offset them to the right a bit? Gain inspiration from other menus you have seen in the past on your favorite DVDs. Take pieces of them and make them your own.

FIGURE 10.5 Sketch your ideas to get an idea of how you want to lay out your menus.

Typography

Be very careful when selecting type for a menu. Multimedia designers tend to believe that everything they do will be seen on a computer screen. That's not true when working with DVD. The resolution of a standard television set is 240 lines of resolution. A DVD is capable of 480 lines. Watch television for a while and observe the type that appears on the commercials, credits, and news programs. The typefaces used tend to be heavy and large. Avoid type that has thin lines and small serifs. The best typefaces to use are bold-faced fonts.

Choose fonts that compliment the design. As is taught in print design, limit the number of fonts to three or less; this keeps the design from looking cluttered and overbearing. Increase the leading of type when creating static screens that will be read (e.g., cast biographies, production notes, etc.). Make sure that the font can be easily read over the image or textured background.

The standard size of a DVD menu is 720 pixels by 540 pixels, so the smallest that type should be is 18 points for reading. Experimentation is best. Find a series of fonts that work well and use them (Figure 10.6).

FIGURE 10.6 Comparison chart of type in the standard size of a DVD menu.

Color

When working with video, colors vary from the computer screen to television. It is best to have a test machine with a television monitor attached for color previewing. Although it is not necessary, it is a good idea to do a test first to see if colors fall within the range of broadcast colors.

A good way to check the color of a menu is in Photoshop. Once in Photoshop, choose View > Proof Setup > Monitor RGB to preview the screen as it would appear on a television monitor (Figure 10.7). Look for colors that might be too vibrant, namely reds and yellows. Lower the saturation of the colors if necessary to dampen those colors.

Examples of DVD Menu Design

Ultimately, good design is in the eye of the beholder. The following rules of good design are a good start. Choosing a good metaphor, colors, fonts, and a personal style can make the design of the menu easier.

For example, take the two screen shots from the "South Beach" menu discussed earlier. It was decided that the characteristics of a B Title

FIGURE 10.7 To test the colors on a menu for compatibility on a television, in Photoshop choose View > Proof Setup > Monitor RGB.

disc would be followed. Notice how the vital menu information is centralized to fit into the title-safe zones (Figure 10.8). The large type is centered in the frame with the options aligned horizontally beneath the type. Images within the large type create a feeling of inclusion for the family members involved. The sandy background is muted as to not be too vibrant, and the noise texture breaks up the colors and keeps it from radiating too much. The water at the bottom of the menu will act as the tide pulling in and out keeping the menu being static. Sound can be added to enhance the experience.

The type size of the options is large enough to read, but small enough to not draw the immediate attention of the viewer. The white behind the type separates it from the background so that it stands out.

The design is symmetrical, keeping a vertical balance in the image. The starfish and shell add to the flavor of the beach.

FIGURE 10.8 The Main Menu screen for the "South Beach" project.

The marker-like type keeps the menu fun as well as easy to read.

The second of the two menus (Figure 10.9) is for the Chapter Selections screen. Notice that the type style and colors are consistent from screen to screen. Other shells keep the image interesting.

As is with all chapter selection screens, limit the number of thumbnail clips to between three and six. Make the layout of the thumbnails simple enough so that the viewer can tell what he or she has selected.

Other menus that follow will employ similar colors, fonts, and imagery to keep the style and metaphor consistent.

The imagery created for this example was done entirely in Photoshop, and all within the same file. DVD Studio Pro allows you to use one file and turn off any layers as needed. How to prepare those files will be discussed later.

For his documentary on a college basketball player in the 1950s, Jim Godfrey chose a nostalgic feel when designing his menus (Figure 10.10).

Using archival footage of college basketball games and photographs of found objects, he constructed his menus to have a somber and reflective feel. Staying with the dark sepia-like tones and choosing an unobtrusive block font, he keeps the feeling subdued. Soft sounds of the score mixed with the sounds of the court could also add to the overall experience of

FIGURE 10.9 The Chapter Selections screen for the "South Beach" project.

FIGURE 10.10 The Main Menu screen for the "Echoes of Estes" project.

FIGURE 10.11 The Biography screen for the "Echoes of Estes" project.

the menus. The type on the biography menu (Figure 10.11) is a serif font, but is large enough to be read correctly on television.

On the Credits page, a film loop roll of the basketball game plays behind the names shown (Figure 10.12).

3D animation and modeling can be used to create imagery for DVD menus as shown in the interface for the EFNM3 DVD (Figure 10.13). The museum-like feel of the rooms, and the animation of the view screen being lowered into the room, draw the viewer into the menu. The type on the wall acts as the home for the option within the DVD, keeping with the installation-type feel. The film loops play in the area of the view, adding a perpetual feel to the menu. Other screens that follow hold to the same interface, but the content on the view screen changes to reflect what has been selected.

Take Time to Look, Listen, and Learn from the Best in the Industry

When learning to develop good DVD interfaces, nothing can be better than getting a membership to your local video store. By renting DVDs and studying their menus, one can determine what makes a menu successful and what makes one look run-of-the-mill.

FIGURE 10.12 The Credits screen for the "Echoes of Estes" project.

FIGURE 10.13 The Main Menu screen for the "EFNM3" project.

Notice how the designers use type, imagery, sound, animation, and transitions to create a unique experience viewing the film. Navigate to every screen possible. Study every menu, every screen, and every still.

Diagramming Menus

In one college class in art theory, the professor taught his students how to take the works of old masters and break down the composition in order to evaluate the shape, balance, perspective, and color. He called the process of this deconstruction *diagramming*.

To diagram the painting, simply take the image (whether it be a photograph, an image from a magazine or book, or a printout) and trace the figures, buildings, plants, landscape, and other objects. By reducing the image to simple shapes, one can focus on the objects and study their relationship to each other as a whole. The focal point can simply be determined, the image's composition becomes obvious, and all the frills have been removed.

One student took the professor's words to heart and began to deconstruct the images by Vincent Van Gogh. As she broke the images down and studied the diagrams, she noticed a trend in his landscapes. Even though they were different colors, the image basically had the same composition—an equal division of earth and sky with an object breaking that plane of equality. As the semester progressed, the student learned that she could easily dissect the images and learn more than just by merely glancing at them on the slide.

This process can be very valuable in the process of designing interfaces for CD-ROM, Web designs, and DVD menus.

Creating a Diagram

Diagramming a menu might seem difficult, but it is not. You do not have to be an artist or a great draftsperson to be successful in this exercise. In order to gain an understanding of menu design, rent DVDs and study their menus. By breaking down the menus, you can find new metaphors and design techniques.

Listed next are the breakdown diagrams of several well-executed DVD menus. To follow this part of the chapter best, you might want to rent the movies listed here to see and understand the concepts being discussed. Besides having nice menus, the listed movies are great shows too.

The Alfred Hitchcock classic *Rear Window* has a simple menu system. By blocking out the areas of the interface we can begin to see a trend in its design. The design is divided into four horizontal sections by three

lines. The top and bottom sections are merely margins. The large section in the middle becomes the area for the content of the menus, while below rests the menus titles and navigation (Figure 10.14).

A. Main Imagery
B. Movie Title
C. Menu Item
D. Submenu Items
E. Menu Title
F. Content

FIGURE 10.14 Diagrams of *Rear Window* shows a simply layout that is repeated throughout the menu system.

The large content area houses a background image with the content placed on top. If the image's focus is on the left, the options and/or text are located to the right, and vice versa. There is a large dominant image placed in the middle of the screen. The areas remain the same through the menu system as to not distract the viewer. Even the Chapter Selections screen keeps all of the information within the bounds of the content area.

The design can also be more complicated than that. For example, the menus that were designed for *Space Cowboys* had an obvious metaphor—

space. The backgrounds were starscapes, with the options overlaid in light text. Images were housed inside of circles on each page. But after diagramming the menus, notice this: the circles were planets, or more precisely the moon. After diagramming the menus, take a look; circles were the dominant shapes in every menu. (Figure 10.15).

FIGURE 10.15 Diagrams of the Main Menu (left) and Chapter Selections menu for *Space Cowboys* reveal that there is a "planet" metaphor throughout the design.

Further studying reveals that in the composition of the secondary menus, the circular area for the images were located in the upper-right portion of the menu. The menu title was located at the upper left of the image, with the text and/or options below, and the main navigation resting consistently at the bottom of the screen (Figure 10.16).

FIGURE 10.16 Diagrams of the Special Feature menus for *Space Cowboys* show that they have the same general composition.

Repetitive Design Elements

The DVD release of the 2000 remake of *Get Carter* had extremely simple menu designs, when reduced to simple shapes. The menus were basically composed of a still frame (from either promotional material or the movie) reduced to grayscale and placed in the background. On the subsequent menus, the titles were treated the same (size, weight, font, color, border, etc.), as were the options and copy text. Through diagramming, it was easy to see that the menu titles, options, and content were in the same place on every screen. The part of the menu that seemed to keep things from being exactly the same were the crosshairs. These crosshairs,

which appeared on the movie's poster and other promotional materials, were carried over into the design (like the "moon" motif from the prior example).

For the first- and second-level screens, the crosshairs were large and stayed to the left of the screen seemingly complimenting the smaller shape of the figure to the right. On the screens that had a large grayscale background image, the crosshairs were small and offset, containing a color image of a character or scene in the movie in its center. The treatment of the crosshairs seems almost decorative, bringing a splash of color to the otherwise steely gray imagery throughout the rest of the menu (Figure 10.17).

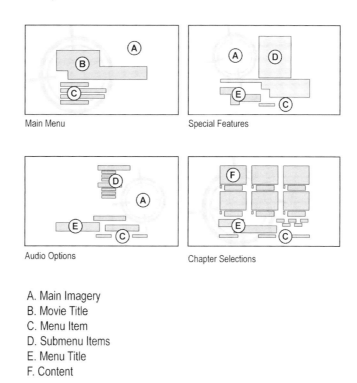

A. Main Imagery
B. Movie Title
C. Menu Item
D. Submenu Items
E. Menu Title
F. Content

FIGURE 10.17 Diagrams of the menus for *Get Carter* reveal the repetition of the crosshairs as a design element as well as the consistency in layout of the options and navigation.

One advantage that a designer has when designing a set of menus is knowing that the viewer is only going to see one menu at a time. It is very easy to cut corners and "fake" consistency. By diagramming the menus, some of these flaws are made evident. As a designer, try to stay true to the design and to the viewer by taking precautions when constructing menus by maintaining consistency.

DVD Studio Pro makes it very easy to stay consistent in your design by working from a single Photoshop file.

How Much Is Too Much?

There are a few of those on the Internet who gripe and complain about DVD menus, advocating the fact that they are not necessary. There was a trend a few years ago where, by default, when the DVD was placed in the player and then started, the movie began to play. One would have to push the "menu" button to see the menu.

Others do not like the fact that you have to sit through every menu introduction and transition to get to the option you want. There is no easy way to jump ahead and skip past the previews, commercials, and special interest ads to get to the movie. Buena Vista Home Video took the incentive of placing a "click the menu button to skip" placard at the beginning of their DVDs so that viewers could go directly to the main menu.

Are there too many options? Some ask that question. Keep the menus simple. Place all of the special feature options on one screen and the audio/video options on another. Keep transitions quick. Keep film loops interesting. Make the menu accessible to all.

CONCLUSION

DVD is such a new media and is evolving at such a rate that things will no doubt get better and it will become easier to design and create DVDs. Apple has made it available for everyone. If you are a proud parent just wanting to make a DVD of the kids for their grandparents, or a budding filmmaker wanting to ready his creation for distribution to festivals, or a student putting together her demo reel, keep in mind the elements of interface design discussed here and your product will emerge looking interesting, dynamic, and professional.

CHAPTER

11 PREPARING FILES FOR DVD STUDIO PRO

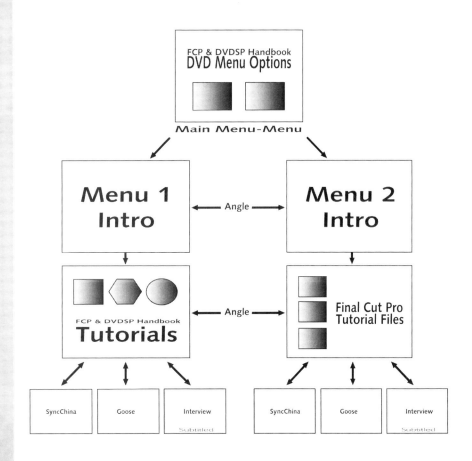

About two years ago, a studio I worked with paid $12,000 for a DVD authoring system. At the time, they were pleased with themselves because the price of the system had just dropped from about $20,000. It wasn't long after that that Apple released iDVD and DVD Studio Pro—much to the studio's chagrin.

Now admittedly, neither package is the end-all of DVD production. iDVD is an incredibly powerful consumer tool, but incredibly limited professional DVD authoring system. Similarly, DVD Studio Pro, although incredibly powerful, still has some limitations. Most of these limitations arise from the fact that DVDSP uses software to accomplish much of what is handled by hardware with the more expensive systems.

This software capability was a big thing when Apple first announced it. Previous to this release, there was little choice besides hardware solutions to encoding video clips into the MPEG-2 stream needed for DVDs and encoding them into the format needed to burn on a DVD. Indeed, even today, this software encoding is still a powerful tool and puts professional tools into the hands of video producers who never would have been able to produce high-fidelity digital video in the past.

However, the affordability of DVDSP and its use of software encoding/rendering come at a compromise. To the user, the biggest issue is that we must take a little extra time to carefully prepare video files before we can use them in DVDSP.

This chapter's primary purpose is to discuss how to do this pre-DVD work—what to look for in video files, how to prepare them, and how to compress them into the appropriate format. We will start by talking in very general terms about encoding, and then we will look at how to prepare and Batch Export the tutorial files we created in previous tutorials.

If you are already familiar with preparing files for DVDSP, skip this chapter and go on to the next. However, if you would like some further theoretical background on the process, or are new to DVD production, read on.

DVD Studio Pro Media Formats

When you drop a DVD into a DVD player on your computer or into a commercial DVD player, the player looks for a specific collection of files. The player is fussy about the order of files on the disc and the structure of those files. We will talk more about the placement of files when it comes time to burn a disc, but the important point here is that since the players are so picky in their use of files, we need to be very discerning when preparing media for use in DVD authoring programs (like DVD Studio Pro).

DVDSP uses MPEG video streams. MPEG stands for Motion Picture Export Group, which was a group that came together in 1980 to establish a standard for digital audio and video. The MPEG streams were developed as a derivative of the JPEG compression. Basically, these MPEG standard streams are video clips that have been compressed and formatted in such a way that all DVD players can read and display such streams.

MPEG-1 and MPEG-2 can be used, although MPEG-2 is generally the format to be used because it allows for a wider variety of image formats (full, wide, 16:9). MPEG-1 streams usually are dealing with only a 352 × 288 resolution for PAL and 352 × 240 with NTSC. MPEG-2 provides for higher picture quality and larger size (720 × 576 for PAL and 720 × 480 for NTSC). Both use what is called a *variable bit rate*, meaning that the amount of data being carried in the image can shift higher or lower depending on how much information is needed. This means that more video can be stored on a DVD as noncomplex scenes will take less space on the disc. MPEG-2 can have a data rate of up to 9.8 Mbps (mega-bits per second). Although some hardware units can encode video into this format, with installation of DVD Studio Pro on your Mac, you will have installed a software encoder. This software encoder is nested within QuickTime, and thus within Final Cut Pro.

Audio on DVD is considerably more varied. Audio can be in PCM, AC-2, and MPEG audio. PAL and NTSC use slightly different stream types. Most notably is that PAL can use MPEG audio, while both can use Linear PCM format or AC-3. Note that PCM or AC-3 (since NTSC can only play these two formats) must be used in for a disc to be playable everywhere. For more details on formats and how they are configured, check out the appendices in the DVD Studio Pro manual. For the most part, the intricacies of the video and audio formats are not difficult to configure, and QuickTime Pro and Final Cut Pro's MPEG exporters help make this configuration very easy.

Preparing Video and Audio

We will assume for the rest of our DVDSP discussion that we are working with MPEG-2 video streams. MPEG-2 is really the standard on most DVDs and produces the best bang for the buck. Similarly, although there are hardware encoding options, DVDSP is fussy about what types of files it will accept from such solutions. Therefore, our discussion will focus on the software solutions that QuickTime provides.

For the remainder of our preparation discussions, we will assume that your video and audio are nested together as they are in Final Cut Pro. Although it is not difficult to encode the two separately, this is

uncommon. Even if you are encoding a video clip prepared in a video editing system other than FCP, the media must still be in QuickTime format to begin with. Thus, the QuickTime movie will probably contain the audio. Therefore, as we talk of exporting the media, realize that we are covering video and audio.

When you installed DVDSP, some nice things were happening under the hood. Most notably, MPEG-2 became an export option within your QuickTime utilizing applications. This makes for some seamless integration with Final Cut Pro (as it is a QuickTime-driven application). This also means that if you happen to use another video editing application for a project, or receive a pre-edited project from another editor, you can still encode the file to MPEG-2 as long as the file you receive is in QuickTime format. Although you can export the video stream directly from QuickTime Player, we will not be discussing this at any length—it turns out that exporting from QuickTime Player is nearly identical to exporting from within Final Cut Pro. Moreover, considering the focus of this volume, the most efficient method is to export from Final Cut Pro directly, and even if you have received a file from another editing application, since it must be in QuickTime format, you can always import the file into FCP and export from there. However, it should be noted that, in a pinch, files can be prepared using QuickTime Player.

TUTORIAL

11.1: EXPORTING DVDSP-READY VIDEO STREAMS FROM FCP

To learn how to prepare files, we will export the results of our past tutorials. This provides several advantages. First, we will have three varying projects to include. Second, through this process we will also have the chance to analyze how FCP's Batch Export functions work.

1. Package the FCP files. Before we can get started on exporting the files, we must do a little bit of aesthetic editing. The idea of this DVD is that, ultimately, the user can simply jump from the menu to any of our three projects. Admittedly, our three projects are just the beginnings of three projects, and so they have not been "packaged" in any type of eloquent way. Usually, a finished project would have some nice titles created with the Text Video Generator, or text created and imported from Photoshop. Therefore, the first thing we want to do is refine our earlier tutorials.

 For now, this "refinement" will consist of fading the video/audio up at the beginning of the project and out at the end. To do this, we will play the "use-a-cross-dissolve-transition-as-a-fade" trick. Open each of the

projects (SyncChina, GooseControlCenter, and Interview) and place the transition Cross-Dissolve (Browser/Effects/Video Transitions/Dissolves) at the beginning and the end of the first and last video clip of the main sequence (Figures 11.1, 11.2, 11.3). Notice that in Figure 11.2 (GooseControlCenter), since the main Sequence actually has three video tracks, a new nested Sequence was created so that only one Cross-Dissolve needed to be placed.

FIGURE 11.1 Sync China project with Cross Dissolves placed at the beginning and end of the first and last clips.

FIGURE 11.2 Goose Control Center with fade ups and fade downs via Cross Dissolve transition. Notice that the original project had three tracks of video; to speed the process, all three tracks were selected and a new nested Sequence was created (Option-C).

FIGURE 11.3 Interview with Cross Dissolve on first and last clips.

Also note that the audio clips in all three images shown earlier also have a Cross Fade (0dB) transition placed at the beginning and end of the audio clips. This transition is found in the Effects tab of the Browser in the folder Audio Transition.

The net effect of all of this is that when the user jumps to a particular clip, the clip will not start up in a sudden mid-stream jump. Rather, the DVD will jump to a black screen with no sound and the sound and picture will fade up. This makes the transitions a little smoother when navigating.

2. Batch Export the clips to MPEG-2 streams. As discussed previously, each clip needs to be exported from the NTSC-DV CODEC that FCP uses into the formats that DVDSP uses. The simplest way to do this if you only have one clip is to use the File>Export>QuickTime pull-down menu and then use the settings described next. However, since we have three different projects, we will use the Batch Export function to export all three at the same time.

 To do this, first select Master Sequence from your Project ChinaSync in the Browser. Select File>Batch Export. This will create a new window similar to your Browser. This new window will have a tab called "Export Queue." Within the window will also be a folder called "Batch 1." The idea here is that you can create multiple batches. Each batch can have its own settings. Then, when you are finished for the night, you can have the Export Queue export all of the batches using their respective settings while you are gone.

 For now, we will just use the same batch (Batch 1) to set up the video stream export. Since all the tutorials we have done thus far will have the same settings, we need to add the other tutorial Projects' Sequences to this queue. The simplest way to do this is to find the most important Sequences for each tutorial (Goose and Interview) in the Browser (you might have to open the Projects if they are not already) and drag the desired Sequence to the Batch 1 folder in the Export Queue. Your Export Queue should look something like Figure 11.4.

3. Configure the Batch 1 settings. Along the bottom of the Export Queue window are three buttons. The Settings… button is of interest to us here. Select the Batch 1 folder and click the Settings… button.

 Much of the dialog box that you will be presented with is rather self-explanatory. The Destination is where the exported movies will be saved. Click the Set Destination…button to define where you want to save the exported MPEG-2 streams. The exported files will actually split the audio and video into two files, so when the process is finished, you will have six different files. Trying to track them all down if you save them on your desktop, for example, is really a waste of time, so make a new folder and save all the files to this location so they are easy to find.

Chapter 11 Preparing Files for DVD Studio Pro | **313**

FIGURE 11.4 Export Queue prepared with all the tutorial projects thus far.

The Format pop-down menu is where things get important. If you have not installed DVDSP yet, you will not have the necessary options here. However, if DVDSP is installed, the setting of MPEG-2 will be visible. This is the setting to choose (Figure 11.5).

FIGURE 11.5 You must use the MPEG2 export settings to export FCP Sequences for use in DVDSP.

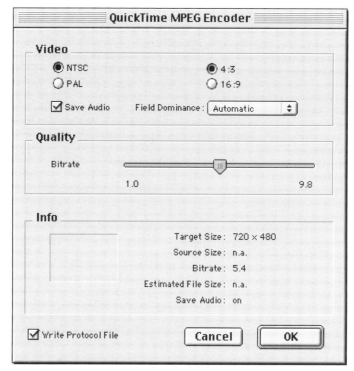

FIGURE 11.6 QuickTime MPEG Encoder dialog box.

Click the Options button to reveal the dialog box shown in Figure 11.6.

Here you can set your video export to NTSC or PAL, depending on where your DVD is most likely to be viewed. You can also choose to use 4:3 or 16:9. Make sure to leave the Save Audio option checked (since we want audio to accompany our video stream), and leave the Field Dominance at Automatic.

The Quality setting is where things can sometimes get tricky. The bit rate is how much data the QuickTime MPEG Encoder will pack into each second of complex video. The higher the bit rate, the higher the quality. However, some DVD players cannot handle bit rates that are too high, and you end up with terrible skips and pops. How high is too high? That is a difficult question to answer, and in most cases it varies from project to project as each project has a different amount of color information that is being pushed through the pipeline. In *most* cases, the bit rate can be left at its default. In our experience, a bit rate of between 5.4 and 8 usually

provides sufficiently high quality, and has no problems playing on any DVD player.

There will be times that you will export your MPEG-2 streams, create your project in DVDSP, and find that you are getting unacceptable pops and stutters. Usually, this is a bit rate problem, and it can be solved by re-Batch-Exporting the offending video streams from FCP with a lower bit rate. Then, you can replace the higher bit rate streams with the new and improved lower bit rate ones, and you are ready to go.

Click OK to get out of the QuickTime MPEG Encoder dialog box.

You can change the Naming Options, but in general, the default method that FCP uses (changing the extension on the end of the file) is sufficient. Click OK to exit the Export Queue dialog.

4. Export the files by clicking the Export button in the Export Queue window. Make sure that the Batch 1 collection is still selected, and click the Export button. Then, take a break. Although Apple is very proud of this software encoding solution and how fast it is, it still is not instantaneous. A window similar to Figure 11.7 will pop up that will show you what file FCP is working on, what its settings are, and how long it thinks it will take.

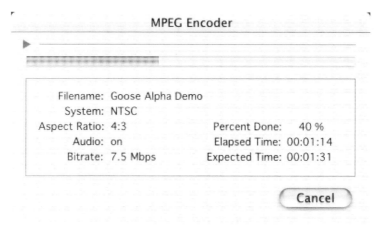

FIGURE 11.7 FCP busy exporting Sequences for use in DVDSP.

When finished, your Destination folder will be filled with a plethora of files for use in DVDSP.

Conclusion

Simple enough, no? Remember that you can export files using QuickTime Pro with much the same method. If you have edited a project in another editing system, export it from the editing system in the highest possible quality. If your editing system of choice uses DV as its CODEC, export the project as a QuickTime file with the default size of 720 × 480.

Then, take the QuickTime output that this creates and open it in QuickTime Pro. Use the File>Export pull-down menu and change the Export pop-down menu to MPEG-2 (Figure 11.8).

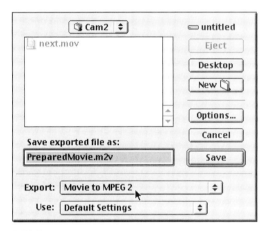

FIGURE 11.8 Using QuickTime Pro to export any QuickTime file.

The Options button reveals a collection of settings that are nearly identical to those discussed earlier in this chapter. Although there really is no way to do batch exports, this can be a fairly easy method to prepare one large file that was edited elsewhere.

Remember that you can also import these files into FCP and use the Batch Export functions. However, generally, it is easiest to simply output the single file with QuickTime Pro.

So, now that the files are prepared and exported, it is time to put them together within DVDSP. In the following chapters, we will look at how to create Still menus with interesting mouse-overs and animated menus. We will look at how to create extra multiple angles, and how to create submenus within projects.

The final DVDSP project will be a fairly large hodge-podge of clips and menus. The goal is not to work with a really distinctive design con-

cept, but rather to explore many of the methods that are available within DVDSP. Since the goal is to explore tools, this probably is not a fantastic portfolio piece for your collection. However, once everything is done, you will have a great idea of how the tools work and how to put them together.

CHAPTER 12

INTRODUCTION TO DVD STUDIO PRO

OK, here's the plan. The project for the remainder of this book will work as follows: First, we will create a main menu in Photoshop. This main menu will allow us to pick between two different submenu options. Each of these submenus actually has an introductory animation that introduces the submenus. While these introductory animations are playing, viewers can use the Angle button on their DVD player remote to jump back and forth between them. Finally, each of these submenu options will allow the viewer to pick and view the results of the FCP tutorials. The planned scheme is shown in Figure 12.1.

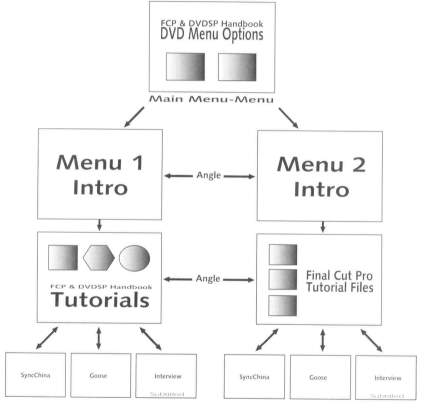

FIGURE 12.1 Planned flowchart of the DVDSP tutorials.

We will create the main menu (a sort of menu-menu) within Photoshop that is a multilayered, multistate file. This means that we will create the various states of interactive buttons for the main menu with various layers within Photoshop. This type of menu is called a *Still menu*. This menu will have interesting button states but a more static feel than the submenus to follow.

The two submenus that actually allow for the selection of the FCP tutorials completed earlier will be moving menus (called *Motion menus*). More dynamic than static, motion-based menus have some drawbacks in the limits imposed on button states. We will be creating the highlights for these motion menus in Photoshop as well.

Finally, when all of the menus are created, we will assemble the menus and functionality in DVDSP. Among the functionality that we will add in DVDSP are all the remote functions, multiple angles, subtitles, and auto-navigation.

TUTORIAL

12.1: CREATING A STILL MENU IN PHOTOSHOP

Still menus are static Photoshop or PICT files that actually sit behind the actual buttons that DVDSP uses. Part of what is interesting about how DVDSP works with Still menus is that it allows you to build menus in Photoshop with multiple layers. Each of these layers can be designed to provide interesting variation for Selected and Activated States (analogous to mouse-over states if you are familiar with Web interactivity). By creating your Still menu in Photoshop, you get to control the entire visual impact of the viewers' interaction with the menu.

When DVDSP brings in a multilayered Photoshop file, it recognizes the multiple layers. You then can define which layers are to be shown, when, and where. There are some rules to this, though, most of which we will cover here.

Since we are focusing on the simplistic analysis of tools, there is no strong metaphor to this design, so do not worry too much about any of the details. Since this is not a Photoshop book, we will not be delving too much into the intricate details of each tool that is used. Rather, we will be skimming over quite a few tools. Hopefully, you are already fairly familiar with Photoshop and can build your own file quickly from glancing at the screen shots. If not, take some time to read the accompanying text for extra hints.

1. Open Photoshop and create a new empty document that is 720 x 480 pixels for NTSC, or 720 x 576 for PAL. Click the Transparent radio button in the Content section to make sure that you truly have a clean slate (Figure 12.2).
2. Fill in the background. One of the benefits of selecting Transparent as your choice for Content when creating the empty file is that the Layers are completely without restriction. This allows you to create things in really any order. For now, let's start on the background. On Layer 1, create a background from a photograph, or fill it in with a flat color, or use a collection

FIGURE 12.2 Creating a blank Photoshop document to create a Still menu.

of filters to create an interesting texture. Figure 12.3 shows a background quickly made with the use of several filters shown in the History Palette.

FIGURE 12.3 Background created with a collection of filters.

If you are unsure about using filters or are in a hurry, use Edit>Fill and select Use>Black from the pop-up menu of the Fill dialog box. This will give you a clean black background.

3. Lay in static elements; in this case, the text is the static element. Figure 12.4 shows some text with a Layer Style of Emboss placed on top of it. The specifics of what the text looks like are unimportant.

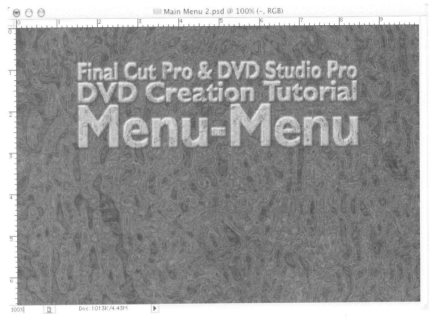

FIGURE 12.4 Static elements added.

When you use the Text tool within Photoshop, new layers will automatically be created. Be sure to consolidate all of the static elements together into one layer. Do this with the Merge Down command in the Layers Palette (Figure 12.5).

4. Create the "Normal State" of the buttons. These will actually be the visual elements with which the viewer interacts. We will be creating three different versions of each of the two buttons to represent what the button looks like, what it looks like highlighted, and what it looks like selected. For now, we will create the button as it looks when it is just "sitting there."

To take a literal bend on the interface, we will play with some Layer Styles to make our buttons look like, well, buttons. To do this, start out by either creating a circle or oval with a solid fill (Elliptical Marquee tool followed by Edit>Fill), or take a screen shot of each of the menus from within DVDSP and copy and paste an elliptical selection into the menu Photoshop

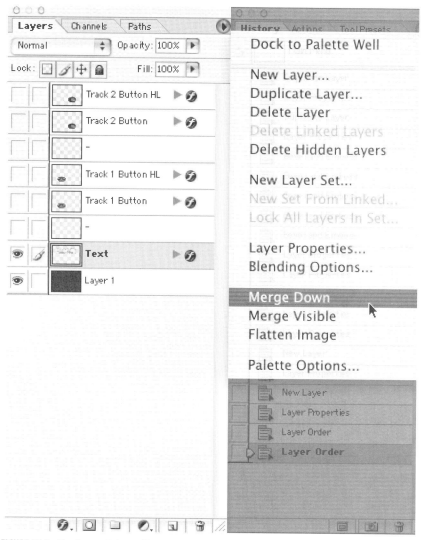

FIGURE 12.5 The Layers Palette allows you to manage and change the various layers of your Photoshop file. Many commands are contained under the pop-up menu in the top-right corner of the palette.

ON THE DVD

file. Alternatively, you can lift the two layers from the tutorial file on the DVD in the folder Tutorials/Chapter12 (Figure 12.6).

To give these two buttons a button look, select the layer that one button is on and go to the Layer>Layer Styles>Bevel and Emboss… pull-down menu. In the resulting dialog box, adjust the settings to taste. Figure 12.7 shows the settings that provide the results shown in Figure 12.8. Once you have the settings you would like on one button, Control-Click the layer in the Layers palette and select Copy Layer Style from the pop-up

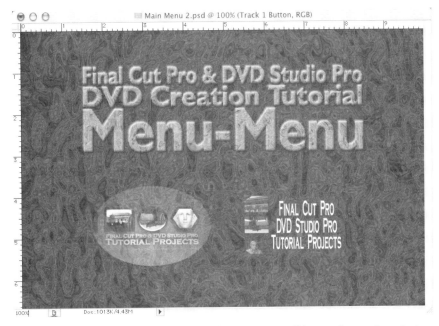

FIGURE 12.6 Pasted and resized screen shots. These two areas will become buttons in a minute. Notice here that the blending options for the two selections is set to "Screen," although this detail is not important to the project as a whole

menu. Then, select the layer of the second button and again use Control-Click to bring up the pop-up menu, and select Paste Layer Style.

Before moving on, take a minute to rename the layers that contain buttons. Name them Track 1 and Track 2 (left to right).

5. Create the Selected State of the buttons. The Selected State is the visual state of the button when it is highlighted by the users with either their mouse or DVD remote. Using this button idea, we will make the button look like it is depressed a little to indicate that the viewer has her "finger" on the button.

Control-Click on the layer Track 1 in the Layers Palette, and select Duplicate Layer from the pop-up menu. In the resultant dialog box, make this new duplicated layer's name Track 1 Button Selected. The layer names will become very important when it comes time to assemble things in DVDSP, so taking time to accurately name every layer is vital. Hide the original Track 1.

This new layer will have the same Layer Styles as Track 1. However, we will want to change the settings so the button appears to recede rather than puff out. To do this, double-click the *f* symbol for the layer in the Layer Palette to open the Layer Styles dialog box again (Figure 12.9).

FIGURE 12.7 Bevel and Emboss settings used to achieve the effect in Figure 12.8.

FIGURE 12.8 Bevel and Emboss…Layer Style can produce a button-like appearance.

FIGURE 12.9 Creating the Selected State of the buttons by reversing the Shading Angle.

The trick here is to simply rework the Shading area of the Bevel and Emboss dialog box. Turn off the Use Global Light checkbox to indicate that you want to use a new light source for this selection. Move the angle indicator to the opposite side, or enter –40 into the Angle input field. This will change the angle of the light and give the button an inward look (Figure 12.9).

Repeat this process (Duplicate Layer, rename to Track 2 Button Selected, hide original Track 2) for Track 2. Now, Control-Click on Track 1 Button Selected, and select Copy Layer Styles from the pop-up menu. Control-click on Track 2 Button Selected, and choose Paste Layer Styles to make sure that both buttons match. You should have two buttons that appear depressed (Figure 12.10).

6. Create the Activated State for the buttons. The Activated State is what is shown when viewers press the OK or Enter button on their remote. It is not visible for long, but can add just a little extra sense of dynamic interaction. To create these states, duplicate both the Track 1 and Track 2 Button Selected layers. Rename the layers to Track 1 Button Activated and Track 2 Button Activated, respectively.

Adjust the Layer Styles for each of these copied layers to match Figure 12.11. The results of this fine-tuning are shown in Figure 12.12.

7. Prepare the file for export to DVD Studio Pro. DVDSP works fairly well with Photoshop files. There are a few things, though, that we need to do to make sure the file fits right into the format that DVDSP will be looking for.

The first is to create spacers between collections of layers. If they are not already, take a moment and reorganize your layers in the Layer Palette so that all the Track 1 Button layers are together and all the Track 2 Button layers are together, one on top of another. Next, create new layers (Layers>New>Layers, or the pop-up menu on the Layer palette). For now, create three layers that sit anywhere.

FIGURE 12.10 Both buttons in Selected State.

FIGURE 12.11 The Activated State of the buttons are created by deepening the depth of the emboss.

FIGURE 12.12 The Activated State of the buttons.

Rename each layer to "-" by double-clicking on the name of the layer. A hyphen indicates a separator in DVDSP and will help when you begin defining all of the button states. Now reorganize these new "spacer layers" so that they rest between groups of button states. They should be organized something like Figure 12.13.

The next thing to do is get those Layer Styles so that they will transfer over. Part of the real power of Layer Styles in Photoshop is that they are continually editable—you can change the setting at almost anytime. The problem is that when you try to open a Photoshop file with Layer Styles in any other application (including DVDSP), the Layer Styles do not come over. Therefore, we need to have the Layer Styles rendered down so that their effects stick. There are different ways to do this, but our favorite is listed here.

Hide all the layers except one that contains a button state (in Figure 12.14, Track 2 button selected). Control-click the *f* symbol and select Create Layers from the pop-up menu (Figure 12.14a). This creates linked layers for each of the effects that has been applied to that particular layer. These new layers will also be visible.

Using the Layer palette pop-up menu, select Merge Visible (Figure 12.14b), which will combine all the pixels of the effects and the source

FIGURE 12.13 Spacer layers created by creating blank layers with a hyphen (-) for a name.

layer together. The result (Figure 12.14c), will be a layer that looks the same as it did before creating and merging layers, only now the Layer Styles will actually be noneditable, but painted onto the layer so that they will transfer to DVDSP. Repeat this process for all layers with Layer Styles or Effects.

8. Save the file as a Photoshop file (.psd) where it will be easy to find, and you are ready to go. Alternatively, the menu we created through this tutorial is also included on the DVD. Break it down in Photoshop if you have any questions about it, or just use it in the later tutorials if you do not want to spend a bunch of time in Photoshop.

Tutorial Conclusion

The file is now prepared for a Still menu. We looked at how to make various states of a button and nest them all within the same Photoshop file. In the next

FIGURE 12.14 (a) Control-click the Layer Style symbol and Create Layers. (b) Merge these layers together. (c) You are left with a layer with no styles or effects, but the results remain.

tutorial, we will begin looking at how DVDSP is laid out, how the information is organized, and how to begin to build interactive menus.

TUTORIAL 12.2: SETTING UP A STILL MENU

ON THE DVD

In keeping with the flow of the project indicated in Figure 12.1, this main menu will allow viewers to choose between one of two menus. Depending on their choice, either the introduction animation for Menu 1 or the introduction animation for Menu 2 will play. As the introductions play, viewers can use the Angle button to switch back and forth between the two. We will talk a bit more about the specifics of multi-angled tracks, but for now, both introduction animations have been prepared for you.

In the Chapter 12 folder in the folder Tutorial 12.2 are all the files you will need for this tutorial. Although the finished DVDSP file is there, do not mess with it for now. The files of importance are Main Menu.psd (the menu created in the previous tutorial—you can import your own file when the time comes if desired), Angle 1 Menu Intro, Angle 2 Menu Intro (two animations prepared and exported as MPEG-2 streams), Angle 1 Holder Menu, Angle 2 Holder Menu (two Motion menus also prepared and exported from FCP), and two audio clips (Menu Intro.aif and Holder Menu.aif). Notice that the files created in the FCP projects are not here. We will get to them in a minute.

The idea behind including all these files is that you can now concentrate on the ideas of DVDSP without having to take time out and create other Motion menus in FCP or elsewhere. You can swap those files out later if you want, but for now, stick with the building blocks included.

1. Create a new folder on your media drive called Chapter 12 Tutorials. Copy the contents of Chapter 12/Tutorial 12.2 to this folder. To get an accurate preview of your project, you will want to run things from your hard drive. In addition, we will need two audio files for a couple of places. For this we will use a great collection of music free for your use via your Apple iTools iDisk. If you do not have an iDisk, make sure to sign up for one at www.apple.com. Once you have one, and you can access it, go to your iDisk>Software>Extrax>Freeplay Music>Promos Volume 2. Within this folder are two files that will be of use. Copy Hackensack Swing 30 and Moonbeams 60 to your hard drive. Open both of these mp3 files in QuickTime Pro and save them as .aiff files. Make sure to save them as Stereo, 48kHz, 16 bits. Place these files in the Tutorial 12.2 folder on your hard drive, and for future reference, rename "Hackensack Swing 30" to "Menu Intro.aif," and "Moonbeams 60" to "Holder Menu.aif."
2. Open DVDSP and import the contents of Chapter 12/Tutorial 12.2. When DVDSP is first opened, you are presented with four windows arranged tightly together. The largest, the Graphic View window provides space for a visual flowchart of your DVD project. This window will help define and illustrate relationships between tracks and menus. At right side of your screen is the Property Inspector, an incredibly powerful and deep tool that we will be discussing quite a bit over time. At the bottom left is the Project View window with plenty of tabs allowing you to view in list form what assets you have begun to place. Finally, between the Project View window and the Property Inspector is the Assets window. This is by far the simplest of the windows in DVDSP and simply is a container that holds all the assets (MPEG-2 streams, stills, audio, etc.) imported into the project.

 To import files into DVDSP, either select File>Import, or simply drag the assets from their location (Chapter 12 Tutorials on you hard drive) to the Assets window (Figure 12.15).

 With these files imported into the Assets window, DVDSP now knows where to go to find all the media it needs as you build the project. Like FCP, DVDSP does not actually bring the media into the file; rather, it simply links to where the files are stored.
3. Save the project with File>Save. Save the file wherever you wish; we will be building on this file for the next few tutorials.
4. Set up the Property Inspector for the characteristics of the to-be-created DVD. Click anywhere in the Graphic View window. By clicking on the light

FIGURE 12.15 (a) Importing files using a simple drag-and-drop method. (b) Results of importing media assets to the Assets window.

gray of the window, you are telling DVDSP that you want to discuss the DVD disc that you are going to create. The Property Inspector will then display the properties for the disc. The sections include Disc, General, Disc Menu Settings, Variable Names, and Remote Control.

We will discuss some of these areas later. For now, the Disc section is of interest. Here you can enter general information about how a burned DVD would appear on a computer desktop. Change the Name to "FCP/DVDSP Handbook Demos" and enter "DVD Creation Tutorials" in the Comments input field. You can change the Label color if you want to, but it is not necessary

The General settings allow you to define where you will be saving information to (DVD-ROM Folder), what type of disc you will be burning to (Disc Media and Number of Sides), what regions of the world you want the disc to be readable in (Region Code [see page 151 of the manual for details on codes and regions]), whether you want to scramble the contents of the disc to encrypt the data (CSS [Contents Scrambling System]) and what you want the disc to do as soon as the DVD player gets a hold of it (Startup Action). For now, leave all the settings as they are. Remember these settings, though—as your projects get ready to be distributed, you might have projects large enough to need to be burned on discs larger than the standard Apple (or third-party) DVD-R. You also might want to take a more proactive control in what is available to whom. Remember, the theory is that Region Codes make discs only readable on DVD players in certain parts of the world. Also remember that this is a fairly hollow method of protection. Hacks are readily available on the Internet to reprogram a computer's DVD

player to read any region. We will return to the Startup Action setting in a bit, as this is very important.

Leave the Disc Menu Settings alone unless you have been working with PAL or 16:9 as you have been building projects. Click the "twiddle" to close this collection of settings to keep your Property Manager cleaner.

Close the Variable Names collection of settings. These global variables can be used for various scripting functions. Unfortunately, we haven't the room or scope in this volume to go into scripting, so we will not have much need for this section.

The final area, Remote-Control, will be hit heavily later in the tutorial, so leave it open. For now, however, leave the settings as they are (Figure 12.16).

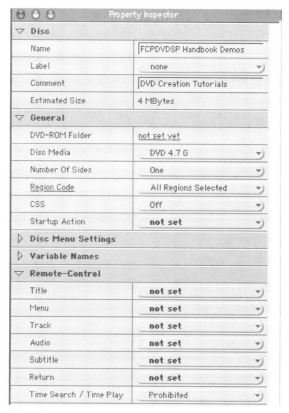

FIGURE 12.16 Settings for the DVD thus far.

5. Create a new menu. The basic philosophy behind building a project in DVD Studio Pro is that the Assets are the basic building blocks of the project. These assets include video, audio, stills, and subtitles. Tracks, Menus,

Scripts, and Slideshows are essentially containers that hold assets. Notice that at the bottom left of the Graphic View are four buttons, allowing you to quickly create these containers (Figure 12.17).

FIGURE 12.17 DVDSP Container buttons in the Graphic View.

Constructing a project consists of organizing your containers of assets and establishing how those containers react and relate to each other.

The first "container" we will talk about is a menu. Menus, of course, are interfaces that allow the viewer to interact with the DVD. There are a few different ways to create menus. For now, click the Add Menu button at the bottom-left corner of the Graphic View window.

A new icon will appear in the Graphic View (Figure 12.18) that looks like a blue tabbed folder. Notice that by default it is named "Untitled Menu." Take a minute to rename it to Main Menu by either changing the input field directly on the icon, or by changing the Name input field in the newly changed Property Inspector.

FIGURE 12.18 A new icon will appear in the Graphic View that looks like a blue-tabbed folder.

Since this new menu is active, the Property Inspector now shows the properties for the menu rather than for the disc. We will be getting to these settings in a bit. For now, just take note that the Property Inspector changes to show the active element.

Also notice that the Project View now contains a new folder called "Main Menu" in the Menus tab. All the windows in DVDSP are heavily interrelated. Working in one usually affects what is seen in the others.

6. Place the asset Main Menu.psd into the Main Menu container. You can do this in a variety of ways, but the most intuitive is to just drag Main Menu.psd from the Assets window onto the purple Main Menu icon in the

Graphic View. As soon as you do this, the Main Menu icon will change to display a thumbnail of the asset it contains.

7. Define the Main Menu buttons. The Main Menu now contains an asset that tells it what media to display. However, DVDSP still does not know how to display the media, and what layers to display when. Further, as of yet, there is no interactivity created.

To change all of this, double-click the part of the Main Menu icon in the Graphic View that is the thumbnail of the Main Menu.psd file it contains. This will open a new window in the Graphic View window (Figure 12.19).

FIGURE 12.19 Double-clicking the image icon in the Main Menu icon of the Graphic View displays an empty window and new settings in the Property Inspector.

Right now, the new window is white with one button sitting forlornly in the top-right corner. This odd setup exists because DVDSP simply does not know how to handle the asset. The Property Inspector shows the relevant properties to this menu. We will be hitting most of the properties here eventually, but for now, the Picture settings are of most interest to us.

Notice that the Asset setting is set to Main Menu.psd. The Layers (always visible) needs to be changed so that a layer within Main Menu.psd is always visible. In this case, Layer 1 is the name of the layer in the Main Menu.psd Photoshop file that contains the background. Select this in the pop-up menu (Figure 12.20).

FIGURE 12.20 The Layers (always visible) defines what is to be seen in the menu.

Now we have a visible background, but the button is still floating in the top-right corner of the image. To begin to define buttons, click on the Untitled Button square in the Graphic View. The button will display the "running ants" form of highlight, and the Property Inspector will change to display the Properties of this button (Figure 12.21).

Take some time to rename the button and leave any comment you want in the first section of the Property Inspector. It is easy to not enter names as you are working, but take the time to do it. When projects get complex, it becomes very confusing when dealing with buttons with names such as Untitled Button, Untitled Button 1, and so forth. For this button, name it "Track 1 Button."

Leave the Dimensions settings alone, as we will visually deal with those in a second. The Display settings are where things get fun. Notice that there are three states listed there (Normal, Selected, and Activated) and a Use Hilite setting. Each of the states is default listed as No Layers Selected. Since we carefully named our layers in Photoshop, choosing the correct layer for each of these pop-up menus is easy.

For Normal, select Track 1 Button. Selected State should be Track 1 Button Selected. Activated State should have Track 1 Button Activated chosen. As soon as you change the Normal state, the button will appear in the Graphic View. You will not be able to see the results of the Selected and Activated States at this point, but we will be able to clearly see the effects in just a bit when we preview things.

FIGURE 12.21 Defining a button starts by selecting it in the Graphic View.

Finally, even though we have indicated what the button graphic is to display, the hotspot for the button is still floating up in the left corner. For most DVD players, this does not matter as navigation happens with the Up, Down, Left, and Right arrows, and with only two buttons, all directions would just toggle to the other button. However, if this disc were played on a computer's DVD-Rom drive, the graphic button would not change to its Selected or Activated states if the mouse were moved over it. Rather, it would only change if the mouse were put over the top left corner of the interface, because that is where the button's hotspot actually resides.

To change this, simply click and drag the button into place over the top of the graphic button in the Graphic View. Next, move the mouse to the corners of the running-ants selection. The cursor will change to a double arrow (Figure 12.22). Click and drag to resize the button's hotspot. Resize the hotspot to fit the graphic button.

To place the second button, click on the Add Button button at the bottom left of the Graphic View window displaying the menu. This will create a new button back up in the default left corner. Select the new Untitled Button and repeat the steps of renaming the button (Track 2 Button), changing the Normal, Selected, and Activated State to Track 2 Button, Track 2 Button Selected, and Track 2 Button Activated, respectively. Move and resize the button's hotspot so that it rests over the new graphic button. The results of both buttons should appear something like Figure 12.23.

FIGURE 12.22 Move and resize buttons to match the graphic representation of the button.

FIGURE 12.23 Two buttons created, placed, and various states defined.

Before we leave here, we will need to play a little trick on DVDSP. When a menu first appears, it automatically selects a button. This button is called the Default Button, and can be useful if you want to guide your viewer toward a specific selection. However, in this case, we want to let the buttons both be sitting unmolested until the viewers use the Up, Down, Left, or Right buttons on their remote. To do this, we will create a Dummy Button.

To create this Dummy Button, either click the Add Button button again, or simply marquee around any small spot in the Graphic View. This will create a new Untitled Button. Select it in the Graphic View and rename it to Dummy Button in the Property Inspector. Next, move down to the Button Links section. This area allows you to define where a viewer can go within a menu while resting on a given button. In this case, we want to define that as the user pushes Left, Track 1 Button becomes the selected button. Similarly, when the user pushed Right, Track 2 Button becomes the selected button. Change these two settings in the pop-up menus. Do not worry about the Up and Down settings, as they are fairly unintuitive in this case. Later, we will define this Dummy Button as the Default Button. Now viewers will be presented with two unselected buttons when the menu opens and can choose one button with the Button Links on their remote.

This Dummy Button has created a problem, though. As you create buttons, DVDSP attempts to guess which buttons should be the Up, Down, Left, and Right Button Links. For example, if you select Track 1 Button in the Graphic View, you will see that the Button Links lists the Up Button Link as Dummy Button. This is bad news because it means that the viewer ends up shuttled to a nonfunctioning Dummy Button that does nothing. Therefore, change the Up and Left Button links to Track 2 Button. Similarly, select Track 2 Button in the Graphic View and change the Down and Right Button Links to Track 1. Basically, the idea is that after the viewers move off the Dummy Button, no matter what direction they go, they will select the other Track *x* button.

Finally, close the window that displays the menu, thus taking you back to the big Graphic View with the purple menu sitting in the middle of the screen. Select the menu, and in the Properties Inspector, under the General settings, change the Default Button to Dummy Button.

Of course, we will return to more details in this menu later. Most notably, we have not told DVDSP what to do once a particular button is selected. Before we do that, we must first create places for buttons to go to.

8. Create a track to contain Angle 1 Intro. We already looked at the Menu container. In the Graphic View, you can grab such containers by their tabs and move them around within the space. For this step, we will be creating another container, a *track*.

Click the Add Track button at the bottom-left corner of the Graphic View. This will create a new green icon in the Graphic View (Figure 12.24). Rename this "Track to Angle 1 Introduction."

FIGURE 12.24 Newly created track.

The track is currently empty. We will want to place two things into this track for now, a video stream and an audio file. Although there are several ways to do this, we will continue with the intuitive drag-and-drop method. Grab the video stream Angle 1 Menu Intro from the Assets window and drop it onto the green Angle 1 Introduction Track.

Notice that in Figure 12.24, there are several buttons on the track corresponding to the track's potential assets and characteristics, including Audio, Subtitles, Markers, Stories, and Angles. Right now, the Audio button reads 0, meaning that there is no audio attached to the file. Drag Menu Into.aif from the Assets window on the Angle 1 Introduction Track. The Audio button will change to show a 1 below it, meaning that this track, when played, will have both video and audio. We will look at the other buttons on tracks later.

9. Create a new track (Add Track button), and place Angle 2 Menu Intro and the same Menu Intro.aif into it. Rename it to Angle 2 Introduction. Figure 12.25 shows a rough approximation of what the Graphic View might look like at this point. Remember that you can reorganize the Graphic View to help you keep track of what is going on.

Notice that there are arrows between Angle 1 Introduction and Angle 2 Introduction, meaning that there is a relationship between these two tracks (which we do not want at this point), but there are no arrows between Main Menu and these tracks (which we *do* want). We will fix this in the next few steps.

10. Establish the Main Menu's relationship to the two tracks. Double-click the thumbnail in the Main Menu icon of the Graphic View. This will open the Graphic View window we had earlier where we defined buttons. We need this window again here because we need to define what happens when those buttons are selected. Select Track 1 Button, and in the Property Inspector, under the Action group, is an Jump when Activated setting.

FIGURE 12.25 Graphic View up to this point.

Click this pop-up menu and select Angle 1 Introduction. Do the same for Track 2 Button, only have it jump to Angle 2 Introduction.

The buttons in the Graphic View will now not only include the name of the button, but also list the track that they jump to (Figure 12.26). Close the Graphic View window that shows the menu/buttons.

FIGURE 12.26 Buttons with assigned actions.

When back in the general Graphic View, grab the Main Menu container and move it a bit—this causes DVDSP to refresh the Graphic View. You should now have arrows extending from the Main Menu to both tracks. The blue line indicates an action-based relationship.

11. Establish Main Menu as the "home" and Preview. Click anywhere that is gray in the Graphic View to indicate that you want to work with the properties for the disc. Under General, change the Startup Action to Main Menu. This means that when the disc starts playing, it jumps to this container. Save (File>Save) and then click the Preview button at the bottom right of the Graphic View to test your work thus far.

DVDSP will spin for a bit, and then take you to the Preview window. Across the bottom of the window will be navigation tools similar to a

DVD remote. Use these to navigate and choose one of your two buttons. Click OK, and your selected track will play.

12. Establish multiple Angles. The idea of multiple Angles is that the Viewer can choose, midstream, to view either a different angle of the same scene or a different scene altogether within the same track. In either case, what happens is that the DVD switches to a different video stream.

 Both of the video streams Angle 1 Menu Intro and Angle 2 Menu Intro are exactly the same length. They were planned to be two angles of the same intro, and so were constructed to the same size. If you want to use Angles, the alternate Angle files must be the same length.

 To place an alternate Angle, click the Angles button on the desired track. For now, click the Angles button on the Angle 1 Introduction Track (Figure 12.27).

FIGURE 12.27 The Angles button on the Track Angle 1 Introduction.

A new window with the tab Angles will appear. To place a new angle, just drag it from the Assets window to this new Angles window. In this case, we want to have Angle 2 Menu Intro be the alternate angle for Angle 1 Introduction, so drag Angle 2 Menu Intro into the Angles window. Close the Angles window when done.

Do the same for Angle 2 Introduction, except this time, place the asset Angle 1 Menu Intro into the Angles window.

13. Create and place two new menus that will hold motion menus. Right now, when Angle 1 Introduction finishes playing, it assumes that it should go on to Angle 2 Introduction. What it should actually do is move onto a menu that allows the user to choose which of the FCP projects to view. These menus are actually to be built from Motion menus, which we will do in the next chapter. For now, let's create the Menu containers and make the Tracks Angle 1 and Angle 2 Introductions flow to their respective menus.

 Click the Add Menu button at the bottom of the Graphic View twice to create two empty menus. Rename one "Angle 1 Menu," and the other "Angle 2 Menu." Drag the asset Angle 1 Holder Menu to Angle 1 Menu in

the Graphic View, and then drag Holder Menu.aif to the same Angle 1 Menu. For Angle 2 Menu, drag Angle 2 Holder Menu and again Holder Menu.aif.

Now we need to establish a relationship *into* these menus. Select Angle 1 Introduction in the Graphic View to activate its properties in the Property Inspector. Under the General group, change the Jump when Finished to Angle 1 Menu. This intuitive step means that once the Track Angle 1 Introduction finishes playing, it jumps directly to the video/audio of Angle 1 Menu. Do the same thing for Angle 2 Introduction, only selecting Angle 2 Menu as its Jump when Finished option.

Your Graphic View should reflect these new relationships (Figure 12.28).

FIGURE 12.28 Graphic View showing Jump when Finished relationships.

Conclusion

In this chapter, we created Still menus, tracks, and the containers for Motion menus. We looked at how to place Assets within menus and tracks

and how to establish multiple Angles for a given track. Through all of this, the Graphic View gives us, well, a graphical view of the relationships between containers of assets. Remember that perhaps the most important aspect of the DVDSP interface is the relationship between the Graphic View and the Property Inspector. Make sure that the desired asset, track, or menu is selected, and you will have all the needed options visible in the Property Inspector.

In the next chapter, we will add interactivity to the Motion menus we created here. We will link the rest of the projects to these new menus, and create *stories* that relate strings of assets or tracks together. After this, we will do a quick subtitle exercise and finally look at how to export the project and burn a DVD.

CHAPTER

13 MOTION MENUS, SUBTITLES, AND OTHER ADVANCED FEATURES IN DVDSP

Moving right along, in this chapter, we will look at how to create Motion menus first. We will use a couple of Motion menus to allow the viewer to access the tutorials created earlier in FCP and batch exported. As we move along further in the chapter, we will finally look at how to create and insert subtitle streams.

As was the case with our discussion of Final Cut Pro, we are not attempting to recreate a manual with this volume. As such, we do not illuminate every corner of DVDSP. Rather, we are taking a functional approach and going through the tools you will most likely use. There will definitely be some areas of the software that we cannot cover with the scope of this volume, but read on; with the knowledge gained from the discussion following, you will have the conceptual understanding to work through any of the other aspects of this powerful software.

TUTORIAL

13.1: CREATING A MOTION MENU

In tutorials in the last chapter we created rather complex Still menus complete with images that swap out for Selected and Activated states. In this tutorial, we will look at creating a Motion menu using simply highlights—or hilites as DVDSP likes to call them.

The last thing we did in the preceding chapter was create two Menus, Angle 1 Menu and Angle 2 Menu. Both of these are video clips (exported to MPEG-2 streams) that were designed as Motion menus. In this tutorial, we will be working with Angle 2 Menu.

1. Double-click the thumbnail of Angle 2 Menu. This will open the video stream into a Graphical View much as the Still menu of past tutorials did. Again, you will be presented with an Untitled Button floating somewhere up in the left corner. Move and resize that button so that it sits over the first clip/button for SyncChina, and name the button "Angle 2 SyncChina." Do not worry about where this button points to for now—we will get to that in a minute.

2. Create and name two more buttons over Goose and Interview. Name them Angle 2 Goose and Angle 2 Interview, respectively. Remember to make sure that the button is the same size as the graphic clip/button it represents. Your Graphical View should look something like Figure 13.1.

 Close the Graphical View of the Motion menu when complete.

3. Create Button Hilites. Back in the general disc Graphical View, select Angle 2 Menu. In the Property Inspector, you will be presented with the editable properties of this particular menu. If everything is set up according to the

Chapter 13 Motion Menus, Subtitles, and Other Advanced Features in DVDSP | **349**

FIGURE 13.1 Three buttons created over a Motion menu background.

last tutorial, the name should read "Angle 2 Menu," the Picture/Asset should be "Angle 2 Holder Menu," and the Audio/Audio should be "Holder Menu.aif." The area of interest to us now is the Button Hilites section.

We will look at an Overlay Picture in the next tutorial, so for now, leave this setting at "not set." Also, leave the Use Simple Overlay to Yes. The next five settings allow us to define colors and transparency settings for the highlights that will pop up when one of the buttons we just defined is selected or activated.

Each of these setting has two pop-up menus. The first defines a color, and the second defines an opacity. Right now, we would see no highlights on our menu because all the states have 0% as their opacity setting. In this case, the Normal will stay at 0%. If we changed the color or opacity, the graphic clips/buttons would be covered with a color even if they were not selected. However, we do want to adjust the Selected Set 1 and Activated Set 1 settings.

The Selected Set 1 will define what color the button turns when selected. Choose a color you like (we chose a dark blue) and set the Opacity setting to 40% or less. If the Opacity setting is too high, viewers cannot see through the button to see what they are selecting. Similarly, choose a

color you like for the Activated Set 1, and set the opacity setting to something perhaps a little higher (around 60% is nice). The settings should look something like Figure 13.2.

FIGURE 13.2 Settings in the Property Inspector for Button Hilites.

4. Test the Button Hilites. Make sure that the menu Angle 2 Menu is selected in the Graphical View, and click the Preview button at the bottom right of the window. This will preview just this menu so you do not have to go through all the other menus before it. If all is well, the buttons on the bottom of the Preview window should allow you to change buttons, which will have a highlight matching what you defined in the Button Hilites of the Property Inspector. If the highlight, in the form of a block of color, is too dense, close out the preview (click the Stop button), and turn the Opacity setting down. Since we have not defined where the buttons are pointing to, you will not be able to see yet what the Activated Set looks like.

ON THE DVD

5. Import the contents of Chapter 13/Tutorial 13.1 from the DVD. This should include the video streams and accompanying audio files for the tutorials we created in earlier chapters. Alternatively, if you have been following along, you might want to import your own MPEG-2 streams that you batch exported earlier.

 Either way, remember that the fastest way to import multiple assets is to simply drag them from the Finder into the Assets window of DVDSP.

6. Create a new track to hold the video stream SyncChina and its accompanying audio stream. To do this, click the Add Track button at the bottom

left of the Graphical View. When the green Track icon appears, drag SyncChina from the Assets window onto it. Then, do the same for SyncChina.aif. Rename this track "Angle 2 SyncChina Track." For now, do not worry about the seemingly errant arrows.

7. Create new tracks automatically for Goose and Interview. To do this, simply grab Goose and drag it from the Assets window to the Graphical View. DVDSP will recognize that it is a video stream and assume that you need a track to contain it. Drag Goose.aif from the Assets window to this newly created track, and rename the track to Angle 2 Goose Track.

 Repeat this same process for Interview and Interview.aif, naming the new track Angle 2 Interview Track.

8. Link the buttons in Angle 2 Menu to these newly created tracks. To do this, double-click the thumbnail of Angle 2 Menu in the Graphical View. This will open a Graphical View window with the buttons we created in Steps 1 through 3. Select each button and change the Jump when Activated in the Property Inspector to the respective tracks. The results should look something like Figure 13.3. Close the Graphical View for the menu.

FIGURE 13.3 Assigning buttons to point to appropriate tracks for Motion menus is the same process for doing so with a Still menu.

9. Make sure that when each track finishes playing, that the viewer is returned to Angle 2 menu. In the Graphical View, first select the track Angle 2 SyncChina. The Property Inspector will display the properties for this track. In the General group of settings, change the Jump when Finished to Angle 2 Menu. This will mean that when the track is done playing, it jumps back to the menu that the viewer used to select SyncChina in the first place—Angle 2 Menu.

 Repeat this for Angle 2 Goose and Angle 2 Interview. When you are done, all the arrows in the Graphical View should logically be pointing between Angle 2 Menu and the Angle 2 *x* Tracks you just finished creating.

10. Test everything by selecting Angle 2 Menu and clicking the Preview button. This time, when you select a button, the Activated State color and opacity will illuminate. Further, when the tutorial clip finishes playing, you will be transported back to Angle 2 Menu.

TUTORIAL

13.2: CREATING A MOTION MENU WITH AN OVERLAY PICTURE

In the last tutorial, we looked at using a Motion menu. This type of movement in the menu has some nice characteristics, but some clumsiness as well. Using Motion menus with standard highlights means no interesting swapped-out images during Selected and Activated states as you have in Still menus. However, there are ways of spicing things up a little more than simply box or rectangular highlights.

An Overlay Picture is a type of map that allows DVDSP to know where to place highlights for a button. More importantly, it allows for the creation of nonrectangular highlights to appear over or around buttons.

DVD Studio Pro is fairly picky about how it accepts Overlay Pictures. Although an Overlay Picture will usually be created in Photoshop, and, technically, DVDSP accepts Photoshop files, you will find that .pict files work best. Further, Overlay Picture must be in "black and white." Now, it is not as simple as pixels being either white or black—there actually is a little room for grays in the process—however, for best results, plan your design around the idea of a bitmapped black-and-white image to define shapes of highlights.

In this tutorial, we will be creating an Overlay Picture for Angle 1 Menu.

ON THE DVD

1. Open a still of the Motion menu as a guide in Photoshop. A version of this file can be found on the DVD in the folder Chapter 13/Tutorials 13.2 called "Angle 1 Menu Background.tif." If you were creating a Motion menu from scratch, you would want to export a QuickTime>Still Image from within

FCP. Although ultimately you will not be seeing this still, it is important to have to give you an idea of where to build your highlights.
2. Create a new layer (Layer>New>Layer).
3. Use the Lasso tool or the Polygonal Lasso tool to draw selections similar to those in Figure 13.4. Remember to hold the Shift key down when starting a new "beam" so that you can have all three distinctive shapes created at the same time. These shapes are meant to be volumetric light that you would see if the lights above the frames were at a high intensity.

FIGURE 13.4 Shape selections created with the Polygonal Lasso tool and feathered by three pixels to give a little softer edge.

4. Feather the selection by three pixels (Select>Feather). This will soften the edges of the selection slightly.
5. Make sure that your foreground color is black, and activate the Gradient tool. Create a linear gradient of solid black at the area closest to the lamps to transparent at the bottom of the shape (Figure 13.5) by dragging the Gradient tool through one of the selected shapes.

FIGURE 13.5 The Gradient tool will create a sort of black light. This black will be transformed to brighter colors in DVDSP.

6. Throw away the Background layer, or the layer showing the still of the Motion menu. You should be left with an image like Figure 13.6. Remember that this is a map. What is you see is not what you will get, so do not be concerned with the black "light."
7. Convert the file to Grayscale (Image>Mode>Grayscale). Remember that Overlay Pictures must be black and white.
8. Convert the grayscale image to a true black-and-white bitmap. Although DVDSP can recognize some grays in Overlay Pictures, the results are unreliable. By changing the file to a bitmap, and in this case using Diffusion Dither as the method, we can get a good idea of the exact shape and look of the highlight (Figure 13.7).

 The results are shown in Figure 13.8. Save this file as Angle 1 Menu Overlay.pct (save it as a pict file). This file is also included on the DVD in the Chapter 13/Tutorial 13.2.

ON THE DVD

9. Import Angle 1 Menu Overlay.pct into the Asset window of FCP. Do this by using the File>Import pull-down menu, or drag and drop into the Asset window from the Finder.

Chapter 13 Motion Menus, Subtitles, and Other Advanced Features in DVDSP | **355**

FIGURE 13.6 Our map is beginning to take place. The black will indicate what the highlight shape will look like.

FIGURE 13.7 Setting for converting the Overlay Picture to a true bitmap image of just black and white pixels.

10. Assign Angle 1 Menu Overlay.pct to Angle 1 Menu. To do this, select Angle 1 Menu in the Graphical View, and then in the Property Inspector, in the Button Hilites area, change the Overlay Picture setting to Angle 1 Menu Overlay.pct.

FIGURE 13.8 A true black-and-white map of what the highlights for Angle 1 Menu will look like.

11. Define the buttons for Angle 1 Menu. Double-click the thumbnail of Angle 1 Menu to open its Graphical View. Again, move and resize the random default Untitled Button that floats at the top of the left corner. Make sure to make the button big enough so that it encompasses both the frame and the lamp. This is important because the button will serve as a type of window. You will only be able to see the Overlay Picture through the button. If it is too small, it will cut off the highlights. Once placed and resized, rename this button "Angle 1 SyncChina."

 Repeat the process for the other two selections, naming them "Angle 1 Goose" and "Angle 1 Interview." Again, since we really have nothing to point these buttons at yet, do not worry about setting any other properties. Close the Graphical View for the menu.

12. Define the color for the Overlay Picture to exhibit. Back in the disc Graphical View, select Angle 1 Menu, and in the Property Inspector in the Button Hilites area, change the Selected Set 1 color to the light blue and the opac-

ity to 20%. Change the Activated Set 1 to yellow and its opacity to 40% (or pick the colors you like).
13. Test the menu with the Preview button. If all has gone well, the interface should look something like Figure 13.9.

FIGURE 13.9 The Overlay Picture allows for the volumetric light effect. The color of the volumetric light is defined by the Selected Set 1 color and opacity.

14. Drag SyncChina, Goose, and Interview into the disc Graphical View area. Select all three and drag them together; this will automatically create three tracks, each containing one video stream. Separate them a bit in the Graphical View and drop in their corresponding audio files (SyncChina.aif, Goose.aif, and Interview.aif). Finally, rename these to "Angle 1 Sync China Track," "Angle 1 Goose Track," and "Angle 1 Interview Track."
15. Point the buttons in Angle 1 Menu to these tracks. Double-click the Angle 1 Menu thumbnail, select each of the buttons, and change Action/Jump when Activated to its corresponding track. Close the menu Graphical View and test the buttons with the Preview button (Figure 13.10).
16. Select each of the new Angle 1 x Tracks, and change the General/Jump when Finished settings in the Property Inspector to Angle 1 Menu. This is the reason why we imported SyncChina, Goose, and Interview twice. By

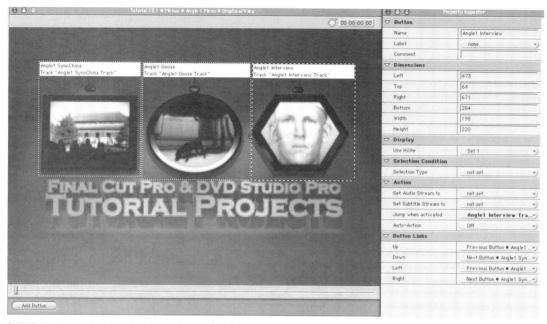

FIGURE 13.10 Graphic View for Angle 1 Menu with all buttons assigned appropriate Jump when Activated settings.

importing them twice, we can make sure that they jump back to the menu from which they were chosen.

17. Add subtitles to the two Interview tracks. Included with DVDSP is a small application called STE (Subtitle Editor). The manual is pretty clear about this small, simple, and easy-to-use application, so we will not go into it here. Along with the other media you imported into the project earlier is a file called InterviewSubtitles.spu. This is a subtitle stream created with STE to match the Interview tracks. To assign the subtitle stream, just drag it onto the track Angle 1 Interview Track and then Angle 2 Interview Track.

18. Clean up Remote-Control settings. The Remote-Control properties are, of course, the areas where you define how DVD players' remotes will interact with the DVD you are constructing. This is incredibly important to get right, as without careful checking and double-checking of the Remote-Control settings, you could leave a viewer confused as to where she is in the organization of the disc, or worse—stranded.

Many folks like to do this as they go, but we find that to make sure everything is as it should be, the most fool-safe method is to go through and adjust the Remote-Control settings for the entire project when it is ready to go.

We will start big and work smaller. Click anywhere in the gray part of the Graphical Viewer to bring up the properties for the Property Inspector.

In the Remote-Control section, make sure that Title and Menu pop-up menus are both set to Main Menu. This means that unless otherwise defined (which we will also do), if users press the Title or Menu button on their remote, they will be taken back to the beginning menu.

For the menus (Main Menu, Angle 1 Menu, and Angle 2 Menu), we have already defined most of the relevant Remote-Control functions. However, the various tracks need some fine-tuning.

For Angle 1 Introduction and Angle 2 Introduction, we want to make it so that if viewers do not want to sit through the introduction, they can skip ahead to Angle 1 Menu or Angle 2 Menu (depending on which one they chose at the Main menu). To shift this, select Angle 1 Introduction. The Property Inspector will show the usual properties, including the last section of Remote-Control. By default, these pop-up menus are all set at Same as Disc. However, we want to make the Menu key actually point to Angle 1 Menu—skipping forward to the menu of FCP results. To change this, just change the Menu pop-up to Angle 1 Menu.

Similarly, select Angle 2 Introduction and set its Remote-Control/Menu setting to Angle 2 Menu.

Moving down to the two groups of three SyncChina, Goose, and Interview, we want to make sure that each of these tracks, when playing, will jump back to the menu that they came from (Angle 1 Menu) if the user presses the Menu button. Therefore, select Angle 1 SyncChina Track, Angle 1 Goose Track, and Angle 1 Interview Track one at a time, and change the Remote-Control/Menu setting to Angle 1 Menu.

Do the same for Angle 2 SyncChina Track, Angle 2 Goose Track, and Angle 2 Interview Track, only make the Remote-Control/Menu setting read Angle 2 Menu.

What this effectively does is leaves the Title button on the remote so that it always jumps back to the beginning Main menu. However, once viewers make a choice down Angle 1 or Angle 2 path, the Menu button will always take them to Angle 1 Menu or Angle 2 Menu, respectively.

TUTORIAL

13.3: OUTPUTTING YOUR DVD PROJECT

Interestingly enough, this is one of the easiest parts of the process. One of the true strengths of DVDSP is its ability to easily prepare projects for output, test the projects, and burn them to disc.

1. Build your project and test it. No matter how good at DVDSP you get, DVDs are still not cheap. It is always worthwhile to test, retest, and then

have someone else test your project. Luckily, DVDSP allows you to create a sort of virtual DVD on your hard drive to test functionality, bit rate, and other details.

Once you are as sure as you can be that everything is as it should be, select File>Build Disc *x*. You will then be asked where to save this built disc. Be sure you create a new folder to keep all of your files collected, and click the Choose button.

Then, sit back and rest. A Progress box will appear, providing information as to what the bit rate is doing and what the throughput is (Figure 13.11).

FIGURE 13.11 The Progress window as DVD encodes your project for DVD.

2. Test your project. Once DVDSP is done building your project to your defined folder, you can open the project with Apple's DVD Player. If you look in the folder you outputted your file to, you will find two folders: VIDEO_TS and AUDIO_TS. Both of these directories are very important. Without these files at the root of a DVD, the DVD Player will not recognize that this is a valid DVD and will not play any auto-launch sequence. This means, in most console DVD players, nothing will ever play. So keep these around. Do not rename or move.

If you are using OSX, Apple's DVD Player is already set up to play files off the hard drive. Simply go to File>Open Video_TS Folder. If you are using OS9, you will need to prepare Apple DVD Player. With Apple DVD Player open, go to Edit>Preferences and select the Advanced Controls tab in the resultant dialog box. Check "Add 'Open VIDEO_TS' menu item to the

File Menu" to let Apple DVD Player know that you want to be able to open files from a hard drive.

In either case, to test your project, in Apple DVD Player, select File>Open VIDEO_TS folder. Then, in the following dialog box, go find the folder where you output your project to, select the VIDEO_TS folder, and click Choose.

You can then use the Apple DVD Player's remote function to carefully go through and check that everything runs as it should. Test every corner, and then have your buddy who has not been involved with the project come in and see if he can break it. When you are sure that everything is on the up and up, you are ready to burn. If you do find problems, go back into DVDSP, rework the problem spots, and rebuild the project again.

3. If all is well, go back to DVDSP and select File>Build & Format Disc "x." When selected, DVDSP will ask you whether to write a DVD image file or write directly to disc (Figure 13.12).

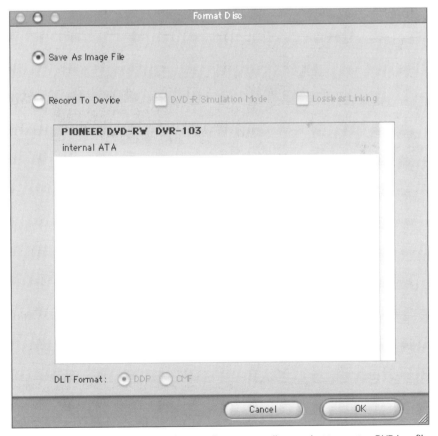

FIGURE 13.12 When you are ready to burn to disc, you actually can select to create a DVD.img file on your hard drive that can be used for duplication with other DVD-burning applications.

If you plan to do mass copies and are using something like Roxio's Toast, a disc image is probably the best option. However, if you are making just one copy, select the second option and prepare your DVD-R.

Then, you will be asked where to temporarily store the VIDEO_TS and AUDIO_TS files that DVDSP needs to create before burning. If you have carefully been testing and retesting by building discs, you can select the location where your last successful test was stored. If you do, DVDSP will ask you (Figure 13.13) if it is all right to use the already encoded version. This can save you loads of time.

 There is VIDEO_TS data at the selected location which has not been modified since the project was last built.
Should this data be reused in an incremental build or deleted prior to a complete build?

FIGURE 13.13 If you have been testing by building discs to your hard drive, you don't need to re-encode when it comes time to burn.

If you do not want to use a previous build, press Delete and your old copy of the VIDEO_TS and AUDIO_TS files will be deleted and DVDSP will encode and save again.

CONCLUSION

There you have it. Of course, this is by no means a comprehensive look at DVD Studio Pro. Still available are powerful features such as slideshows, @ccess Type, Internet Linking, multilingual implementations, and so forth. However, if you can successfully complete the tutorials contained in the last couple of chapters, you have all the primary tools needed to create spectacular DVDs. The tools given here are just the beginning building blocks.

Through the course of the book you got a glimpse of how powerful Apple's Final Cut Pro and DVD Studio Pro really are. However, we are

just scratching the surface in the tutorials. Our discussion and coverage here—broad, but not exhaustive—hopefully provided you with a familiarity with the corridors and corners of these incredible applications and empowered you to wield the tools to create great products.

APPENDIX A

ABOUT THE DVD

The DVD included with this book contains tons of media files and data important to the tutorials. The DVD is divided into chapters, with each chapter containing the necessary media files for the tutorials within that chapter.

The DVD will not act as a traditional DVD. There is not the needed AUDIO_TS and VIDEO_TS on the disc. Although you can create these easily by following the tutorials in the book, it was important to make sure that this disc functioned well as a data storage medium.

When you first open the DVD, you will see three things. The first is the README with all the copyright information (also included here).

One folder contains all the figures used in the book in full color. The images are all about 800 × 600 pixels large to provide sufficient details. Wherever the color becomes important in the book, please reference this folder.

The second folder contains the tutorial files for each chapter. Notice that the Final Cut Pro files and the DVD Studio Pro files are included if you would like to dissect them. However, it is highly recommended that you instead follow the tutorials and build the files yourself. Also contained in these tutorial folders are all the media needed to complete the tutorials. Remember that, as indicated in the tutorials, you will want to copy these media files to your hard drive. The speed of the DVD is insufficient for heavy video editing.

So, there you have it. All the video contained on this disc was shot by the author, and you can use it as you wish for these tutorials. Some audio files needed in Chapter 12 are not included on the disc, but can be freely obtained through your iDisk (*www.apple.com*). The notable exception is the audio file Chinese View.aif. This file is by Axonic, who graciously allowed for the inclusion in this volume. If you like Axonic's music, listen to more of his work at *www.mp3.com/Axonic*.

APPENDIX

B THE MATROX RTMAC

As Final Cut Pro has found increasing acceptance in the editing world, and more and more companies have adopted it as their primary tool, more and more companies have been looking for hardware-driven solutions to the problems of video capture, output, and rendering. In the various tutorials in this book we used a DV camera or deck to capture DV media to your hard drive. However, what if your media is not on DV or miniDV? Well, you could record to DV and then capture from that, but that is really inefficient. As you were working through the tutorials, you undoubtedly noticed that many functions in FCP—including moving clips, transitions, and effects—require FCP to "draw" the information you have presented it in order to render. This is essentially a software-driven process, which is part of why rendering can be so slow.

Several hardware solutions have emerged since FCP's inception that assist in capturing video from non-DV sources—the Matrox RTMac is one of those. The way the RTMac works is that you install the RTMac into one of your empty PCI slots on a G4 Mac. The RTMac has a "break-out box" that is essentially a box with all kinds of ports on it. Among these ports are input and output composite video (CVBS) jacks, S-video plugs, and RCA jacks for audio.

This means you can attach almost any playback device to the In, and then using FCP's File>Log and Capture…command, you can capture off the device. There really is no Logging and Batch Capturing since most non-DV devices are not accurate to the frame. However, it is nice to be able to capture off past footage directly without having to bother with additional transfers to DV.

On this breakout box are also several output options, including composite output on RCA connectors and S-video. RCA jacks are available for stereo audio output. These allow you to output your project as soon as

you are finished. You can also do this by connecting a VCR to your DV camera or deck, but working through the RTMac saves quite a bit of wear and tear on your camera. Speaking of saving wear and tear on your camera, you can also use this composite output to output directly to an NTSC monitor or TV—again, no need to go through your camera.

One of the most interesting features of this device is that it also includes a second computer monitor port. This means that you can hook another computer monitor up to your machine and have twice the desktop space. If you have never worked with a two-monitor setup, you haven't lived. It really is incredibly nice to be able to store tools and media in one window, and your Timeline, Viewer, and Canvas in another.

When you install the hardware for the RTMac, some software also needs to be installed on your system. In addition, FCP has a special set of tools that are only installed when you plan to use an RTMac.

All the input and output options are convenient, but the real benefit of the RTMac is the quantum leap in work productivity it provides. Without the RTMac, you can still get feedback through your NTSC monitor via your DV camera or deck; however, any transitions, layered effects, or drop shadows must be rendered. Although the new version of FCP provides some software-driven real-time effects, these are limited to the Canvas, and you still must render before being able to view on an NTSC monitor or output to tape. With the RTMac, the real-time aspects are truly real time. You see the results of your editing in both your Canvas window and on your NTSC monitor, giving you quick feedback on your project and the ability to output to tape at any time.

Among the truly real-time capabilities provided by the RTMac is a collection of transitions. You can work with two layers of video and one graphic layer, or two graphic layers and a video layer in real time. Even some powerful tools such as drop shadows, zoom, and clip rotation become real-time. Using the RTMac, you can even view color correction for a single frame on the NTSC monitor. It doesn't take long for your humble G4 outfitted with an RTMac to begin to feel like an editing station that costs tens of thousands of dollars more.

Just this type of real-time benefits is worth the cost of the RTMac alone. As projects become more intense, longer, and with larger sections of clips that require rendering, you can lose many hours—and thus, lots of money—waiting for something to render, only to decide that the timing is not quite right and you need to render again. With the RTMac, FCP truly becomes a powerful, streamlined, professional-grade editing tool.

Recently, the price on the RTMac has dropped precipitously, making it a tool that is not only powerful, but (at around $600 U.S.) completely

affordable. If you are the casual edit-my-vacation-video user, the RTMac might not be the tool for you. However, if you are serious about editing, the capabilities offered by the RTMac can pay for the unit itself in one or two jobs.

As a side note, the RTMac also includes some nice benefits if you use FCP in tandem with other packages such as Adobe After Effects or Discreet Combustion. True WYSIWYG capabilities help make the sometimes excruciatingly painful AE rendering times more manageable.

If you are interested in the Matrox RTMac, visit their Web site at *www.matrox.com*. More detailed sites include:

www.matrox.com/videoweb/home.htm (Information about all of Matrox's video editing solutions.)

www.matrox.com/videoweb/products/enduser/rtmac.htm (Page just about the Matrox RTMac.)

www.matrox.com/videoweb/products/enduser/rtmac_benefits.htm (Page outlining benefits of the RTMac.)

APPENDIX C

NOTES ON "RT" (REAL-TIME) EDITING IN FCP AND OFFLINERT

Among the new features touted by Apple at the release of the latest version of FCP (v 3.0.2) were "G4 Realtime Effects" and OfflineRT. RT (real-time) is the "Holy Grail" of software-based editing solutions. FCP, as probably the premiere software solution, does many things in RT that make it truly a powerful tool. You can place clips, reorganize them, and do quickcuts between them in absolute RT. If you are only using quickcuts, in fact, you can output at any time. However, as soon as you start using transitions, multiple layers, or video generated clips, the bliss of RT gives way to the drag of rendering.

Some hardware solutions have emerged to combat this rendering drag. Among them is the RTMac discussed in earlier appendices. However, having to buy new hardware hardly seems like a low-cost solution when you have just dropped $1,000 on buying the software. FCP's Realtime Effects and OfflineRT are aimed at rectifying this situation.

On the surface, G4 Realtime Effects, "If you can dream it you can do it—and see it right now," as Apple has on their Web site, seems a bit too good to be true. And to be frank, it is. Yes, some effects are truly RT in the Canvas. And yes, this means that things like a Cross Dissolve can be seen in RT as you work. If you have a really beefy G4, you can see things like Iris Transitions, Wipes, and Opacity, Scale, and Crop alterations.

This is where the too-good-to-be-true part comes in. The fine print on all of this is that many machines that mortals own—including G3s and most laptops—make little or no use of these software-based RT effects.

Further, RT in this case is kind of a misnomer, because you only get RT previews. This means that the effects are visible in the Canvas (which has value), but will not be RT on your NTSC monitor—which means that before you can output the project, you must render anyway.

Still, when you are in the throes of editing, being able to see an RT preview has immense value. You can see what things will look like and make changes based on the preview you see in your Canvas. Then, when you have everything looking close to what you want in the Canvas, you can leave for lunch or for the day and let FCP render everything out so that you can output. However, just be aware, that the "Holy Grail" has not been found quite yet.

The other highly touted area of the new FCP 3 is the idea of OfflineRT. This is really a great idea, especially if you are doing a lot of traveling or often work on a laptop. The idea behind this technology is that when you are Logging and Capturing with your DV camera or deck, you actually do not capture the full DV-NTSC clips to your hard drive. Rather, you capture a small "proxy" of the clip. That is, rather than a 720 x 280 file, FCP captures little 320 x 240 files using a type of JPEG compression. This means that you can get up to 40 minutes of footage on 1GB of hard drive space—a real help when traveling.

Using these low-res proxies, you can edit to your heart's content inside FCP. The editing is quick and easy to manage. Of course, you cannot see the results on an NTSC monitor as there is not sufficient resolution, but this solution is really aimed at traveling editing anyway. Then, the idea is that when you are finished creating and editing your project, you connect your DV camera or deck again and simply tell FCP that you are ready to do the "real thing." FCP then looks carefully at the proxies and the project you have edited, and then goes back to the original footage (on the DV camera/deck) and captures full-size footage for only the footage that made it to the final output. This requires a little babysitting because you need to stay close to the computer and swap tapes if you originally captured media on several reels, but after that, FCP does all the work for you. It will take this newly captured, full-size footage and compile it into your editing project by replacing the low-res versions.

If you have a good desktop computer with a decent media drive, it is probably not worth the effort to use the OfflineRT functions. However, if you are editing on the road, or are really limited on your hard drive space and do not use an NTSC monitor as you work, this is a great solution.

APPENDIX D

FINAL CUT PRO AND 3D ANIMATION

Earlier in the book, we looked at a tutorial (Goose's Control Room) that made use of some 3D animation. However, we did not talk extensively about the issues to consider when using FCP as an animation-editing tool.

Defining guidelines for using FCP with 3D animation is a slippery slope. Every 3D-animation software package has slightly different methods of outputting their rendering, and each method requires different strategies in FCP. However, there are some general issues to keep in mind if you are using FCP for editing 3D animation content.

- Always output at 720 x 480. Most 3D animation applications list full NTSC at 640 x 480, and others list DV-NTSC at 720 x 486, but look for ways to override that. Making sure to render at 720 x 480 from the start will help ease the process of bringing your rendered projects into FCP.
- If your 3D animation package allows for it, you might be able to render directly to DV-NTSC format. If you can do this, be sure to export at 29.97 fps. If you truly are able to export at DV-NTSC (720 x 480) at 29.97 fps, you can drop these renderings directly into FCP and edit away with no further rendering (besides transitions and effects) to have to worry about. However, if you can render at DV-NTSC, also consider the next suggestion when rendering.
- Always keep in mind the power of rendering sequential .tiffs. Sequential tiffs are a large collection of still images—one for each frame of animation. Other variations of this idea are sequential targas and sequential jpegs. The benefit of this idea is that 3D animation is usually

the process of 3D re-animation, and then re-animating again. However, with such a slow process of rendering a complex 3D-animation scene, re-rendering an entire scene could take hours or even days. If you have sequential tiffs, and you find that your character's hand is passing through the glass for six frames, you only need to re-render those six frames and replace the offending frames in your collection of sequential tiffs. This does mean that you must render your project in FCP; however, rendering a collection of sequential tiffs is usually faster than re-rendering an entire sequence in your 3D application.

Another benefit of sequential tiffs is that you have a high-res, completely lossless compressed version of every frame of your animation. No matter how you finally output your animation (VHS, Beta, Web, CD, etc.), you always have the highest quality version to go from. If you have put in the blood, sweat, and tears to create a 3D masterpiece, it is usually worthwhile to have a perfect rendering of it from which to work.

- If you plan to do compositing, master your 3D application's alpha channel functions. In Goose's Control Center, we worked with a couple of different file types. Some had alpha channels built in, and others had a sort of alpha map that defined what parts of the frame were to be transparent and which were to be opaque. Each 3D application handles the output of alpha channels a bit differently, but the principle is the same. Take some time to master the alpha channel output on your 3D application before trying to output complex projects. If you do not output to true alpha channels, you can end up with a clip with a black background that is impossible to get rid of without much pain and suffering. A little playing around with simple ball and box animations can save you immense amounts of time, and make the process of compositing 3D footage and real footage together a fun process.

Index

A

A, A+, and A++ Title menus, 292–293
Allocation of memory, OS 9.x, 16–17
All Tracks Forward tool, 252–253
Alpha Channels
 keying tutorial, 199–224
 preparation tutorial, 168–171
 tutorial, 185–199
Analog digitizers, 9
Analog video
 digitizing, 9
 quality of, 4
Angles, multiple Angles in Still menus, 342–344
Animation
 keyframes, 114–116
 menu loops, 290
 Sequences of stills, 189–196
 3D animation and FCP, 373–374
Aspect ratios, DVD and widescreen, 286–289
Assets, importing, 350
Attribute effects tutorial, 144–153
Audio
 Audio Filters, 158
 Audio Playback Quality settings, 28
 Audio Waveforms, 30
 clip placement, 71
 DVDSP formats for, 309
 editing audio levels, 256–258
 exporting audio files, 277–280
 fades, 256–258
 imported files, 28
 locking tracks, 75
 music sources, 66
 Real-Time Audio Mixing settings, 27–28
 speaker setup, 14
 track iconography explained, 71–72
 tracks in Master Clips, 129
 waveforms, 67
Audio Filters, 158
Audio Playback Quality settings, 28
Audio Transitions tools, 158
Audio/Video settings, 19
Auto-naming controls, 46–47
Autosave Vault, 29
Axonic, music source, 66

B

Backgrounds, keying tutorial (replacing backgrounds), 199–224
Bars, 268
Batch Capture dialog box, 57–58
Batch Export, 312–315
Batch Lists, 276–277
Bins
 adding new bins, 46
 creating, 52
 defined and described, 62

375

Black Matte for leaders and trailers, 264
Blue screen. *See* Keying tutorial
Blur/Zoom Blur filter, 163–165
Brightness, YUV signals, 3
Browser organization, 53–55
B Title menus, 292
Burning to discs, 359–362
Buttons
 defining, 337–340
 Dummy Buttons, 339–340
 hilites, 348–350
 opacity and color settings, 349–350
 Overlay Picture and placement of, 352–358
 in Still menus, 323–330

C

Cables and connections, 12–13
Cache settings, 28–29
Cameras, 7–8
 as digitizing devices, 12–14
 as VTRs (decks), 9
Canvas, 63–65
 Roll Edit tool and, 178–179
CapRen folders, organizing projects, 32–34
Capture cards, 3–4
"Capture" folder, 32
Capture Settings tab, 47, 49
Capturing
 defined and described, 41
 dropped frames, 29
 and logging in workflow, 38
 from non-DV sources, 367–368
 step-by-step, 52–57
CD-ROM contents, 365
Chapter stops, DVD, 289
Chroma-key. *See* Keying tutorial
Clip Overlays tools, 100
Clips
 defined and described, 62
 deleting with Ripple Delete, 172–173
 junk or trash clips, 51
 labeling, 31
 organizing in bins, 52
 resizing, 109–111

Clip Settings tab, 47
CODECs, 279–280
 storage and, 7
Color
 channels, 185–186
 DVD menu design, 296
Color Key filter, 203
Color settings, 146
Color Tint Filter, 159
Commentary tracks, 289–290
Compositing
 animation and, 374
 defined, 168
 multiple tracks tutorial, 95–105
Configuration, recommended settings for FCP, 18–24
Continuity, 51–52
Copy-paste process, 121–123
Countdowns, 270–272
Crop tool, 211–212
C Title menus, 292
Cutting Station option of User Mode tab, 29

D

Decks, 9–10
Defragging, 15–16
Diagramming, to learn design, 302–306
Digitizing video, 3–4
 analog digitizers, 9
Disk Utility, 15
Dissolves. *See* Transitions
Distort tool, 215–218
Distribution. *See* Output
Down arrows, 71
Drives, 6–7
 installing second drive, 15
 optimizing media drives, 15
 as Scratch Disks, 31
 segmenting drives, 15
 wiping with Disk Utility, 15–16
Drop frames (DF)
 defined and described, 39–40
 Drop Frame option, 30–31
Dropped frames, 29
Drop Shadow function, 145–146
Duration Calculator (Print to Video function), 272

Index

DVD
 audio options, 289–290
 chapter stops, 289
 color and menu design, 296
 commentary tracks, 289
 defined and described, 284–286
 design theory, 293–300
 history of medium, 284
 marketing and design elements, 291–292
 menu systems, 290–293
 multiple language tracks, 289
 Quality settings for Batch Export of files, 314–315
 typography and menu design, 295
 video options, 286–289
 see also DVD Studio Pro (DVDSP)
DVDSP. *See* DVD Studio Pro (DVDSP)
DVD Studio Pro (DVDSP)
 hilites, 348–350
 media formats, 308–317
 output tutorial, 359–362
 video stream export tutorial, 310–315
 see also Still menus

E

Easy Setup Options, accessing, 19
Edge Feather setting for Color Key, 205–209
Edge Thin setting for Color Key, 205–209
Edit Decision Lists (EDLs), 274–275
Editing
 All Tracks Forward tool, 252–253
 Alpha channel preparation tutorial, 168–171
 continuity and logging, 51
 history of, 2–3
 holes, Fit to Fill option, 83
 interviews, tutorial, 228–259
 multiple tracks, 92, 95–105
 Overlay options, 80–85
 Razor Blade tool, 253–255
 real-time and OfflineRT, 371–372
 resources to learn, 60
 ripple and roll edits, tutorial, 172–181
 Slide Edit tutorial, 181–185
 Slip Edit tutorial, 181–185
 subclip creation, 85–87
 SyncChina tutorial, 65–88
 3-point edits, 78–79
 Trim Edit windows, 178–181
 trimming clips, 75–78
 video transitions, 245–251
 see also Layers
Editing Overlay options, 80–85
EDLs (Edit Decision Lists), 274–275
Effects
 Browser effects tutorial, 157–165
 Drop Shadows, 145–146
 glows, 144–148
 Motion Blur, 145
Effects tab of Browser, 157–165
Equipment
 optional, 9–10
 specifications for hardware, 6–10
Exporting files
 audio files, 277–280
 Batch Export, 312–315
 Batch Lists, 276–277
 DVDSP-ready video stream export tutorial, 310–315
 EDLs (Edit Decision Lists), 274–275
 Final Cut Pro movies, 280
 general information, 280–282
 image sequences, 277–280
 MPEG files, 310
 packaging files for export, 310–312
 QuickTime movies, 277–280
 with QuickTime Pro, 316
 stills, 277–280
External drives, 15
External Editor tab, 31
External video warnings, 42–43
Eyedropper tool, 146

F

Fades
 audio, 256–258
 Clip Overlay tools, 100–103

Favorites folder, placing items in, 158
FCP (Final Cut Pro). *See* Final Cut Pro (FCP)
Filmstrip setting, 30
Filter / Motion Bars, 30
Filters
 Effect tab of Browser, 157–165
 Filter tab of Viewer, 111
 reorganizing, 160–161
 turning filters off, 161–162
Filters tab of Viewer, 111
Final Cut Pro (FCP)
 description and development of, 4–5
 settings, recommended, 18–24
Find Edges filter, 162–163
FireWire, 4–5
 audio channels, 14
 cables and connections, 12–13
 drives and, 7
Fit to Fill Overlay Edit option, 82–85
Fonts, DVD menu design, 295
Frame speed, reduced speed clips, 83–84

G
General tab of Preferences, 26–29
Glows, adding, 144–148
Green screen. *See* Keying tutorial

H
Handles, Pen tool to create and edit, 256–257
Hard drives, 6–7
Hardware
 cameras, 7–8
 computer CPU, 6
 drives and storage, 6–7
 Matrox RTMac, 367–369
 see also Hardware setups
Hardware setups
 for quick output to tape, 262–263
 step-by-step, 12–14
 two-monitor setups, 368
Hilites, DVD Studio Pro, 348–350

Holes
 Fit to Fill editing option, 83
 Sequence cleanup tutorial, 153–157

I
IBooks, external drives, 6–7
IDisk, 323
IDVD, 308
IE 1394. *See* FireWire
ILink. *See* FireWire
IMacs, external drives, 6–7
Image Display Area, 112–114
Importing files
 Audio Playback Quality and, 28
 mp3s, 229
 stills, preferences set for, 186–187
In and Out points, 51
 marking during logging, 45
 placing, 74
Insert Keyframe button, 244
Insert tool, 65
Interface organization, 62–65
Interviews, tutorial on creating, 228–259

J
Jog controls, 44–45

K
Keyboard shortcuts
 multiple clip selection, 55–57
 nesting items, 133
 VTR controls, 44–45
Keyframes
 adding, 116, 118
 defined and described, 114–116
 Insert Keyframe button, 244
Keying tutorial, 199–224

L
Labels and labeling
 quality Labels, 53–54, 55
 tapes, 51
Labels tab, 31
Layers
 Clip Overlay tools, 100–101
 compositing, 95–105

creating dynamic movement with, 107–126
Layers Always Visible setting, 336–337
multiple tracks, 92, 95–105
spacer layers "-", 327–329
Superimpose Overlay Edit, 104
texture layers in Browser Effects, 159
Leader (Print to Video function), 269–272
Leaders and trailers, adding, 264
Light sources, virtual, 144–148
Linear editing, 2
Log and Capture window, 42–45
Log Clip button, 47, 50
Logging
 bins, 46
 and capturing in workflow, 38
 clip information, 45–46
 continuity and, 51–52
 defined and described, 40–41
 effective practices, 41–51
 excess footage, 51
 marking ins and outs, 45
 step-by-step FCP logging, 42, 47–51
 VTR controls, 44–45
Logging tab, 45–47
Looping, 272

M

Marker controls, 47
Markers
 defined and described, 68
 naming, 170
 snapping to, 130–131
Mark Good option, 46
Mark In and Mark Out buttons, 45
Master Sequence, opening, 128
Matrox RTMac, 367–369
Mattes
 Black matte for leaders and trailers, 264
 creating, 219–222
Media (Print to Video function), 272
Memory
 allocation for OS 9.x, 16–17
 memory control panel, 17
 multiple undos and, 26–27
 Virtual Memory, 17–18
Menus, DVD, 290–306
 animated (loops), 290
 consistency of design, 305–306
 diagramming to learn design, 302–306
 main menu, schematic and plan for, 320–321
 Motion menus, defined and described, 321
 rollovers in, 290–291
 title categories, 292–293
 see also Motion menus; Still menus
Messages, external video warnings, 42–43
Mixing, Real-Time Audio mixing settings, 27–28
Monitors
 NTSC, 9, 12–13
 setups for, 12–13, 368
Montages
 Montage sequences, 95
 see also Stills
Motion Blur, 145, 148–153
Motion menus
 creation tutorial, 348–352
 defined and described, 321
 Overlay Picture tutorial, 352–359
Motion Paths, 116–118
Motion tab of Viewer, 111–112, 145
MPEG video streams, 309
Music, sources of, 66, 229, 332

N

Names and naming conventions
 Auto-naming controls, 46–47
 for clips, 51
 markers, naming, 170
Nesting Sequences, 61–62
 tutorial, 133–143
Nest Items function, 133–134
Non-drop frame (NDF), 39–40
Non-DV sources, capturing from, 367–369

Non-linear editing, described, 3
NTSC monitors, 9, 12–13
NTSC standards, 3
 Drop Frame option and, 40

O
OfflineRT editing, 371–372
Opacity control, 100–101
Organization in FCP
 bins, 62
 interface organization, 62–65
 Project files, 60
 sequence organizing tutorial, 94–95
 Sequences, 61–62
 sequences within sequences, 128–132
Organization of Sequences
 sequence organizing tutorial, 94–95
 Sequences, 61–62
 sequences within sequences, 128–132
OSX, 17, 360–361
OS 9.x, memory allocation, 16–17
Output
 Batch List exports, 276–277
 burning discs, 359–362
 DVD Studio Pro output tutorial, 359–362
 Edit to Tape method, 273
 exporting EDLs, 274–275
 General settings and, 333–334
 media presets, 278
 Print to Video, 269–273
 Recording Timeline Playback method, 262–269
 Region Codes, 333–334
 for 3D animation, 373
 to Web, 277–280
Overlay Edits options, 80–85, 246–248
Overlay Picture tutorial, 352–359
Overwrites, 71
Overwrite tool, 65

P
Pan & scan reformatting, 287–289
Paste process, 121–123

Pen tool, 102–103, 257
Photoshop (Adobe), still menu tutorial, 321–331
Playback Head, 62
Preferences
 General tab, 26–29
 reverting to factory settings, 25
 settings adjustments to, 24–32
Presets
 adjusting, 22–23
 Easy Setup options, 19
Print to Video for output, 269–273
Project files, 60
 organizing, step-by-step, 32–34
Property Inspector tool, 332–333

Q
QuickTime movies, exporting, 277–280, 316

R
RAM, specifications for, 6
Razor Blade tool, 253–255
Real-Time Audio Mixing settings, 27–28
Realtime Effects, 371–372
Recording Timeline Playback, 262–269
 step-by-step preparation, 267–268
Reference Movies, 280
Remote-Control settings, 358–359
Render Files, 197–199
Rendering, 84, 105
 alternatives to, 119
 animation, 373–374
 effects filters and, 160
 Render Files, 197–199
 Render Quality settings, 266–267
 stills, 251–252, 255
Replace tool, 65
Resizing clips, 109–111
Ripple Delete, 172–173
Ripple Edit tool, 173–176
Roll Edit tool, 176–181
Rollovers in menus, 290–291
RT Still Cache, 28–29

S

Saving, AutoSave Vault, 29
Scratch Disks and Scratch Disks tab, 31–32
 organizing projects, 32–34
Security, 333–334
Selection tool, 75–78
Sequence Preset, 22
Sequences, 61–62
 Attribute effects tutorial, 144–153
 automatic edit updates, 142
 cleanup tutorial, 153–157
 deleting tracks in, 140
 exporting image sequences, 277–280
 layering and multiple tracks, 93–105
 Master sequences, 94–95
 Montage sequences, 95
 nesting Sequences tutorial, 133–143
 opening in Viewer, 148–149
 opening Master Sequence, 128
 placing sequences within sequences, tutorial, 128–132
 Starting Cuts, 129
 Wireframe mode and, 136
 see also Sequences, organization of
Sequences, organization of
 sequence organizing tutorial, 94–95
 Sequences, 61–62
 sequences within sequences, 128–132
Setup
 Easy Setup options, 19
 FCP recommended settings, 18–24
 hardware setups, 12–14, 262–263, 368
Shadows, creating, 212–218
Shuttle controls, 44
Sizing, rescaling with Wireframe, 210
Slate, 268–269, 270
Slate buttons, 46

Slide Edits (slide items) tutorial, 181–185
Slip Edits (slip items) tutorial, 181–185
Slugs, 119–121
Solarize Effect, 159
Sound. *See* Audio
Speakers, set up, 14
Starting Cuts, 129
Still / Freeze Duration preference, 231
Still menus
 defined and described, 320
 multiple Angles in, 342–344
 Photoshop still menu tutorial, 321–331
 setting up, tutorial, 331–344
Stills
 animating, 234–242
 copying, 189–190
 duration settings, 231
 exporting, 277–280
 importing, 186–187
 panning, 239–242
 rendering, 251–252, 255
Storage
 drive installation, 15
 DVD capacity, 285–286
 estimating requirements, 7
 memory allocation for OS 9.x, 16–17
 minimum requirements, 6–7
Subclips, creating, 85–87
Subtitles, 289, 358
Summary Tab of Audio/Video settings, 22
Superimpose Overlay Edit, 104, 233
Sync Adjust Movies Over settings, 27
Synching
 adjusting mis-synced clips with Roll Edit tool, 176–181
 Sync Adjust Movies Over settings, 27
 sync markers, placing, 67–70

T

Tabs, disappearing, 25
3-point edits, 78–79

Thumbnail Caches, 28–29
Thumbnail Display settings, 30
Timecode breaks, 27
 defined and described, 39
 EDLs and, 275
Timecodes, 62
 defined and described, 38
Timeline, 62
 placing Sequences or clips in, 131–132
 Recording Timeline Playback for output, 262–269
 Snapping Toggle, 182
Timeline options and Timeline Options tab, 30–31, 39–40
Title Safe Zone, 113–114
Tolerance setting for Color Key, 205–209
Tones, 268–269
Tracks
 audio tracks, 71–72, 75
 copying and pasting, 121–123
 deleting video tracks, 140
 in menus, 340–342
 multiple language tracks on DVD, 289
 multiple tracks and keyframes tutorial, 107–126
Trailer (Print to Video function), 272
Trailers, 264, 272
Transitions
 changing default video transition setting, 249
 during DVD navigation, 311–312
 EDLs and, 275
 between menus, 290
 placing, 245–248
 tips for video transitions, 248–251
 Video Transitions folder, 245–251, 258
Transport controls, 44
Travel Mattes, 219–222
Trim Edit windows, 178–181
Trimming clips, 75–78
Troubleshooting
 disappearing tabs and windows, 25
 preferences, reverting to factory settings, 25
Typography, DVD menu design, 295

U
Undo, multiple undos, 26–27
User Mode tab, 29

V
VHS tapes, quality issues, 262–263
Video Generators bin, 158
Video tab of Viewer, 111
Video Transitions folder, 158, 245–251, 258
Viewer, 62–63
 tabs described, 111–112
Virtual Memory, 17–18
VTRs, 9–10

W
Waveforms, 30, 67
Web addresses
 Axonic, 66
 camera information, 7
 iDisk (Apple), 332
 Matrox RTMac, 369
 Navy music source, 229
Widescreen format, 286–289
Windows, disappearing, 25
Wireframe mode
 rescaling with, 210
 Sequences and, 136
Wireframes in FCP, 110–111

Y
YUV signals, 3

Z
Zoom Blur filter, 163–165
Zoom Control tool, 67
Zooming on stills, 234
Zoom Slider tool, 67